A Journey Through
Literary America

A Journey Through
Literary America

Thomas R. Hummel

Photography by

Tamra L. Dempsey

Published by **Val De Grâce Books**

Napa, California

VAL DE GRÂCE BOOKS
Napa, CA

All rights reserved. Published 2009.
First Edition

Printed by Toppan Printing Company (SZ) Ltd., China

12 11 10 09 1 2 3 4 5

ISBN: 978-0-9817425-1-9

Library of Congress Control Number: 2009-930059

Credits

"Nothing Gold Can Stay" and excerpts from "My Butterfly," "New Hampshire" and "Birches" from THE POETRY OF ROBERT FROST edited by Edward Connery Lathem. Henry Holt and Company, © 1923, 1934, 1969 by Henry Holt and Company. © 1944, 1951, 1962 by Robert Frost. Reprinted by arrangement with Henry Holt and Company, LLC.

Photo on page 129: "Filming 'Conquest of Canaan' movie at Pack Square, Asheville, NC, 1921" [Herbert Pelton, Photographer]. E. M. Ball Collection, D. H. Ramsey Library Special Collections, University of North Carolina Asheville, 28804.

Hand-drawn map on page 120 of Yoknapatawpha County from ABSALOM, ABSALOM! by William Faulkner, © 1936 by William Faulkner and renewed 1964 by Estelle Faulkner and Jill Faulkner Summers. Used by permission of Random House, Inc.

Hand-drawn map on page 142 of "Zenith – Blocks most familiar to Babbitt" © 2009 JP Morgan Chase, Administrator de Bonis Non, Estate of Sinclair Lewis.

"The Zeppelin Factory," "Under the Viaduct, 1932," and "Gospel" from THOMAS AND BEULAH, Carnegie Mellon University Press, © 1986 by Rita Dove. Reprinted by permission of the author.

"Silos" from GRACE NOTES, W. W. Norton & Co., Inc., © 1989 by Rita Dove. Reprinted by permission of the author.

Website: www.literaryamerica.net

For Rika, who believed.
And for Felix, who has not learned his ABC's
but who will one day read this.

~ Thomas R. Hummel

and

To Decker, Laurel and Maryn,
in memory of your grandfather, George Phillip Dempsey,
who bestowed upon me his reverence for America.
I hope it shows. May this book honor his legacy
into your generation and beyond.

~ Tamra L. Dempsey

A Journey Through
Literary America

*O*N THE MONTH THIS BOOK comes out it will be 13 years since I packed all my belongings into a pale yellow Volvo whose undercarriage was perforated by rust, and left my home state of Vermont to seek my fortune on the West Coast. With me was my intrepid cat, Xerox. On the way, I stopped and picked up a friend in Washington, D.C. He took to calling my car "the Beater"—not for its weak engine but for its air of having had harsh masters before me. We made the cross-country trip in, as I recall, four days, and that includes an unscheduled stop in New Mexico where the Beater temporarily quit. I didn't have much money and getting to point B trumped sightseeing. When I arrived in California, the contents of my trunk were covered with a thick layer of dust from the road.

In hindsight, I believe I was acting out a pattern of restlessness Alexis de Toqueville had noticed among my countrymen and women as early as 1835. In *Democracy in America* he described it thus:

> Born often under another sky…himself driven by the irresistible torrent which draws all about him, the American has no time to tie himself to anything, he grows accustomed only to change, and ends by regarding it as the natural state of man. He feels the need of it, more he loves it; for the instability; instead of meaning disaster to him, seems to give birth only to miracles all about him.

That being said, I don't think my urge to travel came from my American mother, who believes in staying rooted, but from my German father, who came to this country in 1957, learned English, and taught literature, both English and American, for over three decades. His wanderlust was appeased by having a family and by the green mountains of Vermont. Finding a spot and putting down roots is also an American tendency—one that de Toqueville perhaps didn't stay long enough to discover.

For a time, I stayed with my younger brother, another recent migrant, who lived in an unheated guest house—little more than four walls and a roof with some halfhearted plumbing thrown in—behind a sizeable, almost palatial, house in Pasadena. And during those first jobless days I began reading Raymond Chandler, whose novels I had picked up at a used bookstore in Middlebury, Vermont. I will never know whether Chandler's detective stories created my perception of Los Angeles' glamour, diffused light, and world weariness—or whether he simply enhanced my own sense of the place. To read Chandler as a newcomer to Los Angeles was to assemble the pieces of the sprawl I inhabited into the form of an enthralling city. There was no longer any interurban train, whose red cars ran everywhere in his day. There were no more orange groves on Orange Grove Boulevard. But the rich still took refuge in Beverly Hills and Bel Air and Pasadena, in houses like the one I briefly lived behind with my brother. The hillsides smelled like sage, and oil wells bobbed oddly up and down within the city limits. Raymond Chandler-era art deco buildings stood here and there, like stepping-stones across a stream. I had never felt the intersection of literature and place more keenly.

California turned out to be the land of (moderate) opportunity for me. A month into my sojourn, while applying at a Japanese recruiting agency (I had no Japanese language skills and had simply wandered in) I mentioned that I was interested in writing and publishing. A year later, my name came up at the agency in a word search for "publishing" and I was called in for an interview. I ended up landing a job at the West Coast office of Toppan—a Japanese printer of coffee table and art books. Not what I had had in mind when I talked to the recruiter, but a nice example of happenstance. During the next 10 years at Toppan I printed a lot of books for other people. I occasionally and unsuccessfully racked my brain to come up with a book idea that I could contribute to.

When the idea for this book finally came, it was after a bout of reading *American Pastoral* by Philip Roth—a book with vivid descriptions of Newark, New Jersey. My concept, such as it was,

was as plain as day: to produce a coffee table book, with strong writing, on the places that America's great writers had described in their own words. Once I'd had the idea, I was hooked. And I felt keenly, for the second time, the import of that intersection of literature and locale.

It took me a while to mention the book to Tamra Dempsey, who had been a client for as long as I had worked at Toppan. I did so almost casually, thinking she might be interested in a minor role, perhaps to take some of the photographs for authors along the West Coast. Instead, she wanted to shoot the entire project. And thus, a partnership was born.

We assembled a list of 50 authors who wrote with a descriptive sense of place. That list got edited down to 35, and then whittled down some more once Tamra started to work out the logistics of driving to all of the locations. Many exceptional authors were left off the final list. There are several others we discovered along the way but could not, for reasons of time and money, include. One of my deep regrets is that Raymond Chandler is not included. In the end he turned out to be too close to home. We saved him for last and, by the time we started assembling the book, we realized we had overshot our mark in terms of pages. We had too much on our hands without him. I have no doubt that every reader of this book will find gaps they would fill or writers they would substitute. We have made a serious attempt to include a breadth of voices. We don't expect that everyone will agree with our choices, for such is the nature of lists.

In order to make the great loop through the United States that she had planned, Tamra took a three-month sabbatical from work. I, who did not have the luxury of a big chunk of time, did most of my visits to the literary sites on weekends, occasionally on weekdays, often flying to the nearest airport and then driving for hours to the site, only to turn around the next day and repeat the whole thing in reverse. I am not complaining. Part of the journey was getting there.

Once Tamra left on her circuit, the enormity of the project really struck home. If there was a "point of no return," I think that was it. I did not hear from her every day, but we talked often. I had given her a shot list based on my research but she did a lot of research of her own at the locations and on the road

itself. It is remarkable to see what kinds of photographs she was able to get when she only had, at maximum, two days in any one locale. America's literary places really put on their best faces.

When we talked about what she had gleaned, our discussion usually was about whether the lineup of photographs for each author "told a story." From the first, we had the understanding that *A Journey Through Literary America* was not about documenting literary sites but about making you, the reader, see the places that inspired these authors, from as close to the perspective of the authors as possible. I feel very fortunate to have worked on this book with Tamra: loyal friend, close reader, resourceful traveler, who put over 15,000 miles on her Airstream Interstate in pursuit of this book. So many times she captured through her lens what I was trying to describe in words, and just as often she came across things that I hadn't even realized were there. She also designed this book. Its look is her vision, realized.

I would also like to pay tribute to the dedicated librarians, site directors, and guides that we have met throughout the journey. This project had not been commissioned by a major publisher (nor any publisher, really) and yet they took us seriously, made time for us and shared their knowledge. Their energy fed ours. And sometimes we happened upon things that seemed to be signs that we were on the right track: at the public library in Clyde, Ohio, for example, the names of many of the early authors that appear in this book were carved into the eaves in granite. In Reading, Pennsylvania, while Tamra was photographing a home, a woman came out and inquired what she was working on. She then informed Tamra that the house that had moved her to stop and take pictures was the one that had been used as Rabbit's house in the 1970 filming of *Rabbit, Run*.

Close to home, the Santa Monica Public Library was a tremendous resource. They did not always have the most recent biography of an author (though they often did) but I discovered that sometimes the older biographies, written closer to the time when the author actually lived (and sometimes featuring slightly antiquated tones), helped me capture a mood. Research, especially for a book like this, is serendipitous. And that is why I also want to acknowledge Google and, more broadly, the Internet as a tremendous resource. Google showed an uncanny

ability to turn up relevant links. And the controversial Google Books program proved to be a godsend time and time again: for checking quotes, for finding books that were neither in print nor on the library shelves, and simply for panning for nuggets.

American literature, though less than three centuries old, already has a tremendous range. In fact I would say the literature of the United States defies generalization. But without a doubt two themes have emerged from our journey:

1) That there is something out there in the American wilderness on the edges of our encroachments. It awes us and, at times, frightens us. It has been so since the beginning of literary time in this country. I felt it most strongly up in the mountains of the Catskills where this book begins.

2) That, with very few exceptions, the authors in this book never stopped puzzling over, figuring out, and often yearning for the place and manner in which they grew up. In *On Native Ground*, Alfred Kazin noted: "The greatest single fact about our modern American literature [is] our writers' absorption in every last detail of their American world together with their deep and subtle alienation from it." This book is full of that absorption, which often originates with place. The deep and subtle alienation comes, I think, with being a writer.

The words *motion* and *emotion* come from the same Latin root of motus, "to move." And much of the power and passion in the stories in this book derive from motion and the consequences of it. Long after de Toqueville passed away, Americans continued to do as he had observed. The literature of the United States would be much less rich without the relentless traveling and relocation that have gone on across its length and breadth.

Personally, I felt the thrill of motion every time I got out on the road for this book. After I started visiting the cities and towns that were part of my research, I even began to feel like a serial adulterer of place. I found myself imagining new existences in many towns and cities—from Oxford, Mississippi to Reading, Pennsylvania, to locales in New Jersey, to the Ohio communities like Lorain, or Clyde, to Santa Fe, New Mexico, and to the tip of Washington State. Well, I had talented guides: gifted writers who were moved by these places. Travel seemed to awaken de Toqueville's American in me, so I used that restless adaptability, and hunger for miracles, to try and see as fully as I could through the eyes of the writers in this book. At the same time, though, I developed an even more profound and bittersweet attachment to the achingly beautiful state of Vermont that I had departed from when I was young and still so unsatisfied. My roots are in the East and, despite everything Wallace Stegner said about embracing a Western aesthetic, I simply can't fully commit.

It was revealing to crisscross the United States through what turned out to be the height of the real estate bubble, and through two years of an historic presidential campaign during which much talk was devoted to that question of what it means to be an American. American flags abounded. People had money. New shopping centers had cropped up between towns and cities, and numerous large vehicles trawled the roads. The American Dream, it seemed, was being lived all over the United States. It set one to thinking about the relative poverty in which most of the authors in this book toiled before achieving success, the struggles they faced. What a pleasure beyond wealth it was for them to be able to write and, for that matter, to read. I have felt it myself, deeply, for the past two and a half years.

There is much talk about a return to values now that the economy has crashed. (This kind of talk always surfaces after eras of extreme cupidity and usually lasts for about as long as it takes for the economy to regain its swagger.) How do we know what those values are? They can be found in the works of the writers in this book. Reading is inexpensive. So is writing. And, at the height of its art, writing can illuminate life—and place—with a stunning radiance. I hope this book induces more people to experience this country's literature, in all its wonder, its occasional despair, redemption, and sense of place. ✍

Thomas R. Hummel
Santa Monica, California
July 2009

"But the place I mean is next to the river, where one of the ridges juts
out a little from the rest, and where the rocks fall, for the best part of
a thousand feet, so much up and down, that a man standing on their
edges is fool enough to think he can jump from top to bottom."

"What do you see when you get there?" asked Edwards.

"Creation," said Natty, dropping the end of his rod into the
water, and sweeping one hand around him in a circle: "all creation, lad."

— James Fenimore Cooper
The Pioneers, 1823

The glittering line of the **Hudson River** at dawn, as seen from the jagged cliffs of the Escarpment.
From this point Leatherstocking (Natty) fancied he could see "all creation." — Catskill Mountains, New York

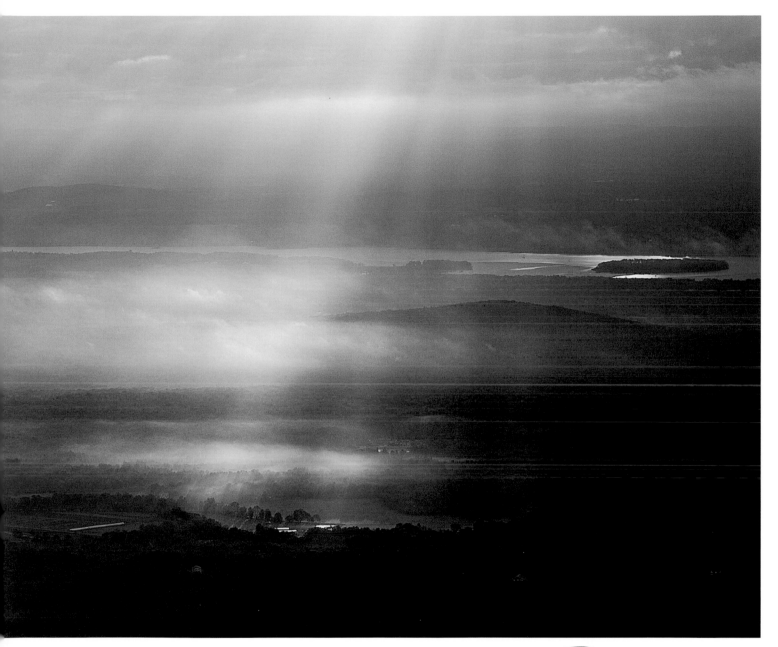

BEGINNINGS

Washington Irving & James Fenimore Cooper

WASHINGTON IRVING (1783-1859)
& JAMES FENIMORE COOPER (1789-1851)

In the beginning, there were the woods. In the beginning, there were isolated lakes, swift-flowing streams, hidden cataracts, rocky promontories and mysterious glens. They were all set deep in the virgin forest, so overgrown that the day was as dim as dusk because the crowns of the trees spread so close together. In the beginning, there were native peoples, swiftly identified by Europeans as savages, who traveled in eerie noiselessness among the trees, silently paddled the waters, and had attached names and legends to every odd-shaped rock or outcropping.

In its spring and summer abundance, the New World was like an answer to a prayer. The streams seethed with fish. Rivers were named for the tribes that lived by them: the Mohawk, the Susquehanna, the Iroquois, the Missouri, the Potomac. They flowed in their channels through the thick forest unimpeded except by the occasional logjam of giant fallen trees. Here there was enough timber to build a thousand stockades and a million chapels. The soil enriched by the river deposits was fertile. Game was plentiful.

Many of the early settlers to these shores thanked God for this. They had come to the New World to exercise their religious freedoms. As Robert Spiller suggests in *The Cycle of American Literature*, the bounty they found affirmed their mission. The wealth they derived from it confirmed their rightness. "Perhaps in the beginning of American civilization can be found a clue to the incongruous mixture of naïve idealism and crude materialism that produced in later years a literature of beauty, irony, affirmation, and despair,"[1] Spiller writes. It is tantalizing but not a little disturbing to think that the attitudes and beliefs of over three centuries ago have been passed on, like DNA, in the hearts and minds of those who followed.

How the Town of New Amsterdam Rose Out of the Mud

"The Indian traditions," Diedrich Knickerbocker writes in *A History of New York from the Beginning of the World to the End of the Dutch Dynasty*, "affirm that the bay was once a translucid lake, filled with silver and golden fish, in the midst of which lay this beautiful island, covered with every variety of fruits and flowers; but that the sudden irruption of the Hudson laid waste these blissful scenes, and Manetho [the Indian god Manitou] took his flight beyond the great waters of Ontario."[2] In 1609, many hundreds of years after Manetho migrated north, Henry Hudson happened upon the selfsame island and its remarkable properties seemed to have been restored. Hudson's first mate, Robert Juet, recorded that the island was "as pleasant with Grasse and Flowers, and goodly Trees, as ever they had seene, and very sweet smells came from them."

The island, of course, was Manhattan. And in the late 1700's, when Washington Irving was born, it was rapidly overtaking Philadelphia as the most populous place in America. Irving was named after the great hero of the recent Revolutionary War. His father was Scottish and pious. His mother was Dutch and fruitful. Washington was one of the eight of the eleven Irving children who survived and he was incorrigible. "Ah, Washington, if you were only good!" was his mother's lament.

In 1809 Irving stepped onto the literary stage in the guise of Diedrich Knickerbocker. According to the fictitious notices at the beginning of the book, the *History* was part of the secretive project left behind by the crotchety, inquisitive old Diedrich Knickerbocker. Knickerbocker had vanished, last seen wearing a fatigued expression on the stagecoach route towards Albany, his last known address the Independent Columbian Hotel on Mulberry Street in Manhattan, where his landlord came upon the manuscript. The good innkeeper had been forced to publish the book in order to cover the old man's debt. This was the first

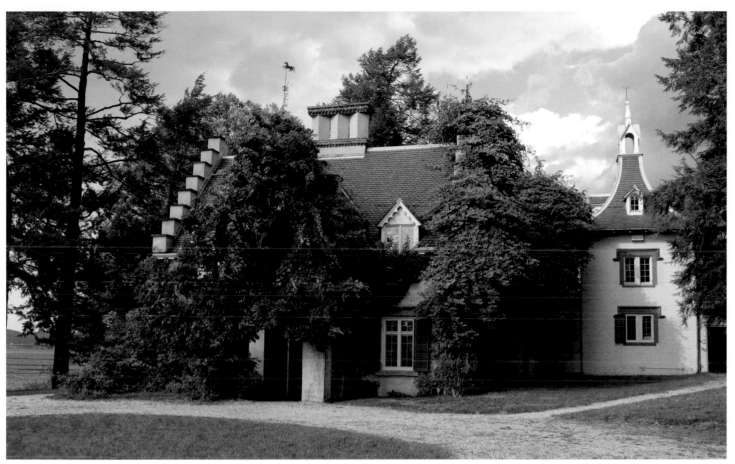

Washington Irving's home - **Sunnyside** - is still standing, just south of the Tappan Zee Bridge. Before Irving purchased it, the house belonged to 18th-century colonialist Wolfert Acker, about whom Irving wrote his sketch "Wolfert's Roost." — Tarrytown, New York

appearance in American literature of a mad genius character toiling away in obscurity on his undiscovered masterwork. It was the first disappearance of one as well. But though the imaginary Diedrich Knickerbocker had vanished, his creator, Washington Irving, was definitely here to stay.

The rest of American literary history, one might say, follows the *History*. It became the first American literary sensation, giving citizens a reason for pride in their native literature and making Washington Irving an early literary icon. The sacred playground of Manetho proved to be good for growing things other than flowers and trees. It has become one of the great cities of the world and the capitol of the publishing industry. Manhattan is the pushing-off point on the journey through literary America.

One Vast Expanse of Woods

Broad belts of virgin wilderness not only reached the shores of the first river, but they even crossed it, stretching away into New England, and affording forest covers to the noiseless moccasin of the native warrior as he trod the secret and bloody war-path. A bird's eye view of the whole region east of the Mississippi must then have offered one vast expanse of woods, relieved by a comparatively narrow fringe of cultivation along the sea, dotted by the glittering surfaces of lakes, and intersected by the waving lines of river. (James Fenimore Cooper, *The Deerslayer*)[3]

The first waving line of river in the American literary imagination was the Hudson. It has its source in Lake Tear of The

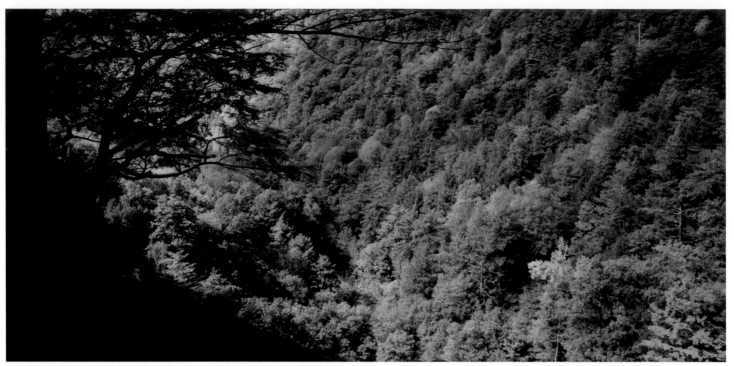

The Catskill Mountains, New York

"...and none know how often the hand of God is seen in the wilderness."
— James Fenimore Cooper, *The Pioneers*, 1823

Clouds, in the recesses of the Adirondacks, from which it tumbles, broadens, deepens, accepts its due from freshwater tributaries and mingles with the salt waters of the Atlantic. The Hudson River's journey, in reverse, was the route that Henry Hudson followed in 1609, and the path that many other white men after him utilized as a way to penetrate into the interior of the country for trapping and fishing, and trading with the Native Americans.

The second chronicler of that river, and the broad belt of woods that surrounded it, was James Fenimore Cooper. By the time his first novel came out, a significant portion of the forest had been cleared and settled. Many of the Indians had been routed out. James Fenimore Cooper was born to a frontiersman who bought a large parcel of wilderness on Otsego Lake in upstate New York. Cooper's father cleared it, built himself an estate, and established a settlement where the present day Cooperstown, home of the Baseball Hall of Fame, now stands. Cooper's father, apparently, was a man of formidable strength,

who "often left his magnificent home at Otsego Hall to show his prowess as a wrestler in some neighboring shanty and who was killed by a political opponent."[4]

In his imagination, James Fenimore Cooper cast back to a New World before the encroachment of settlers. His most enduring character is Leatherstocking, who goes by the name Deerslayer in *The Deerslayer* (and by other names in the other books), and carries in him what Cooper believed to be the best attributes of the Indian and white worlds. "Removed from nearly all the temptations of civilized life, placed in the best associations of that which is deemed savage, and favorably disposed by nature to improve such advantages,"[5] Deerslayer was, in the author's own words, a "seed scattered by the wayside" that had flourished.

Leatherstocking was the first backwoodsman in American fiction to consciously renounce civilization, and the first to bear witness to the inevitable settling of the once vast wilderness. He was the original rugged individualist in American literature, a

man who had never read a book in his life but had amassed all he knew through experience. At a time when the young country was ripe for a literary hero of American proportions, James Fenimore Cooper supplied one.

In those early days of his writing, Cooper was convinced that American scenery had no rival. At his best, Cooper was said to "paint" scenery with his pen as well as others painted with a brush. The landscape that Cooper introduced in the early Leatherstocking novels was one of staggering natural beauty.

The Fairy Region of the Hudson

If one were ignorant of Deerslayer's famous reclusiveness, it would be easy to imagine that he was the Indian trader on the sloop traveling slowly up the Hudson that Washington Irving met when he was a boy:

> Among the passengers on board the sloop was a veteran Indian trader, on his way to the Lakes, to traffic with the natives. He had discovered my propensity and amused himself throughout the voyage by telling me Indian legends and grotesque stories about every noted place on the river, such as Spuyten Devil Creek, the Tappan Zee, the Devil's Dans Kammer, and other hobgoblin places. The Catskill Mountains, especially, called forth a host of fanciful traditions....All these were doled out to me as I lay on deck, throughout a long summer's day, gazing upon these mountains, the everchanging shapes and hues of which appeared to realize the magical influences in question. Sometimes they seemed to approach; at others to recede; during the heat of the day they almost melted into a sultry haze; as the day declined they deepened in tone; their summits were brightened by the last rays of the sun, and later in the evening their whole outline was printed in deep purple against an amber sky. As I beheld them, thus shifting continually before my eye, and listened to the marvelous legends of the trader, a host of fanciful notions concerning them was conjured into my brain, which have haunted it ever since.[6]

By the time Washington Irving was old enough to wear long pants, the Dutch settlers of New Amsterdam had already spread north along the Hudson. Other settlers followed. Engravings from the time show that small towns had taken root in clefts and coves along the river's banks like clusters of wildflowers that bloom in protected nooks and crannies along a mountain trail. It was many years later, while living in England, that Irving wrote about the region that he had passed by as a boy. In *The Sketch Book of Geoffrey Crayon*, he introduced the world to Rip Van Winkle.

The tales of the old Indian trader seem like a plausible source of his inspiration and should, in the absence of any other evidence, be believed. But it also seems possible that Irving came by his considerable gifts in some more supernatural way when, as a youth, he found himself in North Tarry Town after dark. No town in the Catskills was more spellbound than North Tarry Town (the town officially changed its name to Sleepy Hollow in 1997), as Irving suggests in the story of Ichabod Crane and the Headless Horseman who issued forth from the graveyard each night in search of his missing head:

> I recollect that, when a stripling, my first exploit in squirrel-shooting was in a grove of tall walnut-trees that shades one side of the valley. I had wandered into it at noon time, when all nature is peculiarly quiet, and was startled by the roar of my own gun, as it broke the Sabbath stillness around, and was prolonged and reverberated by the angry echoes. If ever I should wish for a retreat, whither I might steal from the world and its distractions, and dream quietly away the remnant of a troubled life, I know of none more promising than this little valley....
>
> From the listless repose of the place, and the peculiar character of its inhabitants, who are descendants from the original Dutch settlers, this sequestered glen has long been known by the name of SLEEPY HOLLOW, and its rustic lads are called the Sleepy Hollow Boys throughout all the neighboring country. A drowsy, dreamy influence seems to hang over the land, and to pervade the very atmosphere. Some say that the place was bewitched by a high German doctor, during the early days of the settlement; others, that an old Indian chief, the prophet or wizard of his tribe, held his pow-wows there before the country was discovered by Master Hendrick Hudson. Certain it is, the place still continues under the sway of some witching power, that holds a spell over the minds

of the good people, causing them to walk in a continual reverie. They are given to all kinds of marvellous beliefs; are subject to trances and visions; and frequently see strange sights, and hear music and voices in the air....It is remarkable that the visionary propensity I have mentioned is not confined to the native inhabitants of the valley, but is unconsciously imbibed by every one who resides there for a time. However wide awake they may have been before they entered that sleepy region, they are sure, in a little time, to inhale the witching influence of the air, and begin to grow imaginative—to dream dreams, and see apparitions.[7]

As Irving described so well, the landscape along the Hudson has an air of enigmatic changefulness. The brow of Storm King Mountain can darken like the face of a wrathful god and, just a few minutes later, as a gust ushers away the wisps of rain, can look as serene as a sleeping baby. The breeze starts and stops like it is alive. It certainly is something to unsettle the imagination. The mind plays tricks.

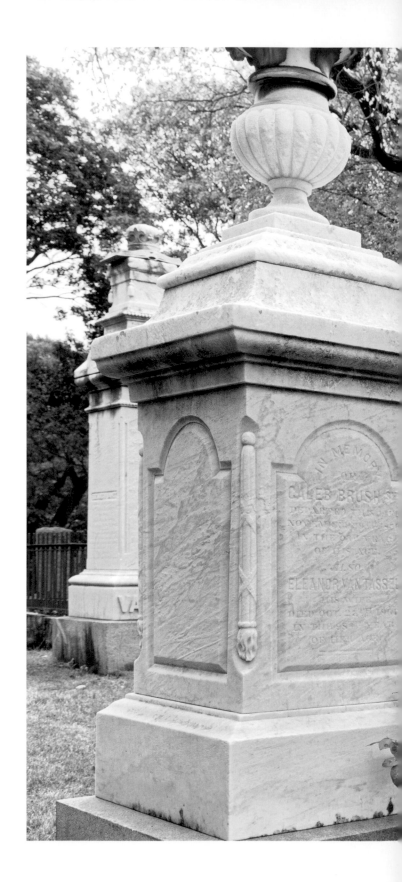

"I hope as the spring opens,
we will make another trip to
Sleepy Hollow, and
(thunder and lightning permitting)
have a colloquy among the tombs."

—Washington Irving
written to an acquaintance, 1849

Grave marking the resting spot of the beguiling Eleanor Van Tassel, thought to be the inspiration for Ichabod Crane's love object in "The Legend of Sleepy Hollow." It is located in the **Old Dutch Burying Ground**, adjacent to the Sleepy Hollow Cemetery, where the story's author, Washington Irving, is buried. — Sleepy Hollow, New York

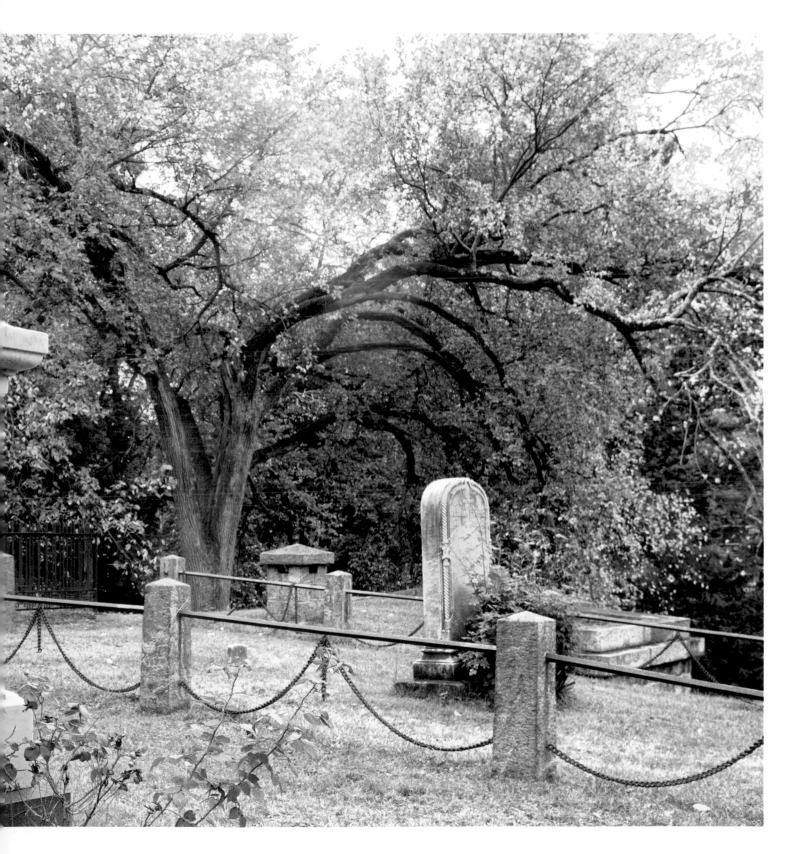

Washington Irving & James Fenimore Cooper

"There the water comes crooking and winding...till it gets to where the mountain divides, like the cleft hoof of deer, leaving a deep hollow for the brook to tumble into."

— James Fenimore Cooper, *The Pioneers*, 1823

All Creation

The upper Hudson was a fairyland to Irving. To Leatherstocking, the solitary wanderer, it was a transcendent vision. As Natty Bumpo in Cooper's *The Pioneers*, he gave his own, more gamy, version of the splendor of the Catskills to a companion:

> "I used often to go up into the mountains after wolves' skins and bears; once they paid me to get them a stuffed panther, and so I often went. There's a place in them hills that I used to climb to when I wanted to see the carryings on of the world, that would well pay any man for a barked shin or a torn moccasin....[The] place I mean is next to the river, where one of the ridges juts out a little from the rest, and where the rocks fall, for the best part of a thousand feet, so much up and down, that a man standing on their edges is fool enough to think he can jump from top to bottom."
>
> "What do you see when you get there?" asked Edwards.
>
> "Creation," said Natty, dropping the end of his rod into the water, and sweeping one hand around him in a circle: "all creation, lad."[8]

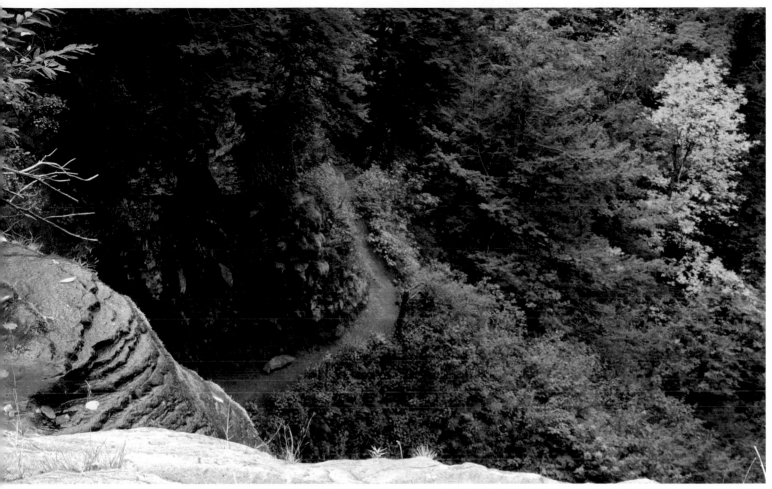

(Above and on pp. 12-13*)* "The Leap" of **Kaaterskill Falls**. — Catskill Mountains, New York

This spot, where the ridge juts out from the rest, has been identified. It is in an area known as the Pine Orchard, a revered spot in 1800's America. But even Leatherstocking was a late-comer to that locale. Chief Shandaken's wigwam had overlooked that inspiring scene years earlier, and it had been the scene of betrayal and revenge. A man named Norsereddin had poisoned the daughter of Shandaken and was burned at the stake.

By the first quarter of the 1800's, the traffic going up the Hudson for something other than trade was steadily increasing. Members of the growing middle class wanted things to do with their leisure time (a new concept in the still-young country). A significant percentage of travelers, the middle class included, were after something loftier than simply seeing the sights: they

were in search of "excitation of the senses." On the exact spot where Norsereddin was punished, one of the most famous hotels in American history was built. It was known as The Catskill Mountain House, though few remember it now. The Mountain House was built at the edge of an escarpment of rock that runs jaggedly for miles along a narrow valley that the Dutch named Kaaterskill Clove.

Visitors came by the thousands up the winding Old Mountain Road (it was an old road even then), to The Catskill Mountain House, built in 1824. Along the way they passed Rip Van Winkle's house and the spot where Rip had played nine pins with Henry Hudson and his crew. At the summit, the Mountain House, with its towering Greek Revival pillars,

Washington Irving & James Fenimore Cooper

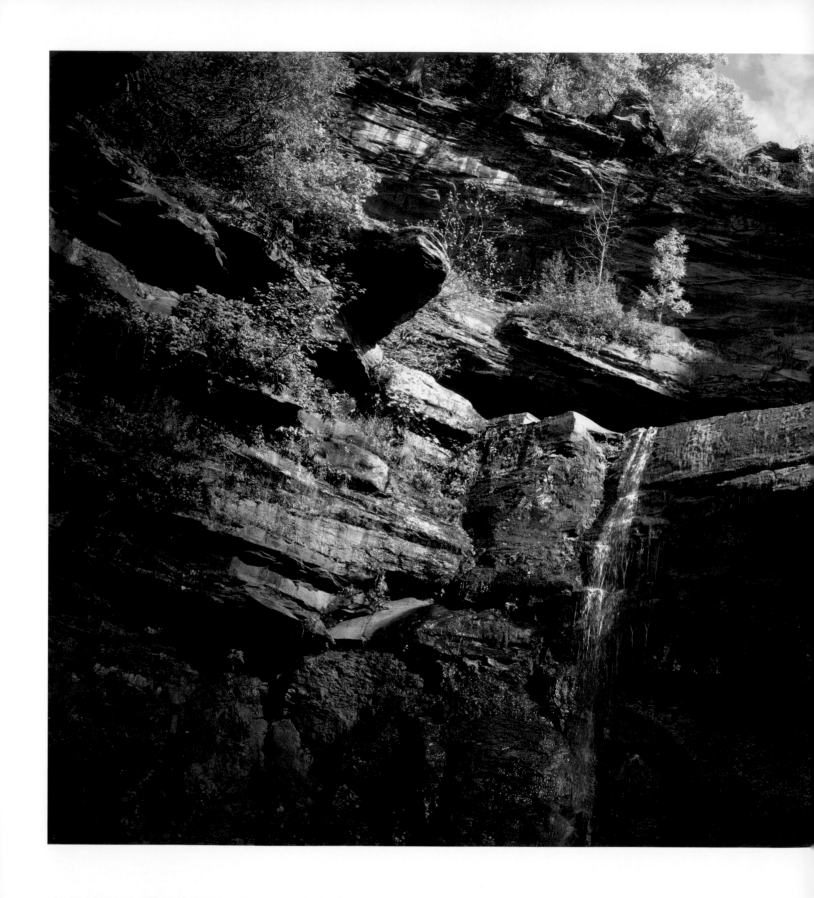

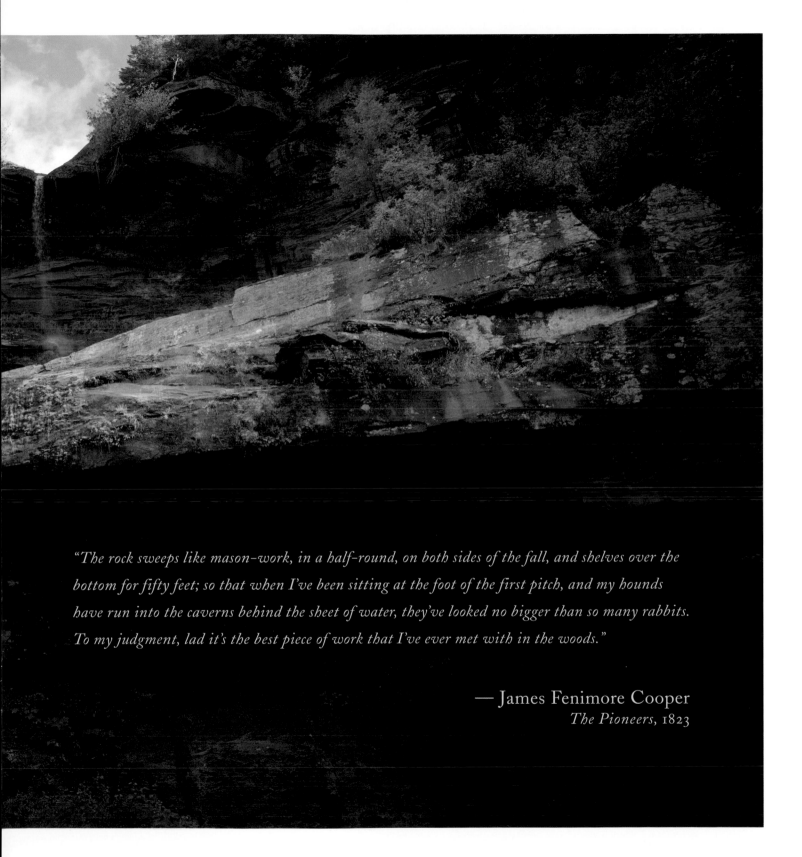

"The rock sweeps like mason-work, in a half-round, on both sides of the fall, and shelves over the bottom for fifty feet; so that when I've been sitting at the foot of the first pitch, and my hounds have run into the caverns behind the sheet of water, they've looked no bigger than so many rabbits. To my judgment, lad it's the best piece of work that I've ever met with in the woods."

— James Fenimore Cooper
The Pioneers, 1823

Washington Irving & James Fenimore Cooper

presided over the surrounding countryside, overlooking "all creation."

It was a time of flowering for English prose and the arts. The Romantic Movement among the English poets was well underway. And an aesthetic system had been established in Europe that sorted scenery into the categories of the sublime and the picturesque. A picturesque scene was one that featured the rustic or tumbledown imprint of man upon it (a farm scene, or a ruined castle). A sublime scene starred nature at her most dramatic (towering cliffs, lofty cataracts, dizzying precipices).

The Catskills were sublime. Once at the Mountain House, one could wander along the Escarpment and look down into the dizzying depths of Kaaterskill Clove and beyond to the ribbon of the Hudson. The trails ran round the hills of the Pine Orchard, providing access to Poet's Ledge, Fat Man's Delight, Badman's Cave, Fawn's Leap, Rip's Lookout Point and Artist's Rock.

Certainly, such a visual spectacle was not lost on artists. Among the first visitors to The Catskill Mountain House was Thomas Cole, in 1825. Cole went back to New York City with some canvases and was discovered when he hung three of them in a bookstore window in New York City. One of those paintings was titled "Lake With Dead Trees," its subject South Lake, one of the two small lakes visible from the Escarpment, that once had the bare trunks of dead trees rising from its surface. Cole became the reigning expert on the Pine Orchard, and he produced dozens of paintings of the area that were suffused with the sublime. Here were gnarled trees, high ledges overlooking great depths, waterfalls, the play of sunlight on the land, skies in moods both threatening and benign. The "Artist's Rock," on the trails in the Pine Orchard, was Cole's rock.

His personality and the scenery drew others, including his pupil, Frederic Church. Nearby Palenville became an artist's colony. This first American landscape movement became known as the Hudson River School. However, its subjects extended beyond the region to other pastoral landscapes of the Northeast and eventually, as the century wore on, to the West, to the Rocky Mountains and Yosemite on the vast canvases of Albert Bierstadt. The Hudson River School celebrated what

America had that the Old World did not: uncultivated newness. As the early American romantic poet, William Cullen Bryant, wrote, "The new world was fresher from the hand of him who made it."[9]

The Best Piece of Work That I've Ever Met With in the Woods

Kaaterskill Falls epitomized the vertical sublime. Here is Leatherstocking's description of the remarkable spot:

> There's a fall in the hills where the water of two little ponds, that lie near each other, breaks out of their bounds and runs over the rocks into the valley. The stream is, maybe, such a one as would turn a mill, if so useless a thing was wanted in the wilderness. But the hand that made that 'Leap' never made a mill. There the water comes crooking and winding among the rocks; first so slow that a trout could swim in it, and then starting and running like a creatur' that wanted to make a far spring, till it gets to where the mountain divides, like the cleft hoof of deer, leaving a deep hollow for the brook to tumble into. The first pitch is nigh two hundred feet, and the river looks like flakes of snow afore it touches the bottom; and there the stream gathers itself together again for a new start, and maybe flutters over fifty feet of flat rock before it falls another hundred, when it jumps from shelf to shelf, first turning thisaway and then turning thataway, striving to get out of the hollow, till it finally comes to the plain….there has that little stream of water been playing among the hills since He made the world, and not a dozen white men have ever laid eyes on it. The rock sweeps like mason-work, in a half-round, on both sides of the fall, and shelves over the bottom for fifty feet; so that when I've been sitting at the foot of the first pitch, and my hounds have run into the caverns behind the sheet of water, they've looked no bigger than so many rabbits. To my judgment, lad it's the best piece of work that I've ever met with in the woods; and none know how often the hand of God is seen in the wilderness, but them that rove it for a man's life.[10]

It was a slower age, in those days. Thoughts on paper unfolded in a leisurely fashion. But the best writing was clear and vivid. The ponderous dullness which characterized much writing of the Puritan age had passed. Nearly everything was a revelation. As Thomas Cole put it, "All nature is here new to art. No Tivolis, Ternis, Mount Blancs, Plimmons, hackneyed and worn by the pencils of hundreds but primeval forests, virgin lakes and waterfalls."[11] Under the spell of the "Fairyland" of the Catskills, writers like Irving and Cooper and artists like Cole and Church granted the region a depth and majesty that was meant to rival that of Europe.

Keep That Earlier, Wilder Image Bright

Cooper's enthusiastic promotion of American landscape waned, after he published the first Leatherstocking tales and traveled extensively in Europe. Although at first he resisted, he gradually fell under the spell of the picturesque and sublime scenery he encountered there, especially in Italy, until at last, when he returned to the United States in 1833 and then wrote about it, he had this to say of his trip up the Hudson: "These rocks strike my eyes as much less imposing than formerly. The passage is fine but it is hardly grand scenery."[12]

There was a sad ending to The Catskill Mountain House as well. After the attention of tourists wandered in the 1940's the hotel failed. The funicular railway fell to rust. The hotel's massive Greek Revival shape reigned above the Kaaterskill Clove for another 20 years. Slowly it was stripped of all its appurtenances and its massive columns, as numerous plans for restoring it were hatched and discarded. Eventually its hulk was sold to the State of New York. Irresistible to explorers and growing steadily more dangerous, on a winter's night it suffered the same fate as Norsereddin had before it. The State burned it to the ground. Flames shot high in the air above the Escarpment and, on the next morning, the monument was gone.

Perhaps William Cullen Bryant, the first well-known poet of America and a close reader of literature, had Cooper in mind when he penned this poem to Thomas Cole:

Sonnet—To an American Painter Departing for Europe

Thine eyes shall see the light of distant skies:
 Yet, Cole! Thy heart shall bear to Europe's strand
 A living image of thy native land,
Such as on thy own glorious canvass lies.
Lone lakes—savannahs where the bison roves—
 Rocks rich with summer garlands—solemn streams—
 Skies, where the desert eagle wheels and screams—
Spring bloom and autumn blaze of boundless groves.
Fair scenes shall greet thee where thou goes—fair,
 But different—every where the trace of men,
 Paths, homes, graves, ruins, from the lowest glen
To where life shrinks from the fierce Alpine air.
 Gaze on them, till the tears shall dim thy sight,
 But keep that earlier, wilder image bright.

In the beginning of America, the land was peopled by the Native Americans whose line of thinking was so different from the white man that they seemed as primitive as the people at the dawn of man. In a sense, America telescoped the history of man. What had been a slow and gradual process of clearing the land and establishing cities in Europe took place in a few brief generations in the United States. And as a result, that early, wild image was fresh to any eye of the 1800's that was open to apprehend it.

Some American writers have documented how traces of the wilderness have slowly receded over time: the arrowheads, ancient fire pits, cave paintings, vestiges of the old growth forests or swamps, the cellar holes of settlers who made a go of it and gave up but weren't completely swallowed up. Other writers have focused on the wildness that still remains. Others do not confront it at all in their writing. But it is there, that earlier, wilder America, like the view from a precipice over a rolling, wooded land punctuated by silver strands of river. And if we look out into the distance, something ancient and wild looks back, sometimes makes its presence felt in the soughing of the breeze or a darkening of the sky. In the beginning, we found America in the wilderness.

(Above and on pp. 18-19) **Walden Pond.** In the 1700's, Walden Woods was a hideout for fugitives. By the 1820's, the once-forbidding woods and pond had become a place of profound inspiration. — Concord, Massachusetts

"They were teachers and educators and bringers of light, with a deep and affectionate feeling of obligation towards the young republic their fathers had brought into being. That New England was appointed to guide the nation, to civilize it and humanize it, none of them ever doubted."

— Van Wyck Brooks
The Flowering of New England, 1936

New England:
Her Early Leafs

Ralph Waldo Emerson & Henry David Thoreau

Nathaniel Hawthorne • Herman Melville

A Later Flowering: *Robert Frost*

Concord, Massachusetts

RALPH WALDO EMERSON (1803-1882)
& HENRY DAVID THOREAU (1817-1862)

— Ralph Waldo Emerson
quoted from a letter to his betrothed
on the eve of their marriage
"Emerson's Genius" The Atlantic Monthly, 1887

RALPH WALDO EMERSON, pillar of the Transcendentalist movement, came to Concord anything but transcendent. He was a young man afflicted by doubt, sadness, and straitened circumstances. Being without money has a way of tarnishing all of life's experiences, and Ralph Waldo Emerson was no stranger to poverty. His father had died when he was a boy, leaving a wife and three sons, so his mother had started taking in boarders. Even so, she could not make ends meet. As one biographer described it, a family friend "found the family one day without any food, except the stories of heroic endurance with which their aunt, Mary Moody Emerson, was regaling them. Emerson and his brother Edward had but one overcoat between them, and had to take turns going to school."[1] He was accepted at Harvard at an early age, and waited tables to defray tuition. But he was an unspectacular student. His brothers were more brilliant than he.

Pursued by what seemed a growing whiff of failure, Emerson turned unsuccessfully to teaching, and later headmastering, at a school in his mother's house. He then decided to go into the ministry, and actually landed a well-paying position. But his talents did not extend beyond the pulpit. A well-worn anecdote has him visiting the deathbed of a Revolutionary War veteran. He fumbled for words of comfort and, finding none, changed the subject to glassmaking. The old man reared up in his bed and bellowed, "Young man, if you don't know your business, you had better go home."

Soon afterward, death struck home for Emerson. In 1831 he lost his wife, Ellen Tucker, to tuberculosis. The same year he left the ministry because he had grave doubts about his religion's emphasis on the "Lord's Supper." He had little regard for his talents. He lacked the common touch. "What is called

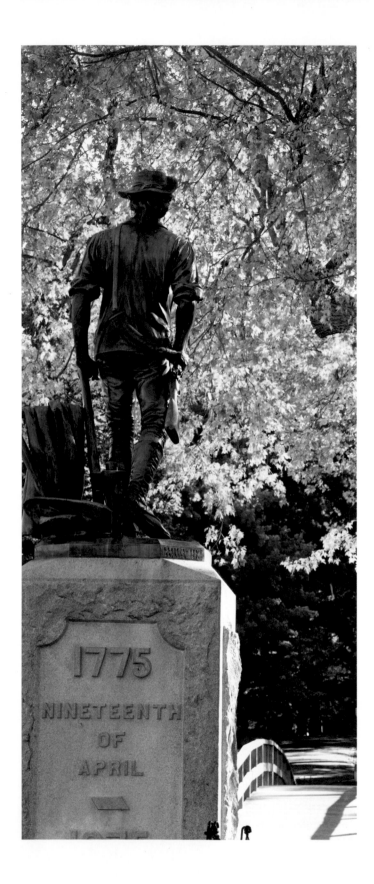

a warm heart I have not," he said. And perhaps he thought too much, or too critically, to be a minister.

Expecting a settlement from the death of his wife, he went on a journey through literary Europe, stopping at the mythic locales that figured in the classics he had studied. He met many of the sages of the day, including Thomas Carlyle and the Romantic poets Wordsworth and Samuel Taylor Coleridge. Upon his return he found himself again at loose ends. He toyed with the idea of establishing a colony of like-minded individuals in the wilds of Maine, but that plan came to naught. It was perhaps with a sense of having nowhere else to go that he decided in October of 1834 to move with his mother to Concord, Massachusetts, into the Old Manse.

The aging house, with its giant cooking hearth in the kitchen, was a remnant from the colonial era. Its owner, the minister Ezra Ripley, had been attached to the same church for 63 years, and seemed to have commanded that all time in his home, and in Concord, stand still. Behind the Manse ran the Concord River, which Nathaniel Hawthorne later described as "the most unexcitable and sluggish stream that ever loitered imperceptibly towards its eternity – the sea."[2]

Above Emerson's head in the attic were stored the thousands of sermons Ripley had given, concerning sin, human weakness, and abnegation. To Emerson they belonged to yesteryear. As he had said in his address at Ripley's funeral:

> "These Puritans, however in our last days they have declined into ritualists, solemnized the heyday of their strength by the planting and liberating of America. Great, grim, earnest men, I belong by natural affinity to other thoughts and schools than yours, but my affection hovers respectfully about your retiring footsteps, your unpainted churches, strict platforms, and sad offices; the iron gray deacon, and the wearisome prayer, rich with the diction of ages."

Emerson was more aligned with William Ellery Channing, who had written in 1820 that the "ultimate reliance of a human being is and must be on his own mind." This concept became a cornerstone of Emerson's philosophy. When he arrived at the Old Manse, he may have viewed it as no more than a relic, and

Concord as no more than a backwater. But it was at least a pleasant one into which to paddle his rudderless boat.

The October air was crisp in Concord, carrying a foretaste of winter. A decade before, when Emerson tried to lay himself in the bosom of Nature, he had found it lacking: "When I took my book to the woods I found nature not half poetical, not half visionary, enough....I found that I had only transplanted into the new place my entire personal identity, and was grievously disappointed." Later, on a hilltop near the Old Manse, Emerson gazed upon the spectacle of morning with lofty emotion. He rhapsodized about how "the long slender bars of cloud float like fishes in the sea of crimson light. From the earth, as a shore, I look out into that silent sea. I seem to partake its rapid transformations: the active enchantment reaches my dust, and I dilate and conspire with the morning wind."[3] In the inspirational environs of Concord, Emerson metamorphosed into what he described as a "transparent eyeball."

Wandering the countryside, the newly observant Emerson found that: "Miller owns this field, Locke that, and Manning the woodland beyond. But none of them owns the landscape. There is a property in the horizon that no man has but he whose eye can integrate all the parts, that is, the poet."[4] Even when he went into the local taverns and listened to the talk of the common folk, he heard the way in which nature influenced their speech. "The immediate dependence of language upon nature...gives that piquancy to the conversation of a strong-natured farmer or back-woodsman which all men relish."[5]

Stimulated by the good clear air of the coming winter and the strong beer and talk in the taverns, he began to feel like himself again—or, rather, *more* than himself. When he paused from his writing in the second floor study of the Old Manse, he could spy a little bridge over the Concord River through the bottle-thick glass. At that very spot, the "shot heard round the world" that started the American Revolution had been fired. For a man whose thoughts were bent on achieving an intellectual revolution in the New World, there could have been no more inspiring sight.

(Left) A minuteman gazes across the span of the **North Bridge**.
(Right) View from the **Old Manse** towards the bridge.
— Concord, Massachusetts

Ralph Waldo Emerson & Henry David Thoreau

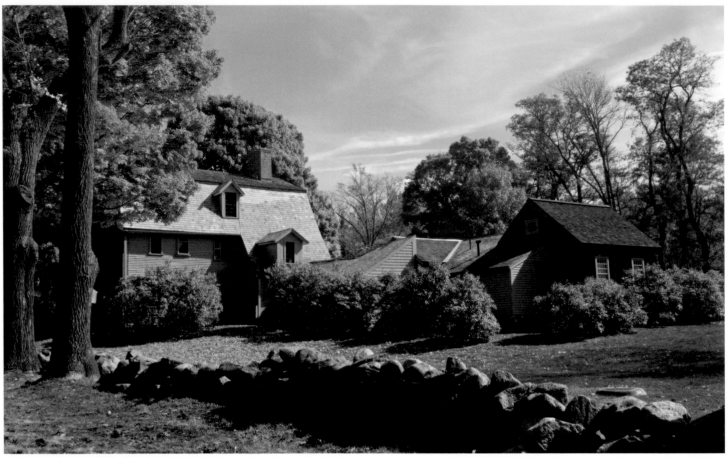

The Old Manse. — Concord, Massachusetts

Around this same time, Emerson's income prospects also underwent a revolution. Two decades before baseball was invented, Emerson engaged in an early game of hardball. He took the Tuckers to court to get his share of his wife's inheritance. He prevailed, to the tune of over $1,000 per year. Around this time he also began doing the lyceum circuit, a decent source of extra income.

The Lyceum Orator and His Powers of Enchantment
The Lyceum movement had its roots in the democracy of ancient Greece. Aristotle had founded his school at the Lyceum, just outside Athens, in 335 B.C. In the early 1800's, a swelling hope for the prospects of their fledgling democracy caused many American towns and cities to build their own Lyceums.

These were halls that traveling lecturers could teach in, and were meant to improve the lot of any who cared to attend.

Ralph Waldo Emerson, possessor of a thrilling and suggestive speaking voice, was a big draw. As future president Rutherford B. Hayes described, "The precious words dripped from his mouth in quick succession, and noiselessly sank into the hearts of his hearers, there to abide forever, and, like the famed carbuncle in an Eastern cave, shed a mild radiance on all things therein. Perhaps no orator ever succeeded with so little exertion in entrancing his audience, stealing away each faculty, and leaving the listeners captive at his will."

34-year-old Lidia Jackson of Plymouth, Massachusetts, still unmarried and well on her way to spinsterhood, was moved by one of Emerson's speeches in the 1830's. She was even introduced

to him at one of his three lectures in Plymouth. So affected was she, in fact, that she was visited soon afterward by a curious vision: She and Emerson were gliding down a set of stairs, in wedding clothes. According to one version of events, "When the vision faded, she found herself blushing from embarrassment and claiming aloud, 'I don't deserve this.'"[6] But she had a second vision, and then shortly thereafter received a letter from Mr. Emerson. In it, the orator, who did not trust himself to eloquently speak of this matter of the heart, soberly professed that: "I am rejoiced in my Reason as well as my Understanding by finding an earnest and noble mind whose presence quickens in mine all that is good and shames and repels me from my own weakness. Can I resist the impulse to beseech you to love me?"

Lidia worried that she did not have the skills that were needed to be a good wife. But Emerson argued his case persuasively, and eventually he won out. There was only one requirement: Lidia, whom Emerson had rechristened as the more poetic "Lidian," must agree to come and live in Concord. In making his case, again by letter, he told her he must be close to nature. "A sunset, a forest, a snow storm, a certain river-view, are more to me than many friends & do ordinarily divide my day with books. Wherever I go therefore I guard & study my rambling propensities with a care that is ridiculous to people, but to me is the care of my high calling." Though reluctant to leave Plymouth, she agreed to the move. What she did not know was that she would be hosting the world.

Build, Therefore, Your Own World

Emerson's insistence upon staying in Concord probably had much to do with what he had been conceptualizing at the Old Manse. His essay "Nature," published as an anonymous work in 1836, was one of those publications whose influence greatly outweighs its sales. The essay was intended to relegate conventional Puritan thinking to the attic. "Why should we grope among the dry bones of the past?" Emerson asked. "The sun shines to-day also." In a series of tightly-worded pages, he argued that, in the new age that was upon him, man should turn his gaze to Nature. The breathtaking enchantment of dawn was part of Nature's portfolio, but there was much more to be learned by its close study. "The world is emblematic," Emerson maintained. All that we saw in Nature we could apply to our human condition. In one of the most striking passages of the essay he wrote:

> What is a farm but a mute gospel? The chaff and the wheat, weeds and plants, blight, rain, insects, sun,—it is a sacred emblem from the first furrow of spring to the last stack which the snow of winter overtakes in the fields. But the sailor, the shepherd, the miner, the merchant, in their several resorts, have an experience precisely parallel and leading to the same conclusions. Because all organizations are radically alike. Nor can it be doubted that this moral sentiment which thus scents the air and grows in the grain, and impregnates the waters of the world, is caught by man and sinks into his soul.

Emerson concluded by exhorting his readers to consider what they had, to treasure what surrounded them, and to transcend themselves: "All that Adam had, all that Caesar could, you can have and do....Line for line and point for point, your dominion is as great as theirs, though without the fine names. Build, therefore, your own world."

In a concrete sense, Ralph Waldo Emerson built and funded his own world in Concord. Bronson Alcott, father of Louisa May Alcott of *Little Women* fame, was an off-and-on resident of Concord—a great thinker and talker who had founded a well-respected school for children in Boston. He then lost it by publishing a book in which he recorded the candid conversations of children about the Gospels. Some of the comments out of the mouths of babes were deemed blasphemous. The early success of Temple School was Alcott's high water mark in terms of reputation and, perhaps, income. After its demise he moved to Concord and it was his friend Emerson who paid for many of Alcott's follies, in order to keep him within his orbit. Emerson also helped the Hawthornes, even though he was not a big fan of Hawthorne's writing. He underwrote a short-lived but landmark literary periodical called *The Dial*. And he increased his dominion in real estate terms, buying up parcels throughout the town and by the shores of the kettlehole pond left behind

by a retreating glacier, whose name was to become as famous as Concord's: Walden Pond. During the residence of Ralph Waldo Emerson, Concord became a great draw. As Hawthorne described it in *Mosses from an Old Manse*:

> Uncertain, troubled, earnest wanderers through the midnight of the moral world beheld his intellectual fire as a beacon burning on a hill-top, and climbing the difficult ascent, looked into the surrounding obscurity more hopeful than hitherto. The light among the chaos—but also, as were unavoidable, it attracted bats and owls, and the whole host of night birds, which flapped their dusty wings against the gazer's eyes, and sometimes were mistaken for fowls of angelic feather. Such delusions always hover nigh whenever a beacon fire of truth is kindled.

The Reach of the Boarding House

Something should be said about the place of the boarding house in the general subsistence economy of America in the 19th and early 20th centuries, for a great many American authors—including Thomas Wolfe, Ralph Waldo Emerson and Henry David Thoreau—were marked by them. The boarding house was the refuge of the house-owning but cash poor families in America. In a century that became known as the "golden age" of domesticity in America, the boarding house concept was at odds with the idea of the self-sufficient and contained family unit that the country held dear. But it was a means of survival.

Boarding house families came in several varieties. There were those family units, like Emerson's, that had lost their breadwinner. Others needed to supplement an income that had gone into decline, as was the case of Thoreau's aunts, who kept the boarding house where Thoreau's family lived. John Thoreau, grandfather of Henry David Thoreau, had come to Boston from France in 1773 and, starting with a single hogshead of sugar, had amassed a sizeable fortune. But by the time his grandson was born, assets were dwindling again. The house was, for many years until the Thoreau pencil factory got off the ground, the family's steady source of income.

Growing up no stranger to strangers seems to have made Ralph Waldo Emerson able to tolerate company, even to invite it. "I seek a garret," was Henry David Thoreau's take on the matter when he graduated from Harvard and returned to his home town. Unlike the gregarious Emerson, he would have no qualms about retiring into solitude in the very midst of the Concord tumult.

"And By the Rights I Soared Above to Show You My Peculiar Love."

— Henry David Thoreau
from the journal of Henry David Thoreau
Henry Seidel Canby's *Thoreau*, 1939

Henry David Thoreau was a bit of an odd bird to begin with. He had quite a beak on his face, and he walked around Concord with his bright eyes constantly fixed on the ground. It is not that he was shy, just that there were so many interesting things crawling, squirming, or darting around on the ground for him to observe. He was built close to the ground anyway, not particularly tall, and he looked very humble in his homespun clothes. Unlike Emerson, who became "something of a country squire," smoking cigars to "mask his diffidence,"[7] there was nothing sartorial about Thoreau.

Thoreau was a native of Concord, which had started out as a milldam near the intersection of a few roads. Like the stems of ferns, the roads had branched into fronds and the fronds unfurled into spinnae of farms and other businesses, such as the pencil factory that Henry's father founded. But it couldn't have been much closer to nature. Roads and buildings merely interrupted the flow of the fields and streams. And fences and boundaries were just interruptions to Thoreau, who felt that he was as much a part of the land as the Native Americans had been.

In his 20th year, Thoreau had advanced beyond being just a wild boy to a "parcel of vain strivings tied by chance bond together." For that was how he described himself in the poem he tied to a bunch of violets and tossed into the window of Lucy Jackson Brown, a boarder at the aunts' house and several years his senior. Exactly what point he was trying to make is a

bit unclear. He was surer about his feelings, but perhaps just as unclear, two years later when Ellen Sewall came to town to visit one of the lodgers at the boarding house.

According to Thoreau's biographer, Henry Seidel Canby, who interviewed surviving relatives, Ellen was one of those girls "with that irradiant beauty which is as much temperament and character as beauty of feature and of countenance."[8] She blew into town from Eastern Massachusetts and swept Thoreau and his brother John off their feet in the three weeks that she stayed in Concord.

When Ellen returned to Scituate, the Thoreau brothers set out on their boating trip down the Concord and Merrimack rivers, a voyage that Thoreau later immortalized in a book. Of the two brothers' rivalry there is not a ripple in his journals, and some believe that the two did not speak of their mutual love. What is known is that almost immediately upon their docking in Concord, John went off to Scituate, with chaperones, and proposed to Ellen. Apparently she accepted. And then recanted.

Ellen's father strongly doubted that either of the Thoreau boys would be good providers. The fact that they both pursued her must have been vexing in the extreme. When Henry David Thoreau sent a letter proposing to her, her father instructed her to write back in a "short explicit and cold manner."[9] She did. With that the love affair was over. "I did not think so bright a day / Would issue in so dark a night," he wrote in a poem.

In his journal, Thoreau fashioned himself an intellectual solution: "To sigh under the cold cold moon for a love unrequited is but a slight on nature; the natural remedy would be to fall in love with the moon and the night and find our love requited." He was never to propose to anyone ever again.

Emerson Owns This Field, and That Shoreline…

Without Emerson, Thoreau might never have been launched on a writing career, or gone to the woods to write *Walden*. From early on, attempts had been made to pair the two men. But they did not take to each other at first. The matchmakers bided their time, for in the swirl of society that was Concord, one needed only to wait and another chance to put them together would arise.

There was much in the boy for Emerson to like. What better companion for Emerson's nature walks could there be than Thoreau, who knew every inch of Concord's wilderness as if it were his own back yard and whose curiosity was unending? What better living proof, furthermore, of Emerson's views on Nature? Thoreau once wrote in his journal:

> And for my afternoon walks I have a garden, larger than any artificial garden that I have read of and far more attractive to me,—mile after mile of embowered walks, such as no nobleman's grounds can boast, with animals running free and wild therein as from the first,—varied with land and water prospect, and, above all, so retired that it is extremely rare that I meet a single wanderer in its mazes.

Was he not, in that passage, describing the same sensibility that Emerson had reserved for the poet in "Nature": the idea that neither a Miller, nor a Locke nor a Manning owned the landscape? By 1838, Emerson and Thoreau had achieved a communion so profound that it verged on interchangeability. A college classmate of Thoreau's noted that, with his eyes closed, he could not tell his friend's voice from Emerson's.

Notwithstanding his wit and his admiration of Emerson, Thoreau was a bit of a trial conversationally. His style interrupted Emerson's flow. "Henry Thoreau's conversation consisted of a continual coining of the present moment into a sentence and offering it to me," Emerson confided in his journal.

Thoreau was also one of those friends that comes along from time to time, who possesses enough individual charm or brilliance that he *almost* induces you to overlook the fact that he thinks he is doing *you* a favor every time you do *him* a favor. "It is difficult to begin without borrowing," as he would phrase it later in *Walden*, "but perhaps it is the most generous course thus to permit your fellow-men to have an interest in your enterprise." Thoreau accepted much generosity from Emerson with the attitude that Emerson was enriched by the giving.

In 1842, Emerson invited Thoreau to move into his home. Installed in "The Bush," Emerson's spacious house, Thoreau fixed things and built things and entertained Waldo Junior,

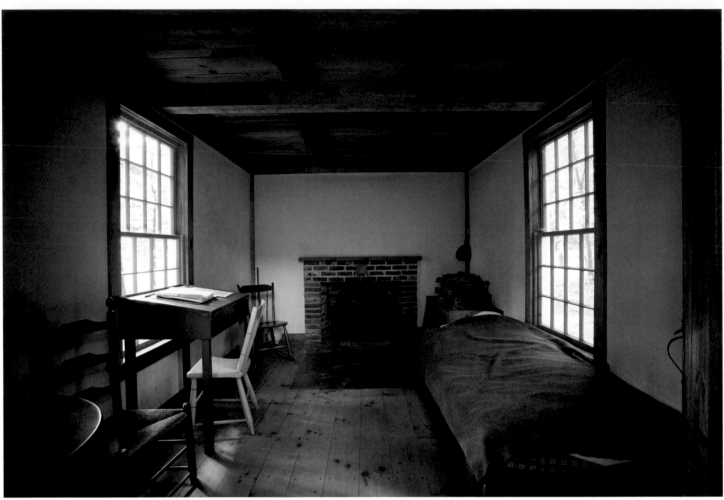

(Above and on pp. 28-29*)* Re-creation of **Thoreau's Walden Pond cabin**, a triumph of economy, where, for two years, two months, and two days he lived a life of the mind, stripped of "bawbels" and "gewgaws." — Concord, Massachusetts

while keeping up his peregrinations in the countryside. He rarely seemed to cross paths with his patron and seldom mentioned him. But he got along famously with Lidian, whose marriage to Emerson was less than the romantic ideal and who had by that time, perhaps, often said to herself in a different tone, "I don't deserve this." As desirous as Emerson had been for a marriage of true minds, he had little time to cultivate it. He was often on the lecture circuit or busy entertaining. Lidian was sickly (and may have been a bit of a hypochondriac). She witnessed a cold side of her husband that was perhaps the other face of his genius. As Canby wrote of Emerson in his biography on Thoreau: "A psychologist today would say, I think, that in love,

which gives and takes without movement of the mind, he was inhibited."[10] Henry David Thoreau, significantly more earthy and warm-blooded, a constant presence at The Bush, seems to have been the cock of the yard. And perhaps this is why in 1843 Emerson shipped him off to New York City, to gain some perspective on life.

New York was not the place for Thoreau. He struggled to commit his thoughts to paper. "In writing, conversation must be folded many times thick," he informed Emerson in a letter. Perhaps the change of environment stalled his creative process. Of what use were the busy streets of Manhattan to a soul that would consider it a luxury to be immersed to his chin in a

swamp, "scenting the sweet-fern and bilberry blows and lulled by the minstrelsy of gnats and mosquitoes"? Thoreau pined for home. He could not sell New Yorkers on his brand of genius.

Still struggling to find a way in the world that paid, Thoreau returned to his beloved Concord. He got engaged in the pencil-making business again. He had aspirations of buying a farm, which foundered. But he eventually made a proposal to clear a bit of Emerson's property near Walden Pond known for its stubborn brush as the "Briars" and to build himself a structure which he would eventually give back to his patron. A deal was struck.

I Went to the Woods Because I Wished to Live Deliberately

Thoreau went to the briar patch with a borrowed axe. He had to make a clearing and cut timber for his house. It was late March of 1845 but the dregs of winter remained. Ice covered the pond, though it was not completely sealed, and snow flurries fell upon him as he worked.

The "house is still but a porch at the entrance of a burrow," he maintained in *Walden*. "Before we can adorn our houses with beautiful objects," he said, "the walls must be stripped, and our lives must be stripped." In the background of all his abjurations to simplify lay one simple practicality: Thoreau himself had no money to spare. This business of building a house and living in the woods was going to be "entered into without the usual capital." And if he were to stay long enough to get a book out of the experience, he would have to husband his resources.

"The fruit a thinker bears is sentences," he wrote in his journal. And in Canby's opinion, the secret to his durability in our canon was his effort to take flashes of insight and "then anxiously develop the impression until a sentence was made that was true to the original inspiration, yet communicable to the reader."[11] In order to do so, he had much need for solitude as well as time for observation of nature. Of all the acts of largesse attributed to Ralph Waldo Emerson, perhaps it is his loan of the unused tract of land near Walden Pond that paid the most dividends.

To be sure, Thoreau meant to take full advantage of his opportunity. Off he went to the woods every day to cut and hew timbers for the frame, rafters and roof. Around noon he'd take a break amid the pine slashings to read the newspaper in which he had wrapped his bread and butter and eat the pine-scented lunch. He was in no rush to complete the project; he did not move in until July 4 and may have set that date as his target from the beginning. Around the middle of April he bought a shanty from an Irishman who worked for the railroad. On the day he took possession, he passed the vacating family on the road. They had all their earthly belongings in one bundle and were headed for new horizons like stalwart pioneers. He did not say whether he praised them for their economy but by all lights he should have.

By early May Thoreau was ready for a house-raising, with the help of some of his acquaintances. It wasn't that he needed their help, he explained, but, in keeping with his "generous course" of making himself available for assistance, he felt it was a prime opportunity to offer them an "occasion for neighborliness." A month of finishing took place. A sturdy chimney was built. And by Independence Day, Thoreau was able to exult in his own economy. In *Walden* he toted up the costs for his superior burrow and they came to $28.12.

Building the house was the first achievement. But the lasting achievement was in the writing. Thoreau would bathe in the pond after his morning activities (perhaps reading, or writing, or hoeing his beans), to wash the dust from himself or to smooth out "the last wrinkle that study had made."[12] And then he would make a daily choice: whether to keep to the woods to observe the animals or go into town to watch the people. He'd become an observer. But he was not a hermit. He had his acquaintances in town, and the people who came by to visit his cabin. He had plenty of time for his thoughts. He would "set sail" for his "snug harbor in the woods, having made all tight without and withdrawn under hatches with a merry crew of thoughts, leaving only my outer man at the helm, or even tying up the helm when it was plain sailing."[13]

He was one hundred years too late to need to be a settler. The train had come to Concord. The town possessed a station, a general store, many merchants. And yet Thoreau was able to cast himself into that primitive state in the few months that it

Ralph Waldo Emerson & Henry David Thoreau

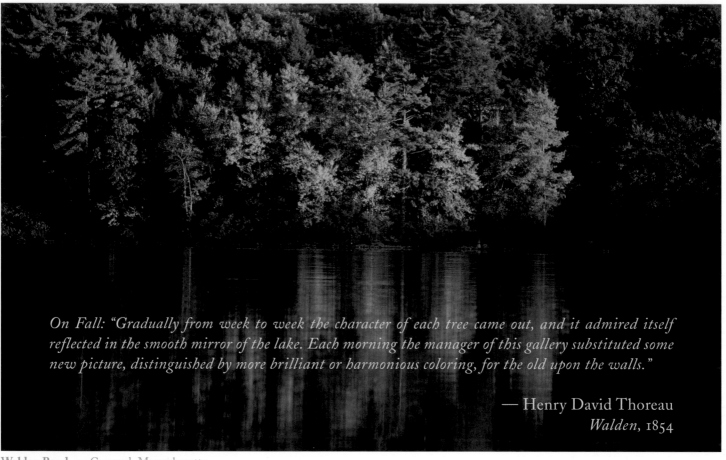

On Fall: "*Gradually from week to week the character of each tree came out, and it admired itself reflected in the smooth mirror of the lake. Each morning the manager of this gallery substituted some new picture, distinguished by more brilliant or harmonious coloring, for the old upon the walls.*"

— Henry David Thoreau
Walden, 1854

Walden Pond. — Concord, Massachusetts

took to make his cabin. There was a major difference though. The settlers of the 1700's had been afraid of the woods, afraid of what lurked in the wilderness and afraid of themselves—casting all of their faith in God. Thoreau wrote a new chapter. He did so by joining woodcraft to the philosophy of Emerson and the Romantics.

"The roots of letters are things," Thoreau stated in *Walden*, in an echo of Emerson's own thoughts. "Natural objects and phenomena are the original symbols or types which express our thoughts and feelings…"[14] From the crazed ice on the shores of Walden Pond to the honking of geese, his symbols are beautifully etched. Read his passage on a war of ants and you will see how closely it resembles the wars between men.

Walden was Thoreau's laboratory and his classroom:

When I see…this luxuriant foliage, the creation of an hour, I am affected as if in a peculiar sense I stood in the laboratory of the Artist who made the world and me,—had come to where he was still at work, sporting on this bank, and with excess of energy strewing his fresh designs about. I feel as if I were nearer to the vitals of the globe, for this sandy overflow is something such a foliaceous mass as the vitals of the animal body.

We return to *Nature*, in which Emerson had written: "There is a property in the horizon that no man has but he whose eye can integrate all the parts, that is, the poet." For two years, two months and two days, Henry David Thoreau occupied that property. And there he lived the poetic life to the fullest. For it was in that cabin and in those surrounding woods that he

painstakingly folded the stiff paper of insights into sentences, which he then folded again, compressing his two-year experience into one cycle of the seasons.

The original cabin lasted for years in its place until it finally was carted off and subsumed into somebody's garage, an act of New England frugality that Thoreau would have applauded. It has since been rebuilt to his careful and detailed specifications. Walden Pond is now a park. These days it is rarely frozen by the end of March. Throughout the summer season, bathers cluster at one edge of the pond, with an otter's eye view of the water that Thoreau made so famous.

In summer, it is good to connect with the playfulness of Thoreau's writing over the sound of children splashing at the water's edge. But in the winter or early spring, when the pond is nearly deserted, it is easier to cast oneself back in time. It is never difficult, anyway, to summon up Thoreau's spirit; one need only go camping or stay in a cabin for a few days and nights. The ties of everyday life in "civilization" begin to loosen. To read Thoreau out in the woods is like having him at your side.

The Pleasures of Friendship Without Stain Like Sallies Into Some Fabled Cloud-Land, Remote and Golden...

Thus Bronson Alcott described his visits to Emerson later in his life, visits that so exalted his brain that it usually took a day and a night's sleep just to restore him for his "customary rounds of study." In 1848, just after the Walden Pond experiment ended, Emerson was somewhat less complimentary about his conversations with Thoreau. He was: "like a woodgod who solicits the wandering poet and draws him into antres vast and desarts idle, & bereaves him of his memory, & leaves him naked, plaiting vines & with twigs in his hands."[15]

Such a likely friendship it seemed at first. And yet the two men were so unalike. Emerson, the elder statesman, first stretched out his hand, but it took a long time for Thoreau to warm to him. Certainly someone as unbending as Thoreau must have had trouble accommodating himself to anyone. To accept as a friend the great Emerson, who had an enviable wife, money and fame, must have been hard. And yet, because of

his uncompromising nature, he probably approached the matter with idealism that rose as close to Alcott's fabled "cloud-land" as a friendship is ever likely to get.

The experience at Walden Pond appears to have mellowed Thoreau. Sophia Hawthorne, the wonderfully perceptive touchstone of the day, said of seeing her former neighbor at the Salem Lyceum: "His lecture before was so enchanting. Such a revelation of nature in all its exquisite details of wood thrushes, squirrels, sunshine, mists and shadows, fresh vernal odors, pine-tree ocean melodies, that my ear rang with music, and I seemed to have been wandering through copse and dingle! Mr. Thoreau has risen above all his arrogance of manner and is as gentle, simple, ruddy, and meek as all geniuses should be."

In time, warmth creeps into Emerson's journals as well, with a recognition of their similarities, and a respect:

> In reading him, I find the same thought, the same spirit that is in me, but he takes a step beyond, and illustrates by excellent images that which I should have conveyed in a sleepy generality. 'Tis as if I went into a gymnasium, and saw youths leap, climb, and swing with a force unapproachable,—though their feats are only continuations of my initial grapplings and jumps.[16]

Henry David Thoreau occupied 45 years in the middle of Emerson's life. And it was with a sense of profound regret that Emerson said goodbye to Thoreau in his funeral address: "His soul was made for the noblest society; he had in a short life exhausted the capabilities of this world; wherever there is knowledge, wherever there is virtue, wherever there is beauty, he will find a home."

Emerson drifted into forgetfulness by the end of his long life. Such a revered figure and a Concord institution was he that, when his house partially burned down, townspeople and friends raised money to restore it and sent him to Europe during the reconstruction. When he returned, he was greeted by a parade. He had, by his writings, his lectures, his generosity, and his very eminence, increased the capabilities of the New World in myriad ways. The works of Emerson were a dazzling spring flower in the blossoming of New England. ∽

Ralph Waldo Emerson & Henry David Thoreau

NATHANIEL HAWTHORNE (1804-1864)

This **stuffed owl** was in Hawthorne's possession at the Old Manse, which he once characterized as an "ancient owl's nest."
— Concord, Massachusetts

THOSE EYES... Everyone noticed Nathaniel Hawthorne's remarkable eyes. Richard Henry Stoddard observed that his eyes were as "unfathomable as night." Hawthorne's sister-in-law said he had "wonderful eyes, like mountain lakes seeming to reflect the heavens."[1] In the most famous portrait of him, painted by Charles Osgood in 1840, those light-colored irises appear unnaturally clear and luminous, as if capable of piercing through walls or of peering deep within. It is not hard to imagine that Hawthorne could see things that others couldn't. His stories delve into subconscious motivations, dark urges that were burned permanently into the American psyche starting almost two centuries before. In those early years, New England had been a network of congregations lashed together by local covenants and sacred oaths—spiritual stockades thrown up against evil to match the physical ones the citizens had built to hold out the dense and danger-filled woods.

By all accounts Nathaniel Hawthorne was extremely handsome and gifted with a melodious speaking and reading voice. He was, however, painfully shy. He fled from most visitors and spoke hardly a word in company. Yet in his inarticulate silences he still gained many admirers, even in a town full of eloquent residents, Concord, where he spent most of his writing life. Always the observer, even in the midst of society he stood far apart. As Henry James suggested, he was a collector of "specimens...with the mark in common that they are all early products of the dry New England air."[2]

Indeed, his pedigree was pure New England. Hawthorne's family hailed from the infamous Salem. He was just four when his father, a ship captain, died at sea. There being no such thing as life insurance in those days, the rest of the family moved in

with relatives in Salem. He attended Bowdoin College in Maine, one of a class of 38 students that included Henry Wadsworth Longfellow and Franklin Pierce, future president of the United States. He possessed a streak of melancholy that was arguably his most "New England" trait. After graduating from Bowdoin, he spent 12 barren years living like a ghost under the garret in the home in Salem. He rarely saw other people. He wrote little, published anonymously, doubted the quality of his work. He languished.

Nevertheless, he had good friends. By 1837, Nathaniel Hawthorne's fortunes were looking up somewhat. His college classmate, Horatio Bridge, had put up money as a guarantee towards the publication of a collection of Hawthorne's writing called *Twice Told Tales*. In the fall, Hawthorne stopped in at the well-known literary salon of the Peabody family and apparently charmed Elizabeth Peabody. But it was Elizabeth's invalid sister Sophia that he fell for. It took five more years of toil until Hawthorne had enough money to feel comfortable marrying her. Sophia brought him out of the shadows. As he wrote to her, "All that seems real about us is but the thinnest substance of a dream—till the heart is touched. That touch creates us."[3]

Hawthorne may have stepped somewhat out of the shadows but he did not cease to peer into them. The married couple moved to Concord, and into the Old Manse, the first sight of which he described in his introduction to *Mosses from an Old Manse*: "The glimmering shadows that lay half asleep between the door of the house and the public highway were a kind of spiritual medium, seen through which the edifice had not quite the aspect of belonging to the material world."[4]

A "manse" is a structure built to house the minister of a local church. It is not a mansion. But the Old Manse was a substantial house. A serious, somber house. It had been home Ralph Waldo Emerson's grandfather, who died in Vermont of swamp fever during the Revolutionary War, and later, of course, to the great transcendentalist himself. Practically in its backyard, the first shots of the Revolutionary War had been fired, at the "Bridge that Arched the Flood." Two British soldiers had died and are buried next to the bridge. In his introduction to *Mosses from an Old Manse*, Hawthorne related some hearsay: The battle had moved on when a local youth who had been chopping wood as the Revolutionary War began wandered towards the bridge and came upon the soldiers. "As the young New Englander drew nigh, the other Briton raised himself painfully upon his hands and knees and gave a ghastly stare into his face. The boy—it must have been a nervous impulse, betokening a sensitive and impressible nature rather than a hardened one—uplifted his axe and dealt the wounded soldier a fierce and fatal blow on the head." To Hawthorne, that episode had "borne more fruit" than any other story of the fight. "Oftentimes, as an intellectual and moral exercise, I have sought to follow that poor youth through his subsequent career and observe how his soul was tortured by the blood stain…"[5] This instinct to delve into the psychological is pure Hawthorne.

For decades before the Hawthornes moved in, the Old Manse had been home to Reverend Ripley, and it is from the Ripley family that the Hawthornes rented the house. "It was awful to reflect how many sermons had been written there,"[6] Hawthorne observed with a characteristic detachment. Despite the agreeable silence in which he passed most of the scant hours he spent with friends, Hawthorne possessed plenty of confidence when he picked up the pen. He was not shy about passing judgment or putting things bluntly. The great Emerson's thinking he dismissed with the statement that he, Hawthorne, "sought nothing from him as a Philosopher." In his voluminous journals, he was frank about other Concord residents. (So, too, was Emerson. He wrote: "Nathaniel Hawthorne's reputation as a writer is a very pleasing act, because his writing is not good for anything, and this is a tribute to the man."[7])

Reading Hawthorne, so eloquent on the page, was different than knowing him. In person, his beauty and his presence promised much and left much unrequited. This contributes to the sense that Hawthorne existed on a different plane, one on which only Sophia was welcome, from which he descended only when necessity dictated. Sophia, always looking on the bright side of her spouse, believed that Emerson found it "refreshing… to find this perfect individual, all himself and nobody else."[8] Henry James called him an "aesthetic solitary." He was "outside of everything, and an alien everywhere."[9]

Other writers might have been intimidated by being in the house where Emerson had written his seminal work. Hawthorne was not. He made Emerson's study his writing room and built himself his own writing desk. With Sophia's diamond ring, he etched on the windowpane, "Nath. Hawthorne. This is his study. 1843." For Hawthorne and his wife, the Old Manse was a bower of wedded bliss and a secluded refuge. They were as devoted to each other as two humans could possibly be. When Hawthorne was away he pined for Sophia. Whenever Sophia wrote about her husband, she did so in the most respectful, even laudatory of terms.

Emerson wasn't the only enlightened individual in Concord. Hawthorne enjoyed meeting up with the wild-spirited Thoreau, from whom he bought a boat. A poet named Ellery Channing also lived there. With him, Hawthorne boated to deserted spots on the river, kindled fires of pine cones and branches, and talked (though Channing did the lion's share of the talking, according to Hawthorne. "The evanescent spray was Ellery's; and his, too, the lumps of golden thought."[10]) Hawthorne delighted in nature, and seemed to believe in the existence of spirits. "And what was strangest, neither did our mirth seem to disturb the propriety of the solemn woods; although the hobgoblins of the old wilderness and the will-of-the-wisps that glimmered in the marshy places might have come trooping to share our table talk and have added their shrill laughter to our merriment."[11] Even at home in the Old Manse they had several ghosts. One "used to heave deep sighs in a particular corner of the parlor." Another, a "domestic" ghost, "used to be heard in the kitchen at deepest midnight, grinding coffee, cooking, ironing…although no traces of any thing accomplished could be detected the next morning."[12]

Herman Melville wrote in an anonymous appreciation of *Mosses from an Old Manse* that in "spite of all the Indian-summer sunlight on the hither side of Hawthorne's soul, the other side— like the dark half of the physical sphere—is shrouded in a blackness, ten times black…Whether Hawthorne has simply availed himself of this mystical blackness as a means to the wondrous effects he makes it to produce in his lights; or whether there really lurks in him, perhaps unknown to himself, a touch of Puritanic gloom-this I cannot altogether tell."[13] At the time

he wrote this, Melville didn't know much about Hawthorne (for more on their meeting see the entry on Herman Melville), but he was right on target. Hawthorne's imaginings reflect the influence of his ancestors' Salem brand of Puritanism, out of which arose what many consider to be his best novel, *The Scarlet Letter*, and after that *The House of the Seven Gables*.

By the time he wrote *The Scarlet Letter*, the Hawthornes (the two parents and three children) had been forced out of the Old Manse. The alterations that the Hawthornes had made to the house (for instance, adding a modern stove to a kitchen that had only held a pre-Revolutionary War fireplace for cooking, or etching words in the venerable old house's windowpanes) had not endeared them to the surviving Ripleys. But that might have been forgivable if they could pay the rent. If he could have collected what he was owed for stories he'd sold, the Hawthornes would have been financially solvent. Instead, they left the Old Manse with ten dollars between them, forced into exile in the house of his family in Salem. It is there, while struggling along in what he called "the darkest hour I ever lived,"

Man's accidents are God's purposes

Sophia A. Hawthorne 1843

Nath Hawthorne

This is his study

1843

The smallest twig

leans clear against the sky

Composed by my wife

and written with her diamond

Inscribed by my

husband at sunset,

April 3d 1843.

In the Gold light—SAH

Words etched in the **windowpane of Hawthorne's study** at the Old Manse. — Concord, Massachusetts

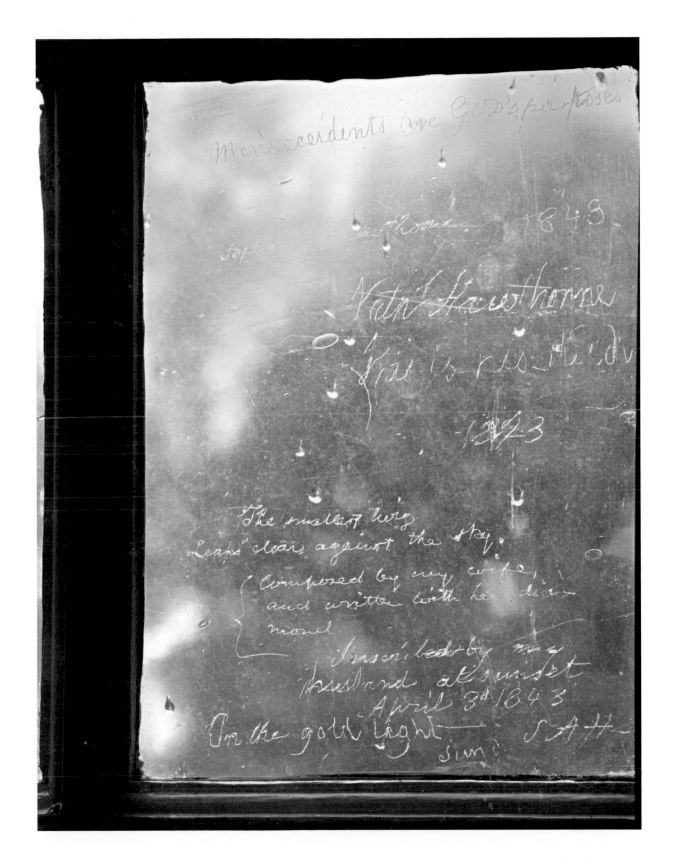

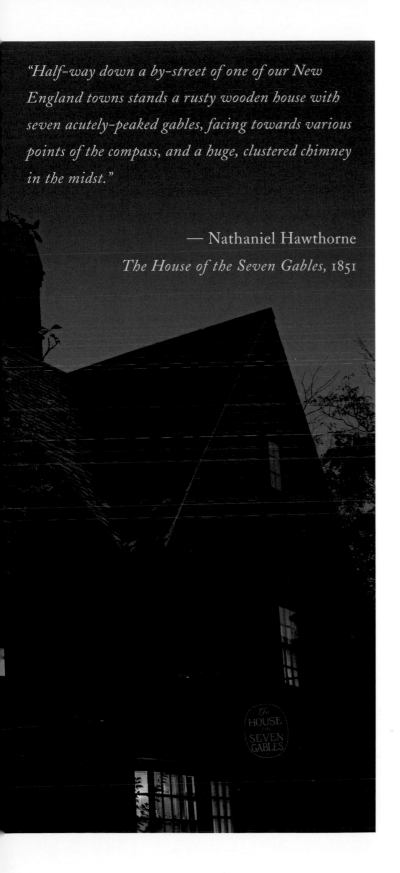

"Half-way down a by-street of one of our New England towns stands a rusty wooden house with seven acutely-peaked gables, facing towards various points of the compass, and a huge, clustered chimney in the midst."

— Nathaniel Hawthorne
The House of the Seven Gables, 1851

The House of the Seven Gables. — Salem, Massachusetts

that an enterprising book publisher named James Fields made a visit to Salem to see if Hawthorne had anything to sell. Ticknor & Fields, by that time, was the publisher of Longfellow, John Greenleaf Whittier, and Oliver Wendell Holmes. As the story goes, Hawthorne maintained he had nothing but finally handed him a manuscript, saying, "It is either very good or very bad—I don't know which." The *Scarlet Letter* was very good.

The titular letter was the letter "A" for "Adultery," which in the story is first seen by a Salem crowd on the dress of the beautiful Hester Prynne as she emerges from the dimness of prison with her bastard baby in her arms. She is required to wear the A for the rest of the time she lives in the town. For years, Hester keeps the secret of who the father might be hidden from all. "Truly, friend," one of the townsmen tells a visitor to Salem, "me thinks it must gladden your heart, after your troubles and sojourn in the wilderness, to find yourself, at length, in a land where iniquity is searched out, and punished in the sight of rulers and people, as here in our godly New England." In his brief novel, Hawthorne lays out the case of the godly Puritans as well as that of Hester Prynne, who felt something like love, and refused, on that score, to betray her lover. As Robert Spiller noted, in this book Hawthorne "had become in ethics the total skeptic who could view calmly the paradox of human will working its own destruction."[14]

Ticknor & Fields were a great relief for him. The two men understood his personality and acted extremely solicitously as his agents. In fact it was Ticknor who recommended the "cheap, pleasant, and healthy"[15] Little Red House in Lenox, Massachusetts, where the family lived from 1850-1852. There, Hawthorne wrote *The House of the Seven Gables* and *Tanglewood Tales.*

It is due to them that Hawthorne was able to muster up the money to eventually buy a house in Concord that had once belonged to the muster master during the Revolutionary War and then had been expanded by Bronson Alcott, brilliant thinker and educator, assiduous journal keeper, father of Louisa May Alcott of *Little Women* fame, financial failure. And what a house it was. What Alcott lacked in practicality he made up for in energy. He had made an addition to the old house by taking

Nathaniel Hawthorne

another house, cutting it in half, and putting one half on either side of the house.

Hawthorne described the setting of the house in a posthumously published novel, *Septimius Felton*. The house was located along the great Lexington road…

> …along a ridgy hill that rose abruptly behind them, its brow covered with a wood, and which stretched, with one or two breaks and interruptions, into the heart of the village of Concord, the county town. It was in the side of this hill that, according to tradition, the first settlers of the village had burrowed in caverns which they had dug out for their shelter, like swallows and woodchucks. As its slope was towards the south, and its ridge and crowning woods defended them from the northern blasts and snow-drifts, it was an admirable situation for the fierce New England winter; and the temperature was milder, by several degrees, along this hill-side than on the unprotected plains, or by the river, or in any other part of Concord.[16]

Bronson Alcott had named the residence Hillside, consciously or unconsciously recognizing the significance of the spot where the first burrows of Concord residents had been dug. Nathaniel Hawthorne re-named it The Wayside because it was situated quite close to the edge of the road. It was the first and last house he was ever to own. The Wayside is an enormous, rambling yellow structure that is rumored to have been a stop on the Underground Railroad. After serving as the home to the bestselling novelists Louisa May Alcott and Nathaniel Hawthorne it was bought once again in 1883 by literary folk. The new owner was, publisher Daniel Lothrop, whose wife, Margaret Sidney, wrote the "Five Little Peppers" books, which were very popular at the end of the 19th and beginning of the 20th centuries and remained a favorite among parents and children for years afterward. Now part of the National Park Service but woefully underfunded, the house is, for all its literary history, undergoing a gradual, mostly unchecked senescence.

Shortly after they moved in to The Wayside, the Hawthornes were posted to Liverpool, England, where Hawthorne acted as

The Wayside. — Concord, Massachusetts

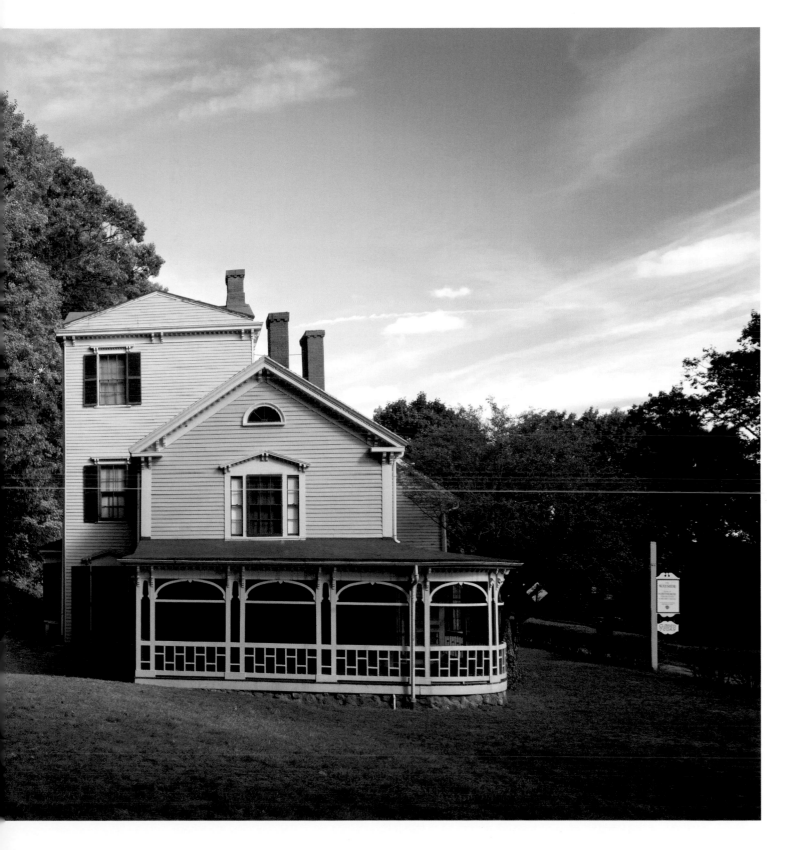

Nathaniel Hawthorne

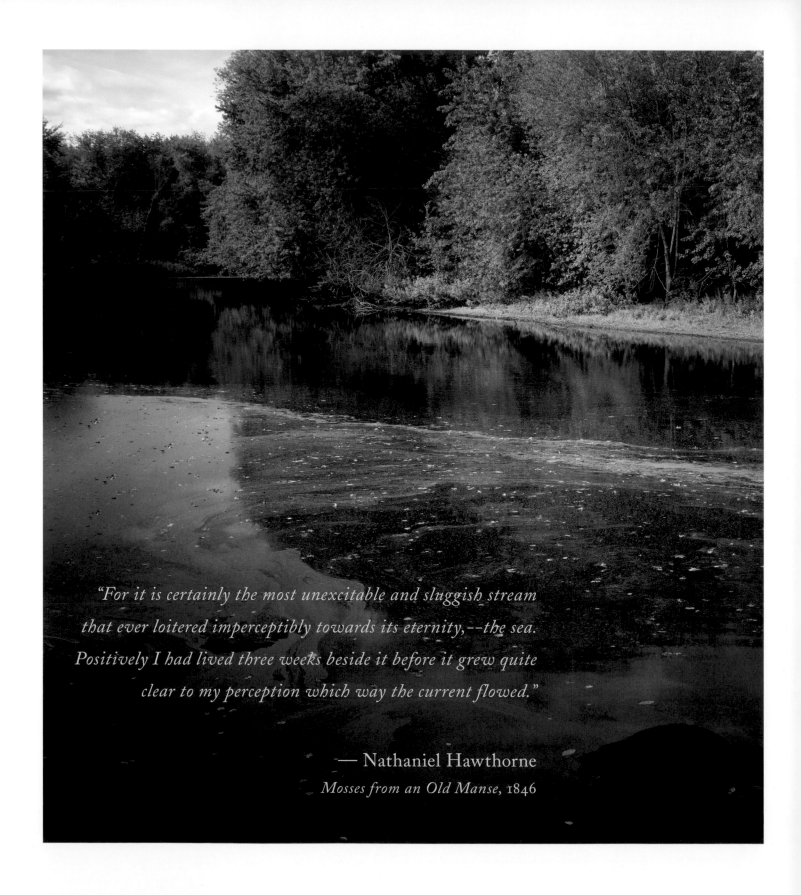

"For it is certainly the most unexcitable and sluggish stream
that ever loitered imperceptibly towards its eternity,--the sea.
Positively I had lived three weeks beside it before it grew quite
clear to my perception which way the current flowed."

— Nathaniel Hawthorne
Mosses from an Old Manse, 1846

general consul—a position he was given as thanks for writing the official biography of his friend and classmate, the recently elected President of the United States, Franklin Pierce. Upon his return six years later, he set to adding a tower to the house like the towers that they had loved during a long visit to Italy. But the graceful tower he had in mind did not much resemble the heavy structure that the native New England builders, not having had the luxury of visiting Europe, constructed.

While Hawthorne had affection for the house, perhaps it was the hillside behind it, from the top of which peaceful Concord lay spread out, that he liked the best. He wore a path up its steep side and paced its narrow peak while musing about what to write. The hill was also a way to avoid intrusions. His neighbor Bronson Alcott described him up there, "screened behind the shrubbery and disappearing like a hare into the bush when surprised."[17] Hawthorn once said; "This path is the only remembrance of me that will remain." Indeed, it still exists, though houses have grown up on the other side of the hill, startlingly close as one ascends to the top.

The fact that the hill was little more than a nub (its "peak" can be reached in minutes) would have been, to Hawthorne, beside the point. His imagination was able to make of the humble hill a windswept pinnacle rising above the mist on which he was the solitary adventurer. Such a flight of fancy was not unusual for him. Out of his imagination and his Yankee background he was able to turn the New England countryside—the white steepled churches, the public roads, the tree-furred rolling hills—into settings of gothic suspense and fear.

In "The Great Carbuncle," a "Mystery of the White Mountains" of New Hampshire, we meet a set of adventurers out in the wild hills, all drawn by a quest for a great shining red gem, visible at night even from the ocean. In a footnote that simply deepens the mystery, Hawthorne dubs the story an "Indian tradition" and adds that "Sullivan, in his History of Maine, written since the revolution, remarks, that even then the existence of the Great Carbuncle was not entirely discredited."[18] In Hawthorne's tale, which took on the dimensions of a moral allegory, no one ended up with the carbuncle, although some

were given a glimpse of it, one perished in the attempt and one adventurer was carried away by the Indians to be ransomed off in distant Montreal.

"What Hawthorne encountered he instinctively embroidered," Henry James wrote, "working it over with a fine slow needle and with flowers pale, rosy or dusky, as the case might suggest."[19] Not only did he have the constant urge to embroider his experiences, he was a master craftsman as well, his ease with words remarkable. His writing shimmers with that light that both women and men admired in his eyes.

But eventually the pen became heavy in his hand. By the time the tower was built at The Wayside, Hawthorne was struggling at the end of a glorious career. He was sick with what was probably cancer, and sickened, too, by the Civil War. In those final years, his handsome New England face thickened and was obscured by a walrus mustache. The shadows he had flirted with all his writing life were drawing closer now than ever.

In 1863, his longtime publisher and friend, William Ticknor, brought him to Washington D.C. to try to stimulate him. But instead, Hawthorne endured the horrible experience of finding Ticknor dead in his room. With whatever strength he had, he got a train back to Concord. Finding no carriages at the station, he walked back to The Wayside, appeared like an apparition before the startled Sophia, and collapsed. "Were man to live longer on earth, the spiritual would die out of him…" Hawthorne wrote at the outset of his career in *Mosses from an Old Manse*. "There is a celestial something within us that requires, after a certain time, the atmosphere of heaven to preserve it from ruin."[20] When Hawthorne's certain time came, he was back in New England, where he had spent so much of his celestial gift. Franklin Pierce brought the aged author on a restorative trip into the rugged beauty of New Hampshire. There, Hawthorne's body finally gave up. With Hawthorne's death, a psychological bridge to old New England—a "touch of Puritanic gloom," in Melville's words—was lost. ॐ

Corncord River behind the Old Manse. — Concord, Massachusetts

Nathaniel Hawthorne

*"It was a wondrous sight.
The wood was green
as mosses of the Icy Glen;
the trees stood high and haughty,
feeling their living sap;
the industrious earth beneath
was as a weaver's loom, with a
gorgeous carpet on it, whereof the
ground-vine tendrils formed the
warp and woof, and the living
flowers the figures. All the trees,
with all their laden branches;
all the shrubs, and ferns, and
grasses; the message-carrying air;
all these unceasingly were active."*

— Herman Melville
Moby Dick, 1851

The Ice Glen, one of the few spots in New England where one might encounter snow or ice in the middle of the summer. The Ice Glen was visited by Melville and Hawthorne on that day in 1850 which forever changed Melville's writing career and life.
— the Berkshires, Massachusetts

HERMAN MELVILLE (1819-1891)

The Climbing Party

ON A SUMMER DAY IN 1850, as a black thundercloud opened onto a huddled party of climbers, one of the men in the group was in a state of strange excitement. The rain that pelted Herman Melville was significantly colder than the downpour that had penetrated through the thick jungle foliage of Nuku Hiva as he and his friend Toby deserted the whaler *Acushnet* years earlier. Back then, he had wondered if the rain was ever going to stop. Now, atop the naked brow of Monument Mountain, he knew that, for all its violence, this was just a passing New England shower. He did not mind if the bracing rain continued until they were all soaked to the skin, for it prolonged his time in the company of perhaps the most fascinating man he had ever met: the great Nathaniel Hawthorne.

Was it his imagination or did the author read his thoughts? Did Hawthorne actually glance over at him and shrug his shoulders as if to say, in the words of his beloved Shakespeare, "Never did I hear so musical a discord, such sweet thunder"? Melville's body tingled as if something had passed between them.

Monument Mountain, where the travelers took shelter, was named for a mound of stones at the bottom of a cliff. They marked the spot where a Mohican maiden had jumped in sorrow to her death, her incestuous love for a cousin forbidden. Had Nature been feeling vengeful that day, she could all at once have decimated the American literary scene. On that day, many of the greatest luminaries of the time were gathered at that spot: earnest and sober Evert Duyckinck, editor of the *Literary World*; Oliver Wendell Holmes, poet and doctor; the dandified James T. Fields, of the famous Boston publisher Ticknor & Fields; Cornelius Mathews, author; Hawthorne, who was living nearby in a red cottage in Lenox; the bearded Herman Melville; and all of their wives. The jovial Holmes fished out of his doctor's bag a bottle of champagne and a silver cup and bade everyone to drink. Fields patted himself off as best he could with a large silk handkerchief. And Melville, feeling as vigorous and athletic as he ever had, climbed a peaked rock, which ran out like a bowsprit, and pulled and hauled imaginary ropes for the delectation of an admiring and somewhat apprehensive audience.

He suddenly stopped, jumping lightly from the rock. The attention had shifted to Hawthorne, who gazed toward the mountain range beyond. Ever observant, Holmes kidded Hawthorne that he must be looking for the great Carbuncle, a giant, glowing red gem of Indian legend that had featured in Hawthorne's famous story. [For more information, see the entry on Hawthorne.]

Starting down the mountain, Melville chafed with impatience as Cornelius Mathews launched into a half-hour recitation of the tragic poem of the Mohican maiden's leap. "Monument Mountain" had been composed by a famous poet of the region, William Cullen Bryant. But Melville was not in the mood for its unrelenting doggerel. He wanted to talk with Hawthorne.

The revelers dined at Fields' cottage. Then they set out again, under the guidance of a Berkshire denizen, to take the treacherous path through the Icy Glen, a cleft in the rocks full of scattered, moss-covered boulders that looked like they had been tossed there by the hand of God. It was one of those spots in northern New England where ice might survive in a cleft, hollow, or talus cave all summer long. Their guide led them on a trail that would wreak the most powerful effect on excited senses. And as they plunged deeper into the forest, the slightly drunk Hawthorne started to call out that they were headed for certain doom.

It was during this adventure that Melville finally got the chance to converse with Hawthorne, and to make his impression. Not only was he won over by the great author's melodious voice and elegant phrasing, he was struck by the depths of the man, and the way those amazing eyes seemed to see into the darkest shadows. If he could have, he might have impulsively thrown the mild-mannered author bodily into a carriage and

taken him somewhere where they could live and write the rest of their days without these worries about money, about dependents, in exquisite and ambiguous companionship. What they talked about is, like so many other tantalizing aspects of the life of Herman Melville, a complete mystery. But it is known that the famously shy and retiring Hawthorne was moved by his meeting with Melville to make the unprecedented suggestion that they should spend a few days together before Melville went back to New York.

We are indebted to Nathaniel Hawthorne's wife Sophia, one of the most trenchant and eloquent observers of her day, for this description of Herman Melville at the height of his powers: "He has very keen perceptive power but what astonishes me is that his eyes are not large & deep….They are not keen eyes, either, but quite undistinguished in any way….He is tall and erect with an air free, brave & manly. When conversing he is full of gesture & force….There is no grace or polish….once in a while his animation gives place to a singularly quiet expression out of these eyes, to which I have objected—an indrawn, dim look but which at the same time makes you feel—that he is at instant taking deepest note of what is before him—It is a strange, lazy glance, but with a power in it quite unique—It does not seem to penetrate through you but to take you into himself.[1]

Melville may have aroused a tinge of jealousy in Sophia Hawthorne. He was one of the few men who drew Nathaniel Hawthorne out. He was also capable of staying at his host's table until the wee hours. She is to be excused for dwelling on Melville's eyes, which provided such a contrast to her husband's beautiful and luminous set. Melville's eyes had already seen much in life, not all of it good. Perhaps something in their small, half-lidded depths was capable of disturbing someone as astute as Sophia Hawthorne.

The Formation of Herman Melville

Herman Melville came from good Colonial stock. His father's father had dressed up as a Mohawk and taken part in the Boston Tea Party. His mother was a Gansevoort, a name that had a stolidly martial ring to it in upstate New York, where her father, General Gansevoort, had famously held Fort Stanwix against the massed forces of the British and Indians. But in 1830, Melville's father, a prosperous New York merchant, saw an investment of his collapse. In a frighteningly short time, he went from being a genteel member of the American mercantile class to being the target of lawsuits, a disgraced pauper with nine mouths to feed. For the next two years he made desperate attempts to restore the family's fortunes. But any glimmer of hope went dark in 1832, as he sequestered himself in the bedroom of the house they could not pay for, lost his grip on sanity, and died in a maniacal state. Young Herman Melville was certainly old enough to have been touched by the hushed tones around the house, the air of malady. Perhaps he even witnessed the ravings.

In a manner typical of families of the early 19th century whose fortunes had suddenly gone bust, the Melvilles became dependent on the kindness of relatives. Herman probably spent the summer of his 15th year with his uncle Thomas Melville, who lived alternately in an imposing mansion south of Pittsfield, Massachusetts, and in the local jail for failure to pay debts. Before he retired to the country to become an impoverished gentleman farmer, Melville had traveled to Tahiti and breathed the fragrant air of the exotic. Certainly his stories fed "a vague prophetic thought" of Herman's, "that I was fated, one day or another, to be a great voyager."[2]

The great voyager set out humbly, in 1839, on the *St. Lawrence*, bound for Liverpool, as the lowest rank of sailor. He described what his life must have been like in *Moby Dick*. They "make me jump from spar to spar, like a grasshopper in a May meadow….It touches one's sense of honor, particularly if you come of an old, established family in the land…."[3]

Melville returned from the sea to the news that his mother's furniture was in imminent danger of repossession. He headed west to seek his fortune along the Erie Canal. He also tried teaching. Late 1840 found him, with his brother Gansevoort, in the famous whaling city of New Bedford, Massachusetts. They attended a sermon in the somber confines of the Whaleman's Chapel, which faith or superstition drove many seamen to visit before taking to the seas. The Chapel was well known for its cenotaphs of sailors who had been lost at sea. No doubt Melville studied the marble tablet put there in remembrance of Captain

Pollard of the *Essex*, which had been rammed by a whale and sunk in 1820, turning the survivors into cannibals. He found a job aboard the whaler *Acushnet*. On January 3, 1841, they sailed out, just as the *Pequod* did in *Moby Dick*, "almost broad upon the wintry ocean, whose freezing spray cased us in ice, as in polished armor."[4]

"A Whale Ship Was My Yale and My Harvard."

— Herman Melville
Moby Dick, 1851

It was quite an education, so far from the Melville parlor, in the midst of crusty seamen, foreign harpooneers and rats. And with a pleasant derangement of the senses he found himself beyond the reach of the cold Northern climes, heading south below the Equator on the lookout for whales from the top mast.

> Lulled into such an opium-like listlessness of vacant, unconscious reverie is this absent-minded youth by the blending cadence of waves with thoughts, that at last he loses his identity; takes the mystic ocean at his feet for the visible image of that deep, blue, bottomless soul, pervading mankind and nature; and every strange, half-seen, gliding, beautiful thing that eludes him; every dimly-discovered, uprising fin of some undiscernable form, seems to him the embodiment of those elusive thoughts that only people the soul by continually flitting through it. [5]

Melville had the ability, or even propensity, to stitch the real to the fantastic—a great gift for an allegorist but dangerous, as he suggested above, if taken too far. In his monumental, two-volume biography of Herman Melville, Hershel Parker calls this tendency "morphing." He also points out a passage in *Omoo* where Melville, having arrived at the bay of Papeete in Tahiti, notices a derelict whaling ship lying bilged upon the beach. "Before leaving Tahiti," Melville narrates, "I had the curiosity to

The Seamen's Bethel, a landmark even before Melville's time. Cenotaphs such as this one were plaintive reminders of sailors lost at sea. — New Bedford, Massachusetts

go over this strange ship, thus stranded on a strange shore. What were my emotions, when I saw upon her stern the name of a small town on the river Hudson! She was from the noble stream on whose banks I was born; in whose waters I had a hundred times bathed. In an instant, palm-trees and elms—canoes and skiffs—church spires and bamboos—all mingled in one vision of the present and the past."[6]

In July 1841, in another coincidence at sea, a chance meeting set the chick within him that would become *Moby Dick* to pecking at its shell. In a maneuver called *gamming* in the whaling industry, the *Lima* of Nantucket and the *Acushnet* pulled up next to each other and the captain and crew exchanged greetings. This gamming took place very near to the coordinates where the unfortunate *Essex* had been rammed by the homicidal whale. And who did Herman meet on board but the son of Owen Chase, who had witnessed the disaster and written the famous account.

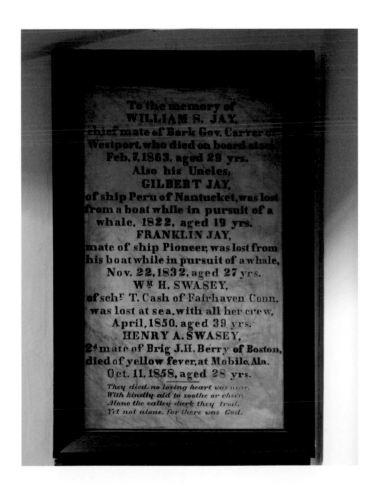

To the memory of
WILLIAM S. JAY,
chief mate of Bark Gov. Carver of
Westport, who died on board at
Feb. 7, 1863, aged 29 yrs.
Also his Uncles,
GILBERT JAY,
of ship Peru of Nantucket, was lost
from a boat while in pursuit of a
whale, 1822, aged 19 yrs.
FRANKLIN JAY,
mate of ship Pioneer, was lost from
his boat while in pursuit of a whale,
Nov. 22, 1832, aged 27 yrs.
Wᴹ H. SWASEY,
of schʳ T. Cash of Fairhaven Conn.
was lost at sea, with all her crew,
April, 1850, aged 39 yrs.
HENRY A. SWASEY,
2ᵈ mate of Brig J.H. Berry of Boston,
died of yellow fever, at Mobile, Ala.
Oct. 11, 1858, aged 28 yrs.
*They died-no loving heart was near,
With kindly aid to soothe or cheer,
Alone the valley dark they trod,
Yet not alone, for there was God.*

Before the ships parted, the son handed him a complete copy of his father's *Narrative*. "The reading of this wondrous story upon the landless sea," Melville later wrote, "and close to the very latitude of the shipwreck had a surprising effect upon me."[7]

But the *Acushnet* could not hold Melville. A year later, when the ship reached Nuku Hiva, he suggested to his friend Toby that they should desert. Toby assented. "We then ratified our engagement with an affectionate wedding of palms, and to elude suspicion repaired each to his hammock, to spend the last night on board."[8]

In a heavy rain, the two made their escape, Melville slipping and injuring his leg. The boys headed for the center of the island. They encountered a friendly tribe of Taipis who welcomed them into their village. And so they stayed among these people, befriended by some of the males and loved by the gorgeous "Fayaway," a maiden of the tribe. Melville had traded his family's sinking fortunes, the tragedy of his father's death, and the abuse of a whaling ship for the indolence of a tropical isle. Everything was idyllic except for two things. Melville's leg did not improve. And, perhaps even more ominously, they saw that it agitated their hosts enormously if, for any reason, they tried to leave the confines of the tribe. There were two possible reasons for that. This Taipi tribe was one of three warring tribes in the valley and perhaps their hosts were interested in protecting them. Another, more disturbing possibility had to do with the three fresh human heads, one of them Caucasian, that these gentle cannibals had tried to hide from Toby and Herman, who later also discovered of other body parts. This led to the question of whether they were being fattened up for a feast.

Toby somehow got away from the tribe on a mission to find medicine for Melville's leg. He vowed to return immediately but he was scooped up by another ship and taken away, leaving Melville in the Taipis' tender trap for three more weeks. With the help of a sympathetic member of the tribe, though, Melville eventually got aboard an Australian whaler, leaving the real-life Fayaway broken-hearted and quite possibly pregnant with his child. He had the misfortune, though, of being rescued by a vessel under the leadership of a captain who was incompetent at best, and sick at the time as well.

On a clear enough day, one can see the long hump of Mount Greylock from the window. Did the "gigantic ghostliness" of a distant and snow-clad Greylock represent the ever-elusive Moby Dick?

— Melville's study at Arrowhead.

Herman Melville

"*Of one thing only was I resolved, that I and my chimney should not budge.*"

— Herman Melville

I and My Chimney, 1856

The ship sailed in disorder to Tahiti. The local authorities threw Melville and several other men who refused to "do their duty" into the "Calabooza Beretanee," the British jail, under the care of the enormous and jovial Tahitian, "Captain Bob." One thing seems certain: there was no confinement in these isles that was not simple to escape from. A bearded, unkempt Herman Melville and his companion, a Yankee doctor nicknamed "Long Ghost," spent their days at the Calaboose in relative freedom and eventually slipped away quite easily by canoe.

Melville eventually boarded another ship and made it to Hawaii. In Honolulu he joined the U.S. Navy and sailed with the *United States* back to Boston, an experience that became *White Jacket*. Why did he decide that the charms of being an *omoo* (a wanderer, or beachcomber, in the local language) in the South Pacific were not enough for him? Biographer Newton Arvin suggested that Melville realized the impossibility of "going back" to a primitive state of being, and that perhaps he was bored as well. The islanders in Tahiti and Hawaii had been subdued by the missionaries and much of their most interesting aspects had become *tabu*, a fact that Melville lamented. (For this, he made several enemies among the God-fearing spreaders of morals and civilization of the time.)

Herman Melville's career as a writer began simply enough: a suggestion from a family friend that he write down the stories of his adventures. They were already well rehearsed, having been honed on sailors during his return to the United States. And he'd already practiced abridging them for the general public, as he used some of the tamer stories to woo Lizzie Shaw, the daughter of Lemuel Shaw, the Chief Justice of the Massachusetts Supreme Court and a friend of the family. They worked on the strong-willed Lizzie, of the rather heavy mannish face and fleshy lips, hair parted severely in the middle—she consented to marry the swashbuckling young sailor—and they became a success in the marketplace as well. For four years, Herman Melville wrote furiously. *Typee* was published in 1846

and *Omoo* in 1847. *Mardi* followed in 1849, along with *Redburn* and *White Jacket*. Over the course of these novels, Melville set loose a surge of words that documented his three-year adventure. They were straightforward books, of the memoir genre of their time: titillating, educational, and with less psychological delving than is popular today.

Pittsfield and Arrowhead

In the early 1850's, with five books behind him and a white whale on the brain, Herman Melville compared himself to "one of those seeds taken out of the Egyptian Pyramids" which had been planted 3,000 years later in English soil and grew. "From my twenty-fifth year I date my life. Three weeks have scarcely passed, at any time between then and now, that I have not unfolded within myself. But I feel that I am now come to the inmost leaf of the bulb, and that shortly the flower must fall to the mould."[9] Rather than English soil, though, he planted himself in Pittsfield, a town he had loved ever since his stay with his uncle Thomas.

After the excursion up Monument Mountain, Melville convinced himself that the whole family must move to the country so that he could write in peace. In a very short time, Melville impetuously bought a large farmhouse with one gigantic central chimney, situated on a swell of land that rolled high enough to allow a commanding view of Mount Greylock, miles away. He named it "Arrowhead," because of the Indian relics he found there, and described his purchase to his friend Duyckinck in his usual ardent fashion: "It has been a most glowing & Byzantine day – the heavens reflecting the tints of the October apples in the orchard – nay, the heavens themselves looking so ripe & ruddy, that it must be harvest-home with the angels... you should see the maples – you should see the young perennial pines – the red blazings of the one contrasting with the painted green of the other, and the wide flushings of the autumn air harmonizing both."[10]

And so he became the latest literary figure that the Berkshires cradled within their mountainous confines. Like Hawthorne, Melville was reclusive and eccentric. When he was seen in town (rarely for any churchgoing purpose) he drove his carriage in

a hell-bent-for-leather fashion. Once, dressed like a Turk, he appeared in town and abducted a young bride, pulling her into his buggy and making the husband and Duyckinck give chase. Who was this luxuriantly bearded man who drove so hard and wrote so hard and wanted so much? Was he was trying to escape from something or to reach something?

By 1851 his goals were simple. He wanted to finish the book that Hawthorne had enhanced by his presence. The Melville family (including his difficult mother) was settled in the farm-house with high hopes of the future, Hawthorne was close by, and the farm itself was almost inactive in the winter, thus sparing him time to write. "I have been building some shanties of houses (connected with the old one) and likewise some shanties of chapters & essays," he wrote in a letter to Hawthorne. And indeed, Arrowhead resembles *Moby Dick* in that way. The farm features a collection of separate buildings of different heights connected together. Similarly, *Moby Dick* is not one long sequence of events but contains many infill chapters devoted to various aspects of whaling. Melville also built a "piazza" in full view of Mount Greylock which he paced like the deck of a ship.

"One Grand Hooded Phantom,
Like a Snow Hill in the Air"

— Herman Melville
Moby Dick, 1851

In March of 1851, Hawthorne paid a visit to Arrowhead. The two men repaired first to Melville's study, where they discussed the "gigantic conception" (Hawthorne's deft choice of words) of the book that was then called the "White Whale," with the view of a snow-covered Mount Greylock "looming" out the study window. It is not known whether they discussed *Greylock* and *Moby Dick* specifically, but the mountains of New England in winter definitely exerted a strong influence over Melville's descriptions. In one passage he compared the whiteness of the whale to that "gigantic ghostliness over the soul"[11] cast by the White Mountains of New Hampshire. In another, he compared the whale's hump to Mount Monadnock (a favorite mountain

among the Transcendentalists). In still another, he compared the fear the whale's whiteness induced to "the bleak rustlings of the festooned frosts of mountains."[12]

The pursuit of the whale was all-consuming. On the whaler *Pequod* it was directed by Captain Ahab, who had lost one leg to Moby Dick and replaced it with one of ivory. Ahab was "gnawed within and scorched without, with the infixed unrelenting fangs of some incurable idea"[13]; namely, to kill Moby Dick. He did not speak like a ship's captain but like a smoldering refugee from a work of Shakespeare. "That inscrutable thing is chiefly what I hate; and be the white whale agent, or be the white whale principal, I will wreak that hate upon him. Talk not to me of blasphemy, man; I'd strike the sun if it insulted me."[14]

This was the book Melville had been longing to write, a work not prettied up for general consumption. A book in which he could let loose, let the blood flow and get to the truth. In it, he celebrated America by adding the Indian legends to the other great legends of the world, putting New England whalers in their proper context as great adventurers of the "watery pastures" of the globe, added the Great Lakes and Erie Canal to the natural wonders of the world, and raised language in an American literary effort to a height it had never seen. This book could confirm for Sophia Hawthorne the contents of what lay behind his lazy glance—both the genius and the insatiable hunger.

At last, the book was written. It had not yet been published when reality took its turn imitating art. On October 16th, 1851, a report that a whaling ship named the *Ann Alexander* had been sunk by a whale prompted Melville to ask: "I wonder if my evil art has raised this monster." He was dead serious. It wasn't the first time he referred to the book, or himself, as something wicked. Despite all that, he seems to have been sure it was a masterpiece. And with that in mind, he dedicated it to the figure that had done so much to influence its course: Nathaniel Hawthorne.

Hawthorne praised the book in a letter that has not survived. But whatever he said touched Melville deeply. Certainly, if the great Hawthorne thought so highly of it, he must have thought, the literary world would too. "Lord, when shall we be done growing?" he exulted to Hawthorne in November 1851. "As long as we have anything more to do, we have done nothing. So

now let us add *Moby Dick* to our blessing and step from that. Leviathan is not the biggest fish; -- I have heard of krakens."[15]

Bold, proud, aspiring words. Words that were buried under a mounting pile of criticism and indifference. It is hard to imagine how reviewers of that day were able to get through its 800-plus pages in time for a copy deadline. Apparently they had been expecting something lighter, more spritely, from their favorite author of sea tales. Even his friend Duykcinck had little to say in favor of the book. Much was riding on its success, including another loan. And its commercial failure must have been almost as devastating as the reviewers' barbs.

Still, Melville continued to write at his usual feverish pace, bringing out his "kraken," named *Pierre*, in 1852. He dedicated it to "Greylock's most excellent majesty" for her "most bounteous and unstinted fertilizations." By then, Hawthorne had left the neighborhood, moving back to Boston. Also that year, reality continued to morph with art. News came that the whale that sunk the *Ann Alexander* had been hunted down by the former captain of that ship. He identified it by the splinters of hull in the killed whale's badly-damaged front, and by the protruding shafts of the *Ann Alexander*'s harpoons.

The book *Pierre* was autobiographical at the core, a glimpse into a family like the Melvilles. But the plot took a turn that Melville's life had never taken. The main character, an author, falls in love with his sister. It was a theme distasteful to many. It was, as W.H. Auden later put it, a critical "shipwreck." Reviews were harsh. The exuberance that had been Melville's when he completed *Moby Dick* was sucked down like the *Pequod* towards the "button-like black bubble" at the axis of a whirlpool.

"*Bitter It Is To Be Poor and Bitter To Be Reviled*"

— Herman Melville
from the journal of Herman Melville, 1939

So wrote Herman Melville a few years after the *Pierre* debacle. He suffered a bad accident when the horse that was sedately pulling his carriage spooked, and lived with pain after that. He could not, or would not, write fiction on demand, and turned to poetry instead. His friendship with Hawthorne had already cooled and no one had replaced his stimulus. Herman Melville seemed, except for his family, suddenly bereft.

Later, while Hawthorne was consul of Liverpool, Melville visited him on his return from the Holy Land. Melville had been sent on the trip to restore his spirits, for he seemed to be losing his grip. It hadn't entirely worked. He told Hawthorne that he had "pretty much made up his mind to be annihilated." With his typical candor, Hawthorne wrote of the desultory visit that "it is strange how he persists…in wandering to- and fro over these deserts, as dismal and monotonous as the sand hills amid which we were sitting."[16]

Herman Melville departed from the Berkshires. He sold Arrowhead to his brother. The house, once no more than a simple farmhouse, was by then famous as the Herman Melville residence—though the price he got from his brother did not seem to reflect that added value. He and Lizzie moved to New York City.

In 1939, W.H. Auden published a poem called "Herman Melville," which sums up the author's life in 41 adamantine lines. To Auden, *Moby Dick* was "intricate" yet "false," with the "unexplained survivor" of the *Pequod* appearing from nowhere and escaping the whirlpool to bring the tale to an end. To him, Melville was like a ship in search of evil, sails filled with a dreadful unsettling that had originated with his father's collapse and insanity.

He and Lizzie remained in New York City for many years, where Melville held a job as customs inspector. He was a changed man, fame left far behind in his wake, quietly entering his third career. But maybe he was at peace at last.

Towards the end he sailed into an extraordinary mildness,
And anchored in his home and reached his wife
And rode within the harbour of her hand,
And went across each morning to an office
As though his occupation were another island.

(W.H. Auden, "Herman Melville")

Herman Melville

A Later Flowering
ROBERT FROST (1874-1963)

"I gnaw wood."

*S*ITTING OVER his mother's kitchen table, 19-year-old Robert Lee Frost chuckled to himself. That had been his retort when his fraternity brothers at Dartmouth asked him what he did on those long walks he took, day and night, in the woods surrounding the campus.

"I was chasing butterflies," he might have told them. They would not have thought him any less strange.

He fit his rangy frame into the wooden chair, picked up his pen and looked down upon the cheap paper notebook where he had lodged his words. He read them:

My Butterfly

Thine emulous fond flowers are dead, too,
And the daft sun-assaulter, he
That frightened thee so oft, is fled or dead:
Save only me
(Nor is it sad to thee!)—

Showing a grace that stood him in good stead in his most recent job as the person responsible for changing the arc lights high above the floor of the bobbin mill, he rose and went swiftly to the door. He latched it firm.

"Save only me," he wrote again. "There is none left to mourn thee in the fields."

He'd come to a clearing. The first stanza felt ended. Behind him, his sister tried to open the door. The jiggle of the latch was like the sound of a twig breaking in a massive wind and darkness. In after thought, the pen's nib moved again:

The gray grass is scarce dappled with the snow
Its two banks have not shut upon the river;
But it is long ago—
It seems forever—
Since first I saw thee glance,
With all thy dazzling other ones,
In airy dalliance,
Precipitate in love,
Tossed, tangled, whirled and whirled above,
Like a limp rose-wreath in a fairy dance.

Robert Lee Frost was still at the kitchen table in Methuen. But the modest walls of the Frost kitchen seemed to have dropped away, replaced by a vastness. The sense of the writing now "was like cutting along a nerve." Small wonder that his sister's furious thumps on the other side of the door were as insignificant as the struggles of a bottle fly trapped inside a glass.

She tired before he did. He would not have cut short that period when the muse was on him. For always afterward Robert Frost remembered the writing of that poem as the moment he came into his own. "The first stanza—well, that's nothing," he said when, years later he recounted the genesis of "My Butterfly" later to Elizabeth Singer Sergeant. "But the second—it's as good as anything I've ever written. It was the beginning of me."

He was right to feel that he had happened upon something. For "My Butterfly" became the first poem he ever published. He submitted it to a periodical called *The Independent*, which was devoted to poetry. Frost had never known such a publication could exist until one day when he visited the Dartmouth library. And finding it may be the most valuable discovery he made while in his brief sojourn at the college.

"I think sound is part of poetry," he wrote in response to a letter from Miss Susan Hayes Ward of *The Independent*, "one but for which imagination would become reason." Miss Ward recognized the talent of the young man whose poem had, through sound, emulated the wayward path of a butterfly in flight. She extended a guiding hand to the headstrong poet when he needed one.

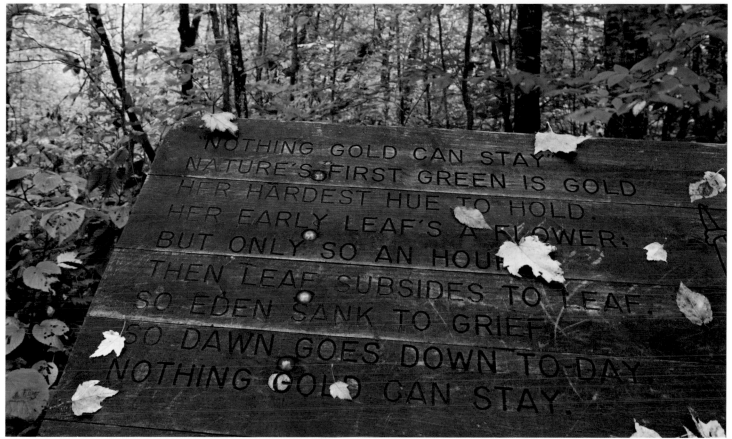

From the **Robert Frost Interpretive Trail**, one of his briefer poems, "Nothing Gold Can Stay" comes to mind at least twice a year in New England: when spring turns the buds to a lovely green gold, and in the autumn when those same leaves fall and carpet the ground. — Ripton, Vermont

A Boy's Will is the Wind's Will

Knowing the poem had been accepted and feeling he was on the verge of his first poetic success, Robert Frost had "My Butterfly" and several other poems printed and bound into a book he titled *Twilight*. He made only two copies: one for himself and one for a girl named Elinor White (much as a similarly "no account" William Faulkner was to do for his Estelle).

Elinor, whose family tree went back to the earliest New England residents, was lovely to behold and as smart as she was a pleasure to look at. Ever since sophomore year at Lawrence High School, Frost had been in love with Elinor. She had kept him at arm's length but did not send him away. They would have made a very handsome couple. Frost had an athletic build, frank blue eyes, sensuous lips. He and Elinor had shared the honor of valedictorian of their Lawrence High School. And then she had

gone off to St. Lawrence College and he to Dartmouth. Only the difference was that she took to college as an upstanding New Englander, given a chance to get a fine education, should. After he walked away from school to work at the mill, she thought less of him for it.

When Frost went to visit her in her dormitory, his two sets of *Twilight* in hand, she took the copy but sent him away. She was flustered by the fact that he had shown up in a dormitory where men were strictly forbidden. But she was also not in the mood for his romantic sally. Exactly what was said is lost to history. But Frost left his copy of *Twilight* in pieces somewhere between the dormitory and the railroad tracks. Smoldering with rejection, he disappeared from New England, perhaps for forever.

He wound up in the Great Dismal Swamp, near Norfolk, Virginia. He intended to end his life. But something that he

found while wandering in the Swamp brought him back. And, in time, something changed in Elinor as well. When she went back to college after the Christmas holiday, she went as the future Mrs. Robert Frost.

So it was that in 1894 Robert Frost got engaged and had a poem published. In a letter he wrote to Miss Ward that year (before the wreck of the *Twilight*) he said, "Even in all my failures I find all the promise I require to justify the astonishing magnitude of my ambition."[1] He sounded very much like the boy whom Henry Wadsworth Longfellow described in the poem "My Lost Youth"—a paean to Longfellow's home town of Portland, Maine and to the thoughts of a boy:

> I remember the gleams and glooms that dart
> Across the school-boy's brain;
> The song and the silence in the heart,
> That in part are prophecies, and in part
> Are longings wild and vain.
> And the voice of that fitful song
> Sings on, and is never still:
> "A boy's will is the wind's will,
> And the thoughts of youth are long, long thoughts."

The entire poem has ten stanzas, each concluding with the same two-line refrain. There is no doubt that Robert Frost felt some kinship with the poem. He paid homage to it when he named his first book *A Boy's Will*. And in time he was to become as inextricably linked with New England as Longfellow.

"They Leave Us So To The Way We Took"

— Robert Frost
"In Neglect"
A Boy's Will, 1915

It would be a long time before *A Boy's Will* was published in a book. And when it was, Frost was again not "home" to receive it (if one would consider "home" by then to be New England). Robert Frost's first two books of poetry were published in

England. But much struggle was to come before they saw the light of day. "We have to be careful not to claim for me that I originated as a bobbin boy, cobbler, or…as a farm hand. I simply turned my hand to most and turned it good (or pretty good) in various situations, as Kipling has it, and never mind what so long as I got by while furtively fooling with poetry."[2] Frost wrote these biographical details to his good friend Louis Untermeyer in 1950 when giving him a brief accounting of his life.

Once married, he'd turned his hand to teaching again at his mother's private school, as had Elinor. Their first child, Eliot, was born in 1896. Frost, despairing of ever making money as an elementary school teacher, applied to Harvard and was accepted. But during his sophomore year he got sick and left the school. The crisis may have been more mental than physical but its symptoms appear to have been serious enough that (in Frost's words) the Harvard doctor sent him home "to die."

It would have been a very inconvenient time to expire. His daughter Lesley had been born in that year and now there were four mouths to feed. Robert and Elinor turned to agriculture. They raised chickens in Methuen. But they were barely scratching out a living. It was Elinor, finally, who approached Robert Frost's grandfather and asked him for the money to buy a small farm in Derry, New Hampshire. His grandfather put up the money, and even (wisely) threw in a hired man to help on the farm. His condition was that Robert turn his hand for only one more year to poetry. And if it didn't pay, he should settle down.

The farmhouse in Derry still exists. It went through a fallow period in the 1950's as a junkyard named "Frosty Acres" but has since been restored to look much like it did when the Frosts lived in it. The white house is attached to the barn by a New England ell that houses a large shed for firewood, thus making it easy to reach the animals in all kinds of inclement weather. The "two-holer" toilet is off the woodshed next to the barn. It would have been a cold journey in winter. As the house's guide will point out, and as many of his Yankee neighbors probably noted, Robert Frost was not the most practical farmer.

"After Apple-Picking" comes to mind outside the **Frost farmhouse.** — Derry, New Hampshire

Robert Frost

As "Two Tramps in Mud Season" will attest, Robert Frost was proud of being well-versed in wood splitting.

The place for hanging clothes out to dry was on the far side of the ell, necessitating a long outside walk. The well was located close to the house but Frost did not get around to running water to the house. He milked the cows at one p.m. and midnight because it fit his poetry-writing schedule.

The kitchen of the house, where Frost did his writing, is located off the woodshed and looks out into a meadow that falls away to a brook. In the kitchen is an old telephone, and in those days the phone in Derry was a party line. If one so desired, one could pick up the phone and hear whatever conversation was taking place between a Yankee farmer and the feed store, a farm wife and her friends. It is thought by some that access to the party line may have assisted Frost in capturing the authentic

New England voice that he brought to his poetry. Frost had his "good fences make good neighbors" neighbor to the north but other neighbors were even more distant, both geographically and personally.

After midnight, when the house was finally cleared of day sounds, Frost wrote. Though, if the urge took him, he walked. As far back as his valedictory address, Frost was already at work on a theory that genius and poetry came from "afterthought." As a boy of 18, up on a stage with Elinor, he had told the audience: "It is when alone, in converse with their own thoughts so much that they live their conventionalities, forgetful of the world's, that men form those habits called the heroism of genius...". A paragraph later, he noted: "The poet's insight is

The kitchen table at which Robert Frost wrote many of his poems. It is thought that Frost tuned his ear to the Yankee vernacular at this shared-line phone. *(Above and Left)* **Frost farmhouse.** — Derry, New Hampshire

his afterthought." Afterthought was what Frost needed time to achieve. The cows be damned and the farmwork too; the poetry was uppermost in his mind. But to complicate matters, two more children were born. Room was made under the eaves. And, while Elinor shouldered much of the burden of bringing them up, Robert was very much present for them as well.

All things considered, the schedule he maintained was unfit for man or beast. It did not allow enough time to draw a significant yield from the farm or from poetry. As Elizabeth Sergeant described in her book:

Friends and relatives in Lawrence, if they came at all, did so to protest that a brilliant mind was being buried in the earth. They

saw a bare cupboard and a halfhearted farmer who dreamed along the furrow—not the touching, flowing poems that were later to reveal how truly were the years of obscurity a matrix for the poet's long life and eventual great body of poetry.[3]

He may have been dreaming but he was by no means lazy. In the poem called "Mowing," he spoke of the "earnest love" that through his arm swung the scythe blade. "The fact is the greatest dream that labor knows," he wrote. He had grasped the profundity of work well done.

With a collective sigh, friends and relatives left Robert and Elinor to the way they had taken. And for those years that the family lived in Derry, their neighbors left them very much to

Robert Frost

themselves as well. In the first eight years, the neighbors did not once invite them for a meal, Frost said.[4] Well, this was not entirely unexpected; Yankee farmers are known to be very reticent. And it was not entirely clear whether Robert was one of them. He'd lived in Derry for less than a decade. And after eight years he had yet to share any work like haying or sugaring with them. This does not a good Yankee farmer make. Frost himself said that he and Elinor did not want or need people. They experienced their joys and sorrows alone, including the loss of two children: the first born, Eliot, and a daughter named Elinor, who only lived for four days.

After six years came a break from the furrows. Robert was invited to read a poem on ladies' night at the Derry Village Men's Club. He read "The Tuft of Flowers," about a farmer who goes into the field to turn the newly mown grass that someone before him had cut down. The farmer, observing the scene, concludes early on that men work alone even when they work together. Even if he were to be working with the mower at the same time in this field, they'd be working by themselves. It is then that a butterfly, coincidentally enough, flits into the poem and leads the farmer to a tuft of flowers that the mower with his scythe had spared. The discovery of this act of mercy on the part of the mower makes the lone grass turner feel he has encountered the traces of a kindred spirit. Then the mower becomes his unseen companion, and the poem finishes with the farmer addressing him:

> "Men work together," I told him from the heart,
> "Whether they work together or apart."

The poem must have appealed personally to the assembled listeners. Many of them had probably reached their own conclusions about this family, that kept itself so aloof and milked its cows at odd times of the day. But surely he touched them on a poetic level as well. It just so happened that there was an opening for a teacher at the local Pinkerton Academy, for which they thought he might be the man.

Frost taught for the next six years. "You might find it grist to your mill," he wrote to Louis Untermeyer in 1950, "that I was most really and truly an all-out teacher back at Salem, New Hampshire, where I presided over 12 barefoot children under 12 in a district school by the woods and often sitting on the lid of a woodbox by the stove wrote poetry (some of the poetry of *A Boy's Will*) on the window sill for my table." He was a respected teacher, and could have stayed. But just like farming, teaching took him away from writing poetry.

He didn't have much publishing success to go on. He had little to sustain him during his self-imposed exile besides a steady and beautiful companion in Elinor, the joys of fatherhood, the hard-won rewards of apple picking, milking, mowing, growing crops, some unpublished successes in verse, and the astonishing magnitude of his ambition.

The Road Not Taken

Unlike some of his contemporaries, such as William Butler Yeats and Robinson Jeffers, Robert Frost was not a mystic. He did, however, have a few mystical experiences in his life, and they were powerful. This one led to the writing of one of his best-known and oft-quoted poems ("The Road Not Taken") and to his decision to leave New Hampshire. He wrote a letter to Miss Ward in 1912 in which he described the experience:

> Two lonely roads that cross each other I have walked several times this winter without meeting or overtaking so much as a single person on foot or on runners. The practically unbroken condition of both for several days after a snow or a blow proves that neither is much traveled. Judge then how surprised I was the other evening as I came down one to see a man, who to my own unfamiliar eyes and in the dusk looked for all the world like myself, coming down the other, his approach to the point where our paths must intersect being so timed that unless one of us pulled up we must inevitably collide. I felt as if I was going to meet my own image in a slanting mirror. Or say I felt as we slowly converged on the same point with the same noiseless yet laborious stride as if we were two images about to float together with the uncrossing of someone's eyes. I fully expected to take up or absorb this other self and feel the stronger by the addition for the three-mile journey home. But I didn't go forward to the touch. I stood still in wonderment and let him pass by.[5]

As Elizabeth Sergeant noted: "Some of the world's great geniuses (Goethe is one of them) have recorded similar meetings with their own images at a moral or mental cross-roads in life."[6] Surely, it set him to wondering about where his double may have been headed. Perhaps he even rued his reluctance to see what would have happened if he had not stood still.

In any case, after that meeting, Robert and Elinor started talking about moving. They talked of going far away. The candidates were Vancouver and England. In the end, a coin toss sent them to England, a country where they knew not a soul. They sold the Derry farm and, with the meager proceeds and the remnants of his grandfather's estate, the unknown poet and his family sailed for London.

Short-Circuiting a Dynamo

The voyagers to England were, no doubt, not without misgivings about the action they had taken. And certainly, passage wasn't made any smoother by the behavior of the captain. Frost wrote to Untermeyer that "the captain hated us all because he was seasick and believed us all of the servant class going back to England to find a coat of arms for ourselves."[7]

After finding a cottage in the country, near where Milton had completed *Paradise Lost*, and not too far from London, Robert Frost set about his work. He took all the poetry he had written over by the fireplace and he burned what he felt didn't measure up. What was good he saved. It became *A Boy's Will*.

"Wholly on impulse," he wrote to Thomas Bird Mosher, a Maine publisher, "one day I took my MS. of A Boy's Will to London and left it with the publisher whose imprint was the first I had noticed in a volume of minor verse....I suppose I did it to see what would happen, as once upon a time I short-circuited a dynamo with a two foot length of wire held between the brushes."[8] The publisher Frost brought it to, David Nutt, had died. But a mysterious Frenchwoman who acted on Nutt's behalf accepted the manuscript and they made a contract to publish it.

A short time later Frost, who had been given the card of Ezra Pound, decided to look up the noted expatriate poet, leader of the Imagist movement. He went to the house and Pound chanced to be home, slightly put out that Frost had not made a pilgrimage to him earlier.

"Flint tells me you have a book." Pound said.

"Well, I ought to have," Frost replied.

"You haven't seen it?"

"No."

"What do you say we go get a copy?"

As Frost related, they went to the publisher and Pound took the first copy, put it in his pocket, and didn't show it to Frost.

"You don't mind our liking this?" Pound asked.

"Oh, go ahead and like it."

Pound started reading and soon said,

"You better run along home. I'm going to review it."

And Frost went home without his book. He had barely seen it.[9]

The review, while positive, was also full of embellishments about Frost's own personal life, "facts" that Pound had winnowed from his brief conversation and extrapolated from the look on Frost's face. No matter. Despite the inaccuracies, Frost was in print and he had an early champion. Pound took him under his wing and, for a time, Frost had the keys to the literary kingdom. But Pound was an odd duck. One time, he showed him his facility with jiu jitsu: "Threw me over his head," Frost related. "Wasn't ready for him at all. I was just as strong as he was. He said, 'I'll show you, I'll show you. Stand up.' So I stood up, gave him my hand. He grabbed my wrists, tipped over backwards and threw me over his head."[10]

Frost proved easier to flip than he was to convert. He resisted being taken into Pound's poetic movement and his friendship with Pound cooled. He made one great friend with a poet while in England, a man named Edward Thomas. With Thomas he had another rare mystical experience, beautifully described in "Iris by Night." One evening, while walking in the mist-saturated fields, the two men came upon a small rainbow like a "trellis gate." And then "the miracle / that never yet to other two befell," the rainbow gathered up its loose ends and surrounded them in a perfect ring. Thomas seems to have touched him like no other men had—or perhaps ever did afterwards—but World

War I ended that. Thomas was killed in the Battle of Arras, shortly after he arrived in France.

At one point, Frost had said that he would stay in England until they deported him but the coming of World War I changed all that. It was clear, too, from the second book of poetry he had published in England, called *North of Boston*, that his heart lay back in New England. And he was to find, when he returned, that much had changed. On the day they disembarked from the ship he went to buy his first American newspaper. He picked up a copy of the brand new magazine, *The New Republic*, and in it he found a review, mostly laudatory, of *North of Boston*, by the well-known poet and critic, Amy Lowell. "If you have ever seen Robert Frost receiving…a prize, you will remember the little smile, pleased, yet something skeptical and secret, almost derisive, that flits across his face at such a moment,"[11] Elizabeth Sergeant wrote.

He may have been penniless. He may have been without an American publisher. But he was returning a known poet.

Yokefellows in the Sap Yoke From of Old

The now-celebrated poet and Elinor returned to New Hampshire where Frost made an offer on a farm in Franconia that wasn't for sale. The farmer, convinced somehow, sold it to him and moved down the road. But it was harder than before to do as he suggested in "Directive" and "pull up the ladder road behind" them, putting up a sign "closed to ALL."[12] His obscurity was over. The man who sold him the farm came to this realization as a steady procession of city folk drove past his door or even called his house in order to reach Frost. So did the man's father, who advised: "Next time you sell a farm, son, find out beforehand if it's going to be used as a farm or a park."[13]

Once his poetic acceptance came, it came in a flood. But even with his credentials (12 years of toil on a Derry farm), it was hard to join the club of Yankee farmers, and Frost struggled for acceptance. The farms had stood shoulder to shoulder for generations, and their gaze was inward.

As he suggested in "The Death of the Hired Man," the New England farmer valued a man's ability to pile hay and find water with a hazel prong. A man might sit on his duff and

write poetry in a farmhouse kitchen but that didn't make him a farmer. He once wrote to Untermeyer, as if establishing his qualifications: "A skeptic once taking my hand and turning it inside out to the light, remarked that it was merely calloused not horny. All right, I said, if he wasn't satisfied, he could coin a word and call me a farmster. Anyway, I have never been without livestock since I was five, and practically never without farm property since I was twenty-five."[14]

Even a poet must make a living, most likely cobbled together, and Frost was no exception. He derived his income from teaching (much of it at the small New England college of Amherst), appearances, readings, correspondence, and trips to New York to see his publisher (for he had one in the U.S. now in Henry Holt). He had become a best-selling poet—north of Boston remained his seat of power.

There in the White Mountains and then the Green Mountains, the poet farmer could see the "chisel work of an enormous Glacier that braced his feet against the Arctic Pole" and feel the "coolness" from him that still lingered in the mountain fastnesses.[15] The intrepid wanderer in upper meadows that crested on views of far off peaks, could find the cellar holes, "slowly closing like a dent in dough," of ill-considered or ill-timed settlements that had not survived. Frost had gone there in "Directive." In "The Wood-Pile," while walking in a frozen swamp, the "view all in lines straight up and down of tall slim trees," he'd come across a cord of maple logs cut and stacked and never used. Here he had come across a brook in "West Running Brook" that could "trust itself to go by contraries," flowing west where all others flowed east. This was Frost country.

There is an ancient rivalry between New Hampshire and Vermont. Frost's presence in both has only stoked the fires higher. Frost did not take a position. Or rather, he took two: "She's one of the two best states in the Union," he said of New Hampshire.

> Vermont's the other. And the two have been
> Yokefellows in the sap yoke from of old
> In many Marches. And they lie like wedges,
> Thick end to thin end and thin end to thick end,

And are a figure of the way the strong
Of mind and strong of arm should fit together,
One thick where one is thin and vice versa.
New Hampshire raises the Connecticut
In a trout hatchery near Canada,
But soon divides the river with Vermont.
Both are delightful states for their absurdly
Small towns—Lost Nation, Bungey, Muddy Boo,
Poplin, Still Corners (so called not because
The place is silent all day long, nor yet
Because it boasts a whisky still—
Because it set out once to be a city and still
Is only corners, crossroads in a wood.)

One morning shortly after he wrote "New Hampshire," dawn broke outside the Stone House where he had struggled all night with a long piece of blank verse. As John Ciardi, the poet and translator revealed, Frost "rose, crossed to the window, stood looking out for a few minutes, and then it was that "Stopping by Woods" suddenly "just came," so that all he had to do was cross the room and write it down."[16] "Stopping by Woods on a Snowy Evening" became one of his most beloved poems. It had the virtue of being brief enough and simple enough for grade school teachers to teach rhyme and perhaps penmanship (and, in Vermont, at least, to introduce the story of Vermont's own Morgan Horse—quite possibly the "little horse" to which the poem referred). It also showed that the deathly lure of the dark woods was strong in Robert Frost, even halfway through his career.

Ciardi did not dispute that the idea of the poem had come that way, but he doubted that a poem with such a complicated rhyme scheme—and the repeated lines at the end—could have come even to Frost so easily. "I always write with the hope that I shall come on something like a woman's last word," Frost told Elizabeth Sergeant.[17] Perhaps, with "Stopping by Woods," he had succeeded.

Certainly, Frost must have had Elinor in the back of his mind when he referred to a woman getting the last word. For this woman whom he was married to for 43 years was not "the conventional helpmeet of genius" that Amy Lowell had reduced her to in one portrayal of Frost. For one thing, she was a hard-won prize. She was also a beauty. As one admirer wrote: "An almost reluctant sweetness showed in the shape of her mouth under a veiled sadness, yet the blue-black eyes when they turned your way looked *through* you."[18] Together with the handsome Frost, the two made a very fine matched pair. But she was more than the sum of those things. The two had a marriage of true minds. After he complained to Untermeyer about Lowell's depiction of her, Frost went on: "Elinor has never been of any earthly use to me. She hasn't cared whether I went to school or worked or earned anything. She has resisted every inch of the way my efforts to get money. She is not too sure that she cares about my reputation….She seems to have the same weakness I have for a life that goes rather poetically; only I should say she is worse than I."[19] Just as New Hampshire guarded "specimens" that she "did not care to sell,"[20] Elinor felt no great urge to share her poet with the world. But there were always money troubles and so the couple had no choice.

The critic, Lionel Trilling, once called him, with admiration, "a poet who terrifies."[21] Part of it must have come from the starkness of the life that he and Elinor led—one that was quite full of moments of despair. More came in 1934, when they lost their daughter Marjorie to complications from childbirth. Then, in 1938, Robert Frost lost "the unspoken half of everything I ever wrote," when Elinor died of cancer.

Acquainted With the Night

But he was not alone. As he had once suggested of another in "The Silken Tent," he seemed to be "loosely bound by countless silken ties of love and thought" to many friends and admirers. "We should have a good talk," he would tell them when he saw them, or wrote to them (it is remarkable to hear the similarity of these accounts). As one of his conversational foils, Reginald Cook, described:

> There are few unintended pauses in it. One thought starts another, and he rambles on while the deep-set blue eyes, the blunt nose, the expressive lips, the formidable chin and the shock of white

hair all help to pin a point down....He always seems at random like a bluebottle fly on a hot midsummer day....Just as the charm of the man comes to focus in his talk, so the total force of the poet comes to focus in the resonant voice.[22]

Vrest Orton, a publisher and book collector, locally famous in Vermont as the founder of the Vermont Country Store in Weston, maintained that to discourse with Frost was to see "genius plain." Out of his discussions with Frost over the years came a book of poetry, *Vermont Afternoons with Robert Frost*. On a succession of nights in 1960 he woke up out of a sound sleep with the conversations he'd had with Robert Frost 30 years before "striving for expression." He took dictation from his unconscious, and later added meter. An example:

What Else had Failed

I

Hardly a man comes up this far
Without asking me the same question:
How can I live so far away!
Since you didn't pose the question,
You'll be the first to have my answer.

II

I came up here to see how man had failed!
Down country he seems to have won all his wars;
He's littered land and befouled water.
He's a stranger to peace and the clean heart.
The fear of God is not in him.
Up here, I thought, maybe someone else
Might have the upper hand.

— Vrest Orton
"What Else had Failed"
Vermont Afternoons with Robert Frost, 1971

Frost stuck in Vermont for part of every year. In the warm months, the talking could take place out-of-doors where Frost, the amateur botanist, could ramble and explore the countryside where man had not yet gained the upper hand.

In 1940, he bought the Homer Noble farm in Ripton, Vermont, close to the Bread Loaf School of English, Middlebury College, which he had co-founded in 1920. The Bread Loaf Writer's Conference, which is held every summer near the top of the Middlebury Gap in the Green Mountains, drew—and still draws—the writing luminaries of the age. There, a cluster of buildings painted a creamy turmeric overlooks a huge meadow and the rolling hills beyond. Established writers and promising new ones gather there to discuss writing.

He spent winters at a cottage in Key West, and summers in a small cabin, simply furnished with wood panels and a large fieldstone fireplace, at the Homer Noble farm. He also owned a home in Cambridge, Massachusetts, which Vladimir Nabokov briefly rented. It must have tickled Robert Frost, lover of the classics, to have happened on a farm owned by a New England farmer with such a promising name. Summers, he rented the farmhouse to the Morrisons (Theodore, a Bread Loaf writer, his wife, Kay, and two children). Kay took care of smoothly scheduling and arranging his appearances for readings and awards and, as other complications fell away, she in effect released Frost the poet "into Timelessness."[23] He still had much to write.

But Vermont was not far enough up country to escape the sorrows of the world. The year he bought the farm, his son Carol took his own life. This death brought the total of Robert Frost's losses to a wife, two sons, and two daughters. Soon, he'd be committing his daughter Irma to a mental institution.

He once wrote to Louis Untermeyer that he was "of deep shadow all compact like onion within onion and the savor of me is oil of tears."[24] Strong forces raged within Robert Frost, a man who grew more formidable as his white hair grew more tousled, his voice fuller of inflection, his lips more skeptical and secret even as they loosened somewhat with age. Frost was a poet of "ulteriority"—motives within motives. And it is small wonder, perhaps, that the force of darkness leaked into his official biographer, Lawrance Thompson, who began as an admirer in his first volume of Frost's life.

"I'm counting on you to protect me from Larry. Remember!" Frost said to Stanley Burnshaw for the first time in 1959. Who

Interior of the **Frost cabin** as it still looks today. — Ripton, Vermont

among us has the benefit of knowing in advance that he will be betrayed? Frost did, but there was no benefit in it.

Two years later, on a freezing cold day, the poet stood in front of a massive audience in Washington D.C. to read a poem at John F. Kennedy's inauguration. He'd composed a poem for the occasion but, after some difficulties seemingly caused by the brightness of the winter sun, waved away Lyndon Johnson's proffered hat to shade him and recited "The Gift Outright" from memory.

This event was surely one of the pinnacles of the influence of poetry in America in the late 20ᵗʰ century. It had a different effect on Lawrance Thompson, who explained to Burnshaw his theory that Frost had manipulated the entire proceeding for his own glory, staged his difficulty reading in order to get all eyes

on himself. Robert Frost died one of the most beloved poets ever in America, but within a few years was made out to be a monster by the next two volumes of Thompson's biography. Burnshaw was moved to write his own reminiscence of Robert Frost to correct the gross wrong that was done.

"I have all the dead New England things held back by one hand,"[25] Robert Frost once wrote, but he seemed to release them one by one in his poetry. In many senses this man, whose life spanned the end of one century and much of the next, was a throwback to the New England writers and poets of earlier times. He lived in their fashion for many years, without benefit of modern conveniences and without much use for them. In that sense he is the last of an era. Nowadays, for a New England poet to spurn the developments of the last 50 years

Robert Frost

would probably come off as an affectation. From his first poem to his last, he was remarkably consistent. He stayed clear of the fads and conventions of poetry over the years. He stuck to his themes. And yet he never lapsed into repetition—not unless he had some purpose. As he wrote in "Into My Own":

> They would not find me changed from him they knew—
> Only more sure of all I thought was true.

Frost believed that you could derive a lot from a little life experience. One should experience a little of New England, in all its nature and changeable moods, in order to understand Frost. Through his verse, it is possible to step into his shoes as he goes walking in the New England meadows and swales or performs farmwork. He is not always easy to understand. "I might easily be deceiving when most bent on telling the truth," he wrote to a prospective biographer. But life is difficult to parse. Frost was no different.

In the end, a gesture of acceptance. On a long granite gravestone next to Elinor's in a churchyard in Bennington, Vermont, the following words are carved: "He had a lover's quarrel with the world." And after having finally made his points, he rested. ↜

Robert Frost's cabin, where he was released "into Timelessness." — Ripton, Vermont

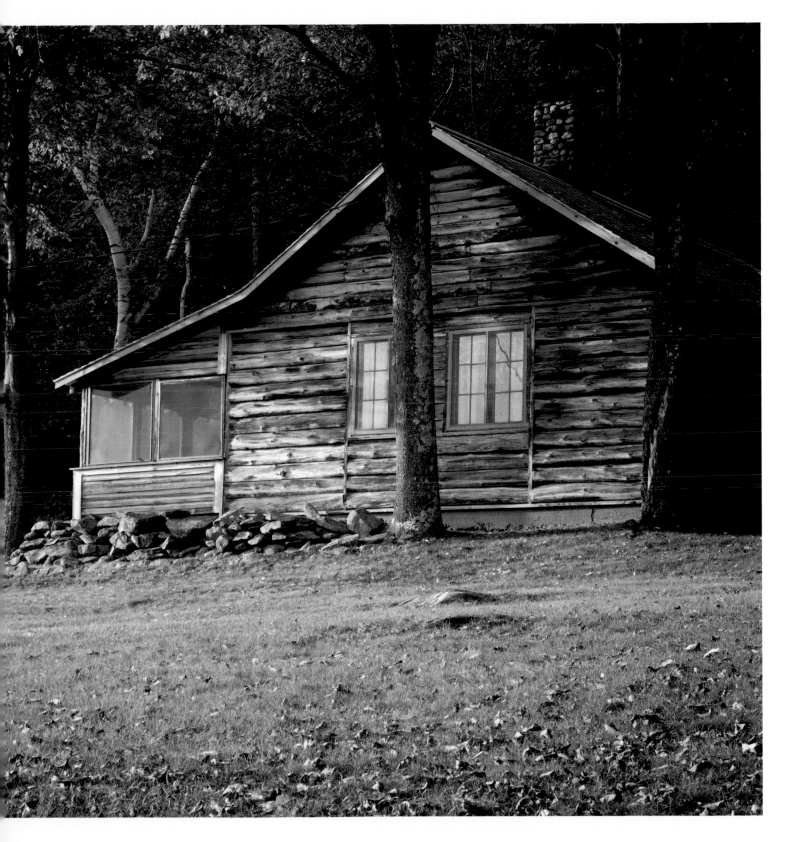

Robert Frost

from "Birches"

It's when I'm weary of considerations,

And life is too much like a pathless wood

Where your face burns and tickles with the cobwebs 45

Broken across it, and one eye is weeping

From a twig's having lashed across it open.

I'd like to get away from earth awhile

And then come back to it and begin over.

May no fate willfully misunderstand me 50

And half grant what I wish and snatch me away

Not to return. Earth's the right place for love:

I don't know where it's likely to go better.

I'd like to go by climbing a birch tree,

And climb black branches up a snow-white trunk 55

Toward heaven, till the tree could bear no more,

And dipped its top and set me down again.

That would be good both going and coming back.

One could do worse than be a swinger of birches. 60

— Robert Frost
Mountain Interval, 1920

Birch trees at the Robert Frost Interpretive Trail.
— Ripton, Vermont

Robert Frost

The 610 acre **Willa Cather Memorial Prairie** preserves an example of the native grassland that once covered Nebraska. — Red Cloud, Nebraska

REELING WESTWARD:

From the Pioneer Spirit to the "Turn of the World"

Willa Cather • Wallace Stegner • John Steinbeck • Robinson Jeffers

Red Cloud, Nebraska

WILLA CATHER (1873-1947)

*"Not A Country At All, But The Material
Out of Which Countries Are Made"*

— Willa Cather
My Ántonia, 1918

HEN WILLA CATHER'S aunt and uncle moved from New England to the prairie in 1873, the year of her birth, they hired a wagon driver at the train station in Red Cloud, measured the circumference of the back wheel, knotted a strip of cloth around it and set off into the alien sea of grasses. Cather captured the trek in "Macon Prairie":

> Through the coarse grasses which the oxen breasted
> Blue-stem and bunch grass, red as sea marsh samphire.
> Always the similar, soft undulations
> Of the free-breathing earth in golden sunshine [1]

Using that strip of cloth as a measuring device, Willa's aunt counted the number of revolutions of the wheel from the town until they felt they must be in the middle of their claim. There was no other way. There were no landmarks to navigate by. When they finally made it from the town to their lot, the aunt and uncle settled down for the night—then a whipping prairie fire scorched their land. The fire may have done them in, with all their possessions, if it hadn't been for the quick action of the driver of the wagon, who started a backfire.[2] The next day, Nebraska's newest settlers learned that the closest water was at their neighbors' place, two miles away—and had been hauled there from Red Cloud, 16 miles distant.

Several years later, nine-year-old Willa Cather and her family also traveled from Red Cloud through the open prairie.

Grain elevator. — Red Cloud, Nebraska

Willa Cather

*Red Cloud (a.k.a. Black Hawk) was a "clean, well-planted little prairie town....
In the center of town there were two rows of new brick 'store' buildings..."* — Willa Cather, *My Ántonia*, 1918

They had left a comfortable life behind in languorous-sounding Willow Shade, Virginia to move to this prairie outpost with the colorful name. In the largely autobiographical *My Ántonia*, Cather gave an account of that journey from Red Cloud through the eyes of Jim Burden, the character based on her own experiences. Unlike Willa, Jim was an orphan. But like Willa and her family, he arrived by train and was taken to the house of his grandparents. Young Jim arrives at night, and his impressions are of the emptiness of the prairie:

> Cautiously, I slipped from under the buffalo hide, got up on my knees and peered over the side of the wagon. There seemed to be nothing to see; no fences, no creeks or trees, no hills or fields. If there was a road, I could not make it out in the faint starlight. There was nothing but land: not a country at all, but the material out of which countries are made....I had the feeling that the world was left behind, that we had got over the edge of it, and were outside man's jurisdiction. [3]

To confront the Divide—a swath of land from the Little Blue to the Republican River in Nebraska—was to feel such a pang of disorientation. But in a short amount of time, the country began to work on Cather. "I was little and homesick and lonely..." she later observed. "So the country and I had it out together and by the end of the first autumn the shaggy grass country had gripped me with a passion that I have never been able to shake. It has been the happiness and curse of my life."[4]

It helped to be young, for farming in Nebraska was back-breaking work, and subject to drought, tornadoes, even plagues of grasshoppers. It was a day's journey by horse for many settlers to get to and from Red Cloud. Come winter, the snow drifted, collecting in the draws so deeply that you could permanently ruin a horse by riding it to town. Blizzards dropped so much snow that it was necessary to tunnel from the main house to the barn. Then the Divide was white against a gray sky as far as the eye could see.

In the best of weather, the eye could not see far enough to spot another neighbor. Settlers not only lived far from town but far from each other. And with such a flat table of land, and such

high grass, one saw only prairie. Most settlers' first houses were constructed of sod. Sod was easy to work with and, of course, plentiful. It also had a tendency to leak and to be infested with bugs. Even with plastered inner walls, sod houses must have seemed to some like a living grave.

Out on the prairie, the howling winds brought about isolation and despair. If you were one of the many immigrants who had brought their families from Europe, you met with the crushing realization that your expectations had far exceeded reality. Papa Shimerda, the Bohemian immigrant father who is featured in the first section of *My Ántonia*, is swindled out of most of the family's money by a countryman who sells him a sod house that is "no better than a badger hole,"[5] his oxen, and "two bony old horses" that are practically useless. His children sleep in a hole that has been dug out of one of the walls of the house. Suffering from deep depression due to homesickness and guilt for what he has done to his family, Papa Shimerda takes his life. He is interred at the intersection of two survey lines, in keeping with the Old Country superstition that a suicide must be buried at a crossroads. Cather wrote:

> Years afterward, when the open-grazing days were over, and the red grass had been ploughed under and under until it almost disappeared from the prairie; when all the fields were under fence, and the roads no longer ran about like wild things, but followed the surveyed section lines, Mr. Shimerda's grave was still there, with a sagging wire fence around it, and an unpainted wooden cross. [6]

In Cather's youth, there was an immigrant just like Papa Shimerda, named Francis Sadilek. He told his wife he was going out rabbit hunting and, instead, went to the barn and shot himself, leaving his family in a terrible spot. The grave of Francis Sadilek can still be found on the prairie today, just as Cather described it.

A Clean, Well-Planted Little Prairie Town

A year after moving in with Willa Cather's grandparents, the Cathers seem to have had enough of the Divide. They moved into a cramped house in Red Cloud, where Cather's father set up a farm mortgage and insurance business. Red Cloud was a small town, much like the town of Black Hawk where Cather set much of *My Ántonia*:

> Black Hawk, the new world in which we had come to live, was a clean, well-planted little prairie town, with white fences and good green yards about the dwellings, wide, dusty streets, and shapely little trees growing along the sidewalks. In the centre of town there were two rows of new brick "store" buildings, a brick schoolhouse, the court house and four white churches.[7]

Red Cloud had started its life as an 80 x 100 foot stockade, with three-foot thick sod walls and a ditch with a drawbridge to protect the settlers against the Native Americans who never evinced any interest in attacking. By the time the Cathers moved there, Red Cloud had a larger population than it has at present—thanks to its relative importance as a depot for the Burlington and Missouri line that brought eight trains through per day. The Cathers were back in man's jurisdiction.

It was in the Red Cloud high school that Cather met Annie Sadilek. Annie was the daughter of the farmer who had taken his life and Annie, whose early years on the prairie had only made her stronger, became her inspiration for the fictional Ántonia. It was also in Red Cloud that Cather got to know the Miners. Mr. Miner owned Miner Brothers' Store, the first department store in Nebraska, a place where, as Mildred Bennett put it, "the whole pioneer drama of hope and despair was played out." The store's motto was "Live and let live"[8] and, without the credit that the store extended to settlers and recent immigrants, many could not have survived. The store was the setting of the first scene in Cather's novel called *O Pioneers!*. The Miner family—scion, matriarch, children—played a large role in *My Ántonia* as the Haring family. And the Miners and the Sadileks intersected when Annie moved in from the country after several years of hard country toil to become the "hired girl" at the Miners'.

For all the enjoyment she got out of associating with the Miner family, with Anna, and with the many other townspeople who also wound up as characters in her books, Cather also felt an "oppressively domestic"[9] Main Street-ness. Cather describes

in *My Ántonia* how one summer a dance "school" came to Black Hawk, and set up business and a dance floor on one of the vacant lots. "At last," Jim Burden narrates with relief, "there was something to do on those long empty summer evenings when the married people sat like images on their front porches."[10] Anyone who could pay the price of admission was welcome to dance. And so the railroad men, the iceman, the farmhands would come and dance with the "hired girls"—Swedes and Norwegians and Bohemians.

Some of the town boys, who were taught to look down on the "hired girls," would sneak off to the Saturday dances. They were expected to marry the proper town girls, who were "refined." But through Jim Burden, Cather describes those town girls. "When one danced with them, their bodies never moved inside their clothing; their muscles seemed to ask but one thing—not to be disturbed."[11] Living in town had made these girls soft. Dancing with Ántonia, by contrast, was an "adventure" for Jim.

The hired girls occupied a special place in Cather's heart, for they were mostly first generation immigrants who had grown up in the "bitter-hard times"[12] and had worked so that their younger brothers and sisters could get some schooling. She described them in *My Ántonia* as being physically "almost a race apart," for "out of door work had given them a vigour."[13] Through the character of Jim Burden, she wrote that the younger brothers and sisters never seemed "half as interesting or as well educated….The older girls, who helped break up the wild sod…had all, like Ántonia, been early awakened and made observant by coming at a tender age from an old country to a new."[14] Some of them, like Ántonia, never lost their old world ways. Others, like the character Lena, adopted Midwestern ways that seemed to throw them into relief. Lena absorbed the figures of speech of the town girls and town women: "Those formal phrases, the very flower of small-town proprieties, and the flat commonplaces, nearly all hypocritical in their origin that became very funny…when they were uttered in Lena's soft voice, with her caressing intonation and arch naïveté."[15]

In real life, Mr. Miner caught Annie Sadilek cuddling on the back porch with a young man (who happened to be the son of a woman he detested). He forbade her to see him again. The spirited Annie, who adored the dances and social life after years of isolation on the farm, refused to agree to that and moved out. In *My Ántonia*, Ántonia was forced out of her job as "hired girl" for a similar reason. The dances also cast a shadow over Jim, who was still living with his staid and religious grandparents. He was caught sneaking out to them and swayed by guilt into staying away. With the elimination of the dances, the shortcomings of Black Hawk became obvious.

> One could hang about the drugstore; and listen to the old men who sat there every evening, talking politics and telling raw stories. One could go to the cigar factory and chat with the old German who raised canaries for sale, and look at his stuffed birds. But whatever you began with him, the talk went back to taxidermy. There was the depot of course: I often went down to see the night train come in, and afterward sat awhile with the disconsolate telegrapher who was always hoping to be transferred to Omaha or Denver, "where there was some life."[16]

What did Cather do in those days after the family had moved to town and people sat like statues? Unlike Jim Burden, Willa Cather had family. In total, there were seven children. It is doubtful that the active Cather spent very much time being bored.

"Optima Dies…Prima Fugit
The Best Days are the First to Flee"

— Virgil
My Ántonia begins with this quote

"I don't even come west for local color," Willa Cather maintained. "The ideas for all my novels come from things that happened around Red Cloud when I was a child. I was all over the country then, on foot, on horseback and in our farm wagons….It happened that my mind was constructed for the particular purpose of absorbing impressions and retaining them."[17] Cather left the prairie for good at the age of 23, when she moved to Pittsburgh to work as an editor. In 1906, she moved

to New York City to write for *McClure's Magazine*, where she eventually became managing editor. Two years later, she met the doyenne of local color writers, Sarah Orne Jewett. It was Jewett who encouraged Cather to stop editing and instead write about those experiences in Nebraska.

Cather followed Jewett's advice. While living with her friend Isabelle McClung in New York, she began writing the novel *O Pioneers!* about a family of Swedish immigrants who come to Nebraska, work hard, and prosper. In 1913 the novel was published, with a dedication to Jewett. Cather had indeed absorbed and retained much. Her well-rounded characters stood out against an eloquent landscape. It was in 1916, awash in love, jealousy and betrayal after McClung decided to marry,[18] that Cather began to compose *My Ántonia*. The novel was a critical success, even hailed by none other than the decidedly unsentimental H.L. Mencken as the greatest piece of fiction written by a woman in America.

Jim Burden's romantic love for the older Ántonia is never requited. As for Cather's relationship with Isabelle McClung—or with the fellow Nebraskan woman with whom she lived for 40 years—biographers can only speculate. Willa Cather was an intensely private person. Cather's seeming inclination towards women adds a level of meaning to *My Ántonia* and, for that, it deserves mention. But the novel is about far more than the love affair: it concerns itself with the material out of which countries are made, the people who plowed the plains, the beauty of the prairie and how it was changing. It is also about youth. Cather once claimed that in order to write well she had to "get up feeling 13 years old and all set for a picnic."[19] Cather's style calls to mind the prairie as well as youth: sentences undulate like the grasses in "Macon Prairie." They flow on and on, gently punctuated by commas, as if they could do so effortlessly forever.

"The best days are the first to flee" comes from a work called *The Georgics*, 2,000 lines of poetry on the subject of agriculture by the great Roman poet Virgil. And it sums up much of Cather's views on the prairie where she had grown up. She was disturbed when she returned to visit by how things had changed. Every tree that was cut down or replaced pained her. There weren't, after all, very many trees to start with. The attitude of the succeeding generations disturbed her as well. "I'm sure not going to work the way the old man did' seems to be the slogan of today," she observed critically.[20] Always a Nebraskan, she followed the goings on in town from afar, taking delivery of the Red Cloud *Commercial Advertiser* at her New York City apartment. Through it, she kept an eye on the local situation and sent money to family and friends if she read that crops had been bad or some calamity had occurred.

Cather went on to publish many other novels, short stories, and poems. One of them, *Death Comes for the Archbishop* (1925), does for New Mexico what Cather had done for Nebraska. It tells the stories of Bishop Latour and his partner in the faith, Father Vaillant, whose diocese is based in Santa Fe but whose territory covers the entire West. Both fictional characters are based on real life figures. Using the book, even today one can visit the places Cather described—such as the 367-foot tall rock pillar of ancient Acoma Pueblo, continuously inhabited since 1100, or the miraculous staircase in a Santa Fe church. They are all preserved in the dry desert air. Cather describes how, even as he ages, and loses Father Vaillant, who died winning lost souls in the gold fields of Colorado, the Bishop always awakes in New Mexico "a young man." The Bishop is a pioneer, just like Cather. He appreciates that a "particular quality in the air of new countries" departs after they are settled and cultivated. "Parts of Texas and Kansas that he had first known as open range," the Bishop reminisces, "had since been made into rich farming districts, and the air had quite lost that lightness, that dry aromatic odour. The moisture of plowed land, the heaviness of labor and growth and grain-bearing, utterly destroyed it; one could breathe that only on the bright edges of the world, on the great grass plains or the sage-brush desert."[21]

After many years, in 1915, Cather visited Annie Sadilek Pavelka. That journey also found its way into *My Ántonia*. It was a bittersweet experience, tinged by regret that she had not visited more often. But in the book, the visit is predominantly joyful, as is Jim Burden's view of the land:

> The old pasture land was now being broken up into wheatfields and cornfields, the red grass was disappearing, and the whole

face of the country was changing. There were wooden houses where the old sod dwellings used to be, and little orchards, and big red barns; all this meant happy children, contented women, and men who saw their lives coming to a fortunate issue. The windy springs and the blazing summers, one after another, had enriched and mellowed that flat tableland; all the human effort that had gone into it was coming back in long, sweeping lines of fertility. The changes seemed beautiful and harmonious to me; it was like watching the growth of a great man or of a great idea. I recognized every tree and sandbank and rugged draw. I found that I remembered the conformation of the land as one remembers the modeling of human faces.[22]

After the death of her mother in 1931, Cather never returned to Nebraska. Too much had changed.

In recent years, the Cather Foundation has set aside 609 acres of prairie that it wishes to return to the condition in which Willa Cather found it. The Willa Cather Thematic District includes 26 individually significant sites and four historic districts, in and around Red Cloud and Webster County. The Foundation oversees what it says is the largest historic district devoted to an author in the United States. Though Willa Cather was buried in faraway New Hampshire, her spirit would find it comforting and familiar to alight in Red Cloud today. ✑

"The land belongs to the future...that's the way it

seems to me...I might as well try to will the sunset

over there to my brother's children. We come and go,

but the land is always here. And the people who love

it and understand it are the people who own it

—for a little while."

— Willa Cather
O Pioneers!, 1913

Farmhouses at sunset. — Webster County, Nebraska

Willa Cather
Red Cloud, Nebraska ❖ 77

WALLACE STEGNER
(1909-1993)

*E*very gateway to the West should be guarded by a sign, preferably painted in peeling letters on a weathered board, that reads: "You have to get over the color green; you have to quit associating beauty with gardens and lawns; you have to get used to an inhuman scale."[1] The quote comes from Wallace Stegner. Never mind the vivid green of the golf courses, parks, and public spaces in the Western cities and towns that we have built. He was talking about the wild landscape of the West: the jagged mountains, snow-capped and forbidding, the vast arroyos that, but for a few hardy plants huddled around a spot of moisture, look as alien and inhospitable as a picture of Mars. The West is a different aesthetic, and Stegner understood that.

Wallace Stegner's father was a boomer, a "rainbow-chaser," who was "always on the lookout for the big chance, the ground floor, the inside track."[2] But he invariably arrived too late to the party. He followed the land rush to North Dakota in the 1890's, only to find that no one had told him they were in the midst of a ten-year drought. He took to operating a blind pig (an illegal saloon) instead. Then the family headed west, for a gold rush in the Klondike that was long over. They wound up in the current home of Microsoft—Redmond, Washington—selling meals to a timbering camp. "The loggers cut down all the trees and left the lunchroom among the stumps," Stegner said. At some point during that ill-fated venture he and his brother ended up temporary residents of an orphanage because their parents couldn't care for them.

In 1914, Stegner's family took a stagecoach from Gull Lake, Saskatchewan to a town that was called Whitemud at the time. In the coach was a character named Buck Murphy, who had a real six-shooter. Some time after they safely arrived in Whitemud, Stegner heard that Murphy had been shot by a Canadian Mountie. In his youth he would tell his friends he

Situated at an elevation of 10,152 feet. — **Leadville, Colorado**

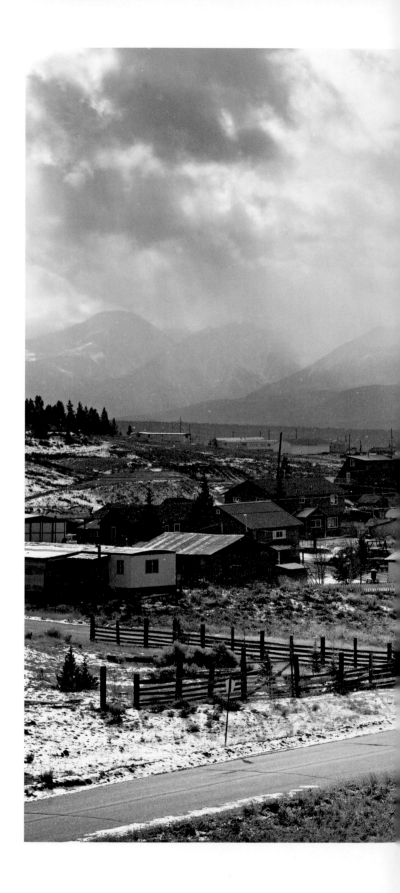

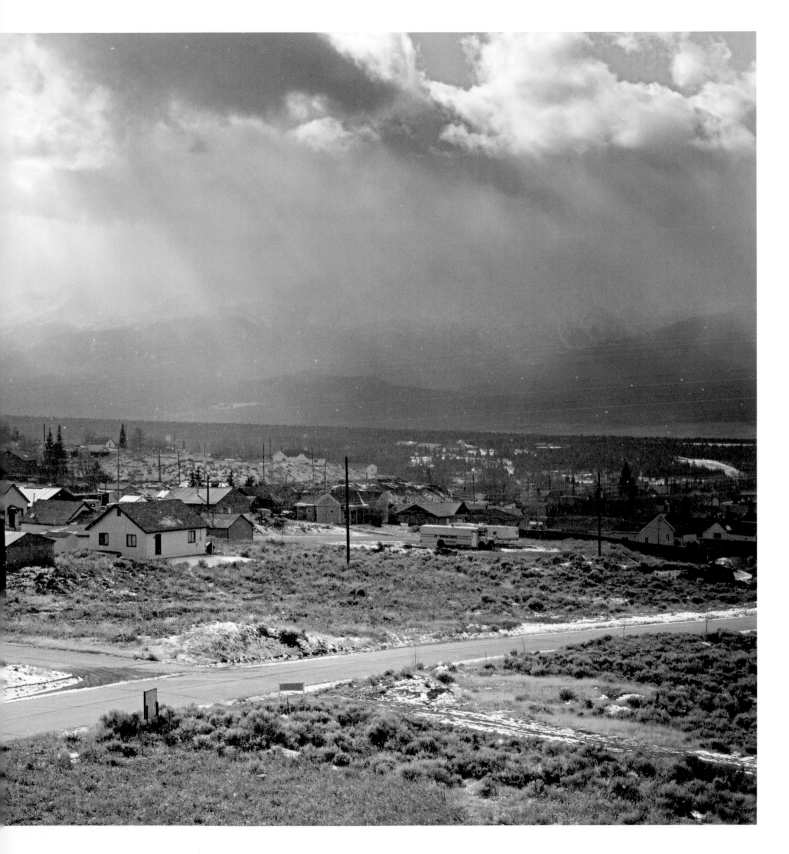

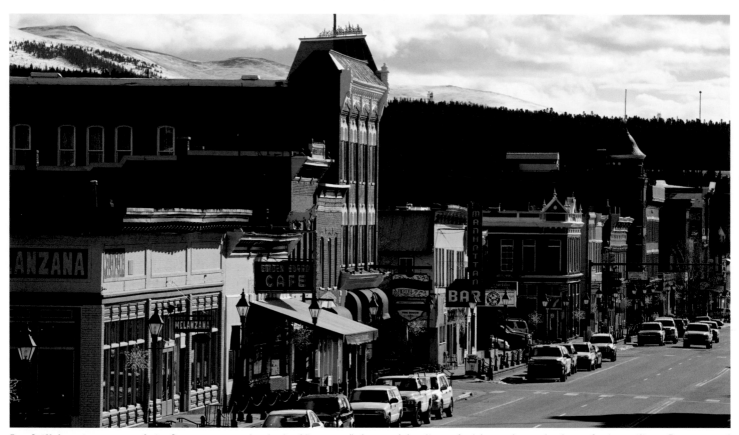

Leadville's main street made its first appearance in *Angle of Repose* as "a long gulch…littered with wreckage, shacks, and mine tailings. It was rutted deep by ore wagons, scalped of its timber….The shacks grew thicker, the road became a parody of a street." — Leadville, Colorado

had witnessed the shootout, even though he hadn't. In *Wolf Willow*, in typically frank Stegner fashion, he strips the varnish off the tale: Buck Murphy was probably not a desperado but just a liquor-loving cattle herder who, like most people in those parts carried a gun. The Mountie who shot him was "scared and trigger happy and would have been in real trouble for an un-Mountie-like killing if Murphy hadn't been carrying a gun."[3] Stegner wasn't too interested in perpetuating the myth of the cowboy but he was certainly caught up in the lure of the West. Even though he was a latecomer to the scene—his stage-coach ride and Buck Murphy's untimely demise took place five decades after the Pony Express, four decades after the transcontinental railroad was built, three decades after Buffalo Bill's first Wild West show—Wallace Stegner spent those impressionable childhood years in what were the last vestiges of the wild western frontier.

Things took a turn for the better during the time the Stegners lived in Eastend, Saskatchewan, though at first they were only marginally better. The first winter there they lived in the abandoned dining car of a train. The next winter they lived in a shack. Eastend grew up to become a real Western town, with plank sidewalks lining its Main Street, a hotel, a bank, a "Millionaire Row" and a "Poverty Flat." And the Stegners struck it rich in 1915, growing wheat that went to the war effort. Armed with that confirmation of his business acumen, his father more than doubled the crop the next year. But 1916 was too wet. Hope springs eternal, but doesn't always deliver a reward; in 1917, 1918 and 1919, Wallace Stegner's father doubled his bets and got wiped out each time. For once they were in on the ground floor of a land rush, but the land was parched there.

It was a lonely life. As he wrote, "I never saw a water closet or a lawn until I was eleven years old; I never met a person with

my surname, apart from my parents and brother, until I was past thirty; I never knew, and don't know now, the first names of three of my grandparents." Stegner admits that he was always hungry for the sense of belonging, damaged by growing up too fast while being undernourished by place. In that sense, Stegner turned out much more like his mother than his father, who died broke and friendless. Like his mother, Stegner was a frustrated nester.

He found a home in Salt Lake City, where the family lived from 1921-1937, and where he attended high school. In an essay entitled "At Home in the Fields of the Lord" he put it this way:

> I have always thought of myself as a sort of social and literary air plant, without the sustaining roots that luckier people have. And I am always embarrassed when well-meaning people ask where I am from. That is why I have been astonished, on a couple of recent trips through Salt Lake City, to find a conviction growing in me that I am not as homeless as I had thought….I am as rich in a hometown as anyone, though I adopted my home as an adolescent and abandoned it as a young man.[4]

In 1927, Wallace Stegner entered the University of Utah. Encouraged to take further studies in writing, he attended the University of Iowa in 1930, and a doctorate program at Berkeley in 1932. But he left Berkeley in 1932 when his mother got sick and he and his wife moved with her to Salt Lake City. After she died, he continued his studies at the University of Iowa. He had no compunction about moving around a lot. He became an expert on the realistic-naturalistic period in American literature, which lasted from the Civil War to World War I. In 1937, he sent a submission called *Remembering Laughter* to a novelette competition and won first prize.

Stegner became a professor at Harvard. But he left the prestige and the lush green of the East to go back West. He dug in at Stanford where he founded the creative writing program and bought a house in the foothills of the Coast Range, "within sight of the last sunsets on the continent." What a few years in the East had taught him was how much he craved the West. The western landscape had modified his perceptions. "If there is such a thing as being conditioned by climate and geography,

and I think there is, it is the West that has conditioned me. It has the forms and lights and colors that I respond to in nature and in art. If there is a western speech, I speak it; if there is a western character or personality I am some variant of it."[5] And as the years progressed, he trained his lens—and the lenses of many other gifted students—on the West.

The frontier was "hope's native home," Stegner maintained, a golden prize that drew millions away from the pull of the East. But it required more than hope to settle the West; serious adaptations were needed. And an author who proposed to write about the West had to be similarly adaptable. In "Thoughts in a Dry Land," Stegner wrote that in order to create literature out of the West: "Our first and hardest adaptation was to learn all over again how to see. Our second was to learn to like the new forms and colors and light and scale when we had learned to see them. Our third was to develop new techniques, a new palette, to communicate them."[6] In his Pulitzer prize-winning novel *Angle of Repose*, he demonstrated a mastery of all three. But just as importantly, he told a story that communicated, more beautifully and more tragically than any essay or dissertation could have, how a great novel of the West can be written.

First order of business: toss away the well-worn metaphors of the classics. They are, in the words of the novel's narrator, Lyman Ward, "about used up." Instead, look to metaphors that are indigenous to the West. Lyman Ward is a former historian who lives in Grass Valley, California, way up in the northern part of the state along Highway 49, numbered after the 49'ers of the Gold Rush. It is 1970 and the Zodiac Mine, which his grandfather, Oliver Ward, ran, is long since closed. For the summer, Lyman is living in the big old Zodiac Cottage by himself. He has a bone disease that has put him in a wheelchair. His wife has left him. His son wants him to move to what they now call an assisted living facility. But Lyman is stubborn as a Forty-Niner's mule. He expects "regular visits of inspection and solicitude," he says, as his son tries to do what is best for him. "Meantime," he says, employing a piquant Western metaphor, "they will walk softly, speak quietly, rattle the oatbag gently, murmuring and moving closer until the arm can slide the rope over the stiff old neck and I can be led away to the old folks' pasture."[7]

Wallace Stegner

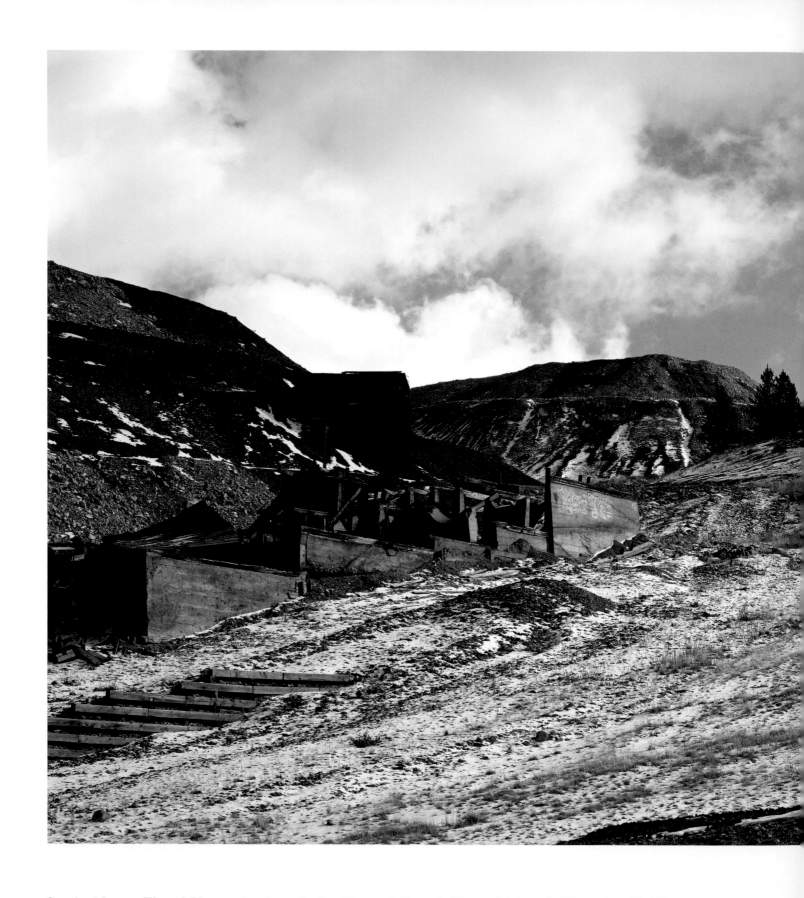

Second order of business: bring the Eastern sensibility west. In *Angle of Repose*, Lyman Ward spends the summer working on a research project concerning his aforementioned grandfather, Oliver Ward, and Susan Burling Ward, his wife, who became a well-known (for her time) writer and artist of the West, and left behind hundreds of letters and other writings. His grandfather, a taciturn man, left behind very little. Ward's purpose, he says, is to get beyond the Doppler Effect, which holds that the sound of any object approaching you will have a higher pitch than the sound of it going away. Ward wants to see what Oliver and Susan felt as life came *at* them, in all its aspirations and promise, and adaptations.

The first sound registered by his Doppler effect is the roar of a waterfall. Early on in *Angle of Repose*, Susan and Oliver make a chaperoned excursion from Milton, New York, where he visits her, to the woods. Susan is Eastern to the core. But she's opted for Big Pond, with its bounding cataract that spills into a marble pool, as something that would be grand enough to satisfy Oliver. He has been working in the West for five years (and courting her by occasional letter) and has seen the magnificence of Yosemite as Bierstadt painted it. "It was incorrigibly Hudson River School—brown light, ragged elms, romantic water," Lyman Ward describes. The two haven't laid eyes on each other in what is an eternity for two young people and there they are, finally together.

"I can see a lot of tableaux," the narrator, her grandson, slyly goes on, "while she is struck speechless by a view or a flaming swamp maple, and he stands there with his hat in his hand before the purity of her sensibilities."[8] Then, Susan does a daring thing. She lies down at the top of the cliff and hangs her head over to look at the rush of the waterfall while he holds her by her ankles. At about the same time in the West, Lyman Ward notes, John Muir was doing likewise (though without a devoted spotter), dangling over the verge and taking in the awesome pounding of Yosemite Falls. Susan stays down long enough to feel at one with the torrent, a span of time also sufficiently long

An engineering term, the **angle of repose** is the maximum angle of a stable slope determined by friction, cohesion and the shapes of the particles. *(Left)* **One of 67 mines** in the mining district east of Leadville, Colorado.

Wallace Stegner

enough to impress Oliver and for something in her to change. When she came back up after that clean Romantic thrill, her grandson tells us, she was in love.

Third order of business in writing a novel about the West: dispel the myths. Stegner does this throughout the book. One of the earliest myths he explodes is that the West was "made entirely by pioneers who had thrown away everything but an ax and a gun." It was also made by "continuities, contacts, connections, friendships, and blood relationships."[9] This is a lesson that had been drilled into Stegner by his own experience in the West, a lesson that also comes forth in Willa Cather's novels. People scattered thinly through barren miles of harsh landscape needed other people. The idea of the "rugged individualist" was, to Stegner, and his narrator of *Angle of Repose*, a fool-hardy concoction.

Through a family connection, Oliver Ward gets a job at New Almaden, California, and he brings Susan to the West. In the words of Lyman Ward, "She anticipated her life in New Almaden as she had once looked forward to the train journey across the continent—as a rather strenuous outdoor excursion."[10] But it makes Susan into a chronicler of the American West. She sends back descriptions and drawings to her two best friends on the East Coast, one of whom is the influential editor of *Scribner's*, an illustrated periodical that had its heyday as the West was being won. Susan becomes a regular contributor. The strenuous outdoor excursion, however, turns into a rootless wandering, and then an exile. In Leadville, the very epitome of the Wild West, Susan carries on a literary salon in a rustic cabin. Oliver remains steadfastly taciturn. Susan has a dazzling East Coast literary moment when a friend of hers quotes Emerson in a flowering meadow: "Oh, tenderly the haughty day / fills his blue urn with fire." A few pages later, as if the Stegner wanted to snap one more mooring that connected her to the East Coast, some thugs beat her friend senseless. From Leadville, Susan and Oliver move on to Mexico and more disappointment. In one of her letters Susan refers to the "angle of repose" as "the angle at which dirt and pebbles stop rolling." That is the engineering definition. What interests Lyman Ward—and Stegner—is "how two such unlike particles clung together, and under what strains, rolling downhill into their future."[11]

One of the harshest features of the West is the lack of water. In his essay "Living Dry," Wallace Stegner cites the 1878 report of General John Wesley Powell that defines the West as beginning at the 98th meridian. Stegner goes on to say that the actual boundary line, which roughly follows the 98th meridian, is the "isohyetal line of twenty inches." West of that line, the mean annual rainfall is less than the amount necessary for growing unirrigated crops. As Stegner said in that essay, "I estimate that I missed becoming a Canadian by no more than an inch or two of rain; but that same deficiency confirmed me as a citizen of the West."[12]

Fourth order of business in writing a novel of the West: give a character an outsized dream—a dream as big and as fraught with potential failure as the West itself. Oliver shows up. He takes her outside on a sweltering August day. Thunderheads are building up on the river. The Eastern sky rains with so much ease it is almost criminal. Oliver pulls from out of his coat a brochure titled "The Idaho Mining and Irrigation Company." It is Oliver's venture, backed by seemingly solid capital, to irrigate a vast swath of Idaho desert with water from the Snake River. This is Oliver Ward's outsized dream—more daring and useful than Stegner's father's dream of making a killing on Saskatchewan wheat, but just as subject to the whims of fate.

Wallace Stegner walked both sides of the line that separates fact from fiction. On one hand he was a historian who wrote a biography of John Wesley Powell and two histories of Mormon culture. On the other, he wrote several semi-autobiographical novels, including *The Big Rock Candy Mountain*, *Wolf Willow* and *Crossing to Safety*. Oliver Ward in *Angle of Repose* was based somewhat on a real figure as well. The character of Susan Burling Ward was based on the letters, articles, and illustrations of a real woman, Mary Hallock Foote.

Stegner came across Foote's largely forgotten work while at Stanford and was impressed. He got around to reading the transcripts of her letters in the Stanford library several years later. "She lay around in my mind an unfertilized egg," he later said; it hatched three years later as the beginnings of *Angle of Repose*. He obtained permission from Foote's granddaughter, living in Grass Valley, to use her letters. Remaining true to the letters tied Stegner in knots as he was trying to write about

his fictionalized Susan Burling Ward, but they became essential parts of the book. They are full of vivacity, telling details and, all too frequently, dashed hope lightly dwelt upon with the stoicism of the age.

Stegner offered to let Ms. Foote read the novel before publication. He was told it wasn't necessary. He went ahead with the book. In an opening statement, Stegner warned that "though I have used many details of their [Foote's family's] lives and characters, I have not hesitated to warp both personalities and events to fictional needs." It was an honest disclaimer from a scrupulous writer. But it didn't prevent bruised feelings from the family when the book came out, and it still generates a small buzz of controversy today. The charge is that he took plagiaristic liberties in reproducing her letters, which he did word for word, without explicitly attributing them to her.

Given time, the reaction of the family to the novel will probably amount to no more than a footnote, ironic because of the accusation that Stegner, like a Western boomer, had somehow plundered the family history and made off with the letters and the story to write his Pulitzer Prize winner. He hadn't; the reminiscences were published by the Huntington Library Press in 1992 as *Gentlewoman in the Far West: The Reminiscences of Mary Hallock Foote* to a far wider audience than would have existed without his novel.

The Wilderness Idea

Another letter, this one written by Stegner, has also retained its vitality after all these years, and shows an expansion of his feeling about the West. That is the famous "Wilderness Letter" he wrote in 1960 to the Outdoor Recreation Resources Review Commission.[13] In his letter, Wallace Stegner argued not for wilderness uses, such as hiking, fishing, and backpacking, but for the "wilderness idea."

In his poem "The Gift Outright," Robert Frost suggested that "the land was ours before we were the land's" and that our salvation lay in our surrender to it. Stegner made a very similar point: there is something to this land of ours that wreaks a profound effect on us. "While we were…slashing and burning and cutting our way through a wilderness continent," he wrote, "the wilderness was working on us. It remains in us as surely as Indian names remain on the land. If the abstract dream of human liberty and human dignity became, in America, something more than an abstract dream, mark it down at least partially to the fact that we were in subdued ways subdued by what we conquered."

He brought a Western sensibility into his statement. Unlike the East Coast, where damage to the land might be effaced in a few cycles of seasons by new growth, in the West the scars remain. In the East the cellar holes of abandoned farms slowly closed, in the words of Robert Frost, "like a dent in dough." In the West we have ghost towns—abandoned mines, dilapidated buildings with false fronts, built in a frenzy of speculation and left desiccating in the desert.

Stegner had another argument for the wilderness idea and, as the letter went on, he let another appreciator of the land make it:

> Sherwood Anderson, in a letter to Waldo Frank in the 1920s, said it better than I can. "Is it not likely that when the country was new and men were often alone in the fields and the forest they got a sense of bigness outside themselves that has now in some way been lost.... Mystery whispered in the grass, played in the branches of trees overhead, was caught up and blown across the American line in clouds of dust at evening on the prairies.... I am old enough to remember tales that strengthen my belief in a deep semi-religious influence that was formerly at work among our people. The flavor of it hangs over the best work of Mark Twain.... I can remember old fellows in my home town speaking feelingly of an evening spent on the big empty plains. It had taken the shrillness out of them. They had learned the trick of quiet...."

Anderson's observation about the bigness outside ourselves is one of the most resounding points of the letter. For that presence has been noted before. It seems to have been working on us since the beginning of literary time here, shapeshifting through the ages. Cooper and Irving and thousands of travelers sensed it along the Hudson. A century later and thousands of miles away, Robinson Jeffers was to encounter it in Big Sur.

One can only wonder what government bureaucrats must have made of Stegner's esoteric pitch on behalf of this "Wilderness Idea." But Stegner seems to have made it at the right moment. He was appointed, for a time, a Special Assistant to the Secretary of the Interior, Stewart Udall, who himself became known for describing America's ecological ideology as the "myth of superabundance." Udall, a fellow Westerner from Arizona, passed the "Wilderness Act" in 1964 and was instrumental in passing the Endangered Species Preservation Act and several other landmark pieces of environmental legislation.

Wallace Stegner, a man with no roots and a wasteful fatherly influence, became a writer of such power and certitude that his influence stretched all the way to Washington. His is what we often like to call a "typically" American story, of the boy (or girl) who grows up in the shack and goes on to great things, inspired by the land. Stegner did nothing more remarkable than to make the most of what America offered.

No doubt he would be worried about the encroachments of mankind on the wilderness. He would be pained by the slow winking out of small towns, the proliferation of the big box stores, as connections and enterprises that have lasted generations come to an end. There is a geographical footnote to Stegner's love of the West: the Santa Clara Valley, Stegner's chosen home, became the "Silicon Valley" and his unobstructed view was cluttered by what one biographer called "obscene 'castles'"[14] In the end, he gravitated towards his summer home in Vermont, a state which he said "has watched humanity go by and has recovered from the visit."[15]

Stegner heard the roar of the American future, with its increasing population, its vast needs, its sometimes rapacious outlook, as it bore down through the century that he spanned. He witnessed the mournful Doppler effect that followed when aspects of the West's colorful landscape and way of life receded into an irreplaceable past. He wrote much about the meaning of place and wilderness, without shrillness, in his own formidable way. Those books, essays, letters, and public efforts were his means to prevent what he loved from disappearing. ꝏ

(Right) **River on the way to New Almaden, California**.
(Next pp. 88 - 89) **Zion National Park, Utah**
where Stegner went camping as a child.

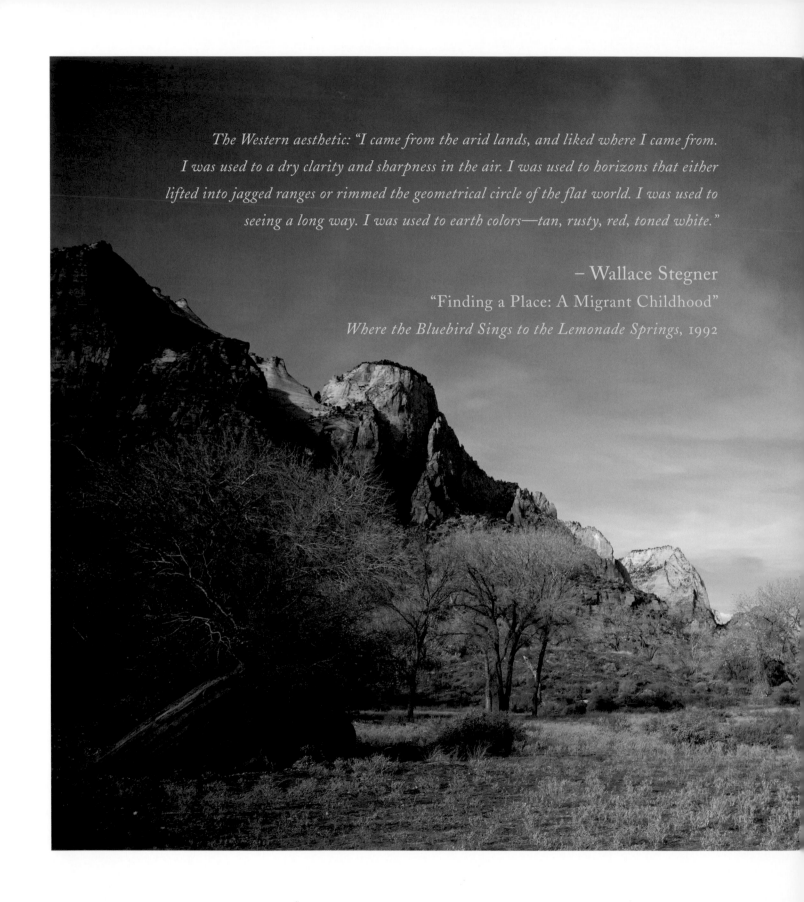

The Western aesthetic: "I came from the arid lands, and liked where I came from.
I was used to a dry clarity and sharpness in the air. I was used to horizons that either
lifted into jagged ranges or rimmed the geometrical circle of the flat world. I was used to
seeing a long way. I was used to earth colors—tan, rusty, red, toned white."

– Wallace Stegner
"Finding a Place: A Migrant Childhood"
Where the Bluebird Sings to the Lemonade Springs, 1992

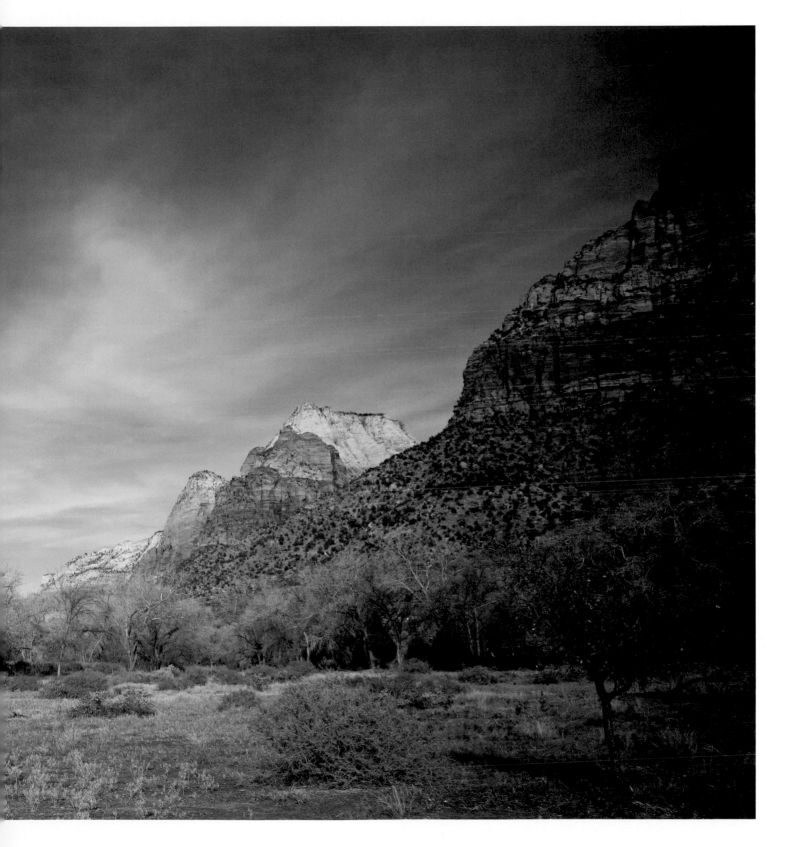

JOHN STEINBECK (1902–1968)

ORN IN A SUBSTANTIAL VICTORIAN HOUSE on the most respectable street in Salinas, California, John Steinbeck fought throughout his youth not to live up to his mother's expectations. A shy boy, conscious that he wasn't good-looking and prone to sudden fits of anger, he spent much of his time up in his room poring over books. He preferred the legend of King Arthur and his Round Table, and similar works of fantasy with high morals and high adventure.

The child grew up to be a man with a gift for telling tales, a keen sense of the world's injustices and the willingness to take on great themes. Perhaps, if he had heeded his mother's wishes, he could have become a great trial lawyer. But young Steinbeck got it into his head that he wanted to be a writer. And write he did—first pages and pages of forgettable stuff—until his hard work and conviction finally paid off. Over an almost 40-year career, Steinbeck made California the setting for the Cain and Abel saga (*East of Eden*), the Promised Land (*The Grapes of Wrath*), and a heaven beset by tragedy (*Pastures of Heaven*). His beloved Monterey became the home to a round table of errant knights (*Tortilla Flat*). He turned Monterey's Cannery Row into a household name, though arguably for all the wrong reasons. He became one of the most successful authors of the 20th century.

The Early Struggles

The Steinbeck house still stands in Salinas. It has become a combination museum and restaurant. Ornamented with gables, gingerbread, and a turret, it is no stretch to imagine the young John Steinbeck upstairs, pretending he was in a castle. Steinbeck's mother reigned over the house. Her husband, John Ernst Steinbeck, had a mild personality[1] and was not the most able manager. In 1910, he ran a healthy flour milling company into the ground, then retreated to the sanctity of *his* upstairs bedroom. After a time, he decided to strike out on his own

in business, but that venture—a feed store—also went under. John Ernst settled into deep despair over his public failure and loss of status. The townspeople of Salinas came together for the Steinbecks and helped them. A job was found for him at the Spreckels Sugar Company.

Though the Steinbecks remained in their home, their standing in the community restored, a son's faith in his father was damaged. And seeing his father and mother's reaction to their fall from grace may have given birth to John Steinbeck's later skepticism about the bourgeois need to preserve status. He developed a sympathy for the working class at the age of 17 when his father got him a job at Spreckels, where he worked for several summers. Another summer, again through family connections, he labored building a slough from Castroville to Salinas, a job in which he learned how to use dynamite. His mother's ambition, though, was that he attend college. And so, in 1919, Steinbeck went away to Stanford, where tuition was free at the time. At Stanford, the only topics that interested him were writing and marine biology. His relationship with Stanford lasted for five years but never resulted in a diploma. He dropped in and out of school, returning to physical labor whenever he took a leave.

In 1925, after his last unsuccessful stint at Stanford, Steinbeck assumed what he believed was the unapologetically squalid life of a writer: drinking, pounding away at an old typewriter in a tackroom behind a slatternly house in Palo Alto. The house belonged to a published writer named John Breck (though her real name was Elizabeth Anderson, and she hadn't been published often) in her late 30's.[2] She provided an audience for his stories and a comfort and aid during his dark nights of the soul. Steinbeck was veering inexorably away from the middle class life that his mother had envisioned for him, and into an uncertain and rather unpromising future.

Steinbeck family house – Salinas, California

After bouncing out of college in June of 1925, Steinbeck landed a job as a caretaker of a lodge at Fallen Leaf Lake, near Lake Tahoe, where he put his dynamiting skills to good use building a dam. Laboring in virtual isolation much of the time, he poured his remaining energy into writing. After a summer of this grueling and lonely routine he determined that he must go to New York, the publishing capitol of the United States. With his savings from the caretaking job he took a freighter through the Panama Canal and up to New York.

Steinbeck wound up working on the construction of Madison Square Garden and part time as a reporter. The hard labor exhausted him and left him with no time to write what he wanted to write. The pay was just enough to sustain him.

Every piece of creative writing he submitted was rejected. So back he went to California, working as an assistant steward on the freighter (thus joining the ranks of Herman Melville, Langston Hughes and Sinclair Lewis—all future writers with restless souls who worked inglorious jobs on the blue ocean). He returned to the lodge at Fallen Leaf Lake, where he worked another year. By the close of 1928, John Steinbeck was quite muscular as a result of much heavy labor, still quite shy about his looks (Sherwood Anderson, upon meeting Steinbeck in the 1930's, said he "looked like a truck driver on his day off."[3]) and plagued by doubts about his abilities. But he was fortunate in love—with a new girlfriend named Carol Henning—and had a finished novel named *Cup of Gold* under his belt.

John Steinbeck

More Hard Times, Then a Measure of Success

In addition to the house in Salinas, the Steinbeck family also had a cottage in lovely Pacific Grove, next to Monterey, which they had managed to hold on to through their fiscal crisis. Steinbeck had visited here often as a child, and had, while at Stanford in 1923, taken a course taught at the Hopkins Marine Station of Stanford University, the first marine laboratory on the West Coast. In 1930, he and Carol got married and they moved to the Pacific Grove cottage, within walking distance of the Marine Station. They lived on an allowance of $25 per month provided by Steinbeck's father, who had since been restored to status with an appointment to the post of Monterey County treasurer— a job he won re-election to many times until he finally retired.

As the Depression hit, the $25 per month was a godsend. And Steinbeck made it part of his lore, along with the fact that he and his wife had made ends meet by fishing. They fished from the rocks near China Point, home of the Hopkins Marine Station and scene of the ruins of what had been a fascinating ramshackle maze of Chinese squid fishermen's shacks that had mysteriously burned to the water line in 1906. Steinbeck had visited that spot often since his youth.[4] But what sustained the couple's hopes through the early 1930's were Steinbeck's ideas. Carol was, for years, a willing and understanding helpmeet. She typed many of his early manuscripts, correcting his punctuation and spelling. (It was also she who later suggested the titles of *Of Mice and Men* and *The Grapes of Wrath*.) She believed in his promise, even when times were so tight that, as legend has it,

"Holy Mother!" he whispered.
"Here are the green pastures of Heaven to
which our Lord leadeth us."

— John Steinbeck
Pastures of Heaven, 1932

This is the real spot, in **Corral de Tierra**, upon which Steinbeck loosely based *Pastures of Heaven*.

John Steinbeck

Monterey, Pacific Grove & Salinas, California ❖ 93

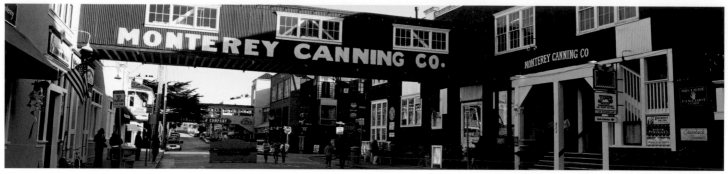

(Above) **Cannery Row**; *(Right Top)* **Ed Ricketts' lab**, 800 Cannery Row; *(Right Bottom)* **The Great Tidepool** in Pacific Grove, a "quiet" and "lovely" little "water world." – Monterey, California

they had to sell their two ducks in order to buy writing paper for *To a God Unknown*.[5]

The young couple would have to be patient, waiting for success that did not come with the first novel. Steinbeck's first published book was *Cup of Gold* (1932), a fictional account of the life of the pirate Henry Morgan. The novel, written in an enthusiastic stream of prose, was marketed in a way that made it hard to take seriously, with a swashbuckling buccaneer manning the cover. Steinbeck, showing his usual self-recrimination, wished he had destroyed it. *Pastures of Heaven* was published in the same year, a series of connected short stories that take place in a lush California valley.

Steinbeck's first critical and commercial success was *Tortilla Flat* (1936), about a young, poor man named Danny who suddenly becomes a landowner when he inherits two houses in the district above the town of Monterey. Thus begins a series of picaresque episodes as Danny's drunken friends take advantage of his generosity. The tone is light-hearted—they are all happy *paisanos*—but the abasement of poverty is never far from sight, as much a part of the setting as lively Monterey herself.

Ed Ricketts

Back in 1923, while taking the marine biology course at Stanford, Steinbeck had encountered a theory/philosophy that was to inform his writing for years to come. The teacher of the course was an enthusiastic proponent of the "organismal" theory of William Emerson Ritter, which held that individual man lived as part of a greater being—the "superorganism"— made up of many

more humans unconsciously acting in concert. As Steinbeck learned, this pattern existed among certain marine organisms. It is also true of some members of the insect kingdom.

In 1930, when Steinbeck met Doctor Ed Ricketts, he was delighted to find another believer in the organismal theory, and one who was a good drinker, conversationalist and womanizer to boot. Ricketts was a marine biologist and entrepreneur. In 1923 he had established a business called Pacific Biological Laboratories, whose whimsical logo was a squid with its tentacles wrapped around a piece of driftwood bearing the company's name. The firm collected biological specimens from the ocean and coastline and sold them to schools and other research-oriented organizations.

Ricketts was also a philosopher. He not only studied the behavior of marine life in groups but applied his observations to the actions of men in groups as well. And out of that he developed a philosophy he called "non-teleological thinking," which held that it was not necessary to keep asking, "why?" Why try to establish why people or organisms behaved in the way they did? They just did, and that was all. To gain a real acceptance of this fact was to realize that every living thing was holy. Ricketts became the model for the character called "The Doc" in *Cannery Row* and *Sweet Thursday*, and appeared in a short story called "The Snake" in *The Long Valley*. His beliefs also took a strong hold in Steinbeck, and they contributed to Steinbeck's brand of realism. Sometimes, in Steinbeck's tales, one grim event comes after another. To Ricketts' way of thinking, and Steinbeck's, that's life.

John Steinbeck

Ricketts' lab was also a gathering spot for writers and thinkers, among them Henry Miller and Joseph Campbell (author of *The Power of Myth*), one of the scenes of the cross-pollination of writers and thinkers that took root in the American literary landscape. Steinbeck was lucky to have found such a good friend as Ed Ricketts. But he would have been well-advised to spend less time at the lab and more time at home, what with the likes of the handsome Campbell around—not to mention the notorious Miller.

Ricketts helped Steinbeck expand the reach of his California chronicles. He collaborated with Steinbeck on a project of cataloging the sea life in the Gulf of California, which was published as *Sea of Cortez* in 1941 and republished in 1951 as *The Log from the Sea of Cortez*.

The Grapes of Wrath

As the Depression wore on, its impact on California—particularly the fertile areas up around Salinas that Steinbeck knew so well—was extreme. From the prairies of panhandle Texas to Oklahoma, years of poor crop rotation had led to light, blowaway topsoil. And then, as the decade of the 1930's began, like a plague from the heavens the rain stopped falling and fierce winds coursed across those flat regions, sucking up all of the topsoil with them. Known as "black blizzards," the wind storms devastated a vast swath of formerly rich land. The farmers, who relied on loans from the banks to tide them over from planting season until harvest, faced a credit crunch. They were foreclosed on by the thousands. Too many of them piled into jalopies with all of their possessions and headed out to California where, rumor had it, there were still agricultural jobs to be had (and at good wages). In the mid-1930's, Steinbeck wrote to a friend that within a few miles of where he and Carol lived (in relative ease, by then, after the success of his latest books), "there are about five thousand families starving to death…not just hungry but actually starving."[6]

When Steinbeck was approached by a newspaperman from San Francisco to write a series of stories about the plight of migrant farmers in California, he accepted. He bought an old bakery truck and installed a stove, a bed, and a few other conveniences. Then he pointed what he called his "pie wagon" towards Route 99, which runs through California's Central Valley until it bumps up against the base of "the Grapevine" north of Los Angeles. All along the route, in Stockton, Fresno and Arvin, and spaces in between, migrant workers had established squatters' camps. They looked, from a distance, "like a city dump."[7] And he was filled with indignation at the lot of these "harvest gypsies," as he called them, who were forced to move around to follow the crops but were nowhere wanted. Steinbeck's articles appeared in the *San Francisco News*. And inside him a bad book was growing. Named "L'Affaire Lettuceberg," it was so poor in fact, that Carol reviewed it in two words. "Burn it,"[8] she said.

Steinbeck followed Carol's advice. Meanwhile, he had another book coming out: *Of Mice and Men*, published in 1936. It did extremely well. In order to evade the media attention, Steinbeck and Carol sailed to Europe. After they returned in 1937, he went to Washington D.C. and said he wanted to

"The wants of the Okies were beside the roads, lying there to be seen and coveted: the good fields with water to be dug for, the good green fields, earth to crumble experimentally in the hand… A man might look at a fallow field and know, and see in his mind that his own bending back and his own straining arms would bring the cabbages into the light, and the golden eating corn, the turnips and carrots."

— John Steinbeck
The Grapes of Wrath, 1939

(Above and on pp. 98-99) **Agricultural fields** — Salinas, California

write a book about the displaced people of the Dust Bowl. He was referred to Tom Collins, who ran the Weedpatch camp in Arvin, California. Steinbeck bought a red convertible and he and Carol drove from Washington D.C. to California. He later claimed that, on that trip, the couple traced the route of the Joads but this part of his lore has been debunked. In any case, he was able to pick up many details along long stretches of Route 66 that they *did* travel. And those help make the book one of the greatest American stories of the road that has ever been written.

In *The Grapes of Wrath* the displacement of a people starts with handbills, distributed among the farmers of the Dust Bowl, offering picking jobs in California. Before long, cars "crawled out of the side roads onto the great cross-country highway, and

then took the migrant way to the West. In the daylight they scuttled like bugs to the westward; and as the dark caught them they clustered like bugs near to shelter and to water."[9] Thus did the Joad family, from grandparents on down to children, set out from Oklahoma on an overloaded automobile, with a former preacher named Jim Casy.

Almost exactly half of the book depicts the journey westward. Steinbeck describes with knowing accuracy the side-of-the-highway establishments, the increasingly foreboding geography, and how to change a cam shaft without the proper tools because one has to. "It don't take no nerve to do somepin when there ain't nothing else you can do," Tom Joad tells a service-station boy. And that pretty much sums up many portraits of the numbed migrants—not only Steinbeck's—that appeared in the 1930's.

John Steinbeck

Before they even reach California, the Joads find out that thousands of handbills had been distributed for 300 open jobs. But it is too late to turn back, and there is nothing to turn back to. Furthermore, even after all of the disappointments of the Joads' journey across the country, and despite the fact that they are almost turned away at the border, the "promised land" of California still possesses abundant power to move them:

> They drove through Tehachapi in the morning glow, and the sun came up behind them, and then—suddenly they saw the great valley below them. Al jammed on the brake and stopped in the middle of the road, and, "Jesus Christ! Look!" he said. The vineyards, the orchards, the great flat valley, green and beautiful, the trees set in rows, and the farm houses…
>
> Ruthie and Winfield scrambled down from the car, and then they stood, silent and awestruck, embarrassed before the great valley. The distance was thinned by haze, and the land grew softer and softer in the distance. A windmill flashed in the sun and its turning blades were like a little heliograph, far away. Ruthie and Winfield looked at it, and Ruthie whispered, "It's California."
>
> Winfield moved his lips silently over the syllables. "There's fruit," he said aloud.[10]

The exodus became, for Steinbeck, a living laboratory for the concept of the superorganism and its eventual triumph. The Joads have the good fortune of ending up at a camp like Weedpatch, where the residents govern themselves, and work together, and are able to hold up their heads. Tom Collins helped Steinbeck write about the camp. He himself seemed to have the mind of a writer, or perhaps a scientist, for he kept many notes about the customs, diction, and situations of the camp residents who were in his care.

Throughout *The Grapes of Wrath*, most of the people from the local towns are portrayed as hostile: evidence, Steinbeck seems to be suggesting, of the small-town bourgeoisie trying to maintain their status quo. This is a version of the facts that the California state historian Kevin Starr later questioned, citing the fact that the counties that most felt the bulge in migrants made substantial efforts to accommodate them, raising their

"The vegetables grew crisp and green in their line-straight rows."

– John Steinbeck
Pastures of Heaven, 1932

John Steinbeck
Monterey, Pacific Grove & Salinas, California ❖ 99

Point Pinos Lighthouse. For Steinbeck this outpost at the western tip of the continent was a moody spot that epitomized loneliness.
— Pacific Grove, California

"He put on his hat and walked out along the sea, clear out to the Lighthouse....
William thought dark and broody thoughts. No one loved him.
No one cared about him....And then he thought how he had a right to live
and be happy just like anyone else, by God he had."

— John Steinbeck
Cannery Row, 1945

taxes and increasing spending on social workers, teachers and nurses. Starr also added that not a single one of the handbills Steinbeck mentioned has ever surfaced, suggesting that it was a point where fiction trumped reality for the author.

Ironically, writing about so much poverty made Steinbeck a rich man—one of those strange dissonances of his success that he had a hard time overcoming. The book was initially banned from some libraries as "obscene," but since it appeared it has taught countless thousands of high school students what life was like during the Great Depression. *The Grapes of Wrath* was made into a movie in 1940, directed by John Ford and starring Henry Fonda, and parts of the movie were actually filmed at Weedpatch (some of whose buildings survive in Arvin to this day).

The Native Son Leaves California

In 1941, Steinbeck left California, and Carol, accompanied by a young songstress named Gwen Conger whom he had wooed in Los Angeles. With her by his side he returned to New York City, certainly a different figure from the man child who had labored on Madison Square Garden. The new Mrs. Steinbeck gave birth to a son in 1943. A year later, Steinbeck and his family came back to California, with intentions to stay. He bought a property he had coveted since he was a child: the historic Lara Soto Adobe house in Monterey, a long, low building with a massive cypress tree out front.

Soon after they moved in, Steinbeck's latest work, called *Cannery Row*, came out. "Cannery Row in Monterey in California is a poem, a stink, a grating noise, a quality of light…a nostalgia, a dream," it began. And from this opening line there unfolded the story of the charismatic but somewhat lonely scientist named "Doc"—unmistakably Ed Ricketts—and the down-on-their-luck men and prostitutes with whom he consorts down near the man-made canyons between the huge sardine packing companies along the waterfront. The book was poorly received by critics and Monterey residents. All of a sudden, in the little city, people would cross the street when they saw the well-known coming.[11] It was the stink, the grating noise, the prostitutes and homeless men that got to the residents. They seemingly failed to appreciate the poetry or the nostalgia.

Steinbeck attributed the reaction of his fellow citizens to resentment of his success. And in a despondent mood, he wrote to his editor that California "isn't my country anymore. And it won't be until I am dead. It makes me very sad."[12] He made good on his words and left the state. He lost his friend Ed Ricketts soon afterward, when the doctor/philosopher's car was struck by a train, the Del Monte Express, in 1948. Following that tragic event, there was even less reason to return. Steinbeck never lived in California again.

In 1960, Steinbeck set out on the road again in a specially-equipped van, leaving behind his third wife, Elaine, but bringing with him his poodle, Charley. "Once I traveled around in an old bakery wagon," he reminisced, a "double-doored rattler with a mattress on its floor. I stopped where people stopped or gathered, I listened and looked and felt, and in the process had a picture of my country the accuracy of which was impaired only by my own shortcomings. So it was that I determined to look again, to try to rediscover this monster land."[13]

Steinbeck traveled over 10,000 miles and revisited, as part of his grand itinerary, the California he had left behind. *Travels with Charley* was published in 1962 and it has become part of the canon of American road books. But though he had many pleasant encounters, and experienced the kindness of strangers, the 60-year-old Steinbeck did not rediscover the country in the same profound way that he had the first time as a young man. Neither was the country the same. "When we get these thruways across the whole country," he observed presciently, "as we will and must, it will be possible to drive from New York to California without seeing a single thing."[14] By that time, the interstate system had already siphoned off much of the business from Route 66 which he, like no other, had put on the literary map. Today the sterility of interstate rest areas and service exits is exceeded only by their convenience. On a busy day they still exude the hum of Americans on the move. It is the roads that have changed, and the vehicles, more than the people. ॐ

IN 1914, ROBINSON JEFFERS got his first look at the rock and surf of Carmel, at the American continent's western edge, where he saw his destiny. There, like a bird of prey at the "very turn of the world,"[1] Jeffers clenched his talons deep into the granite. Warning off visitors with a thicket of "No Trespassing" signs, the poet perched there for more than half a century, gazing with a fierce eye on the Pacific Ocean, setting down his vision in words (many of them) until the day he died. Through his writing, he crafted an identity for this wild piece of the West Coast.

"When the stagecoach topped the hill from Monterey," Jeffers wrote of first sighting Carmel, "and we looked down through pines and sea-fogs on Carmel Bay, it was evident that we had come without knowing it to our inevitable place." Two things made Robinson Jeffers: Carmel and his wife, Una, who was by his side in the stagecoach. By all accounts, the pre-Carmel Jeffers didn't show many signs of poetic promise. His father was a theology professor at Western Seminary in Pittsburgh, Pennsylvania, and his youth was spent on education (he studied Greek, Latin, Hebrew and even some modern languages) and little else.

Jeffers spread his wings somewhat while obtaining a bachelor's degree from Occidental College in Los Angeles, then dabbling in languages, literature and medicine at the University of Southern California, but he was still unformed as a writer when he and Una moved to Carmel. Certainly the greatest thing that he took from his sojourn in Southern California was Una, the wife of a wealthy Los Angeles lawyer, whom he met when she was a student at the University of Southern California. The two became lovers, scandal ensued, and, in 1913, Jeffers wound up with his prize. The entire course of Jeffers' poetry would have been altered had he and Una moved to England as they planned. But World War I reared its head and the Jeffers family decided to go north.

The Jefferses soon bought property on a point in Carmel that was being used for a golf course. It was as rocky as a New England pasture. They built a small stone cottage next to a granite "tor" (a Gaelic word for a rocky outcropping), which is why the residence today is called Tor House. Knowing nothing of building, the young couple hired a contractor. But while construction was underway, Jeffers got involved. Over the next few decades, Tor House expanded into several buildings, all of them stone. Jeffers built them all, with some help, eventually, from his sons. He hauled the stones up from the sea that broke in front of the house. Clearly a man who needed toil, he also planted over 2,000 eucalyptus and cypress trees along the headland, on the property that he and Una began accumulating.

He had begun writing poetry by that time, but until he started working with the granite his poetry was undistinguished. He judged himself to be too influenced by the poets he had studied; just a "verse-writer," not a "writer of verse."[2] But the labor he did with his hands had a positive effect upon his verse. Like a stone wall, the left edges of his poems are as straight as a plumb line, while the right edges are rough. Within the poem every word is carefully chosen for its heft and shape. No chink is left unfilled. Just like a builder with stone, he selected the words that settled together strongly.

Jeffers did not toil long in obscurity. His first published poem was the 72 page epic, "Tamar," originally printed in an edition of 500 copies at his own expense in 1917. The East Coast printer who got the job was so intrigued by the poem that he gave copies to two influential critics. And thus, quickly, a reputation was born.

(Left and on pp. 104-105) **Pacific Coastline** —Big Sur, California

<div style="text-align: right;">The calm and large</div>

Pacific surge heavy with summer rolling southeast from a far

origin

Battered to foam among the stumps of granite below.

Tamar watched it swing up the little fjords and fountain

Not angrily in the blowholes; a gray vapor

Breathed up among the buttressed writhings of the cypress trunks

And branches swollen with blood-red lichen.

("Tamar," 1917)

Jeffers "got" the relationship between the ocean and the land in a way that was simple but profound. The power of the poetry derived from the relentless battering of the sea against Monterey's granite coast and the resistance of the stone. Both boulder and sea were living and wild, nature in her pure form. If he had ended up at Walden Pond instead, writing to the sound of gentle ripples lapping at a sandy shore, Jeffers might just have become a fine building contractor. Big Sur's extreme wildness propelled his vision.

Later, a maturing Jeffers spoke of the Big Sur area:

The coast crying out for tragedy like all beautiful places,

(The quiet ones ask for greater suffering: but here the granite cliff

the gaunt

cypresses crown

Demands what victim? The dykes of red lava and black what

Titan? The

hills like pointed flames

Beyond Soberanes, the terrible peaks of the bare hills under the

sun, what

immolation?)

("Apology for Bad Dreams," 1925)

Was he speaking of the power of Big Sur to turn people insane? It is possible. He and Una were aware of the many characters who roamed the area, haunted or crazy, and of the legends that surrounded it. It could also be that he wasn't speaking about others but about himself, coming to grips with a beauty so great

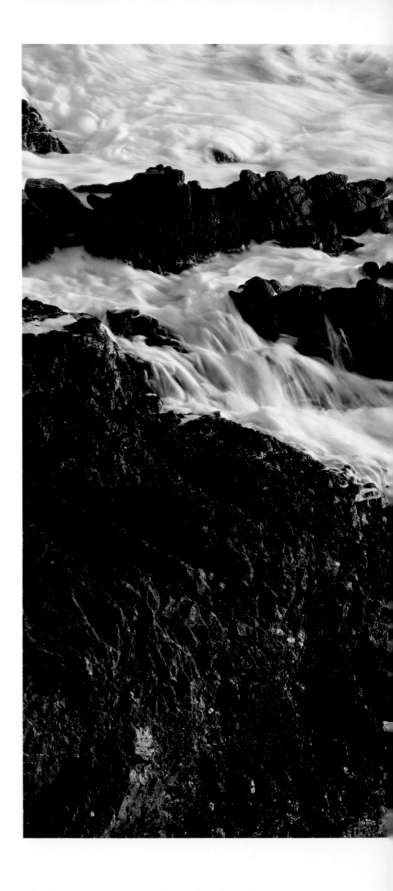

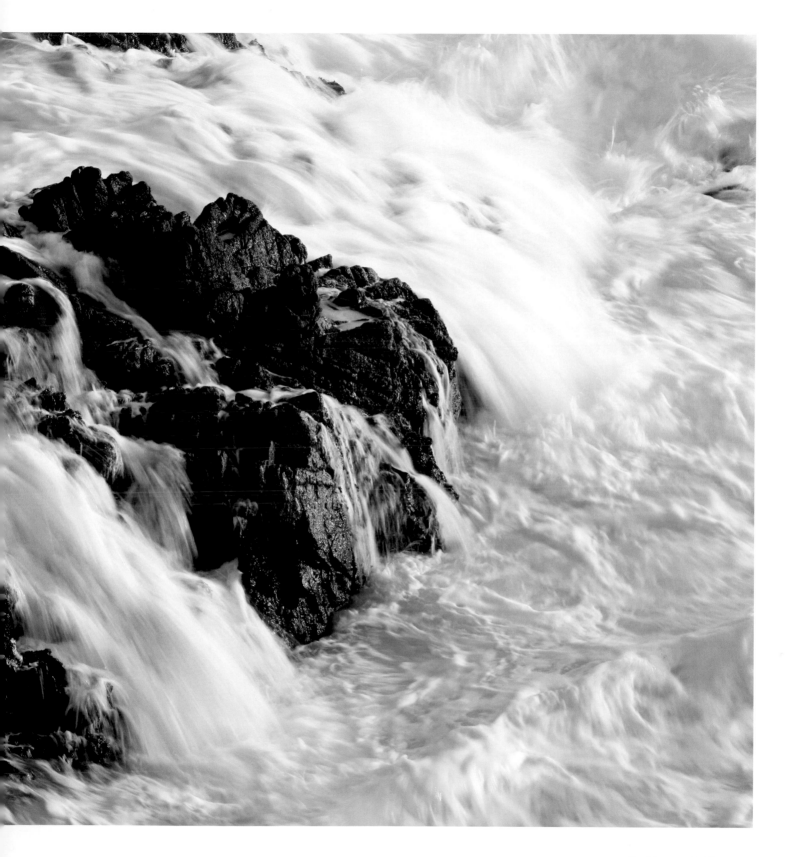

Robinson Jeffers

that it demanded a sacrifice. A few lines further, he admonishes himself: "Better invent than suffer." But again, does that mean he needed to be engaged in some activity (endless writing and building of stone walls) in order to keep sane? Or did he believe he must write poems as one writes spells, to protect himself and his family from what Big Sur demanded? No one knows. The poem, all 121 lines of it, is a tantalizing cipher. Written when he was beginning to hit his stride, it is now looked at as the key to understanding his later works, even as it resists interpretation.

Jeffers focused most of his writing career on the settings of Big Sur and Carmel. He made so much of a connection with the place that he seemed almost able to bend time, to step out of the twentieth century. When they first broke ground for Tor House, he and Una discovered that the ground was littered with abalone shells—a sure sign that the Indians had inhabited that point of land long before they did.

> All the soil is thick with shells, the tide-rock feasts of a
> Dead people.
> Here the granite flanks are scarred with ancient fire
> **("Apology for Bad Dreams," 1925)**

When the couple first moved to Carmel, shepherds still traversed the hills and valleys of Big Sur much as in ancient Greek times. As a student of the classics, Jeffers must have been delighted. He extolled that lifestyle in his poetry, and at home he and his family tried to live that kind of simple life, too. Tor House was primitive inside, heated by fireplaces, lit by candles, for a long time without electricity. The lingering smell of woodsmoke is one of the striking things about the house. It smells like a building that was built in the 18th century—not the 20th.

In one poem, Jeffers revealed his deepest muse. He described it as the "eye that watched before there was an ocean."[3] This eye was both "older and harder than life and more impartial," a force that came from the beginning of time. But it is difficult to imagine Jeffers' success without the presence of Una. The eye that watched before there was an ocean represented all that was forbidding about Jeffers, who had a craggy face that looked as though it too had been hewn from granite. Una's face was soft, more rounded. She was a vibrant Irish woman who injected liveliness into the atmosphere, something that had been lacking in his Calvinist upbringing. Furthermore, Una was his earthly guide and goad—the one who drove him on when he wavered. For example: he followed a schedule of writing in the morning and building in the afternoon. His writing desk was on the second floor of Tor House. Una's writing desk, where she kept up with her correspondence, was directly below his, on the first floor. When writing, Jeffers paced. Thus, Una knew that if she did not hear his treading footsteps, the flow had stopped. She would grab a broom handle that she kept handy and rap it on the ceiling to spur him on.

Una also inspired Jeffers to build a tower next to Tor House, for their two boys to play in. He worked on this tower for four years—an amazingly short time, considering that he had no formal engineering training, no advanced equipment, and no help. Shaded by some of the surviving cypresses and eucalyptus trees, it remains the most impressive feature of the property.

At first Jeffers tried to build a round tower, but he soon realized that he didn't have the skill. What he erected instead has three floors with a main set of stairs and a secret staircase that leads from the first floor to a second floor room that was for Una. From there, a set of stone steps leads up to a landing, and from there to a parapet at the top, with a shard of the Great Wall of China set into the stone.

Robinson Jeffers ascended to this parapet every night to look at the scene before going to bed. He describes it in "Margrave" like this:

> On the small, marble-paved platform
> On the turret on the head of the tower
> Watching the night deepen.
> I feel the rock-edge of the continent
> Reel eastward with me below the broad stars
> **("Margrave," 1930-31)**

He named the tower Hawk Tower because he said that a hawk came every day while he was building it and landed on the stones. This was not the only mystic occurrence during his

Toil before sleep: It was an era of back-breaking work. Steinbeck used dynamite and toiled on the Madison Square Garden construction. Faulkner labored on Rowan Oak. Frost farmed by day and wrote at night. Robinson Jeffers hauled stones and built **Tor House** and the tower, then planted hundreds of trees. — Carmel, California

tenure in Carmel. Una, an admirer of William Butler Yeats (who also owned a tower, in Ireland), was as much of a believer in spiritualism as Yeats. Yeats and his wife practiced automatic writing, during which she went into a trance and believed that her hand was guided by spirits. It seems that Una, and Jeffers, though he was a trained scientist, shared an enthusiasm for probing the spirit world. One of the surprises of the main house is a skull (what Jeffers liked to call a "human brain vault") the couple kept in a hidden alcove under the stairs, presumably for séances.

Jeffers believed in the notion that he was part of some life flow that transcended his own mortality. And, as his poetry became inseparable from the stone and ocean, so too did his fate and his home and his poetry get intertwined. They built the house on a spot where Indians had lived. But the connection did not end there. When they later dug the foundation for the fireplace in the kitchen, they found that the Indians had had their fire pit in the exact same spot. Those coast Indians, who spoke of a fabulous city called Esalen, which no settlers ever found, had disappeared from the land long ago. But they remained alive to Jeffers and to others, who felt the presence of the Indians in the hills of Big Sur.

Other legendary creatures appeared to him as well. In one poem, he described, in careful detail, a merman he had seen one day, waist-deep in the water in front of the house.

> Unmistakably human and unmistakably a sea-beast: he
> Submerged and never came up again,
> While we stood watching.
>
> **("The World's Wonders," 1951)**

Robinson Jeffers
Carmel & Big Sur, California ❖ 107

Una also filled a space in his personal mythology. On one of the rafters in the only first floor bedroom, he inscribed a quotation from Spenser's *Faerie Queene*:

Sleep after toil
Port after stormy seas
Ease after Warre
Death after Life does
greatly please

Like Vergil of Dante's *Inferno*, the main character of Spenser's allegory was accompanied by a guide. Spenser's guide at one time prevented him from committing suicide. That guide's name happened to be Una. It is likely that Jeffers' Una performed the same service for him as well, as he went through several dark times.

The bedroom with the inscription was rarely used but not completely off limits. In fact, Jeffers wrote a poem about the bed in there. In it, he revealed that he had chosen that bed, which had a view out across the grass and rocks to the ocean, as a "good death-bed." He viewed its occasional use by overnight guests as somewhat of a private joke. One day, he wrote, while lying in that bed he would be called to death by a "patient daemon" behind a "screen of sea-rock and sky."[4]

Blood-red lichen along the Carmel coast — Carmel, California

By 1931, Robinson Jeffers had appeared on the cover of *Time* and was widely read and studied. But the advent of World War II affected him deeply. In 1941, the war entered America's shores—in the Pacific, no less—with the bombing of Pearl Harbor. Jeffers' first poetic reaction, called "West Coast Blackout," was completed three days later.[5] As the war dragged on Jeffers was thrown off kilter by the horrors of war.

In 1943 he wrote to a friend that "months have gone by like drops of water, and it isn't because I am particularly occupied with anything. Writing verses and usually burning them, and cutting firewood and heaving stones, with *Time* and the newspapers for anesthetic in the evenings."[6]

By 1948, Jeffers had rallied, of sorts, with a book of verse called *The Double Axe*. In it, he was very specific about causes and effects, only this time his subjects were not mankind and Big Sur so much as they were a warlike America, her behavior and future. Jeffers wrote in one of the *Double Axe* poems: "Truly men hate the truth; they'd liefer / Meet a tiger on the road."[7] And in the book of verse he seemed determined not to sugarcoat the facts as he saw them. "Unhappy country," he wrote, "what wings you have…Unhappy, eagle wings and bleak, chicken brain."[8] Random House had its doubts that the public wanted to hear Jeffers' opinions just then. They published the book with a disclaimer. In the analysis of poet William Everson, Jeffers'

Robinson Jeffers

"descent into the political arena was an unmitigated disaster. For one thing, political poetry itself was then out of fashion…. Moreover, in 1948 the nation at large was enjoying an interval of rare self-esteem. Victory had proved American justice and she stood before the world as the savior of mankind….Into this bland, complacent atmosphere Jeffers' book dropped like a bomb (a stink bomb, many thought)."[9]

The Double Axe, which was savaged by many critics, including the ones at *Time*, Jeffers' erstwhile anesthetic, and one-time admirer, marked the beginning of his swift slide into disrepute. Jeffers, who had once been treated like a prophet and visionary, felt America's cold shoulder. In 1950 Jeffers lost Una to cancer. He was left alone with his convictions in his stone house and tower, and only the sea hadn't changed.

In 1962 he died, just as he had predicted, in the good death-bed by the seaside window, 30 years after he published the poem about it. And on that day in Carmel it snowed—a rare, almost unheard-of occurrence. Like the shells that the Jeffers family discovered when building their house on the land that so moved him, his poetry seems to be preserved under the creepers and undergrowth, waiting to be revealed again in the light of a different day. The presence of Jeffers himself still remains in the rough granite and the lingering smell of woodsmoke of Tor House, beyond which ebbs and flows the startlingly blue Carmel surf. ⌁

My ghost you needn't look for; it is probably

Here, but a dark one, deep in the granite, not dancing

on wind

— Robinson Jeffers
"Tor House," 1926-28

Sand and Cypress Trees. — Carmel, California

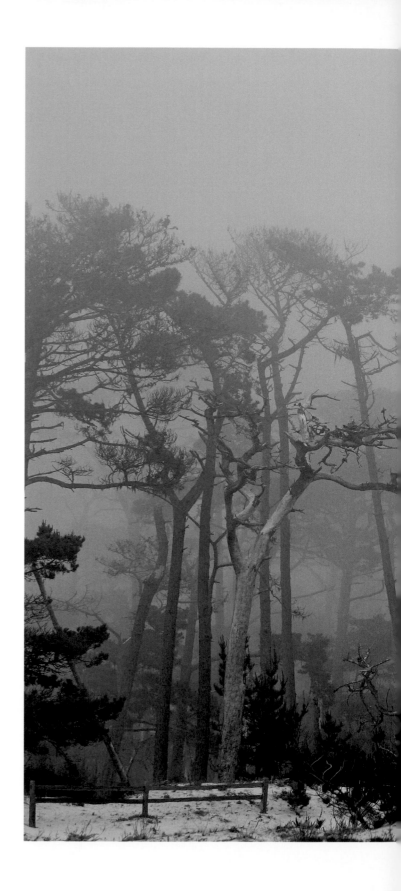

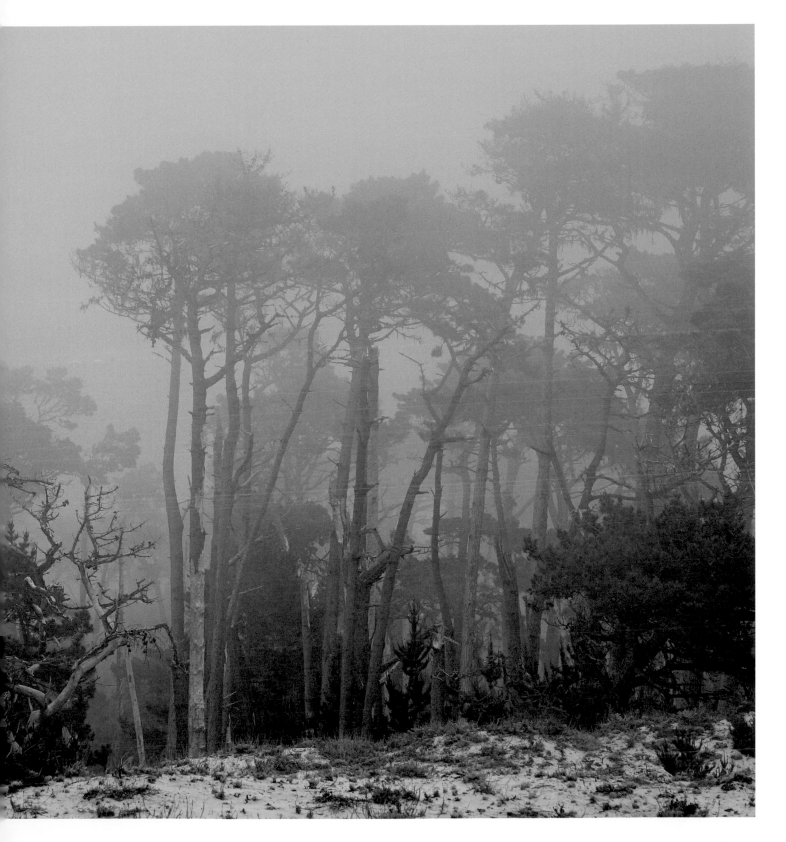

Robinson Jeffers

Thomas Wolfe Memorial, Dixieland — Asheville, North Carolina

"The past is never dead. It's not even past."

— William Faulkner

Requiem for a Nun, 1951

Not Forgotten:

Yoknapatawpha to Altamont

William Faulkner • Thomas Wolfe

WILLIAM FAULKNER (1897-1962)

*B*Y THE TIME he dropped out of high school, Billy Falkner was generally regarded as one of the laziest sons that the town of Oxford, Mississippi had ever known, a strange misunderstood character. He was madly in love with a girl named Estelle Oldham, but painfully shy and painfully aware of his diminutive stature. At five feet, five inches, with a voice he described as cricket-like, he was hardly taller than the confederate soldier who stood atop the Civil War monument in front of the courthouse at the center of the town, forever facing south.

His father, Murry, was a man of fallen fortunes. He had once run the family railroad founded by his grandfather (and Falkner's namesake and inspiration), the fabled "Old Colonel" William Falkner, who had commanded troops in the Civil War and had also written a fairly successful potboiler. Murry's father had sold the railroad out from under him, which drove Murry to drink. He put his son to work at the family livery stable. Most of the time, however, Billy Falkner spent listening to the stories of the hostlers there, or in the shadow of the courthouse where men gathered to swap stories that stretched back to the Civil War. When the livery business failed, Murry bought a hardware store, a purchase that Falkner found quite useful, as the building had a sturdy wall to tilt an old chair against and gaze out at the square for hours at a time. He seemed as useless and unpromising to his family, and Estelle's, as a stunted tree that generated an insignificant amount of shade and little else.

But like a tree, Falkner was sending roots down deep into the rich red soil of Lafayette County. "Men grow from the earth, like corn and trees," he observed in an essay on Sherwood Anderson. And indeed, without knowing what for, or even that he was doing it at all, perhaps, young Falkner was absorbing the lore and the atmosphere of that patch of red earth.

In the summer of 1914, when William Falkner was 17, a dashing young man named Phil Stone drove out to the house to meet him. Son of a family friend, "General" James Stone, Phil

Stone had twin bachelor's degrees from Ole Miss and Yale. He had heard that the young man wanted to be a writer, had already written some poetry, and he was curious. He thought he discerned talent in the directionless boy and decided that what he needed was an education. Stone's mission: no less than to make William Falkner the poet laureate of his native Mississippi. Stone's charge fell in love with verse, a wonderful vessel for his romantic feelings and teenaged morbidity. He decided he'd had enough of school and left it for good after his second attempt at 11th grade.

Valuable as Stone's tutelage and friendship were, however, they did not do much to increase his protege's stature in the eyes of his family. Or Estelle's. Falkner and Estelle had a strong bond between them. But her parents, despairing at the prospects of the jobless high school dropout, steered her towards marriage with the handsome and successful Cornell Franklin. Estelle told Falkner that she was ready to elope with him. But he wanted to act in a manner befitting his family's status (fallen though it was). He went to Mr. Oldham to properly ask permission but the man flew into a rage. Using family connections, Falkner took a bank job to prove he could support himself and Estelle. But it was no use. He crumbled under the pressure of the job and low expectations and, in 1918, Estelle married Franklin.

Distressed beyond belief, Falkner and Stone concocted a plan to get him into the war in Europe, then in its final horrific throes, so that he could die a hero. Ineligible for the U.S. military because of his height, he went up to Canada and joined the Royal Air Force, amending his name, for the first time, to "Faulkner." He also adopted a British accent and told his fellow flight school trainees that he was a Yale graduate. Dashing all his hopes, the war ended before he had a chance to get into it. He returned to Oxford. When his family met him at the train station, they found a distinguished young man in the RAF uniform, who walked with a slight limp he said he had gotten while flying a dangerous mission. He went around Oxford that

When William Faulkner bought **Rowan Oak** in 1930, the cedars that lined its approach had already been in place for 90 years. The house was in terrible disrepair but, with its purchase, the author once again sent a root down deeply into the beckoning past. Back in the 1840's, a Colonel Sheegog had settled in Oxford, cleared a patch of alluvial land, and left behind this Greek Revival treasure. — Oxford, Mississippi

way; stiff, British, every bit the ersatz war hero, fooling no one and earning the nickname "Count No 'Count." This must surely have hurt. But he had gone far in blurring the lines between reality and fiction. And after that he never looked back.

Faulkner bounced around over the next few years. He wrote a lot of poetry. He went to New York City to try to make it as a writer but ended up impressing people more with his prodigious ability to hold his liquor than with his prose. Bottomed out and back in Oxford, he worked for a stint as the postmaster on the Ole Miss campus. But he worked when he felt like it, returned mail, and eventually refused to open even the general delivery window. Released from his job, he went to New Orleans to take a ship to Paris but he wound up staying in New Orleans instead,

a bit like Henry Sutpen from *Absalom, Absalom!*, a "yokel out of a granite heritage where even the houses, let alone the clothing and the conduct, are built in the image of a jealous and sadistic Jehovah, put suddenly down in a place whose citizens had created their All-Powerful and His supporting hierarchy chorus of beautiful saints and handsome angels in the image of their houses and personal ornaments and voluptuous lives."[1]

He fell in love again, with a woman named Helen, whose face later launched him on the ship to Europe. There he was also befriended by Sherwood Anderson, who had struck a nerve with a book of sketches of an American town, *Winesburg, Ohio*, and was one of the most admired writers in America. Inspired by Anderson, Faulkner began his first novel, *Soldier's*

William Faulkner
Oxford, Mississippi ❖ 115

(Above, Right and on pp. 126-127) **William Faulkner's study at Rowan Oak.** An outline of his novel *A Fable* is handwritten on the walls. Tucked behind the door one finds TOMORROW. — Oxford, Mississippi

Pay, a story that paralleled his own fictive experiences as an injured war hero coming home to a small town. Once he got started writing, the project completely swept him up. Phil Stone, impatiently waiting for his poet laureate to emerge, sent him a wire: "WHAT'S THE MATTER. DO YOU HAVE A MISTRESS." Faulkner's response: "YES, AND SHE'S 30,000 WORDS LONG."[2]

Around this time, the outlines of Yoknapatawpha County had begun to come hazily into William Faulkner's view, like a morning mist rising above the fields. There was the town of Jefferson, the county seat, with the courthouse set down right in the middle of it, just like Oxford, and roads radiating out to the points of the compass. It stretched from the sinuous Tallahatchie River in the north—a river that existed in

Lafayette *and* Yoknapatawpha counties—to the Yoknapatawpha river in the south, which existed only in Faulkner's imagination. Yoknapatawpha County was a permeable overlay that covered the contours of the land that William Faulkner knew best. It was populated by unforgettable families like the Snopeses, the Sartorises, the Sutpens, the Compsons, the Varners, and a host of thoroughly black residents like Dilsey and "possible blacks" like Joe Christmas, whose doubts about whether he was black or not led to his violent death. The Snopes and the Sartoris families appeared as early as 1926, in works in progress. The Compsons first appeared in 1929 in *The Sound and the Fury*.

Meanwhile, back in Lafayette County, Estelle, with her two children in tow, had returned from the Orient, where her marriage to Cornell Franklin had fallen to pieces. Faulkner had

pretty much gotten over her (by falling in love with another woman who eventually broke his fragile heart). But her miserable situation and his sense of responsibility moved him. In 1929 he borrowed some money for the honeymoon and married her. *The Sound and the Fury* came out to admiring reviews but little commercial success. Faulkner got a job working the night shift at the University power plant and wrote *As I Lay Dying*, where Yoknapatawpha County was first mentioned.

Over the next four decades, the residents of Yoknapatawpha County came to him insistently. He sequestered himself in his writing room for hours each day, much to the dismay of Estelle. In *Absalom, Absalom!* (1936), he included a hand-drawn map of Jefferson and its environs. [See pp. 120 -121.] The legend reads:

AREA, 2400 SQ MI.
POPULATION, WHITES, 6298
 NEGROES, 9313

WILLIAM FAULKNER,
SOLE OWNER AND PROPRIETOR

Indeed, he was filling in the history of an entire county similar to Lafayette. As he wrote, in an essay called "Mississippi," the state had been settled by the sturdy, wasteful Anglo-Saxon, "roaring with Protestant scripture and boiled whiskey, Bible and jug in one hand and like as not an Indian tomahawk in the other…dragging his gravid wife and most of his mother-in-law's kin behind him into the trackless wilderness…felling a tree which took two hundred years to grow, to extract from it a bear or a capful of wild honey."[3] The Anglo Saxon was to be followed by the slaves and the plantations and then, much later, the carpetbaggers and the Snopeses, a kind of white not-quite-trash that propagated like weeds, giving up farming in favor of devising various ways to milk the community, especially the black people.

Although the histories are not 100% consistent from book to book, they are interrelated. Minor characters from one book reappear as narrators of later books. They live, love, marry, commit murder, take revenge, die, and inherit both money and curses.

William Faulkner
Oxford, Mississippi ❖ 117

MONDAY

II 06:00 The French Regiment mutinies, refuses to leave the trench
to make an attack, is drawn out, disarmed, put under arrest + sent to the
rear.

II The General commanding the division containing the Regiment goes to his Army Group
Commander and officially requests permission to have the whole Regiment executed. The Group
Commander tells the Division Commander, he is ordered to Chaulnesmont Wednesday.

IX ~~The British battalion runner tells the sentry about the lorries carrying blank
A.A. shells up to the front at Villeneuve + Abbaye. The Sentry assaults the Runner.
Both are put under arrest. The Runner's history included~~

12:00 The French front enters armistice with the German one opposite it

15:00 The British and American fronts enter armistice with the German ones
opposite them

TUESDAY

V The people from the district where the Regiment was raised, parents and kin of the
men in it, begin to gather at Chaulnesmont.

II 02:00 The Division Commander returns unofficially to the Group Commander, who tells him
that he is expected by the Allied Commander-in-Chief at Chaulnesmont Wednesday afternoon.

IX ~~The Sentry and the Runner are under arrest with armed guards in separate dugouts in
the British lines~~

III 24:00 The British battalion Runner tells the Sentry about the lorries carrying blank
A.A. shells up to the front at Villeneuve / Abbaye. The Sentry assaults the Runner.
Both are put under arrest. The Runner's history included.

Their glories and follies and fates live on in the collective memory of the townsfolk and countryfolk. Faulkner once wrote that his state was "dotted with little towns concentric about the ghosts of the horses and mules once tethered to the hitch-rail enclosing the county courthouse."[4] This was where things happened, around the courthouse and the country store, where the local wits and halfwits gathered and mingled, creating a sort of Greek chorus to provide background information and comic relief.

In the books set in Yoknapatawpha County, Faulkner's words roll over the pages in intricate bends, sometimes almost looping back upon themselves, like stretches of the nearby Tallahatchie River. The sentences, some of them more than half a page long, are controlled, as if by means of small dams, by commas. The tone and intricacy of the writing differ from book to book, character to character. Faulkner contended that Hemingway had never used a word that needed to be looked up in the dictionary. By contrast, Faulkner's writing was rich with grand words, some of them invented. Others were dusty gems that supported the ceaseless aura of the Old South, where women like his aunts, unvanquished, refused to let the Yankee bullets be dug out of their pillars and porticoes, even so long after the war.

As he once wrote, "The past is never dead. It's not even past." It had been decades since the Civil War, and yet, in a place where every kid, it seems, built models of the battle of Vicksburg out of sand and water, the South was still preoccupied by it. It had also been decades since the emancipation of the black people in the South. And yet that social construct of masters and slaves lived on even though its structure had been abolished. When he and Estelle and her two children moved into Rowan Oak in 1929, he brought with him a former slave named "Uncle Ned," who had served his grandfather, and a woman named Caroline Barr (Mammie Callie), already old when he was a boy, who had helped bring him up and who lived behind the main house until she died at over 100 years of age.

Not only the complicated relations between white and black in the old families seemed "not even past." The younger generation unconsciously carried on old ways. Faulkner described a young woman at a drug store whose grandfather had been a

THE MAP OF YOKNAPATAWPHA COUNTY

From 1957 and 1958, William Faulkner was Writer-in-Residence at the University of Virginia. In several lengthy sessions, collected in *Faulkner in the University*, published by the University of Virginia Press, Faulkner was quizzed by students about his characters, their motivations, and his own. "It was not my intention to write a pageant of a county," he said in one exchange. "I was simply using the quickest tool to hand. I was using what I knew best, which was the locale where I was born and had lived most of my life. That was just like the carpenter building the fence—he uses the nearest hammer." Yoknapatawpha County is what he built.

Two official maps of Yoknapatawpha County have been published. The first version, which is reproduced on the following page, originally appeared in the 1936 first printing of *Absalom, Absalom!*. It was an impressive piece of cartography, separated in two colors (red and black) and it folded out from the endsheets. Faulkner annotated the map in his neat capital letters, which feature the characteristic backwards "N" that also shows up throughout his manuscripts and on the concrete block in front of the Maud Faulkner house in Oxford, Mississippi. The later map, which appeared in *The Portable Faulkner*, had the titles of Faulkner's books positioned in the places where significant events of those novels had taken place, and a note that it had been "Surveyed and mapped for this volume by William Faulkner." It was a more polished version of the map, without the backwards N's. The original map kept appearing in successive editions of *Absalom, Absalom!*, though it was rendered in plain black and white, which diminishes its legibility somewhat.

On the *Absalom, Absalom!* map and *The Portable Faulkner* map, the Sartoris railroad, inspired by the real-life railroad founded by the "Old Colonel," Faulkner's grandfather, runs like a zipper from top to bottom. All of the roads run in beelines from the courthouse in the center of the map, which seems thus to lay "its vast shadow to the uttermost rim of horizon," as Faulkner wrote of the courthouse in *Requiem for a Nun*. The only curve in the roads is near Varner's store, in Frenchman's Bend, in the bottom right quadrant of the map. In Lafayette County—the real country Faulkner based Yoknapatawpha on—the roads don't run in such unswerving lines.

A cottage industry of scholarship has grown up around the analysis of the map, the products of which range from musing on the nature and purpose of maps, to discussion of Faulkner's acknowledgment of the area's Native American past with his mention of the "Chickasaw Grant," to an inquiry into the etymology and connotations of the words "sole owner and proprietor," to opinions on the symbolism of putting the courthouse at the center of his world, and so on. There is also speculation about why he made the map when he did. Had he come to a point in his creation of Yoknapatawha Country where he needed to set everything down to see what he had done so far? Certainly with *Absalom, Absalom!*, Faulkner had filled in the northwest corner of the map with one of his most legendary characters, Thomas Sutpen. The divisive Sutpen comes to the little town of Jefferson from the West Indies in 1833, with a captive French architect, a number of slaves who do not speak English, and a relentless ambition to carve a hundred square mile plantation out of the thick woods. He is not to be denied. And the mansion and lands become known as Sutpen's Hundred.

Faulkner's main subject was people. And the map was one means of putting the Yoknapatawpha County residents he had created into a kind of order. It is an anecdotal map, such as any of us might be able to draw of regions we know well and lives and events we have a sentimental attachment to. "I was trying to talk about people using the only tool I knew, which was the country I knew," Faulkner said later in the University of Virginia dialogue. The map furthered that ambition.

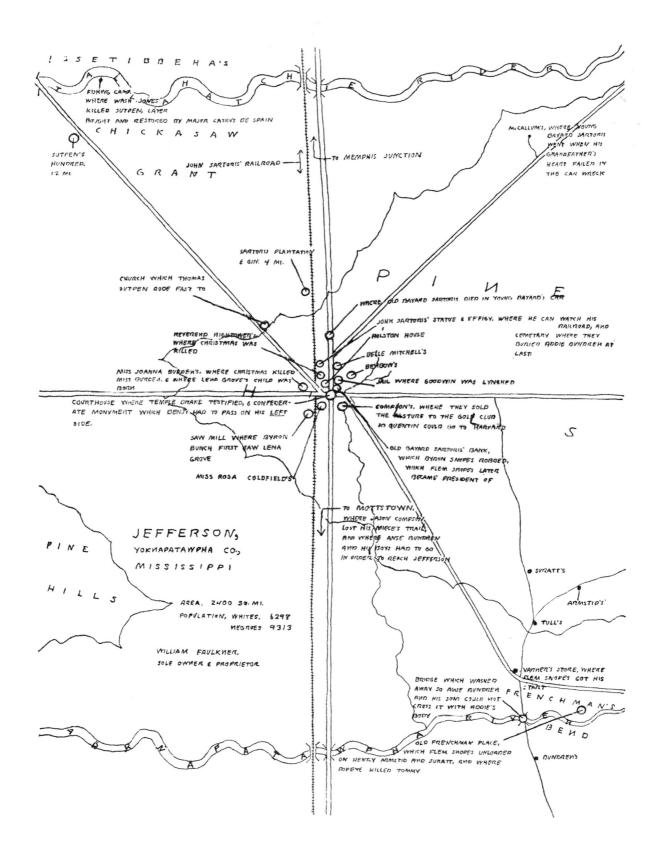

I S S E T I B B E H A'S

T A L L A H A T C H I E R I V E R

FISHING CAMP,
WHERE WASH JONES
KILLED SUTPEN, LATER
BOUGHT AND RESTORED BY MAJOR CASSIUS DE SPAIN

CHICKASAW

GRANT

SUTPEN'S
HUNDRED,
12 MI.

JOHN SARTORIS' RAILROAD

TO MEMPHIS JUNCTION

McCALLUM'S, WHERE YOUNG
BAYARD SARTORIS
WENT WHEN HIS
GRANDFATHER'S
HEART FAILED IN
THE CAR WRECK

SARTORIS PLANTATION
& GIN, 4 MI.

P I N E

CHURCH WHICH THOMAS
SUTPEN RODE FAST TO

WHERE OLD BAYARD SARTORIS DIED IN YOUNG BAYARD'S CAR

JOHN SARTORIS' STATUE & EFFIGY, WHERE HE CAN WATCH HIS
RAILROAD, AND

REVEREND HIGHTOWER'S,
WHERE CHRISTMAS WAS
KILLED

HOLSTON HOUSE

CEMETARY WHERE THEY
BURIED ADDIE BUNDREN AT
LAST

BELLE MITCHELL'S

MISS JOANNA BURDEN'S, WHERE CHRISTMAS KILLED
MISS BURDEN, & WHERE LENA GROVE'S CHILD WAS
BORN

BENBOW'S

JAIL WHERE GOODWIN WAS LYNCHED

COURTHOUSE WHERE TEMPLE DRAKE TESTIFIED, & CONFEDER-
ATE MONUMENT WHICH BENJY HAD TO PASS ON HIS LEFT
SIDE.

COMPSON'S, WHERE THEY SOLD
THE PASTURE TO THE GOLF CLUB
SO QUENTIN COULD GO TO HARVARD

SAW MILL WHERE BYRON
BUNCH FIRST SAW LENA
GROVE

OLD BAYARD SARTORIS' BANK,
WHICH BYRON SNOPES ROBBED,
WHICH FLEM SNOPES LATER
BECAME PRESIDENT OF

MISS ROSA COLDFIELD'S

S

P I N E

JEFFERSON,
YOKNAPATAWPHA CO.,
MISSISSIPPI

TO MOTTSTOWN,
WHERE JASON COMPSON
LOST HIS NIECE'S TRAIL,
AND WHERE ANSE BUNDREN
AND HIS BOYS HAD TO GO
IN ORDER TO REACH JEFFERSON

H I L L S

AREA, 2400 SQ. MI.
POPULATION, WHITES, 6298
NEGROES 9313

WILLIAM FAULKNER,
SOLE OWNER & PROPRIETOR

SURATT'S

ARMSTID'S

TULL'S

VARNER'S STORE, WHERE
FLEM SNOPES GOT HIS
START

BRIDGE WHICH WASHED
AWAY SO ANSE BUNDREN
AND HIS SONS COULD NOT
CROSS IT WITH ADDIE'S
BODY

F R E N C H M A N'S

B E N D

Y O K N A P A T A W P H A R I V E R

OLD FRENCHMAN PLACE,
WHICH FLEM SNOPES UNLOADED
ON HENRY ARMSTID AND SURATT, AND WHERE
POPEYE KILLED TOMMY

BUNDREN'S

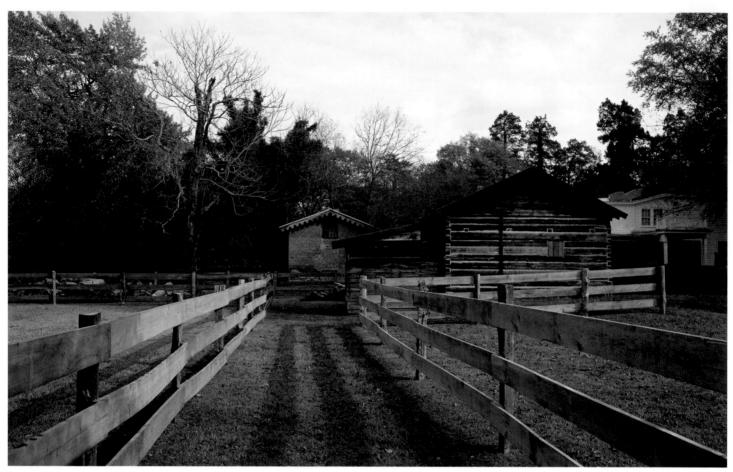

No gentleman farmer: William Faulkner worked the land, built the stable for his horses, established and operated the smokehouse, did most of the house renovation and designed the rose garden. He was certainly justified in once using **Rowan Oak's operations** to turn down a trip to New York to receive an award. "Up until he sells crops," he explained, "no Mississippi farmer has the time or money either to travel anywhere on."

— Oxford, Mississippi

notorious bootlegger in the area, "watching her virginal and innocent and without self-consciousness pour Coca-Cola syrup into the lifted glass by hooking her thumb through the ring of the jug and swinging it back and up in one unbroken motion onto her horizontal upper arm exactly as he had seen her grandfather pour whiskey from a jug a thousand times."[5]

This was the lush, complicated Mississippi that Faulkner loved, and rarely left, in the early days. It was a country that Quentin Compson, a character in *The Sound and the Fury*, missed when he ventured up North. Homesick, Quentin reflects that, "our country was not like this country. There was something about just walking through it. A kind of still and violent fecundity that satisfied even bread-hunger like. Flowing around

you, not brooding and nursing every niggard stone. Like it were put to makeshift for enough green to go around among the trees and even the blue of distance not that rich chimaera." Even in the fullness of summer, at its greenest, the Northeast must have seemed rather thin to someone from Mississippi. Into still and violent fecundity Henry Sutpen ventured with his wild slaves in *Absalom, Absalom!*. And it is no doubt in order to preserve some of it that Faulkner bought Rowan Oak, for the thick alluvial swamp of Mississippi was then, and is now, being cleared and developed, tamed.

Faulkner stubbornly held on to Rowan Oak, a big old mansion in Oxford that he had bought in the 1920's for $6,000, with no money down, at 6% interest. At the time he noted

cheerfully to its seller, "I believe that a little debt is good for a young man." He had many occasions to regret that statement later as he struggled to retain the house and support Estelle in a pared down version of the manner to which she had been accustomed. He churned out any number of potboilers for the magazines. And he was forced to make several trips to Hollywood to work in indentured servitude in the script mills, a prospect that was somewhat improved by his friendship with Howard Hawks and one of Hawks' "script girls." He even moved Estelle and her daughter and the servants out to Los Angeles for one stint. But he always ended up missing Rowan Oak.

At last, ironically, it was the movies that made Faulkner some money, though not any of the ones for which he had slaved away as a hack. In 1948, Random House sold the movie rights to his novel, *Intruder in the Dust*, for $50,000, of which Faulkner's share was $40,000. His reputation also underwent a renaissance. At the time of his death, he and Estelle, with whom, after years of bitter fighting and mutually solitary drinking, he had finally made some sort of peace, were about to move into a big estate in the Blue Ridge Mountains so that they could be closer to their daughter. But Rowan Oak called him back one last time. Riding hard near the house, he had a bad fall from his horse. After three days of pain, he died of a heart attack on July 6, the date of the Old Colonel Falkner's birthday. Even on the day of his passing he looped back to a colorful character from the never-dead past of Yoknapatawpha/Lafayette counties one last time. ✍

"He stood on a stone pedestal, in his frock coat and bareheaded, one leg slightly advanced."

— William Faulkner
Sartoris, 1929

Statue of Colonel W.C. Falkner, the "Old Colonel"
(William Faulkner's great-grandfather) — Ripley, Mississippi

William Faulkner

THOMAS WOLFE (1900-1938)

FOR NO AMERICAN AUTHOR does the term "literary giant" seem so literally accurate as for the six-foot, six-inch, 230-pound Thomas Wolfe. Wolfe, whose creative output was as gigantic as his stature, had one great subject: America, as seen though the lens of himself. Wolfe was born in Asheville, North Carolina, a city surrounded on all sides by the Blue Ridge Mountains. In order to journey to the very beginning of his career, one must come over the lip of those rolling peaks on a sunny day close to the turn of the century. In front of a house that no longer exists, at 92 Woodfin Street, a baby in a basket watches his sister Mabel go up the hill on her way to school. This was his first memory. "I have tried to make myself conscious of the whole of my life since first the baby in the basket became conscious of the warm sunlight on the porch,"[1] Wolfe later wrote.

Wolfe's father, W.O. Wolf, came to Asheville, North Carolina from Pennsylvania, by way of Raleigh. He opened a tombstone shop. He had been married once, and quickly divorced. In Raleigh, he'd ornamented his last name with an "e" (perhaps it looked finer on a tombstone) and gained a second bride. But when they moved to Asheville, he lost her to tuberculosis. He was a tall man for his time, standing six feet four. Asheville residents soon learned that he was larger than life in nearly every other way as well. His appetites—for food, for alcohol, for stimulation, for self-destruction and short-lived self-recrimination—were colossal. His voice was a rich booming instrument, which he was fond of employing on a repertoire of Shakespearean soliloquies.

One day, when the widower was lounging in his tombstone shop, Julia Penland Westall stepped into its dim interior.

The "Old Kentucky Home," known as **"Dixieland"** in *Look Homeward, Angel*. The "dirty yellow" house was Julia Wolfe's foray into the hospitality industry, for which she was ill suited. Young Wolfe was shuffled from room to room according to availability. In the foreground are his sizeable shoes. — Asheville, North Carolina

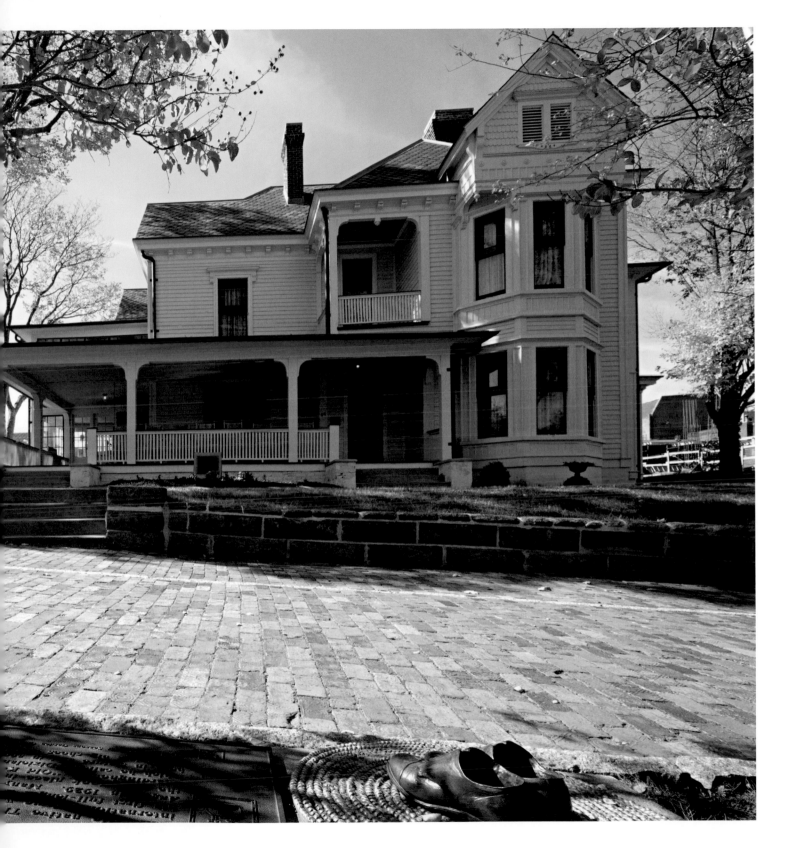

Thomas Wolfe

Pent up behind mountains: Growing up in Asheville, Max Perkins wrote, "a boy of Wolfe's imagination imprisoned there could think that what was beyond was all wonderful." And yet it is the portrait he created of Asheville that is the greatest wonder.

She was all business, a determined woman who had grown up in poverty and vowed never to be poor again. Julia was a distant relative of Davy Crockett and an excellent shot. She might have made a fine pioneer, except that she had no intention of leaving the town. What really got her all fired up was real estate. And Asheville was her Monopoly board. On the day she met W.O., she was going door-to-door selling books to supplement her meager income as a schoolteacher. But both occupations were really just means to make money so that she could buy property.

According to the biographer Ted Mitchell, the book she peddled that day was called *Thorns in the Flesh*. And would that the couple had only heeded the warning. But W.O. fell in love at first sight, and he rolled right over every objection that she put in his path. The two married; Julia took up residence at Woodfin Street; children followed, and then boarders. Julia

was not satisfied with W.O.'s prospects. In Asheville, people "did not die fast enough"[2] for her taste. Her husband's business could have directly benefited from a higher mortality rate.

The Wolfe family carried on a hyperbolic existence in the vine-wreathed house. The dining table was a groaning board. When W.O. made a fire in the fireplace, it roared. W.O. didn't just get drunk; he went on binges. Afterwards, his youngest daughter, Mabel, would feed him as if he were a baby. Sometimes W.O. would escape the city and plow across greater America, drinking and dissipating until he returned weak and exhausted. Once back in the "clustered warmth"[3] of his brood, W.O. would hurl invective at Julia and her clannish family. She fended him off tartly but she was no match for his verbal ability. For Julia it was a constant strain. For the children, it became entertainment.

Thomas Wolfe was the youngest of the brood. We know

Great Smoky Mountains — Asheville, North Carolina

much about his early years from his first novel, *Look Homeward, Angel*. The 525-page book pretty much defined the term "thinly-veiled account," so much so that the first names of some of the Wolfes remain the same in the fiction. W.O. Wolfe became W.O. Gant. Ben Wolfe became Ben Gant. Grover remained Grover. Julia became Eliza, and her side of the family became the Pentlands, a family of skinflints. And pent up they were in that mountain-encircled city of Asheville, reborn as Altamont in *Look Homeward, Angel*.

Thomas Wolfe became "Eugene," a name which, according to *Look Homeward, Angel*, meant "well born." It did not mean, he clarified sardonically, "well bred."[4] Much as he loved his parents, they caused him a great amount of anguish in Asheville, where they were prominent for all the wrong reasons. It is almost impossible, after reading a few chapters of *Look*

Homeward, Angel, to make a distinction anymore between the fictional character of Eugene and Thomas Wolfe himself. The portrait is so deeply felt and so openly autobiographical, the story so clearly of the development of a man and of a writer.

Eugene Gant gives early evidence of an extraordinary sensibility. As Wolfe described, "his sensory equipment was so complete that at the moment of perception of a single thing, the whole background of color, warmth, odor, sound, taste established itself, so that later, the breath of hot dandelion brought back the grass-warm banks of Spring, a day, a place, the rustling of young leaves, or the page of a book."[5] Apparently, though, Wolfe was not in a hurry to learn how to speak. His first word was "Moo"—not an auspicious start. Eventually, Eugene learns how to write. It happens one day as he watches a friend scrawl a school exercise in his notebook. He comprehends all at once

Thomas Wolfe

the "beautiful developing structure of language" that he sees flowing from his friend's pencil. He takes the pencil and copies that one word, and then another, and another. As Wolfe wrote, "Eugene thought of this event later; always he could feel the opening gates in him, the plunge of the tide, the escape."[6]

Dixieland

In 1906, Julia satisfied her desire to acquire real estate. She bought a boarding house. The previous owner had named it the "Old Kentucky Home," in a tribute to his home state. In *Look Homeward, Angel*, Wolfe dubbed it "Dixieland." The boarding house became the closest thing to home for Thomas Wolfe for the rest of his years in Asheville.

He might have stayed at Woodfin Street with the other Wolfes. But Julia took him with her when she moved in to the Old Kentucky Home, away from the tirades of W.O. Two years before, she had lost Grover, who was the apple of her eye, to typhoid. Following that tragedy, for which she blamed herself (he'd contracted it at the St. Louis World's Fair where she'd taken them to earn some extra money), she focused her hopes on her youngest son. But her maternal devotion was compromised by what Wolfe called stingy practicality. He was shuffled from room to room depending on vacancies. Sometimes he had to share the bed with her. If they were fully booked, he had to wait outside until the boarders were done before he could eat.

Thus Thomas Wolfe/Eugene Gant began the second phase of his existence—a sort of exile. He went back and forth between the boarding house and Woodfin Street, where his sister Mabel now presided. He had "no clear idea where the day's food, shelter, lodging was to come from, although he was reasonably sure it would be given: he ate wherever he happened to hang his hat."[7] Living with his mother meant privation and shame. When traveling, she'd make him "scrootch up" to get the lower train fare and feed him the butter and rolls and leftovers she had taken from her restaurant meals. No matter how much property his mother amassed, she never ceased to cry poverty.

Internally, the boy was ablaze with indignation. But he lacked the ability yet to express himself. Later he would say that the "threat of the poorhouse, the lurid references to the pauper's grave, belonged to the insensate mythology of hoarding."[8] But as a youth he was credulous, and felt shame about costing his parents money. His father, by the way, was similarly tight-fisted. He invented a whole series of heart-wrenching stories about a legless little orphan named "Little Jimmy" to get his son to renounce things he coveted.

Wolfe's mother let herself in for criticism that would have withered a weaker individual on account of the kinds of boarders she allowed. There were the "semi-public, clandestine prostitutes of a tourist town"—or "chippies," for short—that populated the faded yellow house. And there were the consumptive boarders (tuberculosis sufferers) whose afflictions she turned a blind eye to despite the health risk they represented. She was, as Wolfe put it, "proudly oblivious to any disagreeable circumstance which brought her in money."[9] A few decent folk stayed there, too. A lot of them seemed to be the wives of traveling salesmen; smooth-talking, mostly absent sorts, out there adding to the raucous voice of the America outside Asheville.

The Angel

Pack Square has been the beating heart of Asheville since 1797. Since early on, it has had a fountain, a feature of the European square that local patron Mr. Pack had in mind to elevate the town. An obelisk—a monument to local hero and Civil War governor Zebulon Baird Vance—stands at the other end of the square. In Thomas Wolfe's childhood, the buildings that surrounded Pack Square were of differing heights. Trolleys ran up and down. Folks gathered. Across the square was the drugstore, whose cool depths contained an onyx soda fountain and various gustatory delights. On one corner stood the single-turreted Pack Library—a former bank building turned castle of books—where Thomas spent much of his time reading.

Today, the obelisk remains. The fountain has been upgraded many times. The latest design unveiled in 2008 is a magnet for controversy. Many of the buildings, including that wonderful library, are gone. A sleek I.M. Pei building flanks one side of the square.

W.O. Wolfe's shop, which was at 22 South Pack Square, is gone. On that corner, in Wolfe's day, the square "dipped sharply"

W.O.'s marble shop and the Pack Library were on this busy square. Photograph: "Filming 'Conquest of Canaan' movie at **Pack Square**, Asheville, NC, 1921" [Herbert Pelton, Photographer]. Wolfe had nothing to do with the movie. But don't overlook the "Welcome" sign on the building across the square—a hero's welcome Wolfe never received. — Asheville, North Carolina

towards the black section of town, "as if it had been bent at the edge." Out in front of the shop stood a marble angel:

> It was now brown and fly-specked. But it had come from Carrara in Italy, and it held a stone lily delicately in one hand. The other hand was lifted in benediction, it was poised clumsily upon the ball of one phthisic foot, and its stupid white face wore a smile of soft stone idiocy. [10]

Angels had a powerful effect on W.O. Seeing an angel at a marble shop in Baltimore inspired him to become a stonecutter, though to carve an angel was a skill that W.O. never mastered. The stone angel lent an air of grandeur to the shop that went along with W.O.'s lofty manner of speaking. Sometimes he used her as a stand-in for his wife and lashed her with insults. When he was drunk, he would sometimes call her "Cynthia," kneel before her and ask for forgiveness, to the amusement of the people on Pack Square.

The angel worked on Wolfe as well. From an early age he was an avid reader and dreamer, "whose eyes were filled with the shadows of great ships and cities."[11] The gawky boy with the unhappy home life believed that beyond the hills of Asheville,

Thomas Wolfe
Asheville, North Carolina ❖ 129

the land "bayed out" into exotic scene after scene. The marble angel was a link to fine art and the great world beyond. In her smile, one reader has said, was "the unverifiable promise of salvation—at once the marker of death and the covenant of life." The symbolism of the angel for Wolfe lay "not with the marbles of the father's failed art and life, but with the transformation of all the beauty and passion of that failure into art."[12]

In *Look Homeward, Angel*, W.O. Gant sells the angel to a local madam, to mark the grave of a young prostitute who died. The real angel that stood outside the Wolfe shop was sold to the respectable Johnson family. She stands, a cool marble white, just down the road in nearby Hendersonville, in a large cemetery that surmounts a hill. Her hand is still raised in graceful benediction. If she was brown and fly-specked she is no longer. She smiles her noncommittal smile to this day.

Caught Up In "The Monstrous Fumbling of All Life"

In 1911, a husband-and-wife team held a student writing contest in Asheville, to try to identify future students for the private school they were founding. Thomas Wolfe was one of the essayists. When Margaret Roberts read his piece, she told her husband, "This boy, Tom Wolfe, is a genius! And I want him for our school." Thence followed a series of negotiations with the parsimonious parents, who finally agreed to let Wolfe attend the school for a reduced tuition.

Wolfe flourished, especially under Margaret Roberts' tutelage (he was not as kind to her husband in *Look Homeward, Angel*). Her love for literature was palpable, and from her he learned discernment, and a respect for erudition. As he wrote to her later, with his customary ardor, "I was…groping like a blind sea-thing with no eyes and a thousand feelers toward light, toward life, toward beauty and order, out of that hell of chaos, greed, and cheap ugliness—and then found you, when else I should have died, you mother of my spirit who fed me with light."[13]

Around the same time, he took a paper route. He was already familiar with selling papers. His older brother, the stuttering Luke Gant in *Look Homeward, Angel*, was the salesman of the family, a real go-getter in the grand American tradition. He sold the *Saturday Evening Post* to everyone he could buttonhole in

town, and then expanded his reach to the tuberculosis sanitariums in the nearby hills, often taking his younger brother with him. But it was brother Ben who got Wolfe the job delivering the Asheville newspaper. He landed the most difficult route in the city. But he went at it every morning at the crack of dawn, the heavy bag biting into his thin shoulders, walking the hills with a "curiously scissored" look before Asheville woke up.

Both the school and the paper route served to bring Wolfe out of himself and draw him into the world. His sensitive exterior began to harden. He became "a sharp blade." He learned cynicism.

He began to have girlfriends. In *Look Homeward, Angel*, Eugene falls head over heels in love with Laura, one of the boarders. She is not a beautiful girl but has a "clean, lovely ugliness," and a virginal quality that is "crisp like celery." By this point, W.O. occasionally terrorizes the boarders. Laura, however, is sympathetic, not repulsed. However, she is 21 and Eugene only 16.

"Oh, you child!" she cries when she learns that her lanky suitor is five years her junior. Eugene asks her to wait for him. Laura agrees. She announces she must first return to her family. Before she goes, there is one bittersweet picnic up in the mountains high above Altamont. The adolescent Eugene looks down at the town that, but for a few trips outside, has been his whole life:

> On the highest ground, he saw the solid masonry of the Square, blocked cleanly out in light and shadow, and a crawling toy that was a car, and men no bigger than sparrows. And about the Square was the treeless brick jungle of business—cheap, ragged, and ugly, and beyond all this, in indefinite patches, the houses where all the people lived, with little bright raw ulcers of suburbia farther off, and the healing and concealing grace of fair massed trees….The town was thrown up on the plateau like an encampment: there was nothing below him that could resist time….Below him, in a cup, he felt that all life was held.[14]

That cup doesn't hold Laura again. Bereft, Eugene leaves Altamont and lives by himself for the first time. He moves

to Richmond and finds a job, hoping to see Laura but never seeking her out. Like his father did so many times, he eventually returns to Altamont.

In real life, the Laura that Wolfe fell in love with was already engaged. She married weeks after leaving the boarding house, bore two children, and died shortly after of influenza.

Leaving Home

There was, in fact, more than one angel in *Look Homeward, Angel*. In addition to the marble one outside W.O.'s shop, there was an angel that hovered over Eugene's brother Ben, the one he would look up to every time he made a sardonic comment. "Oh, my God," he would say, addressing it, "Listen to that, won't you?" Despite the presence of his angel, Ben was withdrawn, unhappy. As Wolfe wrote, "he bore encysted in him the evidence of their [his parents'] tragic fault."[15]

It was Ben who pushed Wolfe to take his parents' money to go to school and make something of himself. Ben had never managed much in the way of higher education, though he did take correspondence courses. Their parents never spent a dime on any of the other kids, he would tell his younger brother, though they had the money to spend. Wolfe should take advantage.

Thomas Wolfe did as his brother urged. He attended the University of North Carolina at Chapel Hill, though he had fought to be sent to Princeton instead. And then, in 1918, when he was halfway through the program, Ben fell ill with influenza that he had gotten from his visiting sister. Wolfe rushed home to where Ben lay on his deathbed in the boarding house. To his last breath, Ben wouldn't let his mother into his room.

"The Asheville I knew died for me when Ben died," Wolfe later wrote in a letter. And after that, he was rarely to return.

Wolfe went on from UNC to Harvard, seeking to be a playwright. He did some teaching and took his first trip to Europe. In New York, he met Aline Bernstein, married, 19 years older than he, and rich. She encouraged him to write a novel about his childhood instead. Written by hand in huge account ledgers, it developed into the massive and unwieldy manuscript that he called, "O Lost." The manuscript caught the eye of a woman named Madeleine Boyd who, like Margaret Roberts before her,

was certain after reading him that she had found "genius." The enormous stack of pages found its way to Scribner's.

"The first time I heard of Thomas Wolfe I had a sense of foreboding. I who love the man say this,"[16] wrote the great Maxwell Perkins, who edited Wolfe, Fitzgerald, Hemingway, J.P. Marquand, Erskine Caldwell and a host of others. But he was persuaded by Ms. Boyd to give the manuscript a look. Perkins tried to read the novel that became *Look Homeward, Angel*, and put it aside after 90 pages. He handed it off to a colleague, who eventually persuaded him to read it again, showing him a scene that occurs later in the book. This second time around, Perkins was convinced. He took on the massive project. However, "when we were working together," Perkins recounted, "I suddenly saw that it was often almost literally autobiographical—that these people in it were his people. I am sure my face took on a look of alarm, and Tom saw it and said, 'But Mr. Perkins, you don't understand. I think these people are *great* people and that they should be told about.'"

The novel contains over 200 characters. There are two incredible sections in which the town of Asheville/Altamont is revealed. In the first, W.O. the wanderer comes back after one of his transcontinental debauches and takes a trolley around town and learns who has been born and who has died. In the second, it is Eugene and his friend who walk around town. Those sections were joined in "O Lost." It was Perkins who separated them. The effect is such that by the time one gets to the second trip through Altamont, the city is illuminated to a degree that very few American novels, save perhaps Faulkner's, have ever accomplished. The café scenes possess the beauty and the undertones of Edward Hopper's best works. The dialogue achieves the depth of feeling and momentum worthy of a great playwright. Altamont comes vividly to life.

Living in New York, Wolfe wore out the sidewalks walking, often deep into the night. He wrote, as always, prolifically. Perkins told the story of how, at two or three in the morning, a fellow New Yorker heard a commotion outside. She looked out the window to find the towering Mr. Wolfe, dressed in a black overcoat and chanting: "I wrote ten thousand words today—I wrote ten thousand words today."[17]

The next book about the Gants was called *Of Time and the River*, and Perkins was again full of forebodings when he saw the dedication, to himself, "in most extravagant terms." Wolfe broke with Perkins soon after that. Critics had made the accusation that without Perkins' guiding hand, Wolfe would be nothing. Perkins forgave Wolfe for leaving him, for he felt that the writer believed he needed the chance to prove this wrong. When he moved to another publisher, Eugene Gant became, in later books, George Webber. But he was always Wolfe. "He had one book to write," Perkins said, "about a vast, sprawling, turbulent land—America—as perceived by Eugene Gant."[18]

Wolfe made enduring impressions on many writers: among them, William Faulkner, who rated him the most significant living novelist. "We all fail," Faulkner stated, "but Wolfe made the best failure because he tried the hardest to say the most."[19] It is said that F. Scott Fitzgerald, whose wife Zelda was undergoing treatment at a sanitarium in Asheville (where she died at the age of 48 in a tragic fire), donated the first Wolfe novels to the Pack Library, which had been operating under a ban on carrying any works by its not-so-favorite son. He reportedly threw the books down on the counter and insisted they be catalogued.

Wolfe almost went back to Asheville in 1936, but due to a misunderstanding with his brother, he never got off the train. He finally made his return in 1937, and told the reporter for the *Asheville Citizen* that he hoped to be able to write another book that would please Asheville more. He never had that chance. In 1939, on a marathon tour of 11 of the National Parks of the western United States, he fell ill with a frightening brain ailment. He was taken back to Baltimore to be operated on. A doctor named Dandy opened him up, took one look and sewed him back up again. Thomas Wolfe had tuberculosis of the brain. Dandy theorized that he'd had TB at some point in his youth and had beaten it, but that his lungs had somehow enveloped the tubercles that were released to his brain decades later. It is seems somehow fitting that one of his pet words in *Look Homeward, Angel* was "encysted," for there is probably no better descriptive term for how those tubercles had been preserved. "Each day we pass the spot where some day we must die," Wolfe wrote halfway through the book. In the pages of *Look Homeward, Angel*, with its looming presence of tuberculosis, and all his talk of encysting, we are, in a sense, given a premonition of Thomas Wolfe's end every few pages.

In his introduction, Maxwell Perkins quoted a passage from *War and Peace* that Wolfe loved: "Prince Andrei looked up at the stars and sighed; everything was so different from what he thought it was going to be." This was a theme for the young Thomas Wolfe, who came to earth trailing clouds of glory, who retained them in his mind but was batted back and forth between Pentland and Gant, a perpetual vagabond. The line about Prince Andrei would seem a fitting epitaph for Wolfe were it not for the success he achieved in his books. At the end of *Look Homeward, Angel*, Eugene Gant meets his brother Ben again, temporarily resurrected, leaning against the porch of his father's shop on the Square and smoking as usual. What happens next is that the marble angels outside W.O.'s shop come alive. What Wolfe achieved in his best writing is no less of a feat. ☙

"The angels…were frozen in hard marble silence, and at a distance life awoke…Yet, as he stood for the last time by the angels of his father's porch, it seemed as if the Square were already far and lost; or, I should say, he was like a man who stands upon a hill above the town he has left, yet does not say 'The town is near,' but turns his eyes upon the distant soaring ranges."

— Thomas Wolfe,
Look Homeward, Angel, 1929

W.O's angel actually made it further out of Asheville than Thomas Wolfe did in death. **The angel** is in a cemetery in Hendersonville, North Carolina. Wolfe was buried in Riverside Cemetery, Asheville. — Hendersonville, North Carolina

Thomas Wolfe
Asheville, North Carolina ❖ 133

At peace with the idea: the residents of Sauk Centre were once outraged at being used as the model for *Main Street*. But this piece of **gentle water tank boosterism** suggests that public opinion has evolved. — Sauke Centre, Minnesota

Main Streets:
Gopher Prairie, Minnesota
to Winesberg, Ohio

Sinclair Lewis • Sherwood Anderson

SINCLAIR LEWIS (1885-1951)

*F*EBRUARY 7, 1885 DAWNED bitter cold in Sauk Centre, Minnesota (population 2,800). Ice glittered on the town's 30 lakes. The wagon ruts down the mud of Main Street were frozen as solid as the iron wheels that had made them. The Great Northern locomotive steam hung over the rails, too frigid to billow. On that day, a baby named Harry Sinclair Lewis was born. It had only been 24 years since the first white child was born in Sauk Centre, a former Indian territory. Harry Sinclair Lewis's parents did not take his convulsive sobbing seriously. Infants find conditions to be unfamiliar and harsh, but they adjust, grow into little children, and naturally find their way in the world. Little did they know that young Harry would continue to find life to be such a trial, that he would eventually make them all famous—or how little they would like that fame.

His father was one of the two doctors in town: the stiff and stern one, the one by whom you could set your clock. He left his home promptly at 7 am to walk down Main Street to his office. He would leave the office at 11:30 on the dot to go home for lunch and change his hat—always the same hats every day, always the same peg for each one. Harry Lewis's mother died when he was six. Dr. Lewis remarried a little over a year later, to a woman in whose family home he had roomed when attending medical school in Chicago. In all, there were three Lewis boys: Fred was nine years older than Harry, Claude seven years older. Fred has been described by Lewis's biographer, Mark Schorer, as a "plodder, without aspirations or abilities."[1] Claude, however, was everything his father could want him to be: handsome, sporting, popular, and, in time, a doctor.

Harry was another matter. The redheaded boy showed no talent for sports and was ineffectual in the manly pursuits of hunting and fishing. He proved to be a bungler in the serious business of making friends as well. He was full of imagination and energy and established several clubs that soon decided they would not have him as their member. His demands were too great and his opinions too forceful. He filled up the gaps in his social life by tagging after his adored brother Claude, who in turn made his gullible younger sibling the butt of many practical jokes. In his 13th year, moved by accounts of the Spanish American War, Harry decided that the U.S. Army needed his help smashing the enemy. So he went to the station to wait for a connecting train. His father found him up there, 50 cents in his pocket to get him to the war. The local paper wrote up his exploit. He became known around town as "Doodle," as in Yankee Doodle. Notoriety

The house at first glance from Carol was: "A square, smug brown house, rather damp. A narrow concrete walk up to it. Sickly yellow leaves in a windrow with dried wings of box-elder seeds and snags of wool from the cottonwoods. A screened porch with pillars of thin painted pine surmounted by scrolls and brackets and bumps of jigsawed wood. No shrubbery to shut off the public gaze."

— Sinclair Lewis
Main Street, 1920

The house where Sinclair Lewis grew up. It bears a striking resemblance to "Doc" Will Kennicott's house.
— Sauk Centre, Minnesota

was the last thing he desired at that point, though. Severe acne had disfigured his face. It's no wonder he craved a change of scenery, someplace distant and dangerous.

While Lewis had many strikes against him in a uniform society, from an unfortunate physical appearance to poor social skills, he was not entirely luckless. He had a strong and loving advocate in his stepmother, whom he designated as "psychically" his real mother. He embraced religion, attending services and Sunday school at the Congregational Church, and also making the rounds of the other churches in town as well. He joined the Young People's Society of Christian Endeavor. He read avidly. He used his knowledge and argumentativeness as a key member of the debate club. From his mother, his church and his reading, Lewis seems to have found enough encouragement to believe that if he only tried hard, prayed devoutly, and loved

passionately, he would find the keys to friendship, success and female companionship.

He escaped the town that smelled of wheat and dust but he could not escape from his own skin, the surface of which the acne ravaged. Lewis headed first to a preparatory school in Ohio, where he was nicknamed "Minnie." Back in those desperately lonely days, this poignant entry appears in his diary: "The other night I had a dream in which I was on the depot platform in S.C. [Sauk Centre] shaking hands with everyone." He was not to get that kind of reception when he returned, nor when he departed for Yale. At Yale, he continued to struggle to make friends. People make cameo appearances in his diaries and then vanish.

In college he initiated a pattern of restlessness that would continue his entire life. As a summer job he signed on to a

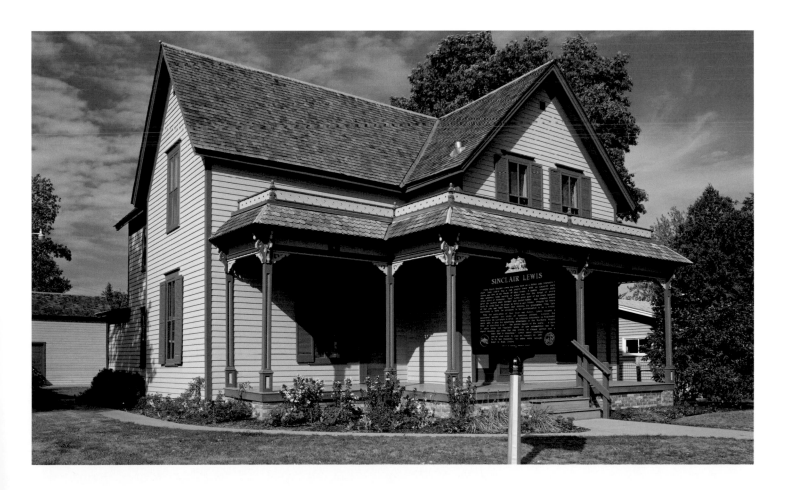

Sinclair Lewis
Sauk Centre, Minnesota ❖ 137

cattle boat in Portland, Maine, bound for Liverpool, England. The passage was filthy, more arduous journey than high seas adventure, but he did distinguish himself, perhaps for the first time, as a storyteller. He and two like-minded sailors formed the "Liars' Club," telling each other yarns to pass the time. In his tales, apparently, Lewis showed a talent for plots.

After graduating from Yale, he got work as furnace tender and odd-job man at an art colony in Carmel, California, where he met Jack London and subsisted mainly on the free and plentiful fresh abalone. He was not the type to settle down in an art colony, though, being more suited to disturbance than communal harmony. But the colony did pay dividends. He sold 14 plots for $70 to London, a writer who, at that point, was perennially hard up for story ideas. Among them were titles like "The Dress Suit Pugilist," "The Doll-House Suffragette" and, tellingly, "The Man Who Could Not Make Enemies." London fashioned another, called "The Abysmal Brute," into a novel that was published in 1913. But when Lewis sent a final batch, he had a hard time collecting. He sent a collection letter with an audacious but respectful tone. London replied, scorning the plots.

Those post-Yale years put the finishing touches on a hard shell Lewis was growing to shield himself from discouragement. With his finances pitifully low, Lewis asked his father for a loan, with interest. He received a chilly reply stating that: "I am not going to put myself short to make you a loan for I want a lot of it for fun this fall and my many years of hard work entitles [sic] me to that."[2] Lewis's mother told him to stop being an idler and get a steady job. Lewis sent a haughty letter in response. "Your letter," he wrote, "is one of the most highly inadvisable which I, a businessman, accustomed to read many inadvisable letters from unsuccessful writers, have had the misfortune of reading."[3] Clearly terribly insulted, he went on in this vein for three more paragraphs before formally signing his name as "Sinclair Lewis."

Until the end of his career, Sinclair Lewis was always fond of repeating that: "The art of writing is the art of applying the seat of your pants to the seat of your chair."[4] He persisted in New York City, honing a gift for imitating other people, finishing a manuscript named *Our Mr. Wrenn* and working his way into the publishing community. He got a job in the publicity department at Frederick A. Stokes, Co., Publishers. Edna Ferber, the author of *Showboat* and *Giant*, was in the Stokes stable of writers. She rendered a good portrait of him in those days when Lewis began to get his feet under him:

> He was a gangling, red-headed popeyed fellow; shambling, untidy, uproariously funny. Together we would go gesticulating and jabbering along the New York streets….He and I had built up two characters which we always assumed when together. Red was Gus, the janitor of a mythical office building, and I was Tillie, the scrubwoman. [5]

Between 1912 and 1914 he finally met with success. In 1912 he met a lovely woman named Grace Livingston Hegger, who worked for *Vogue* and lived with her British mother. He couldn't believe that such a dazzling and polished creature could be interested in a country bumpkin such as himself. But, gloriously, she was. No matter that "her most noticeable habit, which everyone observed, was her habit of affecting an indistinct British accent that seemed to come and go, depending on the occasion."[6] In his adoring state, he was quite willing to overlook this. Then, in 1913, his manuscript was accepted by Harper and Brothers. In 1914, the year *Our Mr. Wrenn* was published, he and Grace were married.

Take Me Back to the Prairie

Rattling around in the back of Lewis's mind for a while had been an idea he called "The Village Virus." It had to do with the conformist way people behave in a town about the size of, say, Sauk Centre. But he had found no way to make it into a book until he took Grace to visit his hometown. The couple stayed with his parents in his childhood home. And as he saw Sauk Centre through Grace's eyes, the outlines of Gopher Prairie—the quintessential small town he made so famous in *Main Street*—began to form.

According to Grace's memoir, it was Lewis's father, never a champion of his son's writing ambitions, who unwittingly

provided Lewis with a breakthrough. When Grace felt sick one morning, Lewis asked that a breakfast tray be brought up to her room. Upon hearing of this, Doctor Lewis griped about "New York fol-de-rols," and declared that, "If Grace is well enough to eat breakfast, she is well enough to come down and get it."[7] Grace later wrote that her husband was struck by "his father's overbearing rudeness, his senseless laying down of the law, and the docile acceptance of his stepmother."[8]

Rather than seething with resentment, Lewis was exultant. He must have already seen that he couldn't write of the Village Virus from his own perspective. But through the eyes of Grace? Now that had possibilities. He squired Grace around town: to the hardware store, to the social clubs, to the drugstore, up and down Main Street. It is easy to imagine him, the decorative and cooperative Grace on his arm, egging on the grocer or the milliner or an old lady from the Ladies' Embroidery Club to new heights of prairie town eloquence, all of which he scribbled down in a notebook after the encounter. His parents may have been somewhat surprised to see him, with his adopted New Yorker airs, seemingly so satisfied to show Grace his home-town: the four-block business district with the three-story Parker House Hotel, the Stone Arch Bridge on the railroad line where he used to sneak smokes and onto which he had carved his initials, the nearby lake.

Main Street took a long time to gestate. The earliest written evidence dates back to 1918. In that early version, the character based on Grace is known as "Fern." She later became "Carol Milford." Carol is the daughter of a judge who let the children read anything they wanted, from the *Encyclopedia Britannica* to Balzac. There are a few girls prettier than Carol in her class at Blodgett College but none more eager. Yet, for all her prettiness and verve, Carol doesn't find a man to marry. She becomes a librarian in St. Paul, and grows fearful of turning into an old maid. One evening, at a dinner party to which she has been invited as the token intellectual, she meets Dr. Will Kennicott. The gruff Doc Kennicott has never seen a town that had such "up-and-coming people" as his own Gopher Prairie, even though he's been to many large towns and once spent practi-cally a week in New York City. Not only that, but his town is

"darn pretty," with lakes nearby, trees, "seven miles of cement walks and building more every day!"[9] Carol sees in the Doc a steady and good man. Ever the improver, she sees in Gopher Prairie the raw materials to make a Midwest village into a town of beauty and culture.

That early typescript of *Main Street* began with Carol arriving in Gopher Prairie by train. The published version of the novel begins instead by introducing Carol at Blodgett College. The train journey to Gopher Prairie follows, post honeymoon. For the agricultural towns strung across the prairie, the arrival of the train was the daily drama, bringing the visitor from the outside world. For Carol, it seems more like a ferry into exile. She has been expecting something special of the town that her husband had so extolled. But:

> The huddled low wooden houses broke the plains scarcely more than would a hazel thicket. The fields swept up to it, past it. It was unprotected and unprotecting; there was no dignity in it and no hope of greatness. Only the tall red grain elevator and a few tinny church steeples rose from the mass. It was a frontier camp. It was not a place to live in, not possibly, not conceivably.[10]

At the station, a bunch of jolly, wisecracking, salt-of-the-earth folks await. There's Sam Clark who owns the hardware store, his missus, Dave Dyer the druggist, Harry and Juanita Haydock. They are all eager to welcome back that "poor fish of a bum medic," Doc Kennicott—the kind of platform welcome Lewis had once yearned for.

Most of the people Carol meets in Gopher Prairie are self-satisfied, intellectually uncurious folks, tireless boosters of *their* town in comparison to all the dusty wheat towns that come before it and after it in the flatness of the prairie. As Lewis writes at the opening of the novel, the Main Street in Gopher Prairie is "the continuation of Main Streets everywhere…the climax of civilization. That this Ford car might stand in front of the Bon Ton Store, Hannibal invaded Rome and Erasmus wrote in Oxford cloisters."[11]

Carol fights the smothering sameness of Main Street with all of the pluck she possesses, and an unmistakable air of

condescension. But she is no match for the forces of the whole town, including her fond but uncomprehending husband. She does find a few souls that fight against the "Village Virus," among them the handsome, intellectual Erik Valborg, with whom she believes she has fallen in love. Eventually, Carol leaves Gopher Prairie, escaping to Washington, D.C. but without making a final break from Doc Kennicott. She finds a job and alone she lives the life of culture she had craved. But she realizes that in D.C. nobody cares about her the way they did in small town Minnesota. She sees Erik Valborg in a bit role in a movie. He has changed his name to Erik Valour. Her husband pays a visit and good-naturedly bumbles around with her, wide-eyed in the big city. In his stolid way, he asks her to return.

At last, Carol comes back to Gopher Prairie and to the square, smug house that she had fled. She is more accepting. *Main Street* ends with a dissonant grace note. Lying in bed, reunited with her husband, she vows that she has "won in this…I do not admit that Main Street is as beautiful as it should be! I do not admit that Gopher Prairie is greater or more generous than Europe!….I may not have fought the good fight, but I have kept the faith." Doc Kennicott, rock solid as ever, voices affirmation and then, as if routinely changing the channel, begins to muse about how it's getting to be time to put up the storm windows. His parting phrase, and the conclusion of the novel, is: "Say, did you notice whether the girl put that screwdriver back?"[12]

From late 1919 until early 1920, "*Main Street* was with us day and night," Grace Lewis recalled. Sinclair Lewis, who had leased an office in which to do his work (he liked to wear a green eyeshade like a reporter when he wrote), "brought home a dozen pages at a time for me to read, never taking his eyes off me as I went through them, and demanding to know what in the pages had caused each change in my expression as I read, what had brought a smile or a laugh, what had made me cry."[13] Lewis leaned on his wife's taste to help him furnish the rooms in Doc and Carol Kennicott's house, to help him dress Carol, to give the benefit of her feminine touch. At the same time, Lewis was patterning the character of Carol on Grace, with her pretensions and airs of superiority. In the initial drafts, biographer James M. Hutchisson claims, he really pilloried Grace. But

as time went by he softened the portrait.[14] Still, Grace herself must have had a relatively thick hide.

In 1919, as the idea for the book grew inside Lewis, Alfred Harcourt quit Henry Holt and Company over a difference of opinion. He considered starting his own company. He was also pursued by other firms. He wrote to Lewis of his dilemma. According to Harcourt's memoirs, Lewis sent him a telegram telling him to be at Grand Central Station at a certain day and time. Harcourt did as instructed and Lewis appeared on the platform to say:

> Hell, Alf, I got your letter….I wrote you a long night letter, and then I said to myself, "This is important."
>
> I drove 125 miles to Minneapolis, put my car in a garage, bought a railroad ticket and berth, and sent you a telegram….What I came on to say is, "Don't be such a damn fool as ever again to go to work for somebody else. Start your own business."
>
> I'm going to write important books. You can publish these.[15]

Harcourt took Lewis seriously. And by 1920, he would be very glad he had. Between its release date in late October, and Christmas, the firm sold 47,000 copies of *Main Street*. 40,000 of those were sold in New York City,[16] a refuge for escapees from Main Streets everywhere.

Lewis was denounced as a villain by the insulted residents of towns like Gopher Prairie and hailed by others as a keen observer of the way things were. The controversy did not hurt sales. By October 1921, nearly 300,000 copies had been sold. Lewis had done his research so well that it was hard to dispute the accuracy of his descriptions. It was, however, his view on the shallowness of the small town that caused debate. Perhaps the most famous—and most delayed—reaction was from Helen Hooven Santmyer of Xenia, Ohio, whose rebuttal to Lewis's vision, titled *…And Ladies of the Club*, became a Book of the Month Club selection in 1984. As a young woman, she had strenuously disagreed with Lewis's portrayal. But it took her a while to write her rejoinder. She was 89 years old and living in a nursing home by the time her 1,176-page response about a women's literature club in the fictional town of Waynesboro,

Ohio came out. ...*And Ladies of the Club* sold 2.5 million copies and stirred up the Lewis debate all over again.

Two Years From Now
We'll Have Them Talking of Babbittry

One of the criticisms leveled at *Main Street* was that the characters were cardboard cutouts, propped up to illustrate various foibles of the small town. This was said even of Carol Kennicott, Lewis's most rounded female character. But at least one critic recognized Lewis's talent. That was H.L. Mencken, of Baltimore, who applauded Main Street from the pages of his literary journal, *The Smart Set*. Mencken spent a great deal of his time poking holes in what he saw as the complacency of America. Perhaps his most famous quote, still trotted out often today, was: "No one in this world, so far as I know ... has ever lost money by underestimating the intelligence of the great masses of the plain people."[17] His favorite target was the "Booboisie"—a vast middle class who got their sustenance not from intellectual discourse but from amiable dialogues about the weather, the superiority of America, or breathless discussions about the latest of the "abounding quackeries" that American salesman, ad men and hucksters churned out. While Lewis had initially been determined to respond to his critics by filling his next book with more rounded characters, it seems that Mencken's influence prevailed. Lewis's next novel, *Babbitt*, was the story of George F. Babbitt, realtor in Zenith, a full-fledged member of the booboisie, with about as much dimensionality as a "For Sale" sign.

"Two years from now we'll have them talking of Babbittry,"[18] Lewis wrote triumphantly to Alfred Harcourt, some time after he finally settled on a name. That term "Babbitt," still in the dictionary and in use today (though the number of people who recognize it shrinks by the day) was nearly a year in the making, after he first considered naming his realtor "G.T. Pumphrey." If Main Street was the "climax of civilization" for residents of places like Gopher Prairie, the city of Zenith was something even grander: a dozen or so Main Streets paved, with miles of concrete sidewalks, and more boosters and self-improvement clubs than Carol Kennicott could have shaken a stick at. "The towers of Zenith," *Babbitt* begins, "aspired above the morning mist; austere towers of steel and cement and limestone, steady as cliffs and delicate as silver rods. They were neither citadels nor churches, but frankly and beautifully office-buildings."[19] In the city of 361,000 citizens, a thousand dramas played out every minute. Men toiling in immense factories produced everything from A to Z.

In Zenith every vice was represented. There were rich bankers, sensational preachers, captains of industry, a flourishing middle class, and many who lived lives of quiet desperation. Perhaps the city's most honored citizen was T. Cholmondely Frink, known as "Chum," the ex-cigar store clerk who'd made it good on a national scale as an unabashed composer of boosterish doggerel he liked to call "poemulations." In Zenith, it was possible to tell the good from the bad: for one thing, the virtuous joined the Good Citizen's League. For another, they found Chum Frink's poemulations to be magnificently droll. The degenerates were cold fish, and possible socialists, who wouldn't get Chum Frink's brand of humor if they were knocked over the head with it. George F. Babbitt, resident of Floral Heights, Zenith, was one of those who thought that Chum Frink was the Midwest's Longfellow and Mark Twain all rolled into one, and was pleased to know the great man.

There was no more desirable a middle-income district in which to live in Zenith than Floral Heights, situated on a gentle rise with views of the city center. And there, on the sleeping porch of a Dutch Colonial house shaded by elms, George F. Babbitt awakes with a vague disappointment at the beginning of *Babbitt*. He'd been having a dream in which he was chasing a fairy girl. Blearily, he goes to the bathroom and shaves. He dresses in a "completely undistinguished" suit and sticks his Booster's Club pin in his lapel. As Edith Wharton put it, Babbitt is "in and of Zenith up to his chin and over."[20]

In order to access babbittry, Lewis returned to his method of immersion. He stayed and lived in a number of cities in the Midwest, essentially going "undercover" in order to get regular people to talk to him freely. It is said that Cincinnati is perhaps the closest model for what became Zenith.[21] But basically, Zenith took on a separate existence in Lewis's head, and in the

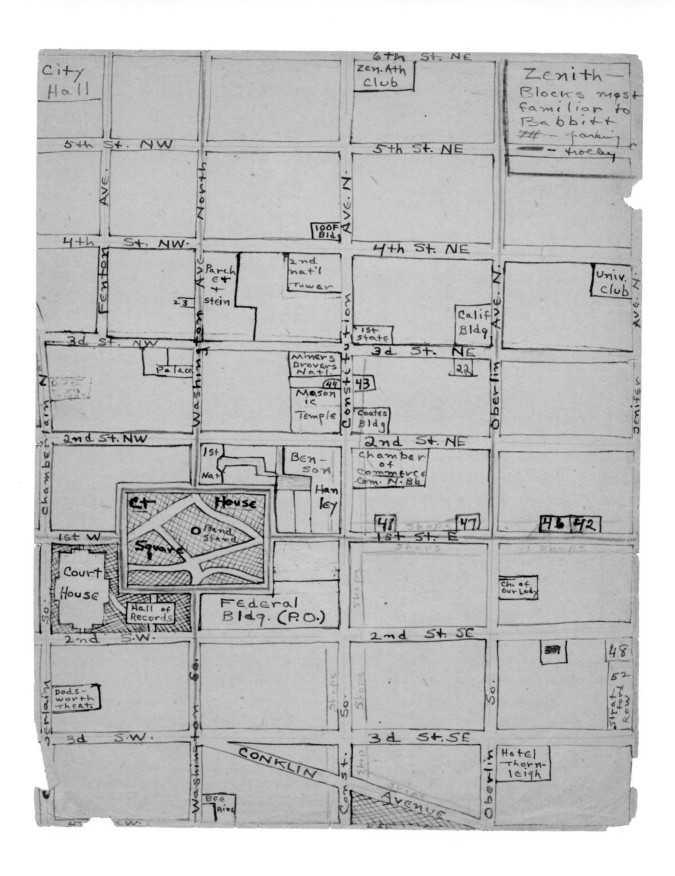

copious notes and maps that he made in his notebooks. Lewis typed out a history of Zenith that extended all the way back to the first explorer who came up Zenith's Chaloosa River in 1740. He chronicled how Zenith was settled in 1792 as the town of Covenant, and how its founding fathers changed its name to Zenith as being "better for business, i.e. for righteousness."[22] He drew up annotated lists of "Businesses Located on the Ground Floors of Office Buildings," of "Department Stores," of "Babbitt's Competitors" and produced biographies of all the principal characters. He also kept notes on "Locutions"—a catalog of figures of speech that Zenith residents might use. The dialogue in Lewis's novels has a slangy radiance, the "secret handshake" of Good Fellows everywhere. In order to get the kind of information about realtors that he needed, Alfred Harcourt said, Lewis put "as much study into the subject matter as a graduate student preparing a PhD thesis,"[23] and spent much time in their presence.

The protagonist, George F. Babbitt, enjoys driving his car from Floral Heights to downtown each day. He admires his world. The realty office of his father-in-law, where Babbitt works, is in the Reeves Building, "as fireproof as a rock and as efficient as a typewriter."[24] The bottom floor of the building, with its shop windows and stone floor is the "Main Street" for the "rustics" who work there and greet Babbitt every morning.[25] But powerful car, bootleg liquor, and the respect of the doormen and shoeshine men are not enough to prevent Babbitt from giving in to a mid life crisis. He escapes on a camping trip to Maine and considers becoming a hunting guide. He returns to Zenith instead, and later has a dalliance with a lonely woman. Roused by the radical Seneca Doane, a former college classmate of his, Babbitt briefly shuns the Good Citizens League—until they shun him in return. In the end of the novel he returns with relief to their good graces and pins his thwarted aspirations on the next generation of Babbitts.

One of 17 detailed maps Sinclair Lewis drew of **Zenith** and its environs. Others include the surrounding towns, Babbitt's office, his neighborhood, his house in Floral Heights. "Here is a cosmos, good and bad," he wrote of Zenith, with "some reason to believe in its inherent greatness."

Babbitt was another smash hit, selling 141,000 copies in its first year. One could find even less character development than in *Main Street*. In a review, Mencken crowed that the book contained "no plot whatever, and very little of the hocus-pocus commonly called development of character."[26] People were clearly not reading it for that. They picked up the book in order to see what Lewis had to say about the American businessman, about life in a medium-sized city in the Midwest, about America. And Lewis delivered: a work of verisimilitude that had been sharpened into rich satire.

Elmer Gantry and Dodsworth

Sinclair Lewis and Grace's marriage became a struggle. She didn't like his nomadic nature or his increased drinking. He resented the pretensions that he had once found charming and which had served him so well as material for his female characters. As his marriage to Grace fell to pieces, Lewis took a plunge downward, almost as if with a sense of relief, into the life of Elmer "Hell Cat" Gantry, former Terwillinger College bad boy and football star turned into two-fisted preacher man. When Lewis decided to commence research on his "preacher novel," the Harcourt Company issued a press release that he was going to Kansas City to do so. This announcement, rather than moving the religious set to clam up, as one might expect, actually caused churches to throw their doors open. In the faith business, a little publicity is usually a good thing. Lewis had regular luncheons at the Ambassador Hotel, jokingly called "Sinclair Lewis' Sunday School Class"[27] where he debated religious issues. Much like a method actor getting into character, Lewis actually preached some sermons in the local churches under an assumed name. He allegedly even went door-to-door as an ersatz bible salesman.

The preacher Elmer Gantry starts out humbly with a small congregation in the town of Banjo Crossing (population: 900), 120 miles from Zenith. His next church is in Rudd Center, with a population of 4,100 souls, then Vulcan, then Sparta (pop. 129,000). He arrives in Zenith in 1920, the same year that George F. Babbitt experiences his midlife crisis. His reception in the Zenith church basement is just like his reception in Banjo

Crossing: the same "rugged, hard-handed brothers, the same ample sisters renowned for making doughnuts, the same brisk little men given to giggling and pious jests."[28] He sets about cleaning up the vice in Zenith by following his nose, which seems unerringly able to sniff it out. *Elmer Gantry* is a 427-page romp through the life of a preacher who sins in private and rails against sin in the pulpit. The book tumbled out of Lewis in 11 months. He dedicated it to H.L. Mencken "with profound admiration."

After *Elmer Gantry*, Lewis's own personal problems caught up with him. Perhaps a bit of that old time religion had crept into him. Perhaps he felt some regret over the unflattering way he had portrayed men of God, some of whom had devoted time and effort to helping him. In 1927, recently divorced from Grace, he left the United States behind and tramped through Europe. He carried with him only a shaving kit, a popular novel, a Bible, and a copy of Thomas à Kempis's *The Imitation of Christ*—a guide to devotion and self-renunciation published around 1415. Then, something happened to pull him out of the ascetic mood. On the journey he met Dorothy Thompson, an American reporter in Europe, who later became the first American journalist to be expelled from Germany after the rise of Hitler. Lewis pursued her until she agreed to marry him in 1928. She figured in *Dodsworth*, published in 1929.

Lewis was obviously affected by the name Dodsworth. The maps of Zenith from the *Babbitt* days feature a Dodsworth Avenue and a Dodsworth Theater. In the eponymous novel, Sam Dodsworth is founder of the Revelation Motor Car Company of Zenith. He is "none of those things which most Europeans and many Americans expect in a leader of American industry… not a Babbitt, not a Rotarian, not an Elk, not a deacon."[29] His wife, Fran, sounds much like Grace: brittle and pretentious, with "a high art of deflating him, of enfeebling him, with one quick, innocent-sounding phrase."[30] In the book, Sam and Fran go on a grand tour of Europe and Fran is seduced by a German nobleman with a charming accent. Sam eventually falls clumsily into the arms of Edith Cortright, an American expatriate living in Italy. Edith—the Dorothy Thompson character—is the spitting image of Dorothy Thompson except for the fact that she isn't a journalist and, in the portrayal by Lewis, seems unlikely to haul off and punch a woman in the jaw for making pro-Nazi remarks, as Thompson is alleged to have done.

Businesses and institutions capitalizing on *Main Street*. — Sauk Centre, Minnesota

Dodsworth was Lewis's farewell to Zenith, a city which, for all of his satirization, Lewis seems to have loved. Sure, he had spent much of his career railing against the insularity of the small town and small- to medium-size city. But he was arguably not without reverence for the spell America can cast. Lewis once said that he would never get the "Sauk-centricities" out of his system. Neither can Dodsworth get Zenith out of his. When he comes home after the first leg of his trip abroad, it is the "dear familiarities" that speak to him:

> Wide streets, clashing traffic, brick garages, the insolent splendor of skyscrapers and, toward the country, miles and miles of white and green little houses where the sort of men he understood played games he understood, poker and bridge, and listened to the radio to the sort of humor and music he understood.[31]

Final Return to Sauk Centre

The 1920's witnessed Sinclair Lewis's own zenith of productivity and influence. Again and again, he came up with readable plots that revolved around the Sauk-centricities and Zenithisms of the heartland. Lewis had what all gifted satiric novelists possess:

an ability to see the tendencies in a particular people and to map how their motivations manifest themselves in a particular age, in fiction that is readable and fresh.

Perhaps Lewis's best novels have stood the test of time because the America he described so well has not changed so much. The years following the destruction of the World Trade Center unleashed a surge of patriotism worn on the sleeve that is evident in the good citizens of Zenith and Gopher Prairie. The recent real estate boom, which would have made Babbitt proud, and rich, was fueled by a Zenithian optimism. If one believes that the building of mini-mansions on too-small lots is something new, one need look no further than *Dodsworth* for evidence to the contrary. Still, much *has* changed. The Internet and air travel have reduced the isolation and insularity of small towns. A Sinclair Lewis coming of age now could take a long-distance learning course at Yale from the sanctity of his bedroom. Even the newspaper—stolid news source, editorial opinionmaker and trumpet of trade—is being battered from all sides. In the last three decades, the American consumer has become more sophisticated, less in thrall to Europe, a buyer of cheap goods and luxury items from the world over. He may have

more ways to stay informed but he reads fewer books. According to a recent IPSOS/Gallup poll, one in four Americans has not read a single book in the previous year.

Sauk Centre has not added so many people since Lewis's time. The population now is 4,111—a gain of just of 1,300 inhabitants. Sinclair Lewis would find a choice of at least 10 churches to attend, including a Kingdom Hall of the Jehovah's Witnesses. He would still find the Parker House Hotel on Main Street, where he briefly worked as a desk clerk and which he immortalized as the Minniemashie House in *Main Street*. Sauk Centre is luckier than many small towns in that its Main Street is a tourist draw. It is a much-bemoaned fact that Main Streets are being gutted, their shops and theaters boarded up and closed. It is hard for new businesses to thrive in small towns. Up until recently, it has been cheap and easy to clamber into the Sport Utility Vehicle, pickup truck or passenger car and take the highway to the nearby shopping center with ample parking, big box stores, and a dismaying lack of anything local except for the employees. There is still no Starbucks within 20 miles of Sauk Centre but the town does have a Wal Mart.

Although Sinclair Lewis died far afield in Italy, his ashes were returned to Sauk Centre and, on as forbidding a day as the one on which he was born, they were buried there. Eventually, the town warmed to him. Now, Sauk Centre proclaims itself "The Original Main Street." It is tempting to imagine what Lewis would say about that. It is even more compelling to wonder what he, once such a keen observer of the American scene, would say about America today. Were he around to satirize our foibles and excesses, would he be as eagerly read? Or would his exposés, as part of a massive flood of media offered up to an increasingly choosy audience, be faced with a much smaller readership, and with a much larger swath of the indifference he railed against? ↝

The Palmer House Hotel, where Sinclair Lewis once worked as a night clerk. He called it the "Minniemashie House" in *Main Street*. Some maintain the Palmer House Hotel is haunted—perhaps even by Lewis's ghost. — Sauk Centre, Minnesota

Sinclair Lewis

SHERWOOD ANDERSON (1876-1941)

SHERWOOD ANDERSON ATTEMPTED to write an auto-biography three times. All three attempts were published but he was never satisfied with the result. He was a teller of stories, a stretcher of facts and re-assembler of events, just as his father had been. "My fancy is a wall between myself and Truth," he said in the introduction to his second autobiography, *Tar: A Midwest Childhood*. "There is a world of the fancy into which I constantly plunge and out of which I seldom completely emerge."[1] He could not grow expansive until he wrote himself into at least a semi-fictional character. And that, of course, somewhat defeated the point of autobiography.

Thus it follows that, in his autobiographies and in his mind, his birthplace became a work of fancy as well. The family did not live in Camden, Ohio long enough for him to have any memories of it. And he avoided visiting there for his entire life, perhaps in order to preserve his conception of it as a "little white town in a valley with high hills on each side,"[2] reached by stagecoach from the nearest railroad town. A town without electricity, or automobiles, where the villagers toiled in the fields during the day. "It was, in short, such a place as might have been found in Judea in Old Testament days,"[3] Anderson wrote. In the story "Godliness," in *Winesburg, Ohio*, the owner of a large farm wishes that God would hover over his field and talk to him as He talked to farmers in the Bible. In Anderson's memories, Camden was a place where God bent down close to earth.

If he could have been paid for telling stories, Sherwood Anderson's father might have been as wealthy as the town grocer. Though maybe, who knows, his fount of tales may have dried up if it were somehow attached to earning a living. He was a ne'er-do-well come up from the South who had "never got himself settled" (Anderson's own words) after the Civil War. As a result, for Anderson "life began with a procession of houses."[4] The family "changed towns as often as they changed houses, slipping them on and off as one slips on and off a night

dress."[5] Eventually, the family wound up in the town of Clyde, 18 miles south of Lake Erie. Clyde had once been Indian hunting grounds. But after the white settlers came, it eventually became a truck farming town, noted for its fine cabbages and several brands of kraut, including "Clyde's Pride."

The Andersons moved into a house on Spring Street, adjacent to the welling spring around which the first settlers of Clyde had built their houses. (The well was filled in in 1900 after a child drowned there.) The spring, it seems, had not watered the property the Andersons rented; in Sherwood's memory, the Anderson homes always seemed to be situated on a "grassless lot," while in the other yards around them there lived a veritable Old McDonald's farm where the "pigs grunted, the cocks crowed, the hens made soft clucking sounds, the horses neighed, the cows bawled." Sherwood Anderson loved farm animals. He spoke of them the way that one speaks to a child about them. But he loved horses most of all, and spoke of race horses as an expert does.

In town, Anderson played baseball, was informally adopted into the family of the local grocer, Thaddeus Hurd, fell in unrequited love with girls, and generally lived a full Midwest childhood. He was tagged with the name "Jobby" Anderson because of his willingness to do odd jobs to earn money. One of the ways he earned a little pocket change was by selling newspapers to the people who got off the trains to stretch their legs at the Clyde stop. He boasted of being able to sell more newspapers than anyone else. Clyde might have been a suffocatingly dull town, but for the fact that several railroads ran through it.

A name like Jobby suggests a real go-getter. But there was a streak of the dreamer in Anderson as well. In one memoir, he related how he had asked a friend what he had been like as a boy. The answer makes him sound very much like a young William Faulkner. "He told me that he remembered me only as a lazy fellow, sitting on the curb on the main street or before the

The train brought excitement to Clyde. And to depart on the train was to embark on "the adventure of life." Once the busy rail platform, this is now a **city park** and site of a plaque dedicated to Sherwood Anderson. — Clyde, Ohio

little frame hotel at evening, listening to the tales told by traveling men. Or I sat with my back against a barn wall listening to men talking within a barn or to women gossiping in the kitchen of a nearby house." Anderson asked how a boy named "Jobby" could have cut such a languid figure and the friend replied (in Anderson's words): "You were both a hustler and bone lazy."

Anderson discovered early that he had the ability to lose himself, as demonstrated in this passage from *Tar: A Midwestern Childhood*: "I would listen for a time to their talk and then their voices would seem to go far away. The things I was looking at would go far away too. Perhaps there would be a tree, not more than a hundred yards away, and it would just come out of the ground and float away like a thistle. It would get smaller and

smaller, away off there in the sky, and then suddenly—bang, it would be back where it belonged, in the ground, and I would begin hearing the voices of the men talking again."[6] The world of fancy into which he constantly plunged probably had its foundation in these early waking dreams.

A patriotic young man, he volunteered for the Spanish-American War but did not see combat. Upon his return, he and his fellow soldiers were greeted at the train station with marching bands, waving flags and the like—a scene that was played out throughout America. It was the only hero's welcome that he ever got from Clyde.

Anderson's way with people and gift for telling stories helped him as a salesman. In 1907 he started the Anderson

Manufacturing Company, guaranteed to preserve any roof with the "Perfect Roof Preserver" compound. "I talked rapidly," he recounted, "rushed through the streets to my office, slammed doors, gave orders to my subordinates in sharp tones. I was merely trying to enact the part of the pushing, bright, successful young business man." He later became the president of a paint company in Elyria. And then, around age 40, he walked into the office one day and called to his stenographer:

"My feet are cold and wet," I said. "I have been walking too long on the bed of a river." Saying these words I walked out of the door leaving her staring after me with frightened eyes. I walked eastward along a railroad track, toward the city of Cleveland. There were five or six dollars in my pocket.

He kept going and wound up living in a tenement in Chicago, from whose residents (he claimed forever afterward) he drew the inspiration for the characters in his greatest book.

Winesburg, Ohio and Clyde, Ohio

My Dear Mr. Frank,
I made last year a series of intensive studies of people of my hometown, Clyde, Ohio. In the book, I called the town Winesburg, Ohio. Some of the studies you may think rather raw, and there is a sad note running through them. One or two of them get pretty closely down to the ugly things of life.

The above letter was written to a magazine editor in New York three years before *Winesburg, Ohio* was published in 1919. The book itself contains 23 short, interrelated tales, each with a title, and a person as a subject. For instance there are "Paper Pills – *concerning* Dr. Reefy" and "The Untold Lie – *concerning* Ray Pearson." *Winesburg, Ohio* was a minor sensation; widely read and influential. But not in Clyde. "Clyde's Pride" was more than a brand of kraut; it was a small-town pride, injured by the unwelcome associations that came with a book that struck far too close to home.

Many of the major streets in Winesburg have the same names as streets in Clyde. There is a Wine Creek in Winesburg that meanders along the farms and then passes through the town at the Waterworks. There is a waterworks in Clyde as well, only in Clyde it's the Raccoon Creek that flows from the fields into the waterworks basin, then out the other side of it. The waterworks apparatus is now gone and only the pond remains, part of a quiet public park. The large basin with the inflowing and outflowing creek looks like the diagram of a stomach.

Many of the proper names of minor characters in Winesburg, Ohio, were similar to those actually living in Clyde. To cite some examples:[7]

Characters from Winesburg	Clyde
Banker White	There were 16 "Whites" in 1896, 6 in 1912
Skinner Leason	Frank "Skinner" Letson had a large house on Buckeye St. Made his fortune from Standard Oil
Turk Smallet	There were three Smallets in Clyde, a respectable family
Enoch Robinson	Dr. Robinson
Voight's Wagonshop	Vogt's Carriage Shop
Hearn's Grocery	Hurd's Grocery

As Anderson described it, Winesburg is a town of tree-lined streets, just like Clyde. Modern-day Clyde has "Grandmother Dunigan" to thank. She started planting maples along the old Seneca Indian trail in 1860, a trail that is now Maple Street. Her efforts were such a success that, somewhere along the line, the town fathers began offering tax rebates to those who planted trees, and the result is a green Clyde, its houses amply shaded.

Situated on the train routes and near the intersection of the old Seneca trail and Route 20, Clyde bustled. It was busy enough to become a center of commerce for the outlying areas, and solid masses of buildings, quintessential downtown blocks, grew up on both sides of Main Street just south of the railroad

Main Street — Clyde, Ohio

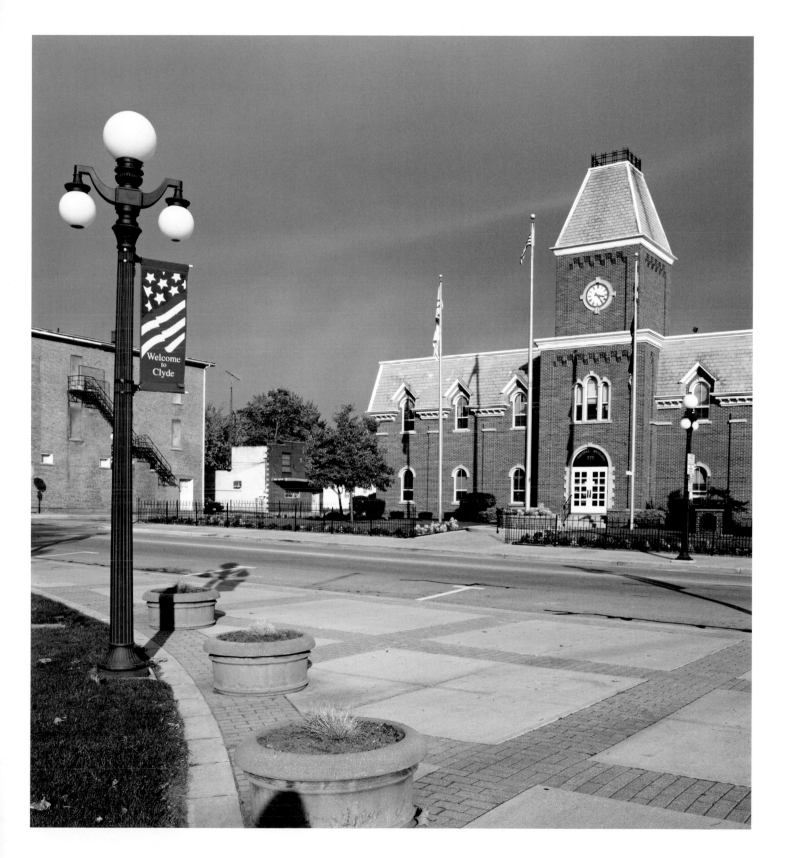

Sherwood Anderson

depot. In Winesburg, this block exists too. It houses the Willard Hotel, the offices of the *Winesburg Eagle* paper, doctor Reefy's office, Hearn's Grocery, Abner Groff's bakery, and Sinning's Hardware Store. The backs of these buildings let out into alleyways that are just as interesting in their less cultivated ways as the storefronts. Anderson loved the fecund nature of the back alleys of commerce, much as he loved vacant lots gone to weed and abandoned factories.

One of the characters with a tale in Winesburg is Elizabeth Willard. She and her son George sometimes look out at the alleyway from her room and a "picture of village life" presents itself to them. Abner Groff appears at the back door of his shop "with a stick or an empty milk bottle in his hand," to chase away the gray cat that belongs to Sylvester West, the druggist. In the alley where he fancies that no one can see him, Groff gets so mad that he flings "sticks, bits of broken glass, and even some of the tools of his trade" after the cat. After seeing this played out one too many times, Elizabeth Willard puts her head in her hands and weeps. It reminds her too much of her unhappy life.

Though much of *Winesburg, Ohio* takes place in broad daylight, what really seems to drive the stories are the events that happen in the messy "back alleyways" of the characters' minds. Elizabeth Willard is not the only unhappy one in Winesburg, Ohio. Many of the residents wrestle with some dark and secret passion.

A few words should be said about Anderson's theory of the "grotesque" because his term, if not in his exact interpretation of it, has become part of the vocabulary of American fiction. Many writers, including Flannery O'Connor and William Faulkner, have been said to be practitioners of it. "Grotesque" is derived from the word "grotto," or cave. On ancient cave paintings, some aspect of the human shapes was distorted, creating a deformity. A literary "grotesque" is such a character, recognizable as human and deserving of human sympathy and yet misshapen, somehow repellent. Anderson made his contribution to the American version of the grotesque with his short piece called "The Book of the Grotesque," at the beginning of *Winesburg, Ohio*.

In Anderson's definition, the grotesque is created by the "truths" by which a character decides to live his or her life. In

choosing these truths (such as "wealth," or "poverty," "thrift," or "abandon"), the character turns them into falsehoods. And the truths-become-falsehoods become the basis, and fascination, of the character. "The Book of the Grotesque" features an old writer who has a vision in which he fancies all the men and women he had ever known as a "procession" of grotesques.

Anderson's character Elizabeth Willard is pock-marked and listless. In her youth she was vibrant. The grotesque in her is that she once thought life was theatrical and so it turned out to be a dull affair. The one happy spot in her days is her bright son, George, a reporter at the *Eagle*. George is the "Sherwood Anderson" character of *Winesburg, Ohio*. He appears in several of the tales and is a friend to many, including the outcasts, in town. Elizabeth Willard's tale ends with George vowing to leave Winesburg. "I don't know what I shall do," he says. "I just want to go away and look at people and think."

The implications of tales like Elizabeth Willard's made Sherwood Anderson a persona non grata in Clyde, where the residents judged that he was a hater of small towns and a spiller of their secrets. But in this he was misunderstood. He loved the little towns of the Midwest. He once upbraided Sinclair

"Houses were like people. An empty house was like an empty man or woman. There were houses cheaply built, thrown together. Others were carefully built and carefully lived in, having careful loving attention."

— Sherwood Anderson
Tar: A Midwest Childhood, 1926

(*Left*) Bell tower, the **Presbyterian Church**. Through the little window, Reverend Hartman spied a woman in bed and was morally shaken. (*Right*) **Dilapidated house**. — Clyde, Ohio

Sherwood Anderson

Lewis for his harsh depiction of Main Street: "For after all, even in Gopher Prairie [Sinclair Lewis's version of Winesburg] or in Indianapolis, Indiana, boys go swimming in the creeks on summer afternoons, shadows play at evening on factory walls, old men dig angleworms and go fishing together, love comes to at least a few men and women, the baseball club comes from a neighboring town and Tom Robinson gets a home run. That's something."[8]

Sadly enough, though, Anderson suffered the kind of fate in Clyde that Lewis had warned of in *Main Street*: a small-town shunning. By local reports, not a single book by Anderson could be found in the local library until 1967. Part of the barrier to his acceptance is the fact that he wrote in a naturalistic way. And like the farm animals he loved, his characters were driven to procreate often, out in the countryside (though with measures of guilt and secrecy that the animals were lucky to lack). This was scandalous to decent, well-meaning folk. After his book came out, the wife of a friend, who had once sat at the dinner table next to him, confessed to him that, "I do not believe that, having been that close to you, I shall ever again feel clean."[9]

The fact that the street grid of Winesburg could be so neatly laid over the street grid of Clyde persuaded the townspeople to take anything negative in the book (and it did "get pretty closely down to the ugly things of life") as a slam, even though Anderson insisted that the characters themselves were based on his fancies of people he had known in the tenement in Chicago, not on the townsfolk of Clyde. According to his loyal but reputable childhood friend Thaddeus Hurd, there was nothing in any of the characters that resembled any real people who were living or had lived in the town. But few residents agreed, or took comfort in this. Perhaps few read the book to find out.

Anderson wrote one letter about visiting Clyde. It was posted in 1916. In it he said:

> How tremendously our American small town life has changed in twenty years. I went back to my home town in Ohio yesterday and spent three hours there. It is a pretty town lying some ten or twelve miles back from Lake Erie. When I was a boy there the town was isolated. To go to Fremont or to Bellevue, eight miles away was to take a journey. Factories had not come in and the people were engaged in farming, the selling of merchandise or in the practice of the crafts in the old sense. Two carpenters met on the streets in the evening and talked for hours concerning the best way to cut out a window frame or build a door. Now doors and windows are made in big factories and shipped in...
>
> As soon as I arrived in town I felt sad and lonely.

What Anderson wrote in *Winesburg, Ohio* and in many of his other books, was a paean to a time gone by as well as a portrait (sparing no rawness) of the way that he believed people are. He spoke as one who had lived much in the world. "The men employed with me," he once wrote in a letter, "the businessmen, many of them successful and even rich, were like the laborers, gamblers, soldiers, race track swipes, I had formerly known. Their guards down, often over drinks, they told me the same stories of tangled, thwarted lives. How could I throw glamour over such lives. I couldn't."

Sherwood Anderson wrote many books after *Winesburg, Ohio*, but none has enjoyed the same critical success. He was betrayed by many up-and-coming writers who he tried to help; writers with arguably more talent than he had, including Hemingway (who wrote the Anderson parody *Torrents of Spring*) and Faulkner, who also cast him aside when he felt he had exceeded him. "He has a humanity and simplicity that is quite baffling in depth and suggestiveness," said Hart Crane of Anderson. That simplicity made him a great storyteller but it also seems to reveal a deep insecurity. Anderson wrote to one critic that "your suspicion that my own mind is like one of those gray towns out here is, I am afraid, profoundly true."[10] There is no doubt, however, about the impact Anderson had on other writers in his heyday, nor about the depth of his identification with this country. To read Anderson is to be set down in a bustling small-town America and encounter the profound truths that came from a time and place where villagers worked with animals, and the land, and beyond the village were still patches of wildness. A quote from Anderson containing one of these truths became a major element of Wallace Stegner's famous "Wilderness Letter." [See the Stegner entry.]

George Willard stops tremblingly by a picket fence under a streetlamp, reflecting: — Clyde, Ohio
"I must get myself in touch with something orderly and big that swings through the night like a star."
— Sherwood Anderson, "An Awakening" *Winesburg, Ohio,* 1919

Clyde nowadays is different and the same as it appeared in its incarnation as Winesburg. The downtown has survived, and seems quite healthy, though on a weekday September afternoon it is quiet. A few pickup trucks drive by. A youth saunters down the street, gets a haircut, later leaves the hair salon and stops to light a cigarette in front of the newspaper vending machine. A banner stretched across Main Street advertises the Clyde Fair. The old fairgrounds of which Anderson wrote so beautifully have been replaced by an elementary school. Nothing remains of it except an old watering trough in someone's back yard. Up near where the old depot used to be, the carnies are putting up the rides for the fair. It is one of the eagerly anticipated arrivals in town. In olden days, the trains used to generate that kind of excitement.

The Spring Street home in which Sherwood Anderson lived is unmarked and unremarkable, and now houses an upholstery shop. But there are signs that Clyde's opinion of its native chronicler has softened. The town recently erected a plaque commemorating him, near the old train station. The public library has a Sherwood Anderson room, paintings of him on the walls. He is featured in an exhibit in the local museum. In his introduction to *The Indispensable Sherwood Anderson*, Horace Gregory writes: "there often seems to be light and air between his sentences."[11] This is true. And if one travels to the Midwest town in which Anderson grew up, one feels that quality of light and air surrounding him. ✥

Sherwood Anderson

— New York, New York

"We build our temples for tomorrow, as strong as we know how and we stand on the top of the mountain, free within ourselves."

— Langston Hughes
"The Negro Artist and the Racial Mountain"
The Nation, 1926

The Inner Migration:

What Happens to a Dream

Langston Hughes • Toni Morrison • Rita Dove

Harlem, New York

LANGSTON HUGHES
(1902–1967)

I've Known Rivers

THESE THREE WORDS open the first major poem Langston Hughes published. The lines came to him as he headed south to visit his father in Mexico in 1920. The train he was on crossed the Mississippi and as he looked out the window at the muddy river he began to think what it had meant to black people. How "to be sold down the river was the worst fate that could overtake a slave in times of bondage."[1] And as the train chuffed its way over that long bridge, he began to write:

> I've known rivers:
> I've known rivers ancient as the world and older than the
> flow of human blood in human veins.
>
> My soul has grown deep like the rivers.
>
> I bathed in the Euphrates when dawns were young.
> I built my hut near the Congo and it lulled me to sleep.
> I looked upon the Nile and raised the pyramids above it.
> I heard the singing of the Mississippi when Abe Lincoln
> went down to New Orleans, and I've seen its muddy
> bosom turn all golden in the sunset.
>
> I've known rivers:
> Ancient, dusky rivers.
>
> My soul has grown deep like the rivers.

It was simple. Expressive. A calling card for a new poetic voice. It took Hughes about 15 minutes to write the poem that was anthologized dozens of times. "Poems are like rainbows," he said. "They escape you quickly." He was 18 years old.

Many of the writers in this book are at their most stirring, and are themselves the most stirred, when they travel back to

Harlem lights glitter in the background of the **George Washington Bridge over the Hudson River**. — New York, New York

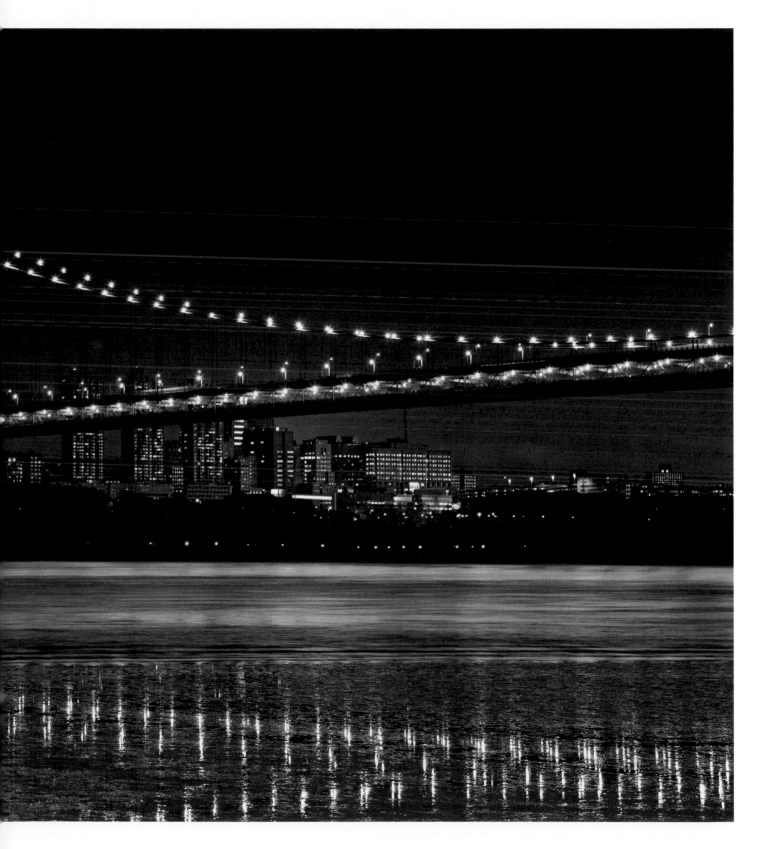

Harlem, New York ❖ 159

their youth. Not so Hughes. "What moron ever wrote those lines about 'carry me back to the scenes of my childhood'?" he exclaimed once in a letter to Carl Van Vechten. He was raised by his grandmother in Kansas until she died when he was 12 years old. His mother traveled quite a lot looking for jobs. His parents had split up and his father lived in Mexico. When his grandmother passed away he went to live with her friend, a churchgoing woman he knew as Auntie Reed. Her husband was a "sinner" and never went to church. But both of them were good people. "No doubt from them," Hughes wrote, "I learned to like both Christians and sinners equally well."[2]

His father came to visit once, when Langston and his mother were living in Kansas. He wired ahead but the pair had recently moved. By happenstance, Mr. Hughes stopped for breakfast at the same Central Avenue restaurant where Langston's mother was waiting tables. They did not talk and, when he left, his mother had her colleagues throw his dime tip out the door. Langston bumped into his father on the street. It played out like a drama:

> "Are you Langston?" his father said.
> "Are you my father?" the boy replied.
> Langston explained that he hadn't received the telegram because of the move.
> "Just like niggers," his father spat out. "Always moving!"

He proceeded to inform his son that he'd already run into his former wife at the restaurant. "If she'd stayed with me, she'd have been wearing diamonds,"[3] he observed.

"You see, unfortunately, I am not black," Hughes wrote in his autobiography, *The Big Sea*. He had the blood of slaves, white slave owners, Indians and French traders in him, mingled with the blood of a man who had died in John Brown's raid at Harper's Ferry. Hughes was light-skinned like his mother, and like his father, who despised African Americans—his own race.

The meeting in Kansas set up Hughes's first trip to Mexico. The train trip on which he wrote "I Have Known Rivers" was his second and last. "James Nathaniel Hughes is the only person Langston Hughes ever describes himself as hating," his biographer,

Arnold Ramperstad wrote. "In one of the more willful pieces of character assassination in our literature, James Nathaniel Hughes is left for dead as a mean, selfish, materialistic man."[4]

Perhaps a foreboding of what was to come led Langston to compose that poem on the train on the long bridge across the Mississippi. It may have helped him arm himself to live in close quarters with his malignant father. And though the poem encompassed all the members of the race, its words described Hughes particularly well. Even at such a young age, he had a broad understanding of people and the ability to speak in many voices. His soul was deep like the rivers.

The Weary Blues and an Icebound Hughes

1922 found him on another river, the Hudson, aboard the freighter the *West Hassayampa*. He'd signed on as a messboy to see the world. But when he got the job he was so excited that he forgot to ask the destination. All he saw of the world that winter was the icy Hudson, and the rusty hulks of a fleet of decommissioned World War I freighters. The *West Hassayampa* was one of the "mother ships" moored there to tend the other boats, mostly leaky tubs that had been badly built in a spasm of war production. But if Hughes wanted a little solitude and space, he'd found it. He made the most of it, doing quite a bit of writing, including a poem called "The Weary Blues." It took place solidly in Harlem, on Lenox Avenue, where the narrator listens to a piano player "droning a drowsy syncopated tune."[5] It was a good example of Hughes's blues poems, which used repetition of certain lines, just as a blues song does, to underscore a point and often to set up a "punch line."

Hughes never felt he got the ending quite right. And so he put away the poem and went back to making friends and getting what experience he could. He spent one night, on a bet, aboard a supposedly haunted freighter. To the stupefaction of the rest of the crew, he survived. In fact, like the singer at the end of "The Weary Blues," he "slept like a rock or a man that's dead."[6] No one else dared to sleep aboard the ghost ship. He admitted in his autobiography that he had done it to demonstrate that African Americans weren't the superstitious, frightened creatures they had been made out to be.

A row of **quintessential brownstones** in splendid condition. Street after street in Harlem looked like this, and still does. — Harlem, New York

To Keep from Crying
I Opens My Mouth and Laughs

1925 was a complicated year for Langston Hughes. He was already a published poet and a member of the "New Negroes" movement in Harlem. The year before, the impoverished Hughes had come from New York to Washington, D.C. with his mother and his brother, Kit, to live with their prosperous black Washington society relatives in the elite black section of the city. But his bourgeois cousins disapproved of his $12 a week job at the wet wash laundry. His mother and brother were similarly beneath the proper social level. "Listen, everybody!" Hughes exclaimed in his autobiography. "Never go live with relatives if you're broke!"[7]

Hughes had been encouraged to submit his poetry to Charles Johnson's 1925 literary contest in New York. Johnson was a sociologist, tireless advocate for race relations, champion of the Harlem art scene and, at the time, director of the national Urban League. As an afterthought, Hughes sent "The

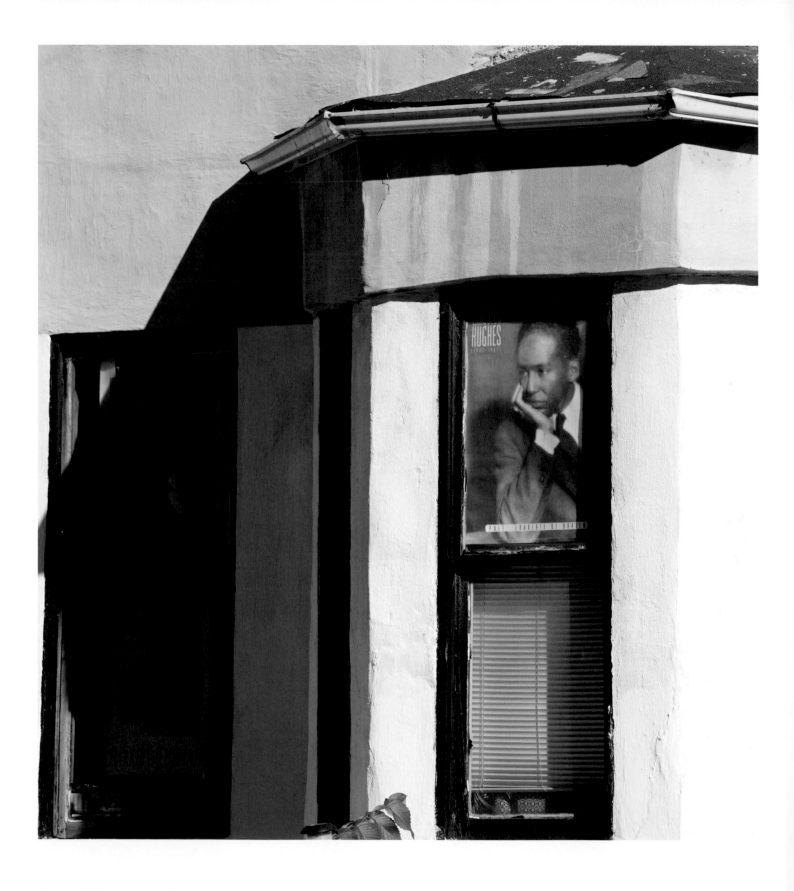

Weary Blues." The poem won the first prize, in front of all the assembled glitterati, white and black, of the day. At that very same party, he met Carl Van Vechten, an instant fan, who soon got him a book contract with Knopf to publish a collection called *The Weary Blues*.

Encouraged by the prize and the recognition, Hughes quit his job, moved in at the YMCA, and tried to devote his life to art. His mother refused to support him. When the experiment failed, he took a job as a busboy at the massive, red brick and white trim Wardman Park Hotel, a building that reigns over the Rock Creek ravine in Northwest Washington, D.C. to this day, now as a Marriott. In late November, he heard that the famous poet, Vachel Lindsay, was going to give a reading at the hotel. He wrote out three poems and put them in the pocket of his uniform:

> In the evening when Mr. Lindsay came to dinner I quickly laid them beside his plate and went away, afraid to say anything to so famous a poet....I looked back once and saw Mr. Lindsay reading the poems as I picked up a tray of dirty dishes from a side table and started for the dumb waiter.
>
> The next morning on the way to work, as usual I bought a paper—and there I read that Vachel Lindsay had discovered a Negro bus boy poet!" [8]

With what a sense of irony Langston Hughes must have greeted the fact that he, who had been awarded a top prize for poetry earlier in the year, had been "discovered" in the dining room of the Wardman Park Hotel! The older generation poet was very kind, and left a biography of Keats for the young poet, with words of advice written in "great, flowing, generous handwriting."

Hughes kept writing blues poems, but not blues poems alone. While blues was a great medium for expressing feelings in a certain key, it could not encompass all the notes of wit, of mirth, of irony that occurred in the life of Langston Hughes. For that, there was blues's sister, jazz.

A homemade **tribute to Harlem culture,** in black and white, just across the street from Hughes's house. — Harlem, New York

When the Negro was in Vogue

Perhaps "The Harlem Vogue" is a better term than "Harlem Renaissance" for what took place from roughly 1921 to 1931. A "renaissance" implies a striking rebirth, whereas the astonishing literary and musical movement in Harlem had been steadily building for some time—and continued to build afterwards. Suddenly, it seemed, everyone who was anyone couldn't get enough of Harlem, that "chocolate-custard pie" of a town. "When the Negro was in Vogue" is the first chapter of Part III of *The Big Sea*. Hughes followed it with chapters like: "Harlem Literati," "Parties," "Downtown" and "Shows." Wallace Thurman, author of *Infants of the Spring* (the best novel about the period, according to Hughes), wrote a piece called "Negro Life in New York's Harlem," and his account, too, devoted much of its attention to its high and low entertainments. For that was what filled the clubs, got the cash registers jingling, and lent Harlem its air of decadent intrigue.

In *The Big Sea*, Hughes tells us the vogue began with a black musical revue named *Shuffle Along*, written by the great Eubie Blake and Noble Sissle. The wattage of talent in the show could have illuminated Seventh Avenue—Harlem's main drag—to eye-popping brilliance. Even Josephine Baker, who later went on to worldwide fame, only made the chorus. The black and white audiences who packed the theater every night were spellbound. Hughes himself was rapt.

Who would have thought, a hundred years before, that such a thing would happen in Harlem? Haarlem, established by the Dutch, raided by the Indians, had for years been a community of farming estates. It slowly lost its luster and declined into a poor region of Irish squatters. With the construction of the elevated railway in the 1880's, it briefly became home to 150,000 Eastern European Jews, whose dream of settling there was denied. They weren't welcomed, and by the 1920's only a few of them seemed to remain, often in resented occupations like landlord and pawn broker. In fact, Hughes titled his second book of poems, *Fine Clothes To The Jew*, from a poem he wrote about a struggling man who often had to pawn his clothes. (Then he wondered in *The Big Sea* why his publisher, Knopf, had let him use such an ill-advised title.) After the

Jews came the Italians, the Irish and the Finns. But during World War I, the city recruited in the South for factory jobs that paid far more than cotton picking, and African American laborers came in droves. The Great Migration, as it was called, sent white residents fleeing and utterly changed the character of the neighborhoods.

1920's Harlem was a scene perfectly suited to Langston Hughes, night owl. The number of Hughes poems that take place in the Harlem night is substantial. There is "Harlem Night Club," which ends with the narrator exhorting the jazz musicians to "Play, play, PLAY!"

> Tomorrow….is darkness.
> Joy today!

From that same collection comes "Harlem Night Song" in which the Hughes-like narrator invites someone to "roam the night together / singing." With companion or without, the diminutive Hughes, perhaps smoking one of his ever-present cigarettes, roamed Seventh Avenue or Lenox Avenue, absorbing everything.

Hughes found Life with a capital "L" in Harlem, "stepping on my feet!" Pushcart peddlers sold their wares with a song. Storefront churches offered storefront salvation. The "hot men" sold wares that had "fallen off the back of a truck" for prices that were much lower than retail. The numbers game was "Harlem's favorite indoor sport."[9] And the blocks were crowded, crowded. African Americans lived cheek to jowl in tiny tenement apartments. They paid sky-high rents for their insubstantial slivers of the pie. And yet in the 1920's Harlem continued to draw in more and more black residents, just as its revues and clubs lured bigger and bigger white audiences, thirsty for a taste of life on the dark side.

Fortunately, the fascination was not limited to music. Black writers were celebrated as well. They were published in greater numbers than ever before and hailed as equals at intellectual

Children's Play Area: Hughes once wrote: "By what sends / the white kids / I ain't sent: / I know I can't / be President." It's a shame he didn't live to see the day. — Harlem, New York

gatherings throughout the city. In Harlem, everyone and his brother was writing a play or a novel or poetry. It was a great time to be young, talented and black.

The Vogue Plays On

Once they discovered her, the white folk flocked to see Gladys Bentley, a huge lady who dressed in a man's clothes, her feet keeping a beat on the floor while her fingers tattooed the keyboard as she played all night and into the dawn for years. Her raunchy lyrics were a revelation and titillation. White audiences couldn't get enough of the performers at the Cotton Club on Lenox Avenue, where they sat and enjoyed the performances among their own kind. Black people were not welcome unless they were performers there or celebrities on the level of Mr. Bojangles.

At more and more black clubs, Hughes said, the whites:

> were given the best ringside tables to sit and stare at the Negro customer—like amusing animals at the zoo.
>
> The Negroes said: "We can't go downtown and sit and stare at you in your clubs. You won't even let us in your clubs." But they didn't say it out loud—for Negroes are practically never rude to white people. So thousands of whites came to Harlem night after night, thinking the Negroes loved to have them there, and firmly believing that all Harlemites left their houses at sundown to sing and dance in cabarets…[10]

The white intellectuals and white audiences stepping out for a night at the cabarets may have run for the Elevated had they peered in to the rent parties. Rent parties came about by the twin evils of high rents and Prohibition. Invitation cards were handed out or posted, often announcing a "whist party," after the quiet and dignified card game favored in the 19th century. Twenty-five cents would gain you admission to someone's apartment with music, free-flowing liquor and food. Whist was about the only thing that *didn't* go on at a rent party. As Thurman noted, "the music will be barbarous and slow. The dancers will use their bodies and the bodies of their partners without regard to the conventions. There will be little restraint."[11] Hughes enjoyed

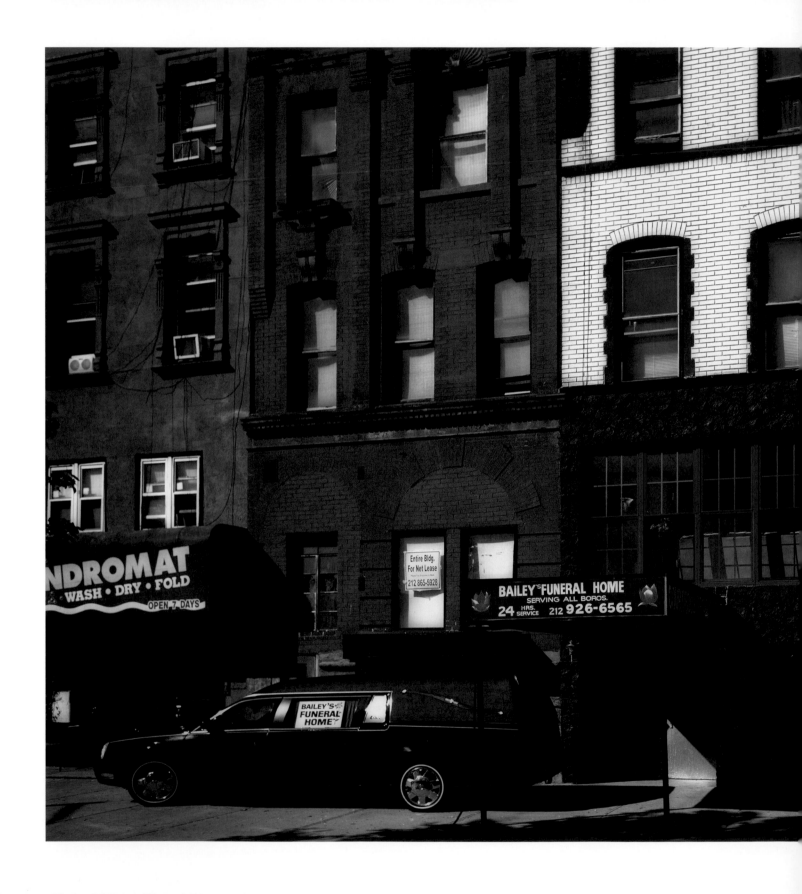

them. He said he went almost every Saturday night that he was in Harlem. Always a bit above the fray, he wasn't out on the dance floor grinding away. "I met ladies' maids and truck drivers, laundry workers and shoe shine boys, seamstresses and porters. I can still hear their laughter in my ears, hear the soft, slow music, and feel the floor shaking as the dancers danced."[12]

One white man who would have braved a rent party was Carl Van Vechten. Van Vechten was a wealthy intellectual, dance and music critic. He was married to a Russian actress but was decidedly if not openly gay. He had developed a fascination with African-American writing and music just at the outset of the Harlem "Renaissance." After the 1925 awards dinner where Hughes walked away with first prize for "The Weary Blues," Van Vechten immediately invited him to visit. The men became lifelong friends and correspondents, often signing off on letters to each other with comic pomp: "ten Cuban coons—with bongos between their knees—Langston," or "204 yellow gals to you singing Love for Sale, Carlo."

Perhaps because of the easy understanding between the two, they were not of much help to each other with literary racial relations. There was Hughes's stumble, encouraged—or at least not discouraged—by Van Vechten with the title of *Fine Clothes for the Jew.* Then Van Vechten published a novel titled *Nigger Heaven* about a love story between black characters in Harlem, and received the scorn of both black and white critics (though the book sold briskly and brought even more curious tourists to Harlem). Van Vechten had broken the rule—of which he was only too well aware—regarding the usage of the "N-word" by white people.

He had his defenders. In the literary magazine *FIRE,* Wallace Thurman wrote:

> The objectors to Nigger Heaven claim that the author came to
> Harlem, ingratiated himself with Harlem folk, and then with a

Bailey's Funeral Home, with a fine black hearse. Hughes, author of "Night Funeral in Harlem," might feel quite in his element—once the sun went down. — Harlem, New York

"but most of all to Harlem

dusky sash across Manhattan"

[they come]

"wondering

wide-eyed

dreaming"

— Langston Hughes
"Good Morning"
Montage of a Dream Deferred, 1951

In his poem "Good Morning" Hughes wrote of immigrants up from Cuba, Haiti and Jamaica, and inner migrants on buses from down in Georgia, Florida and Louisiana reaching New York City.

supercilious grin and a salacious smirk, lolled at his desk downtown and dashed off a pornographic document about uptown in which all of the Negro characters are pictured as being debased, lecherous creatures not at all characteristic or true to type, and that, moreover, the author provokes the impression that all of Harlem's inhabitants are cabaret hounds and thirsty neurotics."

But, as he went on to point out, those who would believe that of Harlem were likely to believe it anyway.

I do not wish to endow Mr. Van Vechten's novel with immortality, but there is no real reason why Nigger Heaven should not eventually be as stupidly acclaimed as it is now being stupidly damned by the majority of Harlem's dark inhabitants.

Van Vechten also had the loyal Hughes in his corner, who devoted a chapter in *The Big Sea* to defending his friend. The beleaguered Van Vechten insisted to the end of his days that he had meant the title ironically. But he had done irreparable damage to his reputation, about which he cared very much. Before that publication, he had achieved a unique status in New York City with his packed, opulent, racially mixed parties. He thought he was a pillar of the "Renaissance," but found out that he could be removed without the ceiling caving in.

Looking across **Central Park toward Harlem** from the Top of the Rock at Rockefeller Center. — New York, New York

The Vogue Plays Out

The Harlem Renaissance was great while it lasted. But even at that time, Hughes didn't think it would have staying power. "Some Harlemites…" he wrote, "thought the race problem had at last been solved through Art plus Gladys Bentley." It was not to be. In his opinion, the air started hissing out of the balloon when A'Lelia Walker, heiress to the Madame Walker Hair Straightening Process fortune and one of the great hostesses of the era's Harlem parties, died. The end of Prohibition marked the demise of the rent parties. Legal liquor was too strictly regulated and the law too muscularly enforced. The Great Depression, of course, was the bitter end of the Harlem Renaissance.

The Blues I'm Playing

"Say, ain't you afraid," the narrator of the poem "Park Bench" (and resident of said bench) asks of a Park Avenue resident, suggesting that one day *he* might be living in one of those Park Avenue apartments. Hughes was no park bench resident but he wasn't too many steps away when he was first introduced to the elderly, white Charlotte Mason at Carnegie Hall. Mrs. Mason was, herself, a resident of 399 Park Avenue, but she was not your typical millionaire. As Alain Locke introduced them at that first meeting, "Hughes looked down at an old white-haired woman, dressed and expensively groomed, who, seated, looked up at him with such grim intensity that her eyes glittered from the

effort."[13] Those eyes were working so hard in order to discern whether the handsome young black poet standing before her was to be her vehicle to uplift the race.

She had Hughes over to Park Avenue and he found her "one of the most delightful" women he had ever met, "amazingly modern" in her notions and in her knowledge of art, literature and Harlem. When it was time for him to leave, she pressed a $50 dollar bill into his hand. "A gift for a young poet,"[14] she said. Shortly, it was decided: Langston Hughes would be a span of "that great bridge reaching from Harlem to the heart of Africa"[15] that Mrs. Mason had dreamed of.

And so it was that Langston Hughes escaped at least the beginning of the Depression. For Mrs. Mason took him firmly under her wing. First she covered the expenses of his summer so that he could write a draft of his novel, *Not Without Laughter*. Then she set him up with an ample allowance, which allowed him to travel and to write another draft of the novel. During that period, tickets to any musical or play were his for the asking. He had only to call her secretary. Moreover, Mrs. Mason's chauffeur was at his disposal, though the driver—a white man—gave off distinct signs that he didn't think much of the arrangement. Economic conditions grew more miserable, but people like Mrs. Mason were so insulated by wealth that their fortunes hardly suffered. And so Hughes rolled silently past people sleeping on park benches in the long town car, feeling "slightly guilty."

Langston Hughes

His patroness also funded another talented young black writer, Zora Neale Hurston, but on a project-by-project basis, whereas her attitude towards Hughes was almost fairy godmotherly. In *The Big Sea*, Hughes says overwhelmingly favorable things about her intelligence, curiosity and commitment.

After he finished *Not Without Laughter*, Hughes didn't feel like writing for a while. As had always been the case, he wrote best when he was unhappy. Being sleek and carefree did not suit him. His inability to write (he managed one scathing poem about the opening of the Waldorf Astoria in the midst of economic misery but other than that couldn't find a groove) did not sit well with her. "More and more tangled that winter became the skein of poet and patron, youth and age, poverty and wealth—and one day it broke!" he wrote. She wanted him to be "primitive" as she imagined black men to be. But Hughes "did not feel the rhythms of the primitive surging" through him and he couldn't—or wouldn't—fake it. They parted ways after a final dispute at her Park Avenue apartment that Hughes later claimed to have forgotten the details of.

In his book of stories named *The Ways of White Folks*, there is a story called "The Blues I'm Playing" about a young, talented female pianist named Oceola Jones who is similarly befriended by a rich, white-haired woman, Mrs. Dora Ellsworth. Mrs. Ellsworth is determined to uplift the race. But even as Oceola's talents flower and she develops into a lovely classical pianist, she keeps being pulled back to blues and jazz, a tendency that Mrs. Ellsworth grows to abhor. While the story differs in its circumstances, the elegant Park Avenue setting presided over by a determined patroness could have come from Hughes's own life. The tension that leads to the break at the end is the same tension that led to Hughes's break with Mrs. Mason: "the old impasse of white and Negro."

"Tomorrow, I'll Be At The Table"

In "I, Too" Langston Hughes riffs on Walt Whitman's famous "I Hear America Singing." Hughes's narrator is "the darker brother," the one who gets sent to eat in the kitchen when company comes. "But I laugh," he continued, "and eat well, and grow strong." Tomorrow, he would be at the table, too. This was

early Langston Hughes, but it established a career-long pattern of hope and defiance.

Many years after composing it, he recited the poem for a Smithsonian recording of his poetry. His was a pleasant and natural reading voice, not particularly deep or high, with a subtle tone of humor. He could use his voice as a trumpet player uses a mute, sliding into a phrase a slightly nasal inflection—a glint of hidden emotion, perhaps—that just as smoothly was concealed again.

"You are the in the final analysis the most consarned and diabolical creature, to say nothing of being either the most egregiously simple or excessively complex person I know," Wallace Thurman once said to Hughes. His frustration was understandable. No one got too close to Hughes. In the torrent of letters that he exchanged with Carl Van Vechten, for example, not once did he mention his troubles with his patroness, nor any other deep despairs. Even Hughes's sexual preferences remain a mystery to this day. He smiled. He ate well. He grew strong (and grew round, as he got older). His mask never came off, not even to his friends.

Putting up that front made him weary. In an interview for the Morehouse College newspaper in 1947, Hughes was asked whether he felt he had suddenly achieved prominence. On the contrary, Hughes maintained, "it was so gradual that I got tired." In that year, in partnership with a friend he called "Aunt Toy," he bought one of the row houses in Harlem at 20 East 127th Street. It was the first and only house he ever owned. He lived there for the rest of his life, in what became a neighborhood institution. He suffered little children gladly, and established the "Our Block Children's Garden" in front of his house. It's not there today. But another one has sprung up down the street.

"The tendencies into which Langston had slipped over the years settled now into certain enduring patterns of life," Arnold Ramperstad writes. "Usually his day began around noon. Then, after much hacking and coughing brought on by over a decade of chain-smoking pungent cigarettes such as Camels and Lucky Strikes, Langston pushed open the heavy velvet curtains to let in the light, took his first cup of coffee, showered and shaved, and settled down to a generous breakfast of whatever Aunt Toy

chose to offer." During the day he was a man about town. He would start writing late in the evening. "Working steadily until just after dawn, he ended his day by going out for the morning newspapers. Then, as the rest of Harlem struggled to rise, he took to his bed."[16]

Harlem continued to fuel his work. It was there that he wrote *Montage of a Dream Deferred*, a poem composed of many poems, marked "like be-bop" with "conflicting changes, sudden nuances, sharp and impudent interjections, broken rhythms… of a community in transition."[17] The poems celebrated the pulse of Harlem, from the neon lights to the movie theaters, from the night funerals to night jam sessions. But underneath all the life, the hubbub of Harlem, was what Hughes saw as the dream deferred: the constant falling short that prompted impatience and frustration of younger African American writers, that led to violence and riots as the years progressed. In "Harlem," Hughes asked: "What happens to a dream deferred? / Does it dry up / like a raisin in the sun?" On the last line, the prescient speculation: "*or does it explode?*"

Langston Hughes died in 1967 after a long and full life. He had become a legend in Harlem and a worldwide ambassador for poetry and for African Americans. His body was cremated and some of his ashes were scattered in the rivers of the world he loved. The rest of his remains were buried under a cosmogram on the floor of the Arnold Schomburg Center for Research in Black Culture in Harlem, between the East and Harlem rivers. But Hughes needs only to be read and he comes to life with the same freshness and snap that he had when he walked the streets. His Harlem lives on, in a similar fashion, in the bright, sharp phrases of his poetry, the sudden nuances, the rhythm of his words. ॐ

Langston Hughes House. — Harlem, New York

TONI MORRISON (1931-)

AN OLD AFRICAN PROVERB, often trotted out, goes: "It takes a village to raise a child." Hillary Rodham Clinton, wife of the man whom Toni Morrison famously called "the first black president," even used it as the title of a book. In the case of Toni Morrison, born Chloe Anthony Wofford, the "village" that raised her is the black community in Lorain, Ohio, a steel town on the shores of Lake Erie. With the support and encouragement of her community, she left Lorain after high school for Howard University to make her way in the larger world. "If black people are going to succeed in this culture," she said in a 1979 interview, "they must always leave. There's a terrible price to pay."[1] But, she went on to say, her departure did not take away her power to "savor" that village she left. It is to Lorain that Morrison returned in her first novel, *The Bluest Eye*, published in 1970. She has not used the city specifically as a setting in later novels, but she has often returned to it—to the way she saw it in her youth—in order to depict what has been the major focus of her art: the "elaborately socialized world of black people."[2]

"When all is told," R.L. Hartt wrote in *The Atlantic Monthly* in 1899, "Ohio is at once North and South; it is also—by grace of its longitude and its social temper—both East and West. It has boxed the American compass."[3] Hartt's words are certainly true of Lorain in 1899. A hundred years earlier, the city now known as Lorain had bluntly been called "Mouth of Black River." In the early 1800's the city, still stumbling towards an identity, briefly became the second city in Ohio named Charleston. But that, of course, would not do. In 1824, the city fathers settled on Lorain, after the French province, Lorraine. A shipbuilding industry was established. In 1893, the port attracted a businessman named Tom L. Johnson, who established a steel plant. He offered workers a dollar and a half per day—one and a half times the usual wage. And over the next few decades, Lorain did its part to box the American compass. Recent European immigrants were lured from the East. They could stop in Lorain, or keep moving along the railroads that passed through to the West. Black families brought color from the South, as they escaped the cotton fields and a legal and economic system that was rigged against them. To the north of Lorain was Oberlin College, a bastion of free thought; the first coeducational college in the United States, it was among the first colleges in the nation to accept black students, and a stop on the Underground Railroad.

Toni Morrison has said that the Wofford family came to Lorain for the opportunity to live the good life. She was born in a modest frame house at 2245 Elyria Avenue, a building that doesn't look much different from the one inhabited by another Ohio native, Sherwood Anderson, in the smaller town of Clyde. It isn't marked with any plaque. It sits there, as if it were nothing special, beaten by the weather off Lake Erie but still standing, like its modest neighbors. Morrison once described a street of "soft gray houses leaning like tired ladies."[4] This could be one of them. A satellite dish is fastened to her porch roof, like an ugly brooch a lady wears because her grandchild gave it to her.

The Woffords did not own the house on Elyria Ave. They were just renters, who moved eight more times during Morrison's childhood. And though the Andersons also moved from rental to rental, the children of the two families certainly had very different experiences, by virtue of race. Sherwood Anderson wrote one semi-autobiographical work called *Poor White*. But Morrison has argued that even very poor white people have a leg up on any black to whom that adjective applies. In 1989, in an interview with *Time* magazine, Morrison explained that, in her view, immigrants in America were at one time unified by their superiority to at least one class of people: the black people. She recalled being a youth and teaching a bright little boy who spoke no English how to read. "I remember the moment he found out

A tired gray lady: The Wofford family once tenanted this **house on Elyria Avenue**, one of many they rented in Lorain. They were living here when Chloe Wofford, now known as Toni Morrison, was born. — Lorain, Ohio

Toni Morrison

Nerve and steel: For over a century, **the steel mill** has loomed over Lorain's Black River ravine and local economy. Toni Morrison's father worked here and, in defiance of the rules, moonlighted to cover her tuition. He was almost fired for it but refused to back down. — Lorain, Ohio

"Grown-ups talk in tired, edgy voices about Zick's Coal Company and take us along in the evening to the railroad tracks where we fill burlap sacks with the tiny pieces of coal lying about. Later we walk home, glancing back to see the great carloads of slag being dumped, red hot and smoking, into the ravine that skirts the steel mill. The dying fire lights the sky with a dull orange glow."

— Toni Morrison
The Bluest Eye, 1970

I was black—a nigger. It took him six months; he was told. And that's the moment when he belonged, that was his entrance. Every immigrant knew he would not come as the very bottom. He had to come above at least one group—and that was us."[5]

The children, black or white, could certainly notice how society treated them differently. Any white child, even on the lowest rung of the social ladder, could put on a bathing suit and carry picnic things, their pails and shovels, to the nearby lake to swim. Black children had to traipse far up the shoreline, out of sight of white eyes, to Slater's Grove, to take a dip in Lake Erie. In the Wofford household, indignation simmered like a pot on the stove, and was capable—especially on Mr. Wofford's

part—of boiling over into anger. These are hard lessons to learn as a child. But learn them Chloe Wofford did, and she passed them along to the next generation. In the same 1979 interview she said, "I probably spend about 60% of my time hiding. I teach my children that there is a part of you that you keep from white people—always."

The black community in the Lorain of Morrison's youth probably seemed unremarkable to the white outsider. But to the young Chloe Wofford, the community and its inner life were like a garden of fruits and flowers, privately tended behind high walls. Along one garden path, bobbing gently like beautiful blossoms, there were the black women who had recently come up from the South. In one lovely passage in *The Bluest Eye*, Morrison describes them:

> They come from Mobile. Aiken. From Newport News. From Marietta. From Meridian. And the sound of those places in their mouths make you think of love. When you ask them where they are from, they tilt their heads and say "Mobile" and you think you've been kissed. They say "Aiken" and you see a white butterfly glance off a fence with a torn wing. They say "Nagadoches" and you want to say "Yes, I will." You don't know what these towns are like, but you love what happens to the air when they open their lips and let the names ease out.[6]

Those are the girls, she goes on, who end up marrying. Elsewhere in *The Bluest Eye*, hidden in plain sight in the garden, one finds the prostitutes. The prostitutes are treated sympathetically. They are robust and unapologetic and fulfill a vital role.

In a rank corner of the private garden lurk other entities. In *The Bluest Eye*, there is a man who is reputedly able to work miracles. He is also a pedophile and he gives off the sickening odor of being rotten to the core. But he is not cut down. In her second novel, *Sula*, Morrison described the attitude of the community toward disturbing elements like that: "Such evil must be avoided…and precautions must naturally be taken to protect themselves from it. But they let it run its course, fulfill itself, and never invented ways either to alter it, to annihilate it or to prevent its happening again."[7] To outsiders this may seem morally lax. But to the narrator of *Sula*, this stance simply demonstrates "the full recognition of the legitimacy of forces other than good ones."[8]

In the village where Toni Morrison grew up, the forces of good and evil coexisted. But there were grandparents, relatives, fathers and, above all, mothers to instruct children how to live and how to choose good over evil. A mother had the authority to mete out punishment, give comfort, or render judgment to any of the community's children as if they were her own.

The children were expected to help take care of the aged. In a 1979 interview, Morrison told of an old man she heard about in Lorain who wandered away from his home and wasn't found until many months later. He had died of a heart attack. When she was young, she said, children would have been sent out to comb the area for one who had wandered away. "There aren't any people to do that anymore, no children, no neighbors. Agencies do it. Well, the town I grew up in used to respond to an event like that almost like a chorus."[9]

Morrison's own imaginative life was tilled by the oral tradition. Her mother, Ella, told stories she'd heard when she was growing up in Greenville, Alabama. Her father contributed the "best, the scariest"[10] ghost stories to her and her sister, Lois. Dreams and visions were treated with a matter-of-factness and respect. Morrison's grandmother had a dream book that translated the subjects of dreams into three-digit numbers. She used her granddaughter's dream numbers in the local numbers game and for a while she won money on them. "Then I stopped hitting for her," Morrison has said, "so she stopped asking me."[11]

Her career as diviner of the future over before it had really begun, the bookish Morrison had to find another way in the world. In high school, Morrison told her father that the thing she wanted most was to attend Howard University. The hardworking Mr. Wofford took on three jobs in order to pay her way, in defiance of regulations at his primary job. He was caught, and called on the carpet. But he explained to his white supervisors that he was determined to put his daughter through school. If they fired him, he would find another job and do the same elsewhere. They allowed him to keep his position.

At Howard University, Chloe Wofford changed her name to Toni. She thought fellow students had trouble pronouncing her given name. She graduated and went on to Cornell, where she received an M.A. She taught English for two years at Texas Southern University in Houston, and then returned to Howard in 1957, where she taught, among others, the radical Stokely Carmichael and Claude Brown, the future author of *Manchild in the Promised Land*.

At Howard, Wofford she met a Jamaican architect whom she married and with whom she had two sons. But the marriage was a battle for dominance. Somewhere behind the lines, in between skirmishes, she began to write. "It was as though I had nothing left but my imagination," she said. "I had no will, no judgment, no perspective, no power, no authority, no self—just this brutal sense of irony, melancholy and a trembling respect for words."[12] She joined a writing group. And one day, at a loss for something to submit, she quickly wrote out the sketch of a story about a little African American girl who wanted more than anything else to have blue eyes. It was based on an experience she had had in elementary school, when a friend confided to her that she had prayed for two years to be given blue eyes. As a child, Morrison had been shocked, and even repulsed, by the significance of the wish.

In 1964, Morrison moved to Syracuse, in upstate New York, to work as a textbook editor for Random House. Alone with her children in an unknown place, she began to refine her short story. It became *The Bluest Eye*, published by Holt, Rinehart & Winston. The book is narrated from the perspective of a young girl named Claudia who, with her sister Frieda, makes the acquaintance of Pecola Breedlove, the girl who desires blue eyes. The parallels between Claudia and Frieda and the young Chloe Wofford and her sister are obvious. Each chapter of the book opens with a distorted quote from that quintessential of all white children's series: *Dick and Jane*.

Unlike Morrison's young friend, Pecola is not at all good-looking. She fervently believes that the blue eyes will change that. She lives with her brother, father and mother in a former store on the southeast corner of Broadway and 35th Street in Lorain, one of those luckless spots in which every commercial enterprise fails. The Breedlove family is as doomed as the location. They are all "relentlessly and aggressively" ugly. Or, at least, they carry that belief within them and it makes them so. And each is limited by circumstances, race and shortage of education. Pecola's parents traveled up from the South in the same Inner Migration that brought the Woffords. But they have ended up on the shoals. Morrison's personal sense of melancholy and irony came out in this story. So, too, did the respect for words.

The city of Lorain hove into view as well, sketched with the loving but clear-eyed perspective of one who left because she felt she had to. Broadway, the main shopping street that residents thronged to on weekends, came alive. There was Isaley's the ice cream place at 1920 Broadway, to which Frieda and Claudia were sent with a quarter for ice cream. The Dreamland Theater at 1926-1934 Broadway glittered with stardust again, as the beautiful and ideal white face of Betty Grable smiled down upon the girls from a movie poster. Zipp's Coal (named Zick's Coal in the novel), formerly located on 1463 Broadway, towards the lake, made an appearance. Zipp's sold the coal that poor families could barely afford. As an alternative, Frieda and Claudia were taken to the railroad tracks as dusk fell, to fill burlap sacks with shards of coal cast off by the trains. Meanwhile, the steel mill, around the elbow of the Black River ravine, dominated the eastern side of the city, a gigantic example of the manmade sublime, a monster belching smoke and spitting fire. "Later we walk home," Claudia relates, "glancing back to see the great carloads of slag being dumped, red hot and smoking, into the ravine that skirts the steel mill."[13]

The Bluest Eye is the only book, thus far, that Morrison has set in the environs of Lorain. But that private garden—the elaborately socialized world of black people she left behind in Lorain—has been an inexhaustible source of material. Her next book, *Sula*, takes place within the black community in the small town of Medallion, Ohio. Medallion does not exist on your AAA map and, unlike Updike's Brewer, Pennsylvania or Wolfe's Altamont, North Carolina, it is not the stand-in for an actual locale. However, Medallion becomes vividly real in Morrison's lush description of it; even beyond real. Fantastical elements in the characters and the terrain are reminiscent of the

South American tradition of writing called "magical realism."

The two main characters, Sula Peace and Nel Wright, are childhood friends who grow up in the area of town known as "The Bottom." But in Medallion, the Bottom is high up in the hills. The name's provenance goes back to a white farmer who offered his slave freedom and a piece of "bottom land" if he would perform some very difficult chores. As the story goes, when the slave claimed his river bottom land, the master tricked him: he said the land he had meant was up in the rocky hills because "when God looks down, it's the bottom…It's the bottom of heaven—best land there is."[14]

Nel Wright remains in town, marries, has children, and becomes a fixture in the Bottom. She lives, like her neighbors, in concert with nature's forces: gardening, putting food by during canning season, doing things the way they have been done for generations. Sula goes away to college and has an education in the world, during the course of which she knows many men. When she comes back 10 years later, Nel notices that the very atmosphere of the Bottom takes on "a sheen, a glimmering as of green, rain-soaked Saturday nights…of lemon-yellow afternoons,"[15] a "magic." But the magic does not last. The two old friends come into conflict. As the book begins there is nothing left of the Bottom. The Time and Half Pool Hall and Irene's Palace of Cosmetology have been torn down and the area has become a golf course. Sula is a study of community, of those that must leave and those that choose to remain behind, of the forces inside black women and the forces brought to bear on them. It is also an homage to things past.

The years since the publication of Sula have treated Toni Morrison, and Lorain, pretty well. It is true that shoppers don't flock to Broadway the way they used to. But the scene there is not of derelict, boarded-up buildings. Lorain has fought back since its nadir in the 1960's, when airline pilots used the big cloud hanging over the city as a navigational tool.[16] Thankfully, for the sake of the local economy, the steel mill that Morrison's father worked for is still in operation, but cleaner. The harbor has been refurbished and the Lorain lighthouse has been preserved, and gives an air of serenity to the bay. The new Lorain Public Library bustles with a steady stream of patrons, young and old, black and white. Perhaps they are partially inspired by the most famous former employee of the old Library, Toni Morrison. The library has a Reading Room dedicated to her, and collects all of her public utterances and mentions. Considering that she wrote a book that showed some unflattering angles of Lorain, and mixed in sex with a scandalous aspect, it is surprising how the city has embraced her. Sherwood Anderson, Thomas Wolfe, and several others, were not so lucky.

Toni Morrison's books have probably been the entry point into African American literature for thousands of readers. Sula was an Oprah's Book Club choice. Her books Tar Baby, Jazz, Song of Solomon and Beloved have sold hundreds of thousands of copies. She won the Pulitzer Prize for Beloved. In 1993 she won the Nobel Prize. Her writing is ebullient, playful, her language luxurious. Interviewers comment on her presence, her sense of humor, the "incantatory flow" of her speaking that is "akin to the lyric moments of her written style."[17] Whether speaking publicly or in a more intimate setting, Morrison "holds sway" in a room, to borrow a description she once used in Sula. She became a formidable presence in literature not only through her writing but also through her position as editor at Random House in New York where she nurtured many young black authors. She taught at Princeton from 1989 until 2006.

Her goal as an author has been to write stories in a way that speaks to anyone. She has discussed how she felt the great black novelists she read in her early years—such as Ralph Ellison or Richard Wright—were saying a lot, but not to her. "I thought they were saying something about it or us that revealed something about us to you, to others, to white people, to men…When I wrote, I wanted not to have to explain. Somehow, when black writers wrote for themselves I understood it better. What's that lovely line? When the locality is clear, fully realized, then it becomes universal."[18] Like many an émigré, the first locality she turned to was her home town. And though her settings have taken her to many other places, she has never left Lorain, and what she learned there, behind. ❧

(Next pp. 178-179) **Lake Shore Park.** — Lorain, Ohio

Toni Morrison

"We reached Lake Shore Park, a city park laid out with rosebuds,

fountains, bowling greens, picnic tables. It was empty now, but sweetly

expectant of clean, white, well-behaved children and parents who

would play there above the lake in summer before half-running,

half-stumbling down the slope to the welcoming water.

Black people were not allowed in the park. And so it filled our dreams."

— Toni Morrison
The Bluest Eye, 1970

Toni Morrison

Akron, Ohio

RITA DOVE (1952-)

Akron, Ohio. Her name is derived from the Greek word meaning "summit." Her mixed skyline of skyscrapers—the graceful white form of the First Merit Tower, built in 1931, the cool black glass of the National City Center from 1969, the square brown First Energy Center from 1976, the peaked roof of the brick Canal Place with its crenellations and graceful white balconies from 1928, the distinctive Quaker Oats building—rise from the acres of concrete like diverse waders at a municipal pool, each with an inner tube of vacant lots, parking lots, low-slung buildings around their middles.

From the north, the Y-shaped All America Bridge carries traffic over the Cuyahoga River gorge. It splits in midair into two concrete spillways leading downtown; one an almost straight shot onto High Street, the other describing a ribbony curve before straightening into Broadway. To the south, Opportunity Parkway leads in or out of the city, depending on your perspective. 21st century Akron. Her population of 200,000 is a little less than it was in 1920, when she was the tire capital of the world and had ballooned by 130,000 citizens in 10 years. She was a city of densely packed smokestacks and steeples then, of smoke-bleared skies. Her eyes have seen their share of triumph and of malaise, of destruction and rebirth. Akron, oh Akron, OH. She has also inspired a child from one of her modest neighborhoods to immortalize her in a series of poems that won the highest literary prize in the land.

Akron's poetic champion is Rita Dove. She has been Poet Laureate of America, the youngest person to ever hold that post. She is only the second African American poet ever to win the Pulitzer Prize. She is as much a product of Akron as a Goodyear tire, but more supple. She ballroom dances and plays viola da gamba. Dove has lovingly rendered her hometown in *Thomas and Beulah*—the book that won her the Pulitzer—in a

Quaker Oats silos in downtown, now a **Crowne Plaza Hotel** that adapted the shapes of the silos for its rooms. — Akron, Ohio

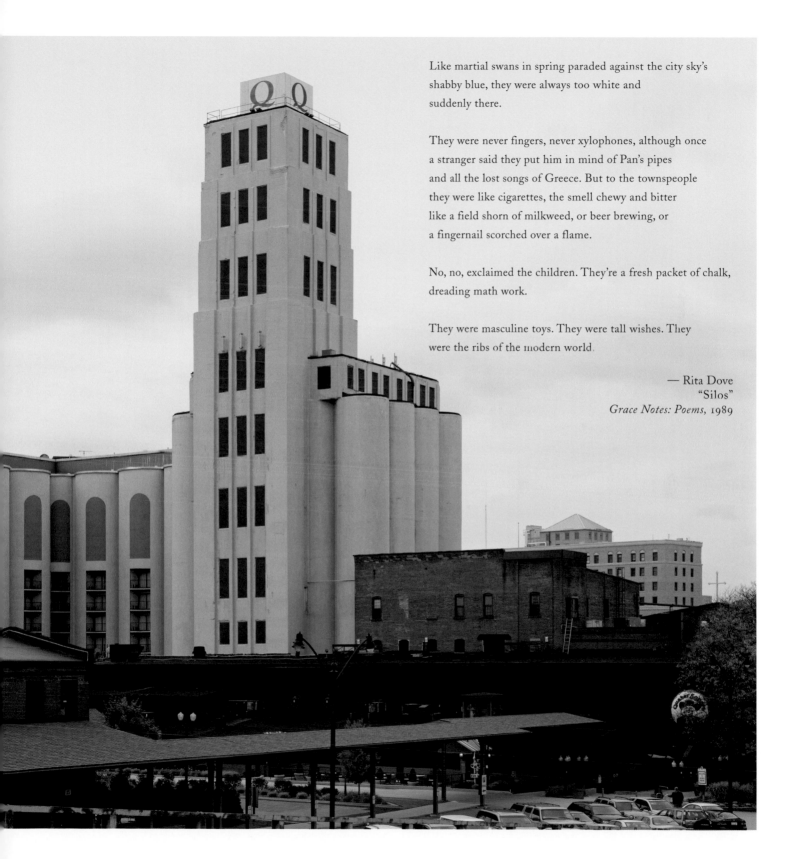

Like martial swans in spring paraded against the city sky's
shabby blue, they were always too white and
suddenly there.

They were never fingers, never xylophones, although once
a stranger said they put him in mind of Pan's pipes
and all the lost songs of Greece. But to the townspeople
they were like cigarettes, the smell chewy and bitter
like a field shorn of milkweed, or beer brewing, or
a fingernail scorched over a flame.

No, no, exclaimed the children. They're a fresh packet of chalk,
dreading math work.

They were masculine toys. They were tall wishes. They
were the ribs of the modern world.

— Rita Dove
"Silos"
Grace Notes: Poems, 1989

Rita Dove

PROPOSED NEW NORTH HILL VIADUCT, AKRON, OHIO.

Artist's rendering of the proposed Akron Viaduct. The finished version was almost equally impressive, another example of the manmade sublime in America that has exerted a grip on the imagination of one of its writers. The Viaduct was completed in 1922. In 1932, in the throes of the Great Depression, the Vice-President of the First Central Trust Company leaped to his death off the Viaduct. Over the next decades, the structure took on a grisly sideline as a popular jumping-off point. When pieces of the Viaduct began crumbling off, it was replaced in 1981 by the "All America" Y-Bridge—one of the few of its kind in America—but the suicides did not stop. As of this writing, a debate rages over whether to fence the bridge. Could be this poem, among other things, is suggesting that, while he may have had his issues, thankfully Thomas was not the suicidal type.

novel called *Through the Ivory Gate*, and in other poems scattered throughout her seven other books of poetry. Rita Dove is no longer a resident of Akron, but when she grew up there, she kept her eyes and ears wide open, and took in the city with a poet's intensity. Her major subject is the stories that do not make it into the history books. In a poem called "The Gorge," she writes of the Cuyahoga river receding, leaving "a trail / Of anecdotes, / The poor man's history."[1] That is Dove's territory.

The history of Akron has everything to do with the rise of rubber. Benjamin Franklin Goodrich started making rubber hoses in Akron around 1870, after seeing a neighbor's house burn down when the fire hose malfunctioned. Harvey Firestone arrived in Akron in 1900 and started a company to make rubber rims for buggy wheels. The Goodyear company was named after

the man who first vulcanized rubber.[2] Faced with a seemingly insatiable demand, Akron expanded, bringing laborers from the South and immigrants from Europe. Just like the steel mills in nearby Lorain that lured Toni Morrison's family, the rubber companies offered the promise of a good life.

In 1906, Rita Dove's maternal great grandparents and their two-year-old daughter moved to Akron from Georgia. Dove's grandfather arrived in 1921. He was born in Wartrace, Tennessee, also the birthplace of Strolling Jim, the first champion Tennessee Walking Horse. He did not originally intend to move to Akron. He and his friend Lem left Wartrace for the riverboat life, "with nothing to boast of / but good looks and a mandolin."[3] As the book *Thomas and Beulah* starts out: one evening, on their slow, churning way up the Mississippi,

Thomas dared Lem to swim to a island that they could see from the deck of the ship. Lem dove into the river and drowned. Alone, Thomas wound up in Akron, "on the dingy beach / of a man-made lake."[4] That man-made lake was Wingfoot Lake, dug in the shape of Goodyear's winged foot logo, near the home of the Goodyear blimp. Thomas wooed Rita Dove's grandmother with his mandolin and his silvery voice. He got a job working at the Goodyear Zeppelin Airdock to support them, and they had a succession of daughters.

Elvira, the daughter who became Rita Dove's mother, was quite bright. She graduated from high school at the age of 16, having skipped two grades. She wanted to attend Howard University but her parents deemed her too young, and ultimately she did not attend college. In his boyhood, Ray A. Dove, Rita's father, lived through hard times. But Ray was gifted in math. His family decided he was college bound and pinned all their hopes on him. During the Depression years, they sometimes went without shoes so that Ray could attend school with a decent pair. Their sacrifice paid off: Ray Dove obtained a master's degree in chemistry and he became the first black chemist in the rubber industry in Akron.

Rita Dove was Elvira and Ray's first daughter. She grew up hearing stories that her grandparents told about their lives. She was encouraged to read, and she did, voraciously. At one point, when a librarian refused to let her take out a book that was considered too adult, she came back to the library with a note from her mother stating that she was allowed to take out any book she pleased. She was also encouraged to work things out for herself, to become self-reliant, for that was how her father had succeeded. He even taught himself German when he was sent to Germany with the military.

There was music in the house, too, and it suffused the home with emotion. If the music on the stereo on Saturdays was Bessie Smith, it meant that her father was feeling melancholy. If classical music was playing, it meant she and her brother were in trouble because he was in an "exacting frame of mind."[5] As a youth, Rita Dove was interested in writing, but she never thought that much about becoming a poet, or a writer of any kind, until one evening in the 11th grade, one of her teachers took her to an appearance

He avoided the empty millyards,
the households towering
next to the curb. It was dark
where he walked, although above him
the traffic was hissing.

He poked a trail in the mud
with his tin-capped stick.
If he had a son this time
he would teach him how to step
between his family and the police,
the mob bellowing
as a kettle of communal soup
spilled over a gray bank of clothes....

The pavement wobbled, loosened by rain.
He liked it down here
where the luck of the mighty
had tumbled,

black suit and collarbone.
He could smell the worms stirring in their holes.
He could watch the white sheet settle
while all across the North Hill Viaduct

tires slithered to a halt.

— Rita Dove
"Under the Viaduct, 1932"
Thomas and Beulah, 1986

of John Ciardi—one of the literary lions of the day, translator of Dante's *Inferno*, fixture at Breadloaf, interpreter of Robert Frost. It was her first encounter with a living writer and it made a deep impression. She went on to study writing in college and the rest, as they say, is history—and History.

In her poetry, Rita Dove has always taken what she has found, or experienced, and spun something from it. As a child, she found

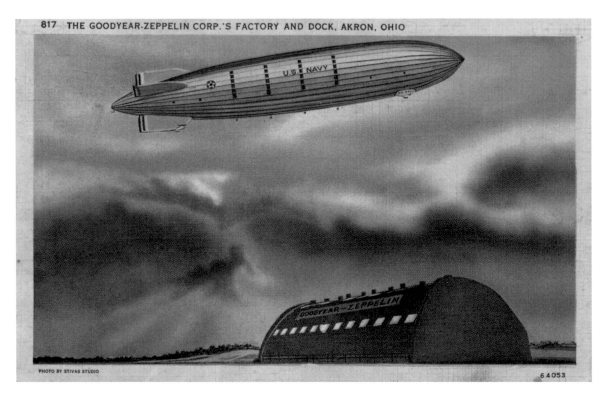

PHOTO BY STIVAS STUDIO

6 4053

In 1923, the Goodyear Tire and Rubber Company formed a subsidiary, the Goodyear Zeppelin Corporation. In 1929, the Goodyear Zeppelin Airdock was built. At the time, it was the largest structure in the world without interior supports. The building was so large that it had its own weather. Besides the minor disaster that the USS Akron experienced in the poem, a major one occurred later when she crashed in 1933 off the coast of New Jersey. Since no life preservers were included, 73 crew and passengers perished. The gigantic shape of the Goodyear Zeppelin Airdock is still visible, and in use, along Route 224, east of downtown Akron.

that she "wasn't represented in History—I'm talking of History with a capital H—neither as a female nor as a black person." She had "the nagging sense that ordinary people were not represented in history, that history gives you the tales of heroes, basically."[6] Dove became adept at poking around in the detritus of history and coming up with treasures. One of her best-known and arresting poems is called "Parsley." The bright green binding of a book caught her attention at a literary event in Germany. Picking it up, she read of an incident she had never seen mention of: On October 2, 1937, Rafael Trujillo (1891-1961), the dictator of the Dominican Republic, massacred thousands of black people on the grounds of a word. The dividing line between salvation and death came down to whether they had the ability to roll the letter "r" in *perejil*, the Spanish word for "parsley." 20,000 black people could not, and were summarily executed.

"My mission," Dove has said, "is to restore individual human fates to the oeuvre."[7] Nowhere has she done that more beautifully than in *Thomas and Beulah*, which is also a loving tribute to Akron. On the cover of the paperback edition, published in 1986 by Carnegie-Mellon University Press, there is a shot taken in 1952—the year of Rita Dove's birth—by Ray A. Dove. In the photo, a proud-looking African American man, his hat at a rakish angle, has his arm around the shoulder of a smiling African American woman. They stand in front of a large automobile. Behind them is what looks to be a road, and in the open fields behind the road stand three objects: a house obscured by a tree; a pair of smokestacks rising out of the field; a typical Ohio frame house painted white. This must be Akron as it was then: the city creeping into the country, smokestacks planted in what were green fields.

Thomas and Beulah consists of 44 poems: 23 from the perspective of Thomas and 21 from the perspective of Beulah. Dove has said that the book was originally conceived of as a triptych, the third "panel" being Akron. While Akron may not have wound up with its own discrete section, physical places in Akron often come into view in the verse. The book is the story of two lives. It is the tale of Thomas, who desperately wants boys but fathers only girls, who hangs up the mandolin and joins the gospel choir, giving up the life of an itinerant musician for the life of a provider. And it is the tale of Beulah, who would have preferred that her man play the pianola to the mandolin, who has dreamed since youth of going to Paris but got no further than a chair lugged behind the garage for a little time to herself while her children napped. Thomas fishes, while Beulah cleans the fish that he catches, and "sweeps the kitchen floor of the river bed her husband saw fit to bring home with it."[8] Beulah outlives Thomas to witness the 1963 March on Washington on her TV set shortly before she is stricken with glaucoma.

The book is like the city of Akron: once one knows the location of a few simple landmarks—the Gorge that splits the city, Market Street that runs parallel to it, the skyscrapers—one can navigate the city. Similarly, certain things have loomed large in Thomas and Beulah's lives—the death of Lem, for example, or Beulah's abusive father—and have set a course to steer by. A chronology at the end of the book helps. It sets down Historical events with a capital "H" along with the events of personal history. In any case, the book is not meant to be roared through as one would do with a car. Each poem, so simply set down, is full of nuance and reverberations and deserves time and attention.

A quote at the beginning of the Thomas section of *Thomas and Beulah*, attributed to Melvin B. Tolson of the Harlem Gallery, asks:

> Black Boy, O Black Boy,
> Is the port worth the cruise?

If you were to ask this question of the Doves, who produced, after their third generation in Akron, a Poet Laureate of the

The zeppelin factory
needed workers, all right –
but, standing in the cage
of the whale's belly, sparks
flying off the joints
and noise thundering,
Thomas wanted to sit
right down and cry.

That spring the third
largest airship was dubbed
the biggest joke
in town, though they all
turned out for the launch.
Wind caught,
"The Akron" floated
out of control,

three men in tow –
one dropped
to safety, one
hung on but the third,
muscles and adrenalin
failing, fell
clawing
six hundred feet.

Thomas at night
In the vacant lot:
 Here I am, intact
 And faint-hearted

Thomas hiding
His heart with his hat
At the football game, eyeing
The Goodyear blimp overhead:
 Big boy I know
 You're in there.

— Rita Dove
"The Zeppelin Factory"
Thomas and Beulah, 1986

Rita Dove

Swing low so I
can step inside –
a humming ship of voices
big with all

the wrongs done
done them.
No sound this generous
could fail:

ride joy until
it cracks like an egg,
make sorrow
seethe and whisper.

From a fortress
of animal misery
soars the chill voice
of the tenor, enraptured

with sacrifice.
What do I see,
he complains, notes
brightly rising

towards a sky
blank with promise.
Yet how healthy
the single contralto

settling deeper
into her watery furs!
Carry me home,
she cajoles, bearing

down. Candelabras
brim. But he slips
through God's net and swims
heavenward, warbling.

— Rita Dove
"Gospel"
Thomas and Beulah, 1986

United States, it is hard to imagine that the answer would be anything other than yes.

Racism in America did not go away. But determination, sacrifice, some individual brilliance, Historical (with a capital "H") events—and the passage of Time—took away some of its venom. The strained relations that Toni Morrison witnessed between European immigrants and African Americans had changed after a generation of assimilation: Dove in fact partially credits Akron for the reason she learned German: "If I hadn't grown up in Akron, which boasted a sizable German-American community, I never would have sung German songs in fifth and sixth grade—thanks to a string of German war brides looking for something to do."[9] Her father set a standard for excelling in that which he set his mind to. In the altered racial landscape of mid- to late-20th century America, Dove rose to the top of her calling and was recognized for it.

Dove has chosen not to focus solely on her blackness in her writing. For her forebears, blackness was so often about otherness, about keeping something back. "We wear the mask that grins and lies," she has quoted from Paul Laurence Dunbar. Dove has said her desire was to write about growing up middle class in the Midwest, about Akron. And she has succeeded admirably. Here is one of those fact-based ironies that she might enjoy: Joseph Priestley, the clergyman and scientist often credited with discovering oxygen, named a substance "rubber" for its ability to rub things out. Rita Dove, daughter of the first black chemist in the tire industry in Akron, has created an oeuvre based on doing the opposite. She has brought those seemingly erased details back. ॐ

In "Compendium," Dove writes that Thomas gave up fine cordials and his houndstooth vest and became a "sweet tenor" in the gospel choir. At some point, it seems to have lost its power to inspire him. According to the chronology at the end, he quit the choir at this **AME Zion Church** in 1946. — Akron, Ohio

— Newark, New Jersey

"The manmade horizon, the brutal cut in the body of the giant city—it felt as though they were entering the shadow world of hell, when all the boy was seeing was the railroad's answer to the populist crusade to hoist the tracks above the grade crossings so as to end the crashes and the pedestrian carnage."

— Philip Roth
American Pastoral, 1997

Twentieth Century Excursions

Henry Miller • Ernest Hemingway • Flannery O'Connor • John Updike

Philip Roth • Raymond Carver • E. Annie Proulx • Richard Ford

HENRY MILLER (1891-1980)

A Patriot — of the 14th Ward, Brooklyn

*A*N 1971, A REMINISCENCE by Henry Miller appeared in the *New York Times*, accompanied by a photo of the author at age four in a dandy suit and enormous hat adorned with a white feather. He stands there with a confident air that survived to his adulthood. And writing about his youth, as an 80-year-old man, he was just as full of wonder as he had been as a boy. "As often as I have written about 'the old neighborhood'," he began, "I never seem to exhaust the subject. I began my sojourn in Paradise in the first year of my life, at 662 Driggs Avenue, Brooklyn, and I remained there until 1899, when the family moved to the Bushwick section and my life began all over again, it seemed."

In those early days, Miller appeared richer than many of his neighbors and friends. His father was a boss tailor and his son had an enviable wardrobe. His fancy apparel required that he become fleet of foot, in order to outrun the boys from other neighborhoods that might beat him up if they found the little fop alone. But happy he was in those days. As Robert Ferguson, one of Miller's biographers, put it: "It seems reasonable to speak of a sort of reverse paranoia in which he suspected others of plotting secretly among themselves to find ways of increasing his happiness."[1] He was a precocious boy who showed a taste for reading early on. And with his doting parents' encouragement, he began to read voraciously. Within his own family, Miller was the child who shone. He had a sister, Lauretta, who was learning disabled. His mother tried to educate Lauretta but it was no use, a frustrating experience that served only to make both of them miserable. Miller became the one upon whom all hopes were pinned.

On the street, however, he was learning the coarser lessons of life. Driggs Avenue was a daily parade of human eccentricity and frailty, fascinating to a boy. There was Mrs. O'Melio, who

(Right) The only house still standing on its block: **Henry Miller's first home at 662 Driggs Avenue**. The Millers left there in 1899.
— Brooklyn, New York

190 ❖ *A Journey Through Literary America* • *Twentieth Century Excursions*

Henry Miller
Brooklyn, New York ❖ 191

fed 35 or 40 cats—on a tin roof no less—over the veterinarian's stable. There was Crazy Willy, who frequently decided he was a horse and went around whinnying and pawing the air. Crazy Willy also gave displays of public masturbation every day at six o'clock to the passengers on the trolley coming home from work, and the boys often made "good sport" of beating him up.

For men in the neighborhood—the German section of Brooklyn, which teemed with breweries—the sport of drinking was king. On the corner of Driggs Avenue there was a conveniently located saloon. In that 1971 article, Miller recalled: "I remember the saloon because as a child I was often sent to get a pitcher of beer at the side entrance; we called this 'rushing the growler.'"[2] A few doors from the three-story brick townhouse in which the Millers lived were "the shanties, two or three decrepit buildings right out of a Dickens novel." One of them was a candy store operated by the Meinken sisters. Farther down the street squatted the Novelty Theater, locally known as "The Bum." The Bum featured burlesque shows frequented by drunken sailors. Henry and his friend used to loiter near the theater trying to pick up dirty jokes.

Miller was the golden boy of 662 Driggs Avenue. But like many a little urchin, he was an accomplished actor, able to slip into an entirely different existence outside the home and then return with an air of innocence and childlike simplicity. Apart from being coddled and encouraged at home, what made those early years a paradise to him was a rich supply of youths, many of whom became his friends. With those friends, he would go on expeditions across town to beat up sissies, and engage in all sorts of looting, marauding and mischief. His greatest friend was Stanley Borowski. Stanley was a leader because "only he, it seemed, knew when to call a halt to our depredations."[3] Stanley also defended Crazy Willy from some of the more zealous bullies in Miller's group. Only he knew how to calm Willy down.

For all his life, Miller reserved great loyalty for the memories of the boys of his youth, his early role models. "The boys you worshiped when you first came down into the street remain with

*(Left and Right)*Brooklyn Relic: the kind of establishment where young Miller might have been sent for a schooner of beer for his father. This **Biergarten** is just blocks away from Driggs Avenue. — Brooklyn, New York

Henry Miller

you all your life. They are the only real heroes. Napoleon, Lenin, Capone—all fiction. Napoleon is nothing to me in comparison with Eddie Carney who gave me my first black eye...Robinson Crusoe lacked imagination in comparison with Johnny Paul... Johnny Paul was the living Odyssey of the 14th Ward; that he later became a truck driver is an irrelevant fact."[4]

When Miller was nine, the Millers moved away from Driggs Avenue to a house on Decatur Street, Brooklyn. Later, he referred to that new locale as "The Street of Early Sorrows." He had quit Paradise for something far inferior. But his relationship with the old neighborhood continued. He chose to attend a high school that was right near Driggs Avenue. And perhaps part of the allure of his first love, Cora Seward, was the fact that she lived in that beloved quarter his family had abandoned, had spent her girlhood on familiar streets. Every night, Miller later related, he would set out to walk by the house of his sweetheart. "I walked these 6 or 7 miles just to see if by chance she were visible at the window downstairs or upstairs (I might add, she never was). But this nightly excursion gave me the chance to walk through the rear end of Williamsburg, so to speak, through streets like Graham Avenue and Flushing Avenue, Maujer, Ainslee, Conselyea Streets, all unforgettable, all terribly nostalgic."[5]

Writing about her, decades later in the *New York Times*, he was finally able to toss the affair off fairly lightly as being "most unfortunate, almost Hamsunesque." Knut Hamsun was one of his great literary heroes, to whom Miller accorded the same lifelong loyalty and admiration as the Stanley Borowskis and the Johnny Pauls. Hamsun's stories were of obsession and powerful emotion. But Miller's love for the fair-haired Cora, an affair that had been carried on as purely as the driven snow—and which may have been requited if he had ever had the courage to act—lingered with him. "In all the years which have since elapsed she remains the woman I loved and lost, the unattainable one. In her China-blue eyes, so cold and inviting, so round and mirror-like, I see myself forever and ever as the ridiculous man, the lonely soul, the wanderer, the restless frustrated artist,

(Left) **Shop window, in the old neighborhood**: Henry Miller and his hero, D.H. Lawrence, did much to bring sex out of the literary bedroom and into the light of day.

(Next *pp.* 198-199) **Fillmore Place**. — Brooklyn, New York

the man in love with love, always in search of the absolute, always seeking the unattainable."[6]

Miller graduated from high school, and the prison-house of maturity began to close upon him. The early promise he had shown in school did not translate into any practical job. He worked in his father's tailor shop. His father was drinking heavily at the time, often to the point of incapacitation, invoking the wrath of his mother, who always felt she had married beneath herself anyway. Miller took up with a dark-haired widow, and eventually married her. It was a good way to get out from under his parents. He was to marry many more times during his life, always to dark-haired women.

By far, Henry Miller's most famous marriage was to June Mansfield, a worthy obsession, who spawned thousands of words in *Tropic of Cancer*, *Tropic of Capricorn*, and the trilogy of "The Rosy Crucifixion." June was attractive, though not stunningly so. But she was tremendously alluring to men and to women. "She's America on foot, winged and sexed," Miller once exulted as he described seeing her on Broadway—June's realm. "Opulence, she has, and magnificence; it's America right or wrong, and the ocean on either side. For the first time in my life the continent hits me full force. Whatever made America made her, bone, blood, muscle, eyeball, gait, rhythm, poise, confidence, brass and hollow gut."[7] What materializes from Miller's writing, and from other accounts of her, is a woman whose every move, every word, every gesture was laden with suggestion that she could be the answer to one's dreams and fantasies. June deserves her own temple within the literary world. For not only did she seduce and inspire Miller. Later, in Paris, she did the same to Anais Nin—one of the most famous writers of erotica of the past century, and Henry Miller's lover.

Paris, and publishable books, came much later. First came the living, the loving, the betrayals and the horrible jealousy, Miller's failed starts as a writer, and the various ways to make ends meet in New York City. June worked as a hostess at the Pepper Pot for a while—a bohemian hangout in the Village where she cultivated many admirers. The two became micropublishers, selling tracts written by Miller, whose childhood self-regard had blossomed into a conviction that he was a great writer. Henry and June ran

a speakeasy at one point as well. It was a bust. The surest way to make money was for June to solicit patronage from her many male admirers. They believed her capable of almost anything—or pretended to, at least. At one point Miller even ghost-wrote a book for June to fob off as her own.

Miller's one memorable stint in employment (and one of his only stints, period) was for the Western Union telegraph company, which he transformed into the Cosmodemonic Telegraph Company when he depicted it in *Tropic of Capricorn*. He made ends meet by sponging off his friends, many of whom he celebrated in *Book of Friends*, published when he was 85 years old. Jimmy Pasta was Miller's rival in school and grew up to be a wheel in the local government. He later helped Miller out with a job and several loans. Stanley Borowski, the leader from boyhood, was writ large in the book as well. He wanted to be a writer, preferably like Joseph Conrad, a fellow Pole who had mastered the English language. Like Jimmy Pasta, he lent a hand to Miller who had by then honed his talent for putting the touch on people to an art form. Perhaps the shamelessness in his approach harkened back to the feeling of entitlement he was bestowed with as a young child, the golden boy. Stanley, however, was as cool and perceptive as he had been as a youth. He invited Miller and June into his home to stay until they found a job. When he realized after a while that they had no intention of actually trying he cleared them out of the house, brought them to the subway station, shook hands and handed Miller a dime. And that was the last Henry Miller ever saw of his first great childhood friend.

From 1928 to 1929, Miller visited Paris for the first time, accompanied by June. In 1930, he moved there, with the expectation that June would follow. From a writing, financial and marital perspective he had been at a dead end. But Miller was always an optimist. It is difficult to imagine what he thought he would do there. Not that he was interested, but the wave of expatriate writers of the period—notably Ernest Hemingway, Gertrude Stein, and F. Scott Fitzgerald—had already passed in the early 1920's. Henry Miller was a very late party crasher, in worn-out clothes, owlish glasses, and a thick Brooklyn accent. He went to the American Express office daily to see if a cable of money had arrived. But every day there was no news. It seemed as though June had deserted him. Despite all his difficulties, he loved Paris. "For one thing," he said, in a *Paris Review* interview, "I found a freedom such as I never knew in America." It was only a matter of time before the irrepressible Miller found friends there who would help support him.

It took going to Paris, losing (or jettisoning) June, and countless hours banging away at the typewriter, before he slowly realized he was meant to write semi-autobiographically. Even though he was virtually abandoned there, with no money and no prospects, he loved the city. He kept up his habit of walking miles and miles, exploring the city, keeping hunger at bay.

He saw much of Brooklyn in Paris. "In Paris I discovered a replica of that microcosm called the 14th Ward. In the poor quarters of Paris where I wandered penniless and unknown for many a day and month I saw all about me the sights of my childhood days when I was a spoiled brat. Again I saw cripples, drunks, beggars, idiots roaming the streets. Again I felt I was in a man-sized world, a human microcosm suited to my taste."[8] He described in a letter to his friend how, in Paris, "you look down one street and it seems like the end of the world is at hand; down another and you feel that you are standing at Eastern Parkway near Atlantic Avenue, Brooklyn….Each street promises the end of the rainbow."[9]

This was similar language to what he used so many years later when writing about Brooklyn and the existence of what he called "dream streets." As he described them, those were "streets which I only imagine I knew, and the memory of which was so strong, so vivid, that years later when I was fully grown, I would return and try to find these streets which never existed except in my dreams. I remember particularly the feeling of alien land about the neighborhood flanking Metropolitan Avenue."

Indeed, on the streets of Paris and New York City, one can get the sensation of being in a dream. One may look down a long avenue or boulevard, a formidable line of facades and rooftops on either side, broken only by cross streets that allow the passage of vehicles and persons that flit across one's perception and disappear on the other side on their way to unknown destinations. The long avenues and boulevards narrow into the distance. If

a cloud formation passes, or a stray radiance pierces that point at the far extent of one's gaze, one can be transported. So it was with Miller, often hungry, or slightly intoxicated, or oversexed, who needed little encouragement to get the sensation that he was looking at things with a cosmic eye.

In the Brooklyn of Miller's youth, brick townhouses like the one on Driggs Avenue and the ones on Fillmore Place (one of his favorite streets) made a similar procession into a near distance that was unknown and fascinating to the young writer. At the beginning of the 20th century, the sights and smells of Brooklyn must have been enough to make one swoon. "When I think of those streets now," Miller wrote, "they are usually in full sunshine. Everywhere bright awnings, parasols, flies and perspiration. No one is running or pushing and shoving. The streets are becalmed, swimming in heat, and slightly perfumed with rotting fruit. At the veterinary's a stallion is pinned to the earth and his balls are being cut off. I can smell the scorched, seared flesh. The shanties, which are already caving in, seem to be melting. From them issue dwarves and giants, or little monsters on roller skates who will grow up to be politicians or criminals, whichever way the dice roll. The brewery wagon with its huge kegs of beer looks gigantic."[10]

There was more to the significance of "dream streets" than a pleasant feeling of disorientation. Miller became increasingly devoted to astrology, for its claim that a system existed in the cosmos that could chart his life. He was a seeker after the end of the rainbow. And for all the rough nature of his youth as a Brooklyn boy, for all of the shabbiness and squalor that surrounded him for more than half of his life, the author Henry Miller wrote exalted prose. From one sentence to another he was capable of suddenly leaving the earth, of making great leaps of improvisation.

Ten years after leaving for Paris, he came back, still penniless. Writing about it later he reflected that the homecoming was one of the "worst periods" in his life. He returned to Decatur Street on the Eighth Avenue subway, which was new at the time, and got lost immediately. "Not that the neighborhood had changed so much; if anything, it was I who had changed. I had changed so completely that I couldn't find my way anymore in the old

surroundings."[11] There was a funeral parlor on the corner of his "street of early sorrows" and he recognized the name of the proprietor as a neighbor from back in the Driggs Avenue days. He wondered, with his trademark humor, whether the man was following them—as if he knew the Millers "would shortly be in need of his services."

Coming home, Miller had much use for his wry sense of humor. He had returned on foot, without any money to show, to a father attached to a urine bag, and a mother and sister who had aged considerably. Almost the first words out of his mother's mouth were: "Can't you write something like *Gone with the Wind* and make a little money?" Miller burst into tears. He had come back to Brooklyn, which on one level he loved so much and on another had tried so hard to escape. Still, at heart he was a Brooklyn boy, one who had developed the ability to talk about everything. He was a Brooklyn boy grown older, who revered a life he had lost, his carefree childhood. It is that knot of emotions, combined with his search for the absolute and unattainable, that gives his best writing the power of a conjuration.

"One passes imperceptibly from one scene, one age, one life to another," he wrote. "Suddenly, walking down a street, be it real or be it a dream, one realizes for the first time that the years have flown, that all this has passed forever and will live on only in memory; and then the memory turns inward with a strange, clutching brilliance and one goes over these scenes and incidents perpetually, in dream and reverie, while walking a street, while lying with a woman, while reading a book, while talking to a stranger…suddenly, but always with terrific insistence and always with terrific accuracy, these memories intrude, rise up like ghosts, and penetrate every fiber of one's being….In youth we were whole and the terror and pain of the world penetrated us through and through. There was no sharp separation between joy and sorrow: they fused into one, as our waking life fuses with dream and sleep….And then comes a time when suddenly all seems reversed. We live in the mind, in ideas, in fragments. We no longer drink in the wild outer music of the streets—we *remember* only. Like a monomaniac we relive the drama of youth. Like a spider that picks up the thread over and over and spews it out according to some obsessive logarithmic pattern."[12]

Horton Bay & Walloon Lake, Michigan

ERNEST HEMINGWAY
(1899-1961)

ALTHOUGH William Faulkner and Ernest Hemingway both became literary giants, in most respects the diminutive Faulkner from Mississippi and the strapping Hemingway from Oak Park, Illinois, couldn't have been much more different. However, as World War 1 drew to a close, they followed a remarkably similar path. Both wanted desperately to be heroes in the Great War. Faulkner joined the Canadian Air Force, though the war ended before he ever flew a mission. Hemingway found his way to the front as an ambulance driver. Neither man had the opportunity to see much action. But one might say they improvised. Each saw a good tailor and returned resplendent in a uniform that was better than standard issue. They practically wore their uniforms out in those months after the war, walking around their hometowns with pronounced limps and retailing tales of their heroism to an unskeptical public still thirsty for heroes. Hemingway's account of valor was in the papers the day after he stepped off the ship. He made sure of that. It was an early sign that he meant to assume full creative license with his life story.

Hemingway did in fact get shot in the leg, while delivering chocolate and cigarettes to soldiers on the Italian front. He spent many nights lying sleepless on a cot in Italy, troubled by pain and shaky nerves. While many young men in his position found their thoughts returning to their home towns and villages, to memories of their families or sweethearts, it seems that his alighted near Walloon Lake, a sliver of water close by Lake Michigan in upper Michigan where his family spent each summer. That was where he had had the most glorious time of his young life.

Horton Bay dock on Lake Charlevoix:
leaping-off point for Hemingway's adventurous life.
— Horton Bay, Michigan

Ernest Hemingway

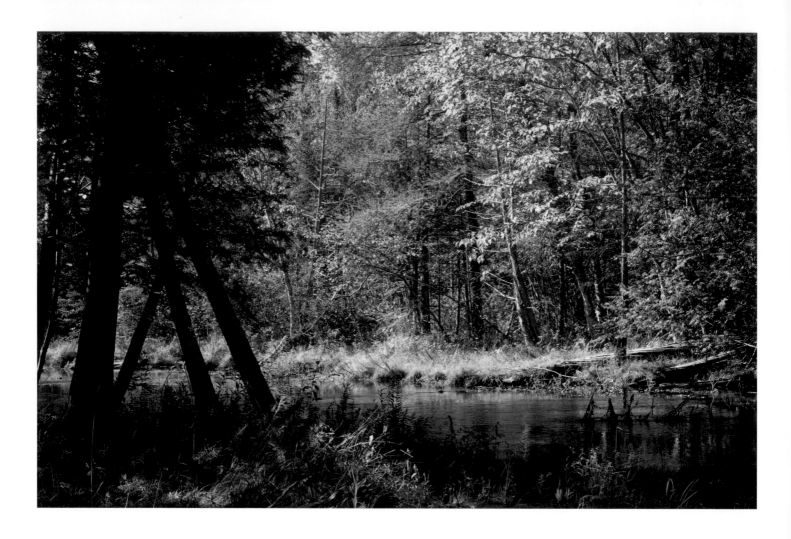

I had different ways of occupying myself while I lay awake. I would think of a trout stream I had fished along when I was a boy and fish its whole length very carefully in my mind, fishing very carefully under all the logs, all the turns of the bank, the deep holes and the clear shallow stretches, sometimes catching trout and sometimes losing them....Some nights, too, I made up streams, and some of them were very exciting, and it was like being awake and dreaming.[1]

The words come from Nick Adams in the short story "Now I Lay Me," but they were written by Ernest Hemingway. Nick Adams was the protagonist of 24 stories that were published over the course of many years. He was one of Hemingway's first alter egos and it is easy to see why he often returned to him.

Nearly every great American author seems preoccupied with his or her youth. But for Hemingway it was just the few months per year he spent at the lake that seemed to interest him. Nick Adams was the vessel for his reminiscence. Lying injured in the darkness in a wartime hospital, just like Hemingway had done, and with thoughts of death lurking in the periphery, Nick Adams did what he could to steel himself. He tried prayer. He tried thinking about girls. But the girls blurred together after a while. The trout streams did not. Nick could always reach the streams.

Nick Adams first appeared as a young boy on a fishing trip. He was ashamed. The night before, his father and his uncle had left him alone in the tent while they did some night fishing. He'd sat up thinking of the hymn that went "some day the

(Above and Left) **Horton Creek Nature Preserve,** whose clear water bulges like a meniscus. — Horton Bay, Michigan

"Nick looked down into the clear brown water, colored from the pebbly bottom, and watched the trout keeping themselves steady in the current with wavering fins. As he watched them they changed their positions by quick angles, only to hold steady in the fast water again. Nick watched them a long time."

— Ernest Hemingway
"Big Two-Hearted River"
In Our Time, 1925

Ernest Hemingway
Horton Bay & Walloon Lake, Michigan ❖ 203

silver cord will break" and realized for the first time, that one day his would too. He panicked and fired the rifle three times, their distress signal. "You don't ever want to be frightened in the woods, Nick," his father told him the next day. "There is nothing that can hurt you."[2] Indeed, the only thing that ever hurt Nick Adams was other people.

At Walloon Lake, Hemingway's father taught him how to hunt and fish. And taught him well; he was an excellent outdoorsman and possessed of an incredible pair of eyes that saw, as Hemingway put it, "as a bighorn ram or as an eagle sees, literally". It was at Walloon Lake that he encountered real Indians: the Ojibway tribe, whose members made their living by selling baskets or berries, or peeling bark from the hemlock trees to be used for tanning. It was there he learned woodcraft from Billy Gilbert, a man who was "a part of the forest, one of the last of the old woods Indians."[3] It was there too, under a canopy of trees, that a girl named Trudie did for the first time for Nick "what no one has ever done better." We are meant to believe that such pleasure was also the young Hemingway's, though biographer, Michael Reynolds, has pretty much debunked the myth.

All of this was quite far removed from Oak Park, Illinois, a bastion of morality and good sense outside of Chicago. There, the Hemingways were not in the upper crust but they were undeniably respectable. Grace Hemingway was a formidable woman with a large and beautiful voice—the very picture of the operatic "prima donna." But her ambitions to be a top opera singer are said to have been thwarted by a most unfortunate physical defect: that the klieg lights were too bright for her weak eyes. Hemingway's father, Clarence, had felt the call to be a missionary like his brother. But he produced a big family instead and ended up ministering to the less needy Oak Parkers. Grace and Clarence shared a love for their children, for God, and for writing letters. Hemingway took to his father's interest in the Indians and to the compulsive letter writing far more readily than the religion.

In the early days, probably no one looked forward to summer at the lake more than Hemingway and his father. Weeks in advance, Doctor Hemingway would draw up the list of provisions to be shipped up. (This is one of the more fortunate traits that Hemingway inherited from his father; he became a careful preparer for trips, a cataloguer of supplies, aware that cutting corners could be deadly.) When the day of departure finally came, the trip to the lake was an adventure involving a steamer from Chicago, two train journeys, and then a jaunt on the steamer *Magic*, which plied the tiny lake.

Every summer up at the lake, Hemingway started out with a full set of arrows in his quiver. He would pitch a canvas tent near the cottage and make that his address until the heartsick end of summer came and all the arrows were gone and it was one last hike, one last dive in the lake, before heading south again. It was a bit different when Hemingway portrayed the lake through the Nick Adams stories. In the early stories, we never see Nick in any location besides Walloon Lake, even though he was depicted as a summer resident. Still, an awareness of impending departure was ever present, an eddy in the famous Hemingway undercurrent of things not said, of things endured but not remarked on, of forebodings that were either very accurate or self-fulfilling.

I Know How to Make Country So that You, When You Wish, Can Walk Into It

— Ernest Hemingway
quoted from a letter to Bernard Berenson
March 20-22, 1953

When it came to woodcraft, Ernest Hemingway possessed the pride and certitude of one who has learned it well, and from masters. As for writing, Hemingway sometimes displayed the fervor of a schoolboy. In the story "On Writing," Nick Adams professed that, "He, Nick, wanted to write about country so it would be there like Cezanne had done it in painting….Nobody had ever written about country like that. He felt almost holy about it."[4] Hemingway seemed to feel as though he were on a quest to master a secret craft, a wholly original method of painting the natural scene with words. It is probably in the Nick Adams stories that Hemingway had his breakthrough.

Grave markers at **Greensky Hill Indian Methodist Church**. Prudence Boulton, Hemingway's first girlfriend, is believed to be buried there in an unmarked grave. — Charlevoix, Michigan

Ernest Hemingway

In those stories, Hemingway limned in the details of the land clearly, but with his customary restraint. He added details and movement and woodcraft. The reader did not stand back watching a flat tableau but approached to the edge of the clearing, the bank of the stream, the hollows behind Nick's eyes, and experienced a living scene. For instance, in "Big Two-Hearted River," Nick returns to Michigan, a war survivor with war baggage, to go fishing in the Upper Peninsula. He takes a train to get there, and then hikes in to the river. By the time he finds a level piece of ground, uproots some sweet ferns and makes a camping spot, cuts some tent pegs with an ax and sets up his tent, the reader of the story is very much along for the experience, smelling the pleasant canvas odor of the tent and how it exudes "something mysterious and homelike." The next morning, the reader leaves the tent with Nick:

> The grass was wet on his hands as he came out. He held his trousers and his shoes in his hands. The sun was just up over the hill. There was the meadow, the river, and the swamp. There were birch trees in the green of the swamp on the other side of the river.
>
> The river was clear and smoothly fast in the early morning.[5]

It is a testament to Hemingway's method of rendering country that Nick spends the next 12 pages catching grasshoppers, and then fishing, and yet the story has all the tautness of a fishing line with a good-sized trout at the end of it.

The Country as Nick Adams Saw It

The land around Horton Bay was sacred ground for Ernest Hemingway. He visited his childhood haunts again and again through the character of Nick Adams, embroidering events from his own life into the stories. What could Nick Adams see? In those days, from the top of the sandy hill by the schoolhouse which still stands in Horton Bay you could spy the lights of Petoskey. If your eyes were young or as good as Nick's (or Hemingway's), you could make out Harbor Springs, across Little Traverse Bay. To get from there to Nick's place it was necessary to take a path through the meadow, climb over a fence and down into a ravine and then up through the beech woods, climbing over another fence to reach the cottage. Nick usually made the trip barefoot, his feet toughened by padding around all summer without shoes.

Occasionally, a big storm blew in and big logs that were being floated to the mill in Horton's Bay would detach from the rest and drift to shore. In one instance, in "The Doctor and the Doctor's Wife," Nick's father hired the mixed-blood Indian, Dick Boulton, and his gang of two Ojibway to cut up the logs. That went badly. Dick needled Nick's father about stealing from the mill. There was a standoff but Nick's father walked away. Hemingway had salted the incident away from an actual confrontation between his father and a mixed-blood Ojibway. It was an early sign of something. Not trouble yet, but something.

Between 1840 and 1910, all the white pines had been cut down so that by the time Hemingway was a boy the lumbering part of the town of Horton's Bay, along the lake, was no more. Bunkhouses, dining house, company store and mill offices had all been abandoned and had decayed in a lot full of sawdust. Broken white limestone foundations were all that were left of the mill and they became the headstones to Nick Adams's adolescent romance with a girl named Marjorie in "The End of Something." He broke up with her in sight of them, then lay there by the fire, his face in the blanket, and listened to her rowing away. Like the confrontation in "The Doctor and the Doctor's Wife," the breakup is believed to correspond to a real incident. However, since the story was written while Hemingway's first marriage was disintegrating, some scholars maintain that he had his wife in mind,[6] as well as the death of the way of life that was the Walloon Lake lumbering industry.

What else could Nick see when his face wasn't buried in a pillow? A lot of water. The ground was saturated with it. A cedar swamp ran alongside Horton Creek, which flowed into Walloon Lake. Horton Creek was a clear running stream so full that the water bulged, a meniscus along its entire length. There was also a hotel patronized by the "change-of-lifers," as the owner, John Packard, put it. The change-of-lifers paid good money to sit along the long porch fronting the lake in rocking chairs, and didn't mind that the hotel didn't have a bar. They negotiated dainty paths to drink from the sulfuric water that

(Above) **Red Fox Inn**. The owner of this establishment, which now sells all manner of Hemingway memorabilia, says his grandfather taught Hemingway how to fish. (Next pp. 208-209 from Left to Right) **Horton Bay General Store, Horton Bay United Methodist Church, The Township School, Bay Township Hall.** — Horton Bay, Michigan

bubbled up through three pipes on the hotel lawn. John Packard hailed from the earlier incarnation of Horton Bay when there had been lumbering. He'd owned saloons. And he later aided Nick when he was on the run from the law.

The Nick Adams stories were not written in chronological order. Eight of the pieces in Scribner's Nick Adams collection, where they have been arranged in order, were unpublished in Hemingway's lifetime. Some of them are fragments. Taken as a whole, they tell much about the foundations of Hemingway's interests (hunting black squirrels in the cool woods surrounding Horton Bay gave way to shooting lions in Africa), his obsession with bravery, and his longing for a time at Walloon Lake that was already past when he was a youth. One of the fragments,

titled "The Last Good Country," is a good example. In it, Nick and his sister, "Littless," fled to perhaps the most treasured spot in Hemingway's personal Walloon Lake landscape. It was an old growth forest, beyond the logged part of Horton Bay, with trees that rose high above the heads of the two fugitives and nearly blocked out the sun. "This is about the last good country there is left,"[7] Nick told his sister when they arrived. "This is the way forests were in the olden days."

Navigating by direction sticks that had been set on three ridges in the days when the land had been peopled by Native Americans, Nick brought Littless to the secret place in the depths of the wood: an old Indian campsite with ancient fire stones, alongside a creek that was the undisturbed haunt of

Ernest Hemingway
Horton Bay & Walloon Lake, Michigan ❖ 207

large, hungry trout un-used to man. There, they made camp. Nick was on the run from two game wardens, one of them vicious. His sister was an innocent but willing accomplice. The story does not have an ending. Perhaps the ending was too terrible to contemplate. Someone would have had to die; definitely a warden, and quite possibly either Littless or Nick. The secret spot would have been despoiled. By not completing the story, Hemingway let them all live. Nick grew up, became a soldier, saw action at the front in World War I, and wound up dreaming of trout streams.

A Far-Off Glint of River

There is another bit of terrain in the Nick Adams stories worth exploring. That is the area around Seney, in the Upper Peninsula. Seney had been a den of sin back in the logging days. But when Nick got his bearings after landing from the train in "Big Two-Hearted River," there was "no town, nothing but the rails and the burned over country. The 13 saloons that had lined the one street of Seney had not left a trace. The foundations of the Mansion House hotel stuck up above the ground."[8] The

entire town had been burned over, a sight of devastation like the ones Nick had seen during the war.

Nick walked over to the railroad trestle over the river and looked down at the water "swirling against the spiles," and trout holding themselves even with the current. Then he set out with his pack on his back for the wild country beyond. At the top of the hill he stopped:

> Far off to the left was the line of river. Nick followed it with his eye and caught glints of water in the sun.
>
> There was nothing but the pine plain ahead of him, until the far blue hills that marked the Lake Superior height of land. He could hardly see them, faint and far away in the heat-light over the plain. If he looked too steadily they were gone. But if he only half-looked they were there, the far-off hills of the height of land.[9]

It is a passage that uncannily, but probably unconsciously, echoes Fenimore Cooper and Washington Irving writing of the magic and grandeur of the Hudson and the Pine Orchard—the beginning of time for American wilderness writing. Nick had once more gotten

away from civilization, but this time to settle his troubled nerves. Unlike his experience in "The Last Good Country"—a story that could not be concluded—this time the escape worked. That night after a strenuous hike Nick, usually tortured by insomnia, "curled up under the blanket and went to sleep."[10]

Ernest Hemingway in Michigan

Ernest Hemingway is not famous for being a Michigan writer. He is more recognized for his life in Paris and in Cuba, for big game hunting in Africa, and for his experiences in and novels about the Spanish Civil War. These are all fit subjects for another book of literature and photography. But Michigan is where the Hemingway legend started.

"Nick in the stories was never himself,"[11] Hemingway wrote, as Nick. And upper Michigan was never quite itself either. Hemingway gave the Big Two-Hearted River its name. He invented stretches of that wilderness that Nick trod in. He invented rail lines that ran through the lonely swamp that Nick walked alongside after he got thrown off the train in "The Battler." He put in the swath of old growth forest that Nick and

Littless could hide in where there hadn't been any old growth trees for decades.

"You should have been an Indian. It would have saved you a lot of trouble."[12] So Nick thought in "The Last Good Country." Being one (at least, a romanticized one) would have saved Hemingway some "trouble," too. For one thing, he wouldn't have had to leave the lake at the end of every summer. For another, he could have drank and caroused to his heart's content without any reprisals from his parents. Finally, it could have explained the chip on his shoulder. That chip sat strangely on Hemingway since he came from two loving parents who had given him much and asked for so little in return.

It wasn't as simple as running away and becoming an idealized Ojibway. His father was suffering increasingly from his "nervous condition" and no longer went to the lake. He couldn't tolerate having so many people around without becoming unhinged. Instead he stayed in Oak Park in the stillness of the empty house and wrote letters to his wife every day. But if he didn't receive one in return he became agitated. He wrote many times to Hemingway that he would come to the lake and that

Ernest Hemingway
Horton Bay & Walloon Lake, Michigan ❖ 209

they would hunt and fish together as they once had. But one broken promise led to another, and another.

His mother expected Hemingway to shoulder the responsibility for upkeep and farming on the two properties the family now owned on the lake (against her husband's advice she had bought a farm with her own money, and defiantly named the cottage on it "Grace Cottage"). But Hemingway was having the time of his life with the "summer people"—all around 20, merry, and seemingly unencumbered. The summer of 1919 he shot a blue heron and got caught with it by a game warden. Unlike Nike, he wasn't warned about it by his sister and he didn't have to flee to the old growth forest. The matter was resolved with a $15 fine. But it was a strain on his mother and on his father, who managed things from Oak Park—or thought he did—by letter after letter.

In his 20th year, when all of summer's arrows were spent, Hemingway didn't leave Walloon Lake. He had no steady job. He was an ersatz war hero living what looked like an extended adolescence, but which could also be considered the preordained journey of the would-be writer. He wintered in nearby Petoskey, working on his stories (which found an appreciative audience among local girls like Marjorie Bump but were rejected by the *Saturday Evening Post* as regularly as they were submitted), generally casting the shadow of the great writer to come, and keeping up his voluminous correspondence.

The summer of 1920 came and he took up where he had left off. Since his father wasn't there to challenge, Hemingway had it out with his mother instead. Grace Hemingway, whose mental condition was more stable than her husband's but who was physically worn out from having raised her children increasingly on her own, reached the breaking point and wrote him a devastating letter in which she compared mother's love to a bank. "Many mothers I know are receiving these, and much more substantial gifts and returns from sons of less abilities than my son," she told him. "Unless you…come to yourself,

cease your lazy loafing and pleasure seeking…stop trading on your handsome face, to fool little gullible girls, and neglecting your duties to God and your Savior Jesus Christ – unless, in other words, you come into your manhood – there is nothing left before you but bankruptcy: *You have over drawn*."[13]

Hemingway got the message this time. He moved out of the cottage. Soon he went to Chicago, where he met Sherwood Anderson and also the first Mrs. Hemingway, Hadley Richardson. On the advice of Anderson, they moved to Paris instead of Italy, as they had planned, living close by the Luxembourg Gardens where Faulkner had whiled away hours dreaming of his Estelle. Hemingway's father shot himself while they were in Paris, initiating a tradition of suicide in the Hemingway family. Hemingway was distraught. "My father is the one I cared about," he wrote to his editor, Maxwell Perkins.

If asked later, Ernest Hemingway might have said that his leaving Michigan was absolutely necessary. "The writer who can't leave his country, " he wrote, "is the local color writer." A great writer, he suggested, "five thousand miles away from it looking at the whitewashed wall of a cheap room in any land you can name," can "make it truer than anyone can who lives in it."[14] He spent several years in Paris before he had any publishing success.

Hemingway went back to Walloon Lake for his first honeymoon. So, too, did Nick Adams. Rumor has it that Hemingway returned once more and then never again, commenting that it had gotten too civilized. Nowadays, if one were to get in a car and drive north from Oak Park, Illinois to Walloon Lake, the trip would take about seven hours, counting a bathroom stop and a lunch break at a fast food joint off the highway. A hand-painted sign on the paved road to Horton Bay says, "Jesus died for your sins." In September, some of the year-rounders have firewood for sale at the roadside. By winter those signs are gone. Horton Bay has the look of a place that feels the brunt of the Arctic wilderness but isn't next-door neighbors with it. It consists now, as it did then, of a white painted one-room schoolhouse, the same general store, and a hotel and shop next to it that caters to Hemingway enthusiasts. It could never look the way it did in the Nick Adams stories. Nor did it back then. The writing of Ernest Hemingway made it truer than it could actually be. ✒

Ernest Hemingway

FLANNERY O'CONNOR
(1925-1964)

W HEN I WAS SIX I had a chicken that walked backward," Flannery O'Connor said in a 1959 interview telling of how she and her chicken made it into the local newspaper. "I was just there to assist the chicken but it was the high point in my life. Everything else has been anticlimax."[1] While the backwards-walking chicken earned O'Connor early fame, surely it didn't rival the publication of her first novel or a National Book Award for excitement. The statement is, however, a good introduction to Flannery O'Connor's trademark wit.

Mary Flannery O'Connor was born into a devout Catholic family in Savannah, Georgia, the beloved only daughter of Regina Cline O'Connor and Edward O'Connor. When she was 13 years old, her father moved to a boarding house in Atlanta to be near his job and she and her mother moved to Milledgeville, a genteel town that had once been the capitol of Georgia. There they lived with Regina's two unmarried sisters in a spacious house. And they were regulars at the little Sacred Heart Catholic Church downtown, an understated place of worship in a region of the country where countless denominations advertise salvation in foot-high letters that can be seen across three lanes of traffic.

O'Connor's father was a family man who carried around pictures of chickens that his only daughter had drawn. But he was absent quite a lot. "I really only knew him by a kind of instinct," she told a friend in 1955.[2] When O'Connor was 15, Edward suddenly died of lupus—a disease which, in 1940, was only vaguely understood, and fatal.

Flannery O'Connor was a shy girl. But she showed early evidence of a strong personality and sense of humor. As the story goes, she didn't like the reporter who came to cover the chicken who walked backwards so she refused to let the bird do the trick. Much later, as a student at the Georgia State College for Women, its placid, tree-shaded campus just a five-minute

walk from her home, she contributed stories and cartoons to the *Corinthian*, the college literary magazine. But although she had been writing throughout college, her decision to apply to the master's program at faraway University of Iowa—one of the most celebrated writing programs in the country—must have shocked her mother. She was spreading her wings and making motions as if to leave the nest.

O'Connor was accepted into the program. In Iowa, she started working on her first novel, *Wise Blood*. It is a book that takes place in the South and is populated with misfits, what Sherwood Anderson called "grotesques." [See Sherwood Anderson entry for more details.] The main character is Hazel Motes, a troubled boy obsessed with God, who founds a "church where the blind don't see and the lame don't walk and what's dead stays that way." More than once, she suggested that Hazel Motes was a projection of herself, though his rejection of the essential miracles of the church is clearly at odds with the Catholic religion she embraced. She once joked that her writing belonged to the "School of Southern Degeneracy."

The year 1950 found her in New York City, still working on the novel. As she put it, "I don't have my novel outlined and I have to write to discover what I am doing. Like the old lady, I don't know so well what I think until I see what I say; then I have to say it over again."[3] But it was good to be a promising writer in the publishing mecca of New York, with a book contract (though no book yet) and literary friends.

If her friends noticed that she looked very ill, perhaps they didn't mention it—or perhaps, knowing of her father's fatal lupus, she didn't want to hear of it. When she came home to Milledgeville for a Christmas visit that year she was immediately hospitalized. On December 23rd, she wrote to a friend, "I am languishing on my bed of semi affliction, this time with AWTHRITUS of, to give it all it has, the acute rheumatoid arthritis, what leaves you always wanting to sit down, lie down, lie flatter, etc....I will be in Milledgeville Ga. a birdsanctuary for a few months, waiting to see how much of an invalid I am going to get to be."[4]

But it wouldn't be a few months. Like her father before her, she was diagnosed with lupus. Lupus is a perverse disease that

affects the immune system, convincing antibodies that healthy cells are enemies and should be attacked. Fortunately, treatment was more advanced than it had been in her father's time, though the remedies were sometimes as harsh as the disease itself. Thus prematurely ended O'Connor's footloose period. She was never to live anywhere but Milledgeville for the rest of her shortened life.

Andalusia

Regina O'Connor determined it was best that she and her daughter move out to the deserted farm that belonged to her unmarried brothers, a few miles down the red clay road from town. With no background in farming but a shrewd head for business, Regina transformed Andalusia from vacant farm to thriving dairy operation. Over the years it was populated by cows, ducks, a goose who chased automobiles, scores of

"I am better, up, and working and have just ordered myself a pair of peafowl and four peachicks from Florida—at a price far exceeding my means–"

— Flannery O'Connor
quoted from a letter written to
Sally and Robert Fitzgerald
1952

Perhaps the letter, and the peafowl, marked a turning point. Starting in late 1952, she produced one amazing short story after another. — Georgia

Flannery O'Connor

peacocks that O'Connor ordered by mail, the hired help, and the two spinsters. Nineteen years after she taught her chicken to walk backwards, Andalusia supplied O'Connor with plenty of fowl to observe, probably more than she had ever hoped for. The farm became the well from which she drew to create her fiction.

It must have been exceedingly difficult to accept the prospect of confinement to her mother's care for the rest of her life. In her story "The Enduring Chill," she appears to have dramatized the situation. It begins with a young artistic type returning from his sojourn in the city:

> Asbury's train stopped so that he would get off exactly where his mother was standing waiting to meet him. Her thin spectacled face below him was bright with a wide smile that disappeared as she caught sight of him bracing himself behind the conductor. The smile vanished so completely, the shocked look that replaced it was so complete, that he realized for the first time that he must look as ill as he was.[5]

Young Asbury takes to his bed and wakes up with "a pink open-mouthed face hanging over him," which turns out to be the doctor, who can't diagnose what is wrong with him. Over the next few days, as Asbury gets worse, he is agonized by his mother's endless going on about the dairy cows and their "intimate functions." His mother insists that he must go out on the porch and "enjoy the view" and at last he drags himself out there.

> His hands gripped the chair arms as if he were about to spring forward into the glaring china blue sky. The lawn extended for a quarter of an acre down to a barbed-wire fence that divided it from the front pasture. In the middle of the day the dry cows rested there under a line of sweetgum trees. On the other side of

The front porch at Andalusia. At the outset of a brilliant career, O'Connor came back home for Christmas, only to find she had been stricken with lupus. In her story "The Enduring Chill," Asbury Fox came home from New York in the grip of a serious illness and wound up sitting miserably on a porch just like this, while being nagged by his mother to "enjoy the view."
— Milledgeville, Georgia

Flannery O'Connor
Milledgeville, Georgia ❖ 215

the road were two hills with a pond between and his mother could sit on the porch and watch the herd walk across the dam to the hill on the other side....

He listened irritably while his mother detailed the faults of the help.[6]

There is a front porch at Andalusia that stretches across the front of the house. O'Connor's room was just inside the front door to the left, at the bottom of the stairway. It is easy to imagine her, recently diagnosed and depressed, sitting in a black mood on one of the white porch chairs after having surrendered to a barrage of admonitions to enjoy the view.

Flannery O'Connor's collected letters, *The Habit of Being*, begin when she returned to Andalusia. Its 600 pages of correspondence (uncorrected grammar and imaginative spelling included) are essential to the understanding of her writing, not only because her theories of writing are espoused in there but because they provide such a complete picture of herself and her life on the farm. Something of the precocious, sheltered child lingers in her letters, also a warmth that is obscured in the darker, fiercer stuff of her fiction.

The farm, and a character fitting Regina's description, stepped into several stories. The dairy barn played a role in "The Enduring Chill," "The Displaced Person" and "Good Country Folk," all of which featured a single woman running a farm. Andalusia's appealing little white wooden water tower appeared in "A Circle in the Fire," a story about a boy named Powell and his two juvenile delinquent companions who take advantage of a Mrs. Cope's good Christian offer of some lunch.

One of Powell's eyes seemed to be making a circle of the place, examining the house and the white water tower behind it and the chicken houses and the pastures that rolled away on either side until they met the first line of woods. [7]

Mrs. Cope is the owner of the farm and the land and prides herself on it. But her pride is put to the test. Powell and his band camp on her land, setting free the bull, riding the horse bareback, and fanning her fears that a blaze will consume her precious

woods. (Even today, Andalusia is liberally posted with signs admonishing visitors not to smoke anywhere on the grounds.)

In Flannery O'Connor's fiction, good Christian offers regularly backfire, or are revealed as shams. One story that illustrates this, and seems to be modeled most closely on the workings of Andalusia, is "The Displaced Person." The story takes place on the widow Mrs. McIntyre's farm. It opens with the wife of the dairyman, Mrs. Shortley, climbing a hill, followed by a peacock, so that she can get a good view of the Polish family that Mrs. McIntyre has hired. Their name is Guizac (though Mrs. Shortley and Mrs. McIntyre ignorantly refer to them as the "Gobblehooks" before they arrive). They are survivors of the horrors of World War II and have been hired through a Christian charity.

She ignored the white afternoon sun which was creeping behind a ragged wall of cloud as if it pretended to be an intruder and cast her gaze down the red clay road that turned off from the highway.

The peacock stopped just behind her, his tail—glittering green-gold and blue in the sunlight—lifted just enough so that it would not touch the ground.[8]

The peacock, the red clay road, and the abiding curiosity of the dairyman's wife are undoubtedly Andalusia. The description of the afternoon sun creeping behind the cloud like an intruder is pure Flannery O'Connor.

In "The Displaced Person," Mr. Guizac turns out to be a whiz with machinery and a very hard worker. Regina O'Connor had this same experience with the family of displaced Poles that she brought to Andalusia. As O'Connor put it, "He's the kind who isn't happy unless he's working, and as my mother is the kind who isn't happy unless she's working, they get along just fine." But the new arrivals must have caused a strain in the way things had run at Andalusia, just as they did in the story. The farm was used to a slower pace, and one driving force: Regina. In the story, the hard work of Guizac upset the balance.

View from the porch toward the mule, the one farm animal currently living at Andalusia. — Milledgeville, Georgia

There were resident farmers living at Andalusia all the time. The most notable were named Shot and Louise, an African American couple. With much relish, O'Connor related their activities to her friends. Shot was apparently a bit slow. Regina O'Connor believed that African Americans must be guided with a firm hand, and in her letters her daughter, too, took up this tone of amused but tolerant exasperation with the hired help that thankfully sounds old-fashioned today.

Their attitude toward Andalusia's white help was similarly patronizing. One anecdote jumped full-blown from one of O'Connor's letters into the "The Displaced Person." It concerns the curtains that Regina and the dairyman's wife were making out of old chicken feed sacks for the windows of the displaced person's new home (Regina was parsimonious, a virtue her daughter inherited). "Regina was complaining that the green sacks wouldn't look so good in the same room where the pink ones were," O'Connor wrote, "and Mrs. P (who has no teeth on one side of her mouth), says in a very superior voice, 'Do you think they'll know what colors even is?'"

Flannery O'Connor had a keen ear for the preposterous statement. Her letters are sprinkled with phrases that she had picked up somewhere, such as: "Do you know what the undertakers are doing with the ashes of the folks they cremate? Well, they're sending them to the cannibals to make Instant People out of." Her southern characters uttered all sorts of phrases, many of them deeply ignorant. The word "nigger" is used often, in many different contexts in her stories. A friend related a story about a prominent white southern writer, John Crowe Ransom, who was asked to read one of O'Connor's stories out loud. Every time he got to the word "nigger" he substituted "Negro." "It did spoil the story," O'Connor said, "the people I was writing about would never use any other word. And Mr. Ransom knew that quite well. But he did the only thing a good man could do."[9]

Her Catholic religion strongly influenced her writing. But Catholicism, refracted through O'Connor's eyes, came out strangely. The stories rarely display overt Catholicism. The protagonists often sin (hers was a fallen world) but they don't often find a "happy ending." A recent reviewer made the point that, judging from the stories alone, though one might become confused about how O'Connor felt about God, one could never conclude that she was indifferent to him. "If her God seems unfamiliar," Lesser writes, "it's because he's not one we've seen much of in the centuries since he left off torturing his saints with arrows, flames, and boiling oil."[10] O'Connor once wrote in a letter that, "fiction is the concrete expression of mystery— mystery that is lived."[11] In Catholicism, the greatest concrete expression of mystery is how when one is served bread and wine at the end of a mass, one is eating the body of Christ and drinking his blood as a reminder that he died for the sins of the world. Flannery O'Connor's stories sometimes give one the feeling of digesting a reminder of sin.

Flannery O'Connor's own pungent brand of humor, her numinous subjects, and her unblinking portrayals of rural Southern life made her one of the most contrarily original writers America has ever produced. One wonders if, at such an early age, Flannery O'Connor felt a kinship with the backwards-walking chicken that she took under her wing. They were both gifted with talents that made them different from the norm, talents that their contemporaries would find it difficult to fathom.

Regina and her daughter established a close relationship over the years of O'Connor's stay at Andalusia—one that worked despite their differences. Marryat Lee, one of her main correspondents, described O'Connor and Regina's life in her journal, a year after O'Connor's death:

> They were not antisocial. Oh no. Most days at noon after the 3 hours of writing they drove into town & ate at Sanford House where they met friends (her mother's friends) & kin folk. They picked up the mail and dropped by "Sister's" house ...and then drove back to Andalusia—the whiteboard farm house on rolling hills—with pastures and pine forests. People have described this place in grand terms. It is a simple old, but not early, farmhouse with a screen porch & glorified by dozens of pea fowl perched on the roof and around the yard.[12]

Flannery O'Connor's room at Andalusia, where she wrote, carried on her correspondence, and laid down her crutches, temporarily. — Milledgeville, Georgia

After O'Connor died in 1964, following her long battle with lupus, Regina closed up the place and moved back to town. As a result, Andalusia is like a time capsule. Inside the house, the plaster is buckling in places. But the furnishings are much the same as they were when the two women lived in the house. The artwork on the walls is religious. The aesthetic is ascetic. In O'Connor's room, the metal crutches lean against the wall. Her typewriter is there, a phonograph, some books. The room is furnished like a monastic cell—with few reminders of worldly things.

Outside, the little watertower peeps over the house on its four wooden legs, looking like a cute toy. The outbuildings are still upright but they sag in the way that old barns do and are festooned with danger signs. Many of the fields have returned to woodland. As a consequence, the treelines, which played a role in so many stories, have been foreshortened. There is a meadow, though, and a perfect pond.

In the time since the two women inhabited the remote farm, the town has moved closer, as if it were trying to swallow it up. A screen of woods and a field separate Andalusia from busy Highway 441, a classic American strip chock full of motor inns, chain restaurants, furniture stores and car dealerships with vast strings of colored balloons reaching into the sky. This gives Andalusia the dubious distinction of being perhaps the literary home most conveniently located to reasonably-priced motels and restaurants, and gasoline—a true boon for the literary tourist.

Back on the grounds, trees muffle the sound of the rushing traffic. Because of the dearth of farm animals (there is one resident donkey), the place looks abandoned. But to delve into her short stories and letters is to bring it all back to life: the harsh wail of the peacocks in the trees, the lowing of cows, the force of nature that was Regina, the sound of distant mowing, the comforts of home. ॐ

In need of a savior, some of the **Andalusia outbuildings**
are falling into an advanced state of dilapidation.
— Milledgeville, Georgia

JOHN UPDIKE (1932-2009)

JOHN UPDIKE, AN ONLY CHILD, spent his first 13 years blissfully being a "boy about town," in the relative worldliness of Shillington, on the outskirts of Reading, Pennsylvania. There was a movie theater for a boy who loved movies. There was a fascinating street near the Updikes' house with Becker's Garage, the yellow brick Stevens Luncheonette, Henry's Variety Store, the Dairymaid and a bookstore where a precocious boy could buy Big Little Books. But this paradise was not to last. His mother had a powerful urge to move back to Plowville where she had come from, several miles distant amid the alien corn. Linda Updike's ancestral home was an 1812 gray stone farmhouse with walls as solid as a German castle.

Unlike his fellow southern Pennsylvanian, Daniel Boone, the asthmatic, bookish John Updike was no coonskin capwearing outdoorsman. In fact, he hated the country. To him the move had the trauma of exile. In one story, "Pigeon Feathers," from his first collection, *Olinger Stories*, he wrote: "When they moved to Firetown, things were upset, displaced, rearranged. A red cane-back sofa that had been the chief piece in the living room at Olinger was here banished, too big for the narrow country parlor, to the barn, and shrouded under a tarpaulin. Never again would David lie on its length all afternoon eating

"The motions of Grace, the hardness of the heart; external circumstances."

— Blaise Pascal
from the epigraph of
Rabbit, Run, 1960

Robeson Evangelical Lutheran Church, which Updike attended as a youth. — Plowville, Pennsylvania

John Updike

raisins and reading mystery novels and science fiction and P. G. Wodehouse." Clearly, Updike remembered the trauma of his move, and drew upon it as inspiration for his character.

When they moved to Plowville, his mother quit her job at a Reading department store which was, to Updike, an exotic, elegant locale. The move also placed him further away from the Reading public library, which exerted a strong influence on him. In some remarks upon receiving an award in 1998, he said:

> If I reflect on the psychological history that led me to become a cottage laborer in this industry [writing], an impression of glamour was part of it. There was something glamorous about the Reading, Pennsylvania public library, a stately Carnegie-endowed edifice at Fifth and Franklin, next to a sweet-smelling bakery.... The towering walls of books seemed conjured from a realm far distant, utterly mysterious and gracious, the little numbers inked onto the spines, the pockets for a borrower's card at the back, all these angelic arrangements. Who had done this for me?[1]

Like her son after her, Grace Hoyer Updike was a writer. On the farm she had time to write and John got an early education in writerly ambition, watching the many brown submission envelopes launched from the house towards periodicals that published fiction. (She did not meet with much success. She did, however, publish a novel called *Enchantment* under her maiden name, Linda Grace Hoyer, in 1971. Updike reportedly edited it heavily before publication.) It is surely from his mother that he got his literary bent and half his smarts. His father, a high school math teacher, was also brilliant. But like John, his father was displaced on the farm. In "Pigeon Feathers," the father, also a schoolteacher, "spent his free days performing, with a kind of panic, needless errands. A city boy by birth, he was frightened of the farm and seized any excuse to get away."

John's only way off the farm was with his father, with whom he shared the intimacy of the long commute—and any subsequent adventures—on the way to and from school. "But it was beautiful," Updike said in an interview, "because I saw what it was like to be an American man. I saw that it's a struggle, and not easy to be an American male."

Governor Mifflin High School, right next to Becker's Garage, also brought Updike back to the neighborhood he had been uprooted from when he was 13. The school was divided between jocks and non-jocks, between farmers from the outlying areas and non-farmers from Shillington. Probably the nearest the angular Updike approached to the jock set was by doing the invitations for all the track meets.

Talented at drawing, he wanted to be a humorous cartoonist. *The New Yorker* had started coming into their house, courtesy of an aunt, when he was 11 or 12, and he studied its black-and-white cartoons with their italicized captions, a rarified sense of humor from an urbane realm many hills and dales away from Plowville. He went to Harvard as an aspiring cartoonist, but graduated in 1954 with a determination to write instead. That same year his first poem was accepted for publication in *The New Yorker*. Fiction, however, became his focus. For one thing, he had to make a living. But in addition, "I found when I attempted fiction," he said in the Academy of Achievement interview, "it's sort of like a horse you don't know is there, but if you jump on the back there is something under you that begins to move and gallop."[2]

The New Yorker made a lifelong impact. In 1954, it hired him as an essayist for the "Talk of the Town" section. "I was very good at making something out of nothing,"[3] he explained. He joined during a golden era of influence, when the magazine was the vessel of sophistication that had fascinated him as a boy. He continued to appear there for over half a century. "I could not help but think," he wrote in his introduction to *The Early Stories*, "of all those *New Yorkers*, a heedless broad Mississippi of print, in which my contributions among so many others appeared; they serviced a readership, a certain demographic episode, now passed into history – all those birch-shaded Connecticut mailboxes receiving, week after week, William Shawn's notion of entertainment and instruction."[4]

Updike moved his family to New York City for his 20-month stint at the magazine but, a small town boy at heart, he found the city too crowded with people, and with writers, and seems to have been dismayed by its lack of free parking. They moved to Ipswich, Massachusetts. "I arrived in New England with a

"In folds of familiarity the land tightened about him," Updike wrote in the short story "Home." A **Pennsylvania Dutch dairy farm**, near the Updike home, still rural and bucolic after all these years. — near Plowville, Pennsylvania

Pennsylvania upbringing to write out of my system," he writes in the introduction to his collection, *The Early Stories*. Indeed, all of his initial stories are set there, as well as his novels, *The Poorhouse Fair* and *The Centaur*, and the Rabbit novels.

The quadrant of Pennsylvania that Updike came from is loaded with evocatively-named towns—perhaps the greatest concentration anywhere in America: Intercourse, Bird in Hand, Sinking Springs, Bareville, Cocalico, even the prosaic Plowville, Limekiln and Wagontown. Updike habitually changed the names of the towns to something similarly evocative (for example, Plowville became "Firetown") and began to write what he knew.

He rented a little office in Ipswich between a lawyer and beautician. "I smoked nickel cigarillos to allay my nervousness at the majesty of my calling and the intricacy of my craft; the empty boxes, with the comforting image of another writer, Robert Burns, piled up. Not only were the boxes useful for storing little things like foreign coins and cufflinks but the

caustic aura of cigars discouraged visitors. I felt like I was packaging something as delicately pervasive as smoke, one box after another, in that room, where my only duty was to describe reality as it had come to me – to give the mundane its beautiful due."

The Rabbit Novels

Updike's talent for raising mundanity to the level of beauty, in language approaching poetry, is nowhere more in evidence than in the Rabbit series, four books spanning the decades from the 1960's to the 1990's. They chronicle the life of former high school basketball star Harry "Rabbit" Angstrom, after his moment in the sun has passed. In a way, Rabbit was Updike's alter ego, as he said in the Academy of Achievement interview: "Rabbit…and I share roughly the same age and [were] born in the same place, but I've long left Berks County. He stayed there, and it's a kind of me that I'm not. I never was a basketball star. I wasn't handsome the way he is, and nor did I have to

John Updike

undergo the temptations of being an early success that way, so that for me it was a bit of a stretch. Not an immense stretch to imagine what it's like to be Rabbit, but enough of one that it was entertaining for me to write about him, and maybe some of the self-entertainment got into the book....I can kind of walk around Rabbit in a way it's hard to walk around, say, the auto-biographical hero of some of your short stories, where it's your twin, you know, and you're attached. It's the idea of breaking that attachment, I think, that matters and where the fiction really begins to take off when you can get somebody else in your sights."[5]

Not only did Updike get Rabbit firmly in his sights but also the other characters in the book: Rabbit's wife, Janice, his son, Nelson, his parents, Janice's parents, and a host of other characters, including Reading itself, which he named Brewer. Rabbit is not an easy man to love; he is selfish, often disloyal, startling

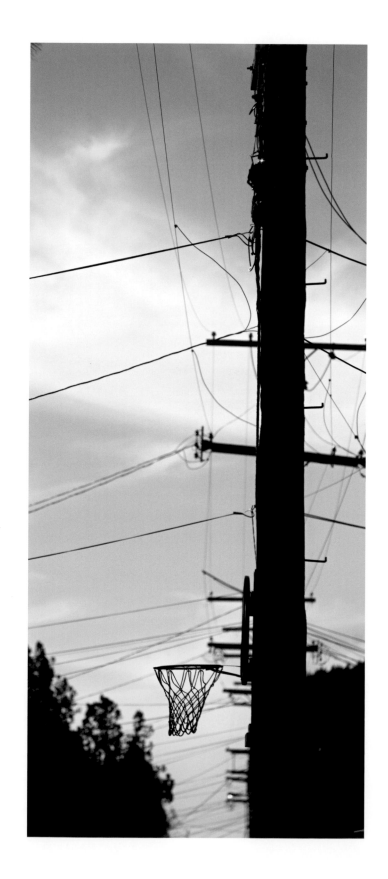

"Boys are playing basketball around a telephone pole with a backboard bolted to it. Legs, shouts. The scrape and snap of Keds on loose alley pebbles seems to catapult their voices high into the moist air blue above the wires. Rabbit Angstrom, coming up the alley in a business suit, stops and watches, though he's twenty-six and six three."

— John Updike
from the opening page of
Rabbit, Run, 1960

in the narrowness of some of his viewpoints. The books feature much lust and infidelity. He floats along in what seems like a perpetual undertow that threatens to suck everyone, including himself, under. "Breaking the attachment" allowed Updike to make of Rabbit someone who can do more than his fair share of damage.

Rabbit Angstrom actually started out as Fred "Ace" Anderson, former basketball star, in an early story called "Ace In the Hole." But Ace is just a sketch; hold him up to Rabbit and it is like seeing the difference between the first cartoons of Bugs Bunny and what became a Warner Brothers great. There is little that is lovable in the flip, cigarette-obsessed characters of Ace and Evey. Somehow those two underwent a metamorphosis into Rabbit and Janice—characters that offer more to grab hold of, real humanity.

But there is also something about society in the old-fashioned Pennsylvania Dutch region that is willing to forgive the mistakes of members of their own established families. For despite all his shenanigans, Rabbit remains a native son, a taller one than most, who even plays Uncle Sam in an Independence Day parade in *Rabbit at Rest*. Reciprocally, throughout his life, Rabbit's trips through Brewer are acts of devotion not unlike the stations of the cross. As Joyce Carol Oates put it in her review of *Rabbit at Rest*: "This, not the fallen adult world, the demoralizing morass of politics, sex and money, the ravaging of the land, is the true America, however rapidly fading. The Rabbit novels, for all their grittiness, constitute John Updike's surpassingly eloquent valentine to his country, as viewed from the unique perspective of a corner of Pennsylvania."

Rabbit in Reading

A big man tagged with a diminutive nickname that somehow fits, Harry "Rabbit" Angstrom, former high school basketball star, is a mythic figure in his own imagination. "I'm a saint. I give people faith," he announces to Ruth, the country girl he cohabits with after he runs away from his wife, Janice, for the second time. An opportunity to visit the city that was the real life model for his hometown of Brewer, would be hard for a man of Rabbit's self-regard to pass up. Brewer is where he competed,

where became a known quantity. John Updike himself couldn't resist bringing him back as a ghost in a novella called "Rabbit Remembered." So it is not such a stretch to imagine a specter of Rabbit arriving in Reading to take a look around. The quoted passages in this section come from the Rabbit tetralogy. Each one is a fragment of Updike's homage to his hometown.

Rabbit, Run begins with these enigmatic words by Blaise Pascal: "The motions of Grace, the hardness of the heart; external circumstances." This epigram from the ultra-ascetic Pascal suits the self-indulgent Rabbit remarkably well. As some stars and former stars will do, he sometimes seems to conflate athletic grace with the notion that he exists in a state of grace. And at those times, when he feels above reproach, one feels the hardness of his heart. The force that exerts a far greater sway on Rabbit than his limited basketball career, though, is Brewer—seventh largest city in Pennsylvania and the near horizon of Rabbit's external circumstance.

Once in Reading, Rabbit's first move might be to pick up a copy of the family-owned *Reading Eagle* to get his bearings. He's a fan of newsprint. In his early career he worked alongside his father as a typesetter at the Verity Press in Brewer. When he started, they still printed a German language journal called *Der Schockelschtuhl* with hand cut wooden borders and ornamental letters and a bristly old German named Kurt Schrack on the staff to set the type. Soon, Schrack was gone. Rabbit's own tenure ended when the *Brewer Vat* newspaper started printing by offset. Nowadays, the *Reading Eagle* fights for readership and relevance against many online sources.

Changes are everywhere, not just in the newspaper industry. At the Kutztown German festival, still a popular event today, Pennsylvania Dutch cooking is a lure for tourists. Rabbit remembers that, in his youth, people ate that way because "it couldn't be helped." Over the latter half of the 20th century, most of the children of those German speakers who ate the heavy local food and read *Der Schockelschtuhl* became (except for the Amish and the Mennonites) indistinguishable from their fellow middle Americans. The recent wave of immigrants has not blended in so seamlessly. The entire Eastern Seaboard from New York City on down is like a system of catchbasins for immigrants.

Thousands of them flood into New York City, jostling for space and jobs. Those that don't make it there spill into Newark or Trenton or Camden or Philadelphia. Or the inner city of Reading, where over 30 different nationalities live in the greater metropolitan area. There are bodegas, and beauty stores offering Dominican hair blowouts. Walking by such establishments might induce in Rabbit a longing for the dusky tropical exoticism that these new residents seem to hold tantalizingly out of reach of his soft white man's fingers. Except for a brief stint in the army in the distant land of Texas, he didn't travel far for his adventures. He was all for thinking globally but acting locally.

Drifting through the streets of Reading, a pale white ghost on a hot day, it would seem again to Rabbit as if "milk hangs in a sky that seems too exhausted to clear." The Pennsylvania heavens above Reading today are made of the same stuff that arched over Brewer in Rabbit's day. The sky has not visibly changed. The people seem to have, though. Back in Rabbit's youth, a typical Pennsylvania visage was: "eyes squinting and mouths sagging open in a scowl that makes them look as if they are about to say something menacing and cruel." As time went by, the people wearing that expression dwindled on the earth. From the vantage point of a bus, Rabbit once studied his father standing outside a bar. His father was one of the: "little men, whittled by the great American glare, squinting in the manna of blessings that come down from the government, shuffling from side to side in nervous happiness that his days work is done, that Armstrong is above him, that the U.S. is the crown and stupefaction of human history." As the Depression became part of a distant past, fortunes rose and fell—but mostly rose—and America decisively won the cold war. The expression on many faces softened into something more complacent and harder to read, though that too could be changing.

Certainly the inner city's fortunes could not be described as rising. In 1930, Reading had 111,000 residents. By the most recent census it was down to 81,000. The sustained leak of manufacturing jobs has gone on for a long time. Reading was once known

"Take a ride on the **Reading Railroad**" – The once mighty railroad only exists on the Monopoly board now. It was laid low by government regulations and a sharp drop in coal revenues in 1971, the year *Rabbit Redux* came out. — Reading, Pennsylvania

John Updike

for pretzel making and cigar making and for its monumental railroad. Those industries have gone. The Luden's cough drop plant recently contributed to the disappearance of the industrial base. Hershey's, just down the road in its own town, announced plans to close it as part of a "wider move to cut labor and materials costs." Gone forever the wafting aroma of wild cherry cough drops being made. Kroll's department store, where Janice sold candy and cashews in a white uniform, would probably not have survived in Reading to the present day either.

Large scale changes filter down to the local level. That was what Rabbit comprehended. New franchises sprang up. Strips developed. The white residents moved out to enclaves of safety and leafy patches of lawn. Even as the inner city ailed, the townships around it thrived. In Rabbit's prime, when he tried to picture the outskirts of Brewer, the city petered out into "an empty baseball field, a dark factory, and then over a brook into a dirt road." But in the intervening years, the suburbs have grown up like vines, taking over the farms with avenues that wind without purpose and cul de sacs that lead nowhere.

Rabbit grew up in a Brewer neighborhood called Mt. Judge, built along the side of Mount Judge, where the frame houses climbed the hill "like a single staircase. The space of six feet or so that each double house rose above its neighbors featured two wan windows, wide-spaced like the eyes of an animal." In Reading, there is a neighborhood named Mount Penn, and one can imagine that running on its steep streets would have been ideal for producing the leg strength so necessary for a scorer like Rabbit, with his soft shooting touch. Mount Penn, however, seems to be on a different slope of the mountain than the neighborhood of Mt. Judge. From his house on Jackson Street, Rabbit could see the lights suddenly wink off in the early-to-bed-early-to-rise hinterlands. Mount Penn would have to have eyes in the back of its head to get the same view, like the eyes his old coach, Manny Tothero, said Rabbit had when he was a star. Rabbit has always regarded Mt. Judge with a fierce, complicated devotion, similar to the feeling he had for his mother.

Reading's **neighborhood of Mount Penn**, where frame houses climb the hill "like a single staircase."
— Reading, Pennsylvania

"*The frame homes climb the hill like a single staircase. The space of six feet or so that each double house rises above its neighbor contains two wan windows, wide-spaced like the eyes of an animal*"

— John Updike

Rabbit Run, 1960

John Updike

To Rabbit, Brewer was the flowerpot city, "a red city, where they paint wood, tin, even bricks red, an orange rose flowerpot red that is unlike the color of any other city in the world yet to the children of the county is the only color of cities, the color all cities are." Reading, too, must have been a flowerpot city in its day. It has long stretches of brick rowhouses with narrow breezeways in between them that seem like the holes a child would punch in the lid of a jar to let in the air for a captive insect.

Above both cities looms the mountain. In Reading, a road named Skyline Drive snakes its way to the top of Mount Penn which was, of course, Mt. Judge in Brewer. Mount Penn has a pagoda at the top that looks over the city, a flight of fancy from an age when Reading was at the height of her powers. It was built as a hotel in 1908 by a local quarry owner. He was trying to make up for the gashes he had made in the mountain. It failed as a hotel but succeeded as a landmark. In Brewer, the structure atop Mount Judge was the Pinnacle Hotel, from whose parking lot one could see the city "spread out like a carpet," the neon sunflower of the Sunflower Brewery, the gleam of the Running Horse River.

It is up the flanks of Mount Judge that Rabbit runs from the burial of his daughter at the end of *Rabbit, Run*. Even at that age, gravity weighs on him. Yet there is "a resilience in the burial ground that sustains his flight, a gentle seeded bumpiness that buoys him up with a memory of the dodging spurting runs down a crowded court." He finds himself in the deeper, old growth pine forests of the mountainside that muffle the light all around him. He is running into the forest primeval of old Pennsylvania, apprehending nature as one of Reading's settlers might have: something phantasmagoric and alive among the twisted trunks and strewn boulders and cellar holes. His fear fills the "winding space between the tree trunks with agile threats." With a great sense of relief the fleeing Rabbit reaches the asphalt of the road that ascends to the Pinnacle Hotel. He is back in the familiar world he knows and cherishes.

It is doubtful that Rabbit would visit the 156-year-old Aulenbach Cemetery on the border of Mount Penn and Reading to re-create his escape route. Of course, he has nothing to fear now that he is a ghost. But that flight wasn't his proudest moment. He would probably prefer to go down Penn Street, which was Conrad Weiser Street in Brewer, and cross the Schuylkill River, which was the Running Horse River in Brewer. On the bridge Rabbit might recall how in his youth it ran thick with coal silt. One time a man had attempted suicide by jumping off the bridge but he landed smack in the silt and stuck.

One's hometown is built up over time by a steady accretion of such observations and events. There are well-worn paths, mysterious districts, ordinary locations made profound by some happening, buildings that seem like the grandest palaces in the world until one travels for the first time to Philadelphia or New York City. But even if the sublime things of one's own Brewer, or Reading, undergo a diminishment by experience of the wider world, they do not lose their power to stupefy. They lean like canvases in a shadowy storage corner of the memory, brought to light in dreams and reflections. ☙

Author's Note: In 2007, while I was in the process of doing the research for this book, Herb Yellin, of Lord John Press, arranged for my wife, my brother and me to be taken on a tour of Shillington, Plowville and Reading by David Silcox and Jack De Bellis (author of *The John Updike Encyclopedia*), two great experts on Updike's Pennsylvania haunts. They took me to the 1812 farmhouse that Linda Grace Hoyer moved her family to. The owner, a relative of Updike's, grew up nearby and used to sometimes get rides to school from Updike and his father (he said Updike's father ran the same stop sign every time). The current owner was in a different group in school (the jocks), married his high school sweetheart, and became a successful businessman. He bought the place from John Updike after Linda Grace Hoyer passed away and left it overrun by 45 cats. They modernized the house without compromising the integrity of the location Updike grew up in. They do not welcome literary pilgrims or gapers. They also fixed up the barn, stand in for the scene of the bird slaughter in "Pigeon Feathers" (it apparently never happened in real life). There, standing over the pigeons' mass grave, Updike's alter ego David was "robed in this certainty: that the God who had lavished such craft upon these worthless birds would not destroy His whole Creation by refusing to let David live forever."

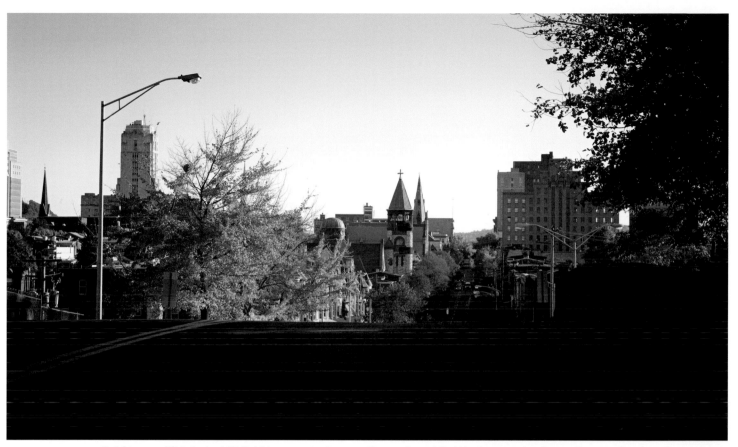

Rabbit, run. This is the hill Rabbit ran up in the 1970 film version of *Rabbit, Run*, starring James Caan. — Reading, Pennsylvania

To stand on those grounds, hallowed by the childhood of one of America's undeniable literary geniuses, on a humid Pennsylvania day of the kind he would have recognized so well, was a thrill and a privilege. The visit was also a revelation. For, as far as his agile mind had taken him, there was one group he would never break free from (he never really wanted to), and that was the people who had known him before he became famous. In high school, especially, one attains enough awareness of the world to slot people into categories that they will never again, in memory at least, elude. At that age, Rabbit was setting scoring records. It defined his life. A Pennsylvania youth defined the non-jock Updike, who had the same ease with writing that Rabbit had with a basketball, differently. But to his high school classmates, he never changed.

In 2009, John Updike's Lutheran God finally saw fit to sully His Creation by taking Updike away. When he knew his end was near,

the writer revealed to his children that he had retained 53 acres of farmland that had been part of the old family homestead. He apologized that "my sentimental streak prevented me from selling (the land) in my lifetime...but you seem to be the generation that should bring the Pennsylvania family connection to a close."[6] How often it seems that the place we feel we must leave in our youth becomes a cherished location in our memory. How fortunate we are that John Updike lavished such attention on Pennsylvania. ◡

(Next pp. 234-235) **Pagoda at the top of Reading's Mount Penn,** known as "Mount Judge" in the Rabbit novels. From the pagoda, a failed business venture that became a curiously exotic landmark for Southern Pennsylvania, one can see the city spread out beneath and imagine the fantastic old neon signs that once graced the middle distance of Rabbit's Brewer. — Reading, Pennsylvania

John Updike

John Updike

PHILIP ROTH (1933-)

T̲HE AUTHOR PHOTO on the back jacket flap of *The Plot Against America* shows the 71-year-old Philip Roth, in coat and tie, a large map of Newark on the wall behind him. An elbow of the Passaic River curves up past his left shoulder. Streets radiate from behind his shoulders and his head. If one were to pinpoint on the map the block of Summit Avenue where Roth lived as a child, it would be located pretty much right between the author's slightly smiling eyes. "A child of my background had a sixth sense in those days, the geographic sense, the sharp sense of where he lived and who and what surrounded him,"[1] Roth wrote in *The Plot Against America*. It shows. The sense of provenance—that environment matters—has informed much of Philip Roth's work.

Philip Roth was born to Herman Roth and Beth Finkel Roth in Newark, New Jersey in 1933. Herman Roth was a native of Newark. His wife had grown up in nearby Elizabeth. Their parents had come from the Old Country, making Philip Roth and his brother, Sandy, members of the first fully-assimilated generation—one upon which many hopes were pinned. Home for the Roths was the second-floor apartment of a two-and-a-half-family house on 81 Summit Avenue in the Weequahic section of the city, where wooden frame houses dominated and most of the residents were hard-working lower-middle class Jewish families like the Roths. "I was brought up in a Jewish neighborhood," Roth has said, "and never saw a skullcap, a beard, sidelocks - ever, ever, ever - because the mission was to live here, not there. There was no there. If you asked your grandmother where she came from, she'd say, 'Don't worry about it. I forgot already.' To the Jews, this was Zion."[2]

The "Brick City" of Newark had long been known for its excellence at any manner of manufacturing—from the primitive art of tanning leather in the early 1800's to the first commercially successful method of making plastic, called celluloid, in the mid-1800's. Newark's factories lured immigrants from all over Europe. The Morris Canal, completed in 1831, carried coal from Pennsylvania to feed Newark's iron industry, and brought in produce from the farms in New Jersey's hinterlands. But Newark was not solely blue collar. Since the mid-1800's, she had also attracted insurance companies. In 1933, when Philip Roth was born, Herman Roth was an agent at one of the biggest: the Metropolitan Life Insurance Company. Throughout the Depression and the war years that followed he was a top performer, a dynamo. What he, and a lot of the other fathers in Weequahic had in common was, in the words of Philip Roth, "ardor. Vigilant programmatic industriousness. What their Gentile betters called pushiness was just this—the ardor that was everything."[3] On occasion, Mr. Roth brought his son with him when he went to the office or to other parts of Newark, introducing Philip early on to a league of associations and fascinations that had its headquarters in the neighborhood and branched out through the complex and begrimed city.

Philip Roth entered onto the literary scene in 1959, with the publication of *Goodbye, Columbus*—consisting of five short stories and the eponymous novella. The novella's protagonist, Neil Klugman—poor but well-educated—works for the Newark Public Library. The Library, in the heart of downtown Newark, is situated next to a park where, a plaque announces, George Washington trained his army. Neil Klugman falls for Brenda Patimkin, the attractive daughter of an upper-class Jewish family that lives in park-like surroundings in one of the townships around Newark. It's cooler out there in the summer, and the neighborhood streets are named after prestigious Eastern colleges. His first journey out there by car, beyond the train tracks and commercial strips at the outer clutches of the city, has a pleasantly disorienting feel:

Newark Public Library: Roth once said he doubted his father had been there more than once. It was the sons and daughters of people like his parents who used it as a ladder up. — Newark, New Jersey

Philip Roth

Weequahic High School athletic field. In *American Pastoral*, this was the scene of the Swede's gridiron exploits, which, along with his baseball and basketball prowess, filled an entire community with pride. — Newark, New Jersey

Inside my glove compartment it was as though the map of The City Streets of Newark had metamorphosed into crickets, for those mile-long tarry streets did not exist for me any longer, and the night noises sounded loud as the blood whacking at my temples.[4]

Goodbye, Columbus garnered praise from critics and fellow writers. Saul Bellow commented: "Unlike those of us who come howling into the world, blind and bare, Mr. Roth appears with nails, hair, teeth, speaking coherently."[5] The book, with stories like "Defender of the Faith"—about a few conniving Jews in a U.S. Army unit—and "The Conversion of the Jews," in which the faith was questioned, drew denunciations from some Jewish leaders, who called Roth "a self-hating Jew."[6]

In 1961, Roth made a literary stir with the publication of a piece in *Commentary* called "Writing American Fiction." In it, he made the argument that America in the middle of the 20th century had become so tabloid in its news and its news appetites—the "fixes, the insanities, the treacheries, the idiocies"[7]—that an American writer of his time had a difficult time making sense of it all, much less topping it through works of the imagination. As a result, Roth maintained, the dominant writers of the day were shying away from reality—or pretending to examine real social issues but then slapping a happy ending on their works rather than digging deep. "And why is everybody so bouncy all of a sudden?" he asked critically, citing the indulgent prose of some of the dominant authors of the time. In his conclusion, Roth quoted from the last sentences of William Styron's *Set This House on Fire*, in which the protagonist chooses being over *nothingness*. Roth's reaction: "Being. Living. Not where one lives or with whom one lives—but that one lives."[8] One can sense the disdain in his voice. If you wrote without

Weequahic High School. Its most famous graduates are Roth and the character of Portnoy. In 1969 a *New York Times* reporter interviewed Roth's English teachers. The consensus: "A quiet boy, intelligent but unimpressive, displaying no indication of a major author absorbing material for future fiction."

— Newark, New Jersey

a concrete sense of location, you wound up with dislocation, which was practically nothingness after all.

Considering Roth's belief in the importance of place, it is small wonder, then, that in his 1969 book, *Portnoy's Complaint*, we meet a very "located" person: Alexander Portnoy, born in the same year as Philip Roth and undoubtedly a product of Newark. Portnoy is a graduate of Weequahic High School, which Roth also attended. Weequahic High School, just down the street from Summit Avenue, was predominantly Jewish and proud of it. There, the young Alexander Portnoy chanted with his buddies at football games:

> Ikey, Mikey, Jake, and Sam
> We're the boys who eat no ham
> We play football, baseball, soccer
> We keep matzohs in our locker.[9]

Alexander Portnoy's "complaint" is "a disorder in which strongly-felt ethical and altruistic impulses are perpetually warring with extreme sexual longings, often of a perverse nature."[10] *Portnoy's Complaint* achieved instant notoriety for its sexual content. Its tone, while not bouncy, is rakish. But it never loses the sense of place. Towards the end of the book we find Portnoy, now in Israel, recollecting himself seated on the wooden stands of a Newark ballfield not so long ago, and avidly thinking: "How I am going to love growing up to be a Jewish man! Living forever in the Weequahic section, and playing softball on Chancellor Avenue from nine to one on Sundays, a perfect joining of clown and competitor, kibitzing wiseguy and dangerous long ball hitter."[11]

Overnight, *Portnoy's Complaint* built Roth into a cultural figure. But he didn't seek the limelight. He spent time at the artists' retreat, Yaddo, traveled in Asia, moved to Woodstock,

New York, and continued writing. In 1972 he bought a farmhouse on 40 acres in Connecticut—a fair distance in atmosphere and mileage from Newark—and spent much of his time there, always writing.

If one goes in search of the sense of place in Philip Roth, the problem will not be in finding it but in processing it all. This entry focuses on two of the standouts, which dwell primarily on Newark but also venture further afield, to the historic townships in the western part of the state, where signers of the Constitution rest in iron-fenced cemeteries and the orange-lit industrial sprawl of the Atlantic coastline seems a world away.

Don't Invent, Just Remember

The Plot Against America, published in 2004, begins during the years in which America debated whether or not to enter World War II. The main characters of the story are the family of Roths: Herman, Beth, Sandy and Philip, who live in a house on Summit Avenue in Weequahic. At the outset of 1940, the Roths are a happy family unit. Seven-year-old Philip feels secure, and securely American. For example: every year, a bearded man with a black hat comes to collect donations for the establishment of a Jewish homeland in Palestine. Philip's parents always give him and his brother a few cents to contribute. But it is "largess," Philip deduces, "dispensed out of kindness so as not to hurt the feelings of a poor old man who, from one year to the next, seemed unable to get it through his head that we'd already had a homeland for three generations."[12] That idea of homeland comes into doubt when the trans-Atlantic flying ace, known anti-Semite and fierce isolationist Charles Lindbergh is nominated on the 20th ballot at the Republican National Convention and goes on to defeat Roosevelt in the race for president of the United States.

Roth has stated that the inspiration for the novel came from a note in a book by Arthur Schlesinger that mentioned that in 1940 some Republicans had tossed around the idea of nominating Lindbergh. "My eye landed on the sentence," Roth said in an interview, "and in the margin I wrote, 'what if they had?'"[13] The rest followed, as Roth took a detour through history; one that wouldn't seem so chillingly real if it weren't for the verisimilitude which Roth layered into the project. He starts with the description of the house he grew up in, which any person armed with a map of *The City Streets of Newark* could unerringly find. Since 2005, the house has had a plaque on it, and the intersection of Summit and Keer has been re-named Philip Roth Plaza. In the course of the novel, Roth's own childhood home becomes a stage on which much of the drama of this alternate history of America is played out.

Summit Avenue, the Roths' street, is not now, and never was, glamorous. It is a street of large and solid houses, with small front lawns and long driveways that lead back to garages next to small back yards. It is pleasant and unremarkable. To get to gray granite Weequahic High School, its entrance flanked by pillars carved in relief, you go down the street and make a right at Chancellor Avenue, one of the main thoroughfares. It is not far. A temporary chain link fence surrounds the front of the school, looking somehow permanent. The football field is well kept. The neighborhood has changed since the Roths lived there. Portnoy's rah rah chant would elicit curious looks there nowadays, for the Jewish families have largely vacated the area.

In the book, home stretches outward beyond Summit Avenue. It extends to the crest of the hill of Chancellor Avenue, where the Lenni Lenape tribe were said to have had a tiny village on ground that years later became Anna Mae's, "the sweetshop that had succeeded the Indians' teepees and whose tantalizing scent honeyed the air less than a two-minute walk from our house."[14] It spreads into the back alleys where Philip's cousin gambled with his friends. The hallowed ground stretches into downtown Newark, to the movie theater where the newsreels showed the progress of the war, to the hotel where the Roth parents had been married, and beyond to the Delaware River boundary with Pennsylvania that resembled, to schoolchildren and their teachers, the back of an Indian's headdress.

At one point in the book a threat arises that could remove the Roths from their neighborhood and send them into exile. The day the bad news comes has been gloomy. The clouds have been spitting rain. But, as Philip looks through the window screen towards the street, the sun comes out. It causes an upwelling of adoration that far exceeds the attributes of their modest block, and inspires a fierce vow:

Tinged with the bright after-storm light, Summit Avenue was as agleam with life as a pet, my own silky, pulsating pet, washed clean by sheets of falling water and now stretched its full length to bask in the bliss.

Nothing would ever get me to leave here.[15]

Roth has said he repeated one motto when he got bogged down in the writing of the book. "Don't invent," he told himself, "just remember."[16] What he "remembered" is like a core sample; drawn up from under 68 years of subsequent events, its smells, sounds and sights as pristine as when it had (seemingly) been deposited there, but fictive. It evokes the warmth of a close-knit family and brings the old Weequahic neighborhood back to life, glistening in the stream of remembrance.

American Pastoral - Newark

In the 1961 piece in *Commentary*, Philip Roth had advanced that "the American writer...has his hands full trying to understand, and then describe, and then make *credible* much of the American reality."[17] By 1968, of course, the Vietnam War, cultural unrest, violence and scandal made 1961 seem like a halcyon time. In 1997, Philip Roth looked back to the late 1960's, when America descended into the "desperation of the counterpastoral...the indigenous American berserk."[18] The book was *American Pastoral*.

American Pastoral is narrated by the author Nathan Zuckerman (another one of Roth's alter egos), who figures in a series of books. But Zuckerman's presence in *American Pastoral* is muted; it is really the story of Seymour Irving Levov—known as "The Swede" to his friends and admirers, who are legion (of enemies he has very few). The Swede is a terrific athlete—a letter man in football, baseball and basketball. He comes by his name because he was the most fair-haired and fair-complexioned of Jews—a veritable Viking—and handsome as all get-out. During the Second World War and its sickening aftermath, the Swede is one of the few sources of fantasy for the Weequahic Jews, an inspiring athlete of overwhelming prowess, also as stoic and unspoiled as any good sports hero should be.

As a child, Zuckerman was in the same class as the Swede's younger brother, Jerry. Zuckerman had idolized the Swede then and his fascination never goes away. Years later, when Zuckerman is recovering from a bout with prostate cancer, the Swede asks him to tell his story. How could Zuckerman refuse? He still worships the guy. But when he and the Swede meet to discuss it, there seems to be no story—just one endless happy ending to the fairy tale of the charmed athlete. It later takes the Swede's splenetic brother Jerry to give Zuckerman the key to unlock the truth about the Swede, who has since passed away. Zuckerman goes to work in earnest, visiting the places where the Swede lived and inhabiting "this person least like myself."[19]

American Pastoral is an homage to industrial Newark, and a history and geography lesson not only about Newark but the western countryside beyond the city as well. The Swede's father founds a glove-making company. The name of the company is Newark Maid—perhaps a play on the words "Newark Made." When the Swede is a boy, he apprentices to his father. He accompanies Lou Levov as he goes to pick up completed gloves from Italian families. As they pass ancient factories that have been around since the Civil War, his father narrates inexhaustibly how the city had been built on brownstone and brick. Zuckerman's own view of Newark starts in the neighborhood: "Perhaps by definition a neighborhood is the place to which a child spontaneously gives undivided attention; that's the unfiltered way meaning comes to children, just flowing off the surfaces of things."[20] But the Swede has a sixth sense of geography that is broader than Weequahic. With his father he visits the old Italian neighborhoods. And as an impressionable kid he has his "first encounter" with what Roth calls the "manmade sublime." It is the railroad viaduct that "divides and dwarfs"[21] the residents of the old Ironbound district. The viaduct is "the city's Chinese wall, brownstone boulders piled 20 feet high, strung out for more than a mile and intersected only by half a dozen foul underpasses."[22]

In time, Lou Levov leases and then buys an old umbrella factory on the corner of Central Avenue and 2nd Street. He lands a few big accounts and becomes one of the biggest glove producers in America. The Swede turns his back on a

promising baseball career and joins his father in the business. The factory is still pumping out gloves by the time the riots erupt in Newark in 1967.

The historic Newark riots began on July 12, ostensibly after the arrest and beating of a cab driver named John Smith. Rumors flew that Smith had been beaten to death by the police. 24-hours after the arrest—after, in fact, the rumors had been dispelled—bricks from the "Brick City" and rocks and bottles were hurled at the precinct station. Looting followed. The next day, the Newark Mayor called in the National Guard after he was informed that the Sears & Roebuck, which sold guns, had been broken into and looted. In the course of the riots, the National Guard fired over 10,000 rounds of ammunition, the State Police chipped in over 2,000 rounds. Rogue elements of the State Police spent much of that ammunition on the windows of black-owned businesses in the so called "Soul Brothers riots." When the Newark Riot ended, 23 lay dead and 725 were injured. Block upon block had been laid to waste. Eighty-three percent of the businesses at the epicenter of the riot reopened after the riot. But few, unless they were bars, survived.

In *American Pastoral*, Newark Maid is one of the companies that gets its windows shot out, as its forewoman is black. It reopens after the riots. For reasons known only to himself, the Swede soldiers on in Newark, even though the attention to detail and the quality by the mostly African American staff drops sharply after the unrest. In Newark, the architectural details—the mullions and cornices, the moldings, the cobblestones of some of the oldest streets—are being systematically looted. Those whites who hadn't already left the city are fleeing to the suburbs, some moving their businesses to the commercial strips at the outer reaches of the city, like the ones Neil Klugman passed through on his way to the verdant suburbs in *Goodbye, Columbus*.

American Pastoral - Old Rimrock

Before the riots, the Swede has already moved out to the country with his daughter and his Gentile wife, a former Miss

The **factory on Central Avenue and 2ⁿᵈ Street** upon which Roth based the Newark Maid glove factory. — Newark, New Jersey

New Jersey. He hopscotched over the closer-in suburbs like Livingston and Short Hills—destinations of white flight—to a town named Old Rimrock, in the rural western part of the state. He still commutes to Newark every working day. The Levovs reside in a massive old stone house that he has coveted ever since he was 16, when he saw it on the way to a baseball game against Whippany. It was the first stone house he'd ever seen and, to a city boy, it was an "architectural marvel."[23]

The "Old" in Old Rimrock could be for Old Families and Old Money. Situated in Morris County, it was once the location of the thriving iron industry—a western point of the Morris Canal that led into Newark, and survived in the city until around the time of the Swede's birth, when it was paved over into a boulevard. Close by is the site of the Kenvil munitions plant that had exploded in 1940 and killed 52 people. Nearby were some of the truck farms that gave New Jersey its nickname: "The Garden State." George Washington famously had his headquarters in nearby Morristown. Some families have lived there since that time—a reminder to the Swede of how lately he and his own family arrived on the scene. Like Philip Roth, the Swede is the third generation of his Jewish family in America.

Old Rimrock, with its combination post office and general store, is a fictional locale. But there are some who hold that Roth, a meticulous researcher, based Old Rimrock on Mendham, a town at the edges of New Jersey's horse country. Though it is much busier now than in its fictional incarnation, when the Swede used to walk into town with his loping athletic stride to collect the mail and chat with the proprietors of the general store, Mendham still trails off into countryside and possesses a combination post office and general store. A black-and-white photograph of innocent-looking young men and women posing outside just such an establishment appears on the cover of the first edition of *American Pastoral*. In the cover art, however, the photo is being consumed by flame. So it is with the Swede's dream. This stunningly handsome man, with his beauty pageant wife and bright young daughter, comes upon Old Rimrock and believes that he has attained the American pastoral. But before the riots come to Newark, the "indigenous American berserk" comes to the Swede and his family. Old Rimrock was to be the apex of the Swede's accomplishment. It turns out instead to be a symbol of incomprehensible failure.

Newark: A Fit Subject For a Life's Work

Out in front of the Essex County Courthouse one will find a bust of Charles Cummings (1937-2005), historian, a man whose affection for Newark was as deep as Roth's own, and whose knowledge of the city was even more complete. The inscription, by Philip Roth, refers to him as a man of "heroic stature" for the fruits he bore from his "seemingly workaday labors." Cummings was raised in Virginia and adopted Newark only in 1963 after accepting a post at the Newark Library. When he died, he was eulogized on the floor of the U.S. Senate by New Jersey Senator Frank Lautenberg. Cummings was an invaluable source of information for details of Roth's Newark. It was he who found Roth a candidate for the Newark Maid factory building: a structure on Central Avenue and 2nd Street that became the "smoke-darkened brick pile fifty years old and four stories high"[24] to which Lou Levov and the Swede were so devoted.

Cummings embraced Newark—and the New Jersey beyond it—with the unstinting generosity of a born historian who had found a fit subject for a life's work. Roth came at it from a different angle, that of a native son. In an interview, he once confessed to being "mesmerized"[25] by Newark. He did not become the kibitzing wiseguy and dangerous long ball hitter of Weequahic softball fields that Portnoy once dreamed of being. Roth left when he was young and, unlike many of his high school friends, never returned to live in or around the city. Meanwhile, beyond its appeal as a hometown, Newark became a symbol for Roth as well:

> The place has come to represent for me, I suppose, modern times in America, and the fate of Newark has been the fate of many other cities. Detroit is probably one that most comes to mind. And others which have just—were tremendously productive industrial towns, had a hardworking, fully employed working

The combination **General Store and Post Office** in Mendham, New Jersey, thought to be the inspiration for Old Rimrock.
— Mendham, New Jersey

class. Had good, strong, corrupt city administrations, as they had in those years. And in other words the city worked, these cities worked. And the people worked in a different sense. And that's all been destroyed.[26]

An attitude of regret for the vanishing past has been part of the American literary canon since its beginnings. James Fenimore Cooper, one of the authorial pioneers, mourned the disappearance of Indian habitats and their way of life. We continually find a source of beauty and tragedy in the destruction that we have willfully caused or allowed to happen, through (the famous words of economist Joseph Schumpeter) our "perennial gales of creative destruction." If one alights from a train into the shadows and grunge of the once glorious Penn Station, and walks for a piece along the Chinese Wall of the Viaduct, it seems that Newark has been passed over by the magic wand of bubble-driven prosperity. Cities like Newark (or Detroit), not substantially uplifted even by a sustained period of prosperity, usually bear the full brunt of economic malaise.

Philip Roth has raised Newark into the nation's literary pantheon. It will endure there. The brick and brownstone city has a storied history. It was more than half a century old when George Washington was young. Let us hope that future Newark residents will feel the same ardor for the city that Herman Roth poured into his work and that his son has devoted to his writing. May a little prosperity be sprinkled here and there. May Newark thrive. ∽

From the **Ironbound District**, one can see that insurance companies still hold sway in Newark. The Prudential Building is one of the tallest in the city. — Newark, New Jersey

Philip Roth

Newark & Mendham, New Jersey ❖ 247

RAYMOND CARVER
(1938-1988)

Raymond Carver Junior grew up at 1515 South 15ᵗʰ Street, in a neighborhood of the Eastern Washington lumber town of Yakima called "The Hole." There is no topographical "hole." The grid of streets is as flat as a board from the nearby mill. In this context, "Hole" describes the undesirability of the place as well as a situation most of the residents seem to find themselves in. The neighborhood is full of slatternly fences, ominous "Beware of Dog" signs, vehicles in decline, general trash. The Carver lot has been replaced by two trailer lots. There is no plaque commemorating his childhood home.

When he was a boy, as he noted in an essay called "My Father's Life," their house was equipped with an outdoor toilet, like many other houses in The Hole. The neighbor kids used to relocate the outhouses from the backyards they belonged in to other peoples' backyards. Once they even set fire to the Carver toilet. "Junior" (as he was known then) used to practice what in the Hole was known as "bombing"—tossing rocks at the neighbors' toilets when he saw someone go inside. In time, though, the targets thinned, until the Carvers became the last family in the neighborhood with an outdoor toilet.

Early on, Carver was introduced to a cycle of low expectations. In the poem "Shiftless" the narrator describes his goal to sit in front of the house doing nothing, except,

> Once in a while hailing a fat, blonde kid like me
> and saying, "Don't I know you?"
> Not "What are you going to be when you grow up?"

And in a poem called "Bobber," Carver tells of a fishing trip with his dad and a man named Mr. Lindgren, who he says

The address of Carver's childhood home. "The Hole," it seems, has stanched the tide of every real estate boom to come its way since Raymond Carver was a boy. — Yakima, Washington

1515 SO 15 ST

Living on a staple of bitterness. This lot, **site of the Carver family home**, has been split into two lots wide enough for trailers. — Yakima, Washington

he liked "better than my dad for a time." Small wonder, since Mr. Lindgren doesn't drink, lets him steer the car and makes conversation with him. Meanwhile, since they are using fish flies baited with maggots, Raymond Senior sits there keeping his maggots alive under his lower lip. Mr. Lindgren tells "Junior" that he'll always remember the trip, will grow up to be "a fine man," will one day take his own son fishing.

> But my dad was right. I mean
> he kept silent and looked into the river,
> worked his tongue, like a thought, behind the bait.

A Dust Bowl migrant, Raymond Senior had hitchhiked and ridden the trains from Arkansas to Washington in 1934. He got a job building the Grand Coulee Dam, made a little money, and then returned to Arkansas to bring back his parents, who were

in a bad way. Back home in Arkansas he met his future wife. He was drunk. They had a whirlwind courtship. His mother told Carver later that she wished she had had a crystal ball when she first ran into him on the street. Raymond Senior was a saw sharpener. A skilled profession. But he had other women, never had any money, and developed a serious drinking problem. He had a nervous breakdown when Carver was in his teens, recovered (of sorts) and then died early. And yet Carver's mother stuck by him.

Raymond Carver's early reading diet was heavy on Edgar Rice Burroughs but also included Robin Hood, King Arthur, and other books that typically appealed to boys of that age. In 1956, after graduating from high school, he and his mother moved to Chester, another lumber town, in northern California, where his father was living. In November of that year he moved back to Yakima and got married. Two years later, he moved his

From short orders to short stories. Establishments like **Traylor's** preserve settings that seem typical of Carver's short stories from decades ago. Diners were familiar territory for the author, whose mother worked in several of them when he was younger. — Port Angeles, Washington

first wife Maryann, his daughter and his in-laws to Paradise, California, where he began taking classes. He had a son. A year later he took Creative Writing 101 from the legendary John Gardner at Chico State College.

The demands of a family and a full-time job, not to mention drinking, pushed Carver into short stories and poetry. Over time he honed the style that he is known for today. The way he described it, it was quite similar to breaking and entering: "Get in, get out. Don't linger. Go on." His stories are remarkable for their economy of words. They seem effortless, hardly literary, so minimal as to almost be written in shorthand. But this is an illusion. The stories were painstakingly crafted.

With the exception of a two-year stint as a janitor, Carver's trajectory resembled that of most relatively successful contemporary American writers: schooling, publications, teaching writing. But he lived hard, in a way that Raymond Senior would have recognized. A poem called "Our First House in Sacramento" begins: "This much is clear to me now – even then / our days were numbered." The narrator loses the grocery money in a poker game. Someone, in frustration, drives his fist through a wall. They eventually abandon the house in the middle of the night, loading everything on a U-Haul trailer, the narrator wondering what the neighbors must think to see the family going from room to room by lantern light, packing.

Night escapes from landlords come up several times in Carver's earlier writings. The neighbors also play a big role in the stories, a dynamic that seems a little out of place in the America of today. No one these days sits in the front yard in suburbia and asks, "Don't I know you?" A lot of these episodes sound like they could have taken place during the Depression. In one of his earliest poems, "Distress Sale," the narrator helps a neighbor take all his possessions out to the sidewalk for the

sale, even the favorite easy chair that the family had named "Uncle." "Must everyone witness their downfall?" he asks. "This reduces us all."

And yet, in Carver's writing, the family unit perseveres or, at least, doesn't easily fall to pieces. In "Are These Actual Miles?" Toni and Leo need to sell a convertible before the lien gets put on it. Leo has Toni do it because she "is smart and has personality." She leaves early that day with the convertible. But she has to make full use of her charms to sell it. Near dawn, the sales manager of the used car lot drops her off at home with the check for the car. She stumbles to the bedroom. "Bankrupt," she mutters as she falls on the bed and groans. How couples like this one ended up together, no one knows, and his stories never reveal whether they will make it, but they are always trying, always sticking it out, just as Carver's mother stuck it out with his father or Carver with his wife. Enduring and smoking. A spate of reading Carver is like smoking a carton of cigarettes in one sitting.

In "The Student's Wife," Nan tries to tell Mike all the things she likes and the things she doesn't like. She starts out, "I like good foods, steaks and hash brown potatoes, things like that…" and she expands on her list to include friends, sex, the movies. The simple pleasures. And then:

> "I'd like to have nice clothes all the time. I'd like to be able to buy the kids nice clothes every time they need it without having to wait.… I'd like to stop moving around every year, or every other year. Most of all, I'd like us both just to live a good honest life without having to worry about money and bills and things like that."

Mike slumbers, either disinterested or unable to cope. Nan has a cigarette and weeps. She ends up on her knees at dawn, asking "God, God, will you help us, God?"

Those lines at the end of "The Student's Wife" may be the saddest lines in all the stories. But there are some bright moments in the stories, too. In "Distance," a young husband

struggles with the lure of going hunting versus staying with his wife and their sick infant. In this story, the husband compares himself and his wife to the geese he loves, who mate for life. Indeed, a theme of the beauty of young love and trying to stay together runs throughout his stories, even when circumstances turn from thick to thin. These stories are not about how horrible life is; they are intimate stories of life being lived on the margin.

At a certain point people get inured to their circumstances because they must. In a poem called "Limits," Carver's narrator tells of a goose hunting expedition with a companion. They stop at a farmhouse to get a drink of water and the farmer offers to show them a live Canada goose he keeps in a barrel and uses as a decoy to attract other geese. The narrator takes a look at the goose in the barrel and, though he and his friend leave and go back to goose hunting that day, the moment stays with him.

> for years
> and years afterward, living
> on a staple of bitterness, I
> didn't forget that goose.
> I set it apart from all the others,
> living and dead. Came to understand
> one can get used to anything,
> and become a stranger to nothing.

In 1977, Raymond Carver quit drinking. He had been hospitalized several times and it was considered a miracle that he was able to stop. He reunited with his wife. About halfway through his book of selected stories called *Where I am Calling From*, published in 1986, appears the story that the book is named for. It takes place at Frank Martin's "drying out facility," out in the woods near the spot where Jack London had a big ranch. Before that point, many of the stories are about drinking and its effects. After Frank Martin's place, the stories get longer, the subject matter shifts, even the humor gets broader. The poetry, too, changes. The bitterness lifts.

Robinson Jeffers wrote of America in "Shine, Republic": "You were not born to prosperity, you were born to love

Raymond Carver

freedom." Carver's material came up from the thick seam of poverty that has run through America as long as there has been an America. And in a way, the many stories and poems about fishing, or rambling through the countryside goose hunting are, in that way, as American as any pioneer or western story about a person who takes his gun or fishing rod into the hills to try to rustle something up. He had a sportsman's appreciation for the land, an appreciation he shared with two of his friends and literary contemporaries, Tobias Wolff and Richard Ford. In the poem "Prosser," about a town just down the road from Yakima, he writes of the two kinds of wheat that you can find on the hills in winter. One is

> fields of new green wheat, the slips
> rising overnight out of the plowed ground,
> And waiting

The other is:

> wheat stubble-fields that reach to the river.
> These are the fields that have lost everything.
> At night they try to recall their youth

The poem becomes a reflection on what remains in the memory. He still sees an early hunting trip with his father, but barely; his father "squinting through the windshield of that cab, saying, Prosser."

Carver also loved water. The poem called "The River" contains a beautiful description of river fishing. It begins:

> I waded, deepening, into the dark water.
> Evening, and the push
> and swirl of the river as it closed
> around my legs and held on.

In "Where Water Comes Together with Other Water" he comes as close to gushing about a subject as he ever did, saying how he loves creeks and "rills, in glades and meadows." He concludes by saying how pleased he is to love rivers, and their

sources, "loving everything that increases me." Whether intentionally or not, this statement reflects back to "Distress Sale" and how having that family's worldly possessions out there on the lawn "diminishes us all." And it seems to demonstrate that what Carver was after, and what sustained him through what he called the "Bad Raymond" years, was to do the things that increased him. And writing was certainly one of those things.

It has been said that Carver reinvented the American short story. He was a master of the oblique title and of the opening line. He has been called a minimalist. But he was less a minimalist than someone who reduced things down to their essence. It is useless to try to paraphrase Raymond Carver. When one tries to take out extraneous lines, one realizes he had already done such a good job of that that to do so just diminishes the meaning. He had a lot of help with this from his editor, Gordon Lish, who became the fiction editor at *Esquire* and published many of his stories. In some cases, Lish would cut as much as 70 percent of Carver's original stories in order to arrive at what some called minimalism—and others, "Kmart Realism." Carver was after something more "increasing" than that. In an essay he wrote called "*On Where I'm Calling From*," Carver quotes from a story by Isaac Babel, in which the narrator comments on Guy de Maupassant, one of the finest short story writers ever, saying: "No iron can stab the heart with such force as a period put just at the right place."

In 1978, Raymond Carver separated permanently from his wife and shortly thereafter began a collaboration with the writer, Tess Gallagher, that lasted until his death in 1988. He described these years as "gravy." And in those final years he seems to have achieved the life he had referred to in one of his early poems called "The Other Life," which opens with a quote from Lou Lipsitz: "Now for the other life. The one without mistakes." In this other life, he was productive, he won awards, he was nominated for the Pulitzer Prize. He also broke, painfully, with Lish, writing to him in 1982 that "I can't undergo the kind of surgical amputation and transplant that might make them [his stories] someway fit into the carton so the lid will close." From then on, his stories became even more expansive, as befits a man who is enjoying life more.

The map of Raymond Carver's Port Angeles haunts notes that "**Ray kept boat here.**" The marina's glittering waters are sheltered from the Strait of Juan de Fuca by the Ediz Hook; a slender spit of land that arcs eastward like one half of a wishbone.— Port Angeles, Washington

He moved back and forth between Syracuse, New York, where he taught with Tess Gallagher, and the lovely city of Port Angeles, Washington, at the outer tip of the state, where he did a lot of writing of essays, poems, reviews and stories. He kept a boat in the marina at Port Angeles and loved to fish off the point of slender Ediz Hook on the Strait of Juan de Fuca.

His poem "Our First House in Sacramento" had ended with the lines:

> I saw firsthand
> what frustration can do to a man.
> Make him weep, make him throw his fist
> through a wall. Set him to dreaming
> of the house that's his
> at the end of a long road.

It seems that in 1984 he had reached the end of that long road. He owned a house in Port Angeles, a two-story clapboard house with a picket fence, gables, gingerbread. At the end of the road was a high bluff that looked out over Ediz Hook and all the way to Canada. In 1987 he was diagnosed with cancer. He had been a heavy smoker all his life. Surgery was performed but a year later the cancer returned. He passed away in 1988, at peace, lionized by his contemporaries, far above the hole he had started in. ⌒

*(Next pp. 256-257)*A gray mood. On a day like the one on which this photograph was taken, **mist obscures the Canadian border** across the Strait. Many of Carver's stories seem to take place under similar skies, also reminiscent of the smoke from numerous cigarettes. — Port Angeles, Washington

Raymond Carver

E. ANNIE PROULX
(1935-)

*N*OT WORTH A CENT." That was Daniel Webster's assessment of the territory of Wyoming in 1844, which he deemed "a region of savages, wild beasts, shifting sands, whirlwinds of dust, cactus, and prairie dogs."[1] It has always been hard to scratch out a living there. The Native Americans had survived there, yes. The first white explorers encountered them when they arrived. But those tribes were probably not descended from the prehistoric settlers—with pictographs, quarries and caches of pottery—that had made a go of it and abandoned their settlements long before. Their elders did not know who arranged the cairns of the Stonehenge-like Medicine Wheel in the Big Horn Mountains, only that it had been built "before the light came."[2] Those earlier civilizations had either up and left, or were dead and gone.

Trappers started making their way through the territory in the 1820's. Among them was the Frenchman named Joseph Maria La Barge, an ancestor of Annie Proulx. Those trappers who weren't killed by hostile Native Americans, or the elements, established a trading post at what is now Laramie in 1834. From 1840-1869, 300,000 people passed through Wyoming lands on the Oregon Trail. But few stayed. After the discovery of gold in California in 1849, thousands more traveled through Wyoming on their way to the mines, jettisoning anything that weighted them down in their haste to get over the mountains. In Wyoming especially, the trail became a dumping ground, "strewn with anvils, crowbars, drills, axes, grindstones, trunks, clothing, and furniture."[3] Only in the late 1880's did Wyoming finally have a reason to be worth stopping in. That was when the cattle came, hundreds of thousands of heads, many of them driven north from Texas to graze on the open Wyoming ranges. With them came ranchers, cowboys, and the enduring myths that grew up around them like the clouds of dust they raised. But profitability was, for many settlers, short-lived.

Long sightlines under a brooding sky. — Wyoming

Due to its harsh weather and aridity, Wyoming was inhospitable to man and beast. But the territory was, in some ways, surprisingly tolerant towards women. In Wyoming, women were granted suffrage in 1869. In 1870, Esther A. Morris was appointed justice of the peace of the "rip roaring" mining town of South Pass City [4]—the first female justice of the peace in the United States. In 1920, the town of Jackson Hole voted in the first all-female town council. Several of the newly-elected council members had sent their own husbands down in defeat. As one such member, Rose Crabtree, explained:

> The men had made just a mess of running this town….Keeping a little town like Jackson is like keeping house….Who ever heard of a good man housekeeper? Why, look at the old bachelors around here. Most of them live like wild animals. As for cooking, all they know is how to open a tin can into a frying pan.[5]

George Napoleon Proulx, Annie Proulx's father, was a French Canadian whose family hailed from Quebec. He worked his way up from bobbin boy to vice president of a New England textile mill. Her mother, Lois Nelly Gill Proulx, was American, a painter and amateur naturalist. Proulx says that her mother taught her to observe everything, "from the wale of the corduroy to the broken button to the loose thread to the disheveled mustache to the clouded eye."[6] Proulx always wanted brothers with whom she could take part in "vigorous outdoor activities."[7] Her lot was four sisters instead.

Proulx's education and work followed the often-haphazard pattern that typifies the lives of many writers. She briefly attended Maine's Colby College in the 1950's. When she left she worked some bit jobs: waiting tables, working at the post office. She got a bachelor's degree in history from the University of Vermont in 1969 and a master's in 1973 from Sir George Williams University in Montreal. By 1975 she was at her fourth school, enrolled in a Ph.D. program, and on her third marriage. The marriage ended. So did the hunt for the Ph.D. Though she had never succeeded in getting a brother, she was by then mother to three sons, whom she raised as a single parent. She moved to Vermont—then, as now, a favorite destination of back-to-the

landers. In the mid-1970's, the Green Mountain State was really quite rugged, with raw winters, isolation, rural poverty and plenty of opportunity for vigorous outdoor activities.

The writing career began thus:

> I was living in very remote, rural, difficult situations, and the question of how to make a living miles and miles from the nearest town came up. Writing seemed like a likely enough thing. I had sold a couple of stories in the past that I'd written just for fun, so I began writing articles."[8]

She also wrote books, though not the sort that might be nominated for a Pulitzer Prize. Among her works were: *Sweet & Hard Cider: Making It, Using It, and Enjoying It*, and *Plan and Make Your Own Fences and Gates, Walkways, Walls and Drives*. Proulx arrived on the literary scene very late in her life. Her first fiction book, *Heart Songs and Other Stories*, was published in 1988, when she was 53. *Postcards*, published in 1992, was about a New England farmer who kills his partner, buries her on the family farm, and then takes off across the country. The novel won Proulx the PEN/Faulkner Award, making her the first female recipient. *The Shipping News*, which takes place in Newfoundland ("I've got a thing about cold weather," she has said), won the Pulitzer Prize in 1994.

In, after the journalistic world had beaten a path to her remote Vermont door, Proulx moved to Wyoming. While it was changed from the place her trapper ancestor had passed through 170 years before, one thing hadn't: the long sightlines. As she told Charlie Rose in an interview, "When you can stand at your kitchen sink and look out your window and see a hundred miles down the road…you're 'on the beam.'"[9] She says that Wyoming is her writing place. "You go into it and it's almost as if you were trailing a little cord behind you, plugged into the side of the mountain."[10]

Out of Proulx's move to Wyoming came a book of short stories entitled *Close Range: Wyoming Stories*. Through it runs a cast of characters who might generally agree with Daniel

A plot waiting to happen. — Wyoming

Webster that the land is not worth a cent. Culinarily, many are still at the level of opening a tin can into a frying pan, or worse. These Wyoming residents scrabble together a living doing whatever they can do. That said, many have a passion for the lives they lead; there are rodeo riders portrayed in the book who keep doing it, for almost no monetary reward, until their bodies fall apart. Many of the book's ranchers have worked their acres for generations; families such as the Dunmires in "People in Hell Just Need a Drink of Water." Despite the fact that they have seen it all—"prairie fire, flood, blizzard, dust storm, injury, sliding beef prices, grasshopper and Mormon cricket plagues, rustlers, scours, bad horses"—the Dunmires find that "the country, its horses and cattle, suited them and if they loved anything that was it…there builds up in men who work livestock in big territory a kind of contempt for those who do not."[11] Ranching and rodeo'ing are two sorts of business to succeed or fail at in Wyoming. In another story, "Job History"—one of the shortest and most affecting stories in the collection—Proulx lists several others, including hog farming, service station ownership, ranch supply store ownership, truck driving and short order cooking.

In the Charlie Rose interview, Proulx revealed that her stories come from place. From place comes the economic situation, "which is really what moves peoples' lives…people have to make their living doing this, this, and this, and somehow the story is there."[12] The Wyoming stories are shaped by self-reliance. The seal of the Wyoming territory states: "Let arms yield to the gown." But Proulx seems more fond of what seems to be the unofficial state seal: "Take care of your own damn self."

There is a certain loneliness to taking care of your own damn self, especially in a region where "it is said you can look farther and see less than any other place in the world."[13] It lends itself to characters like Mrs. Freeze in "Pair a Spurs," who must have been married once but has been alone as long as anyone can remember, a "hard old woman…like a rope stretched until there was no give left."[14] It leads to forlorn mottos like "There's no lonesome, you work hard enough."[15] There is a beauty in lonesome as well. Proulx describes it in various ways. One of the most striking examples is in "A Lonely Coast," a story narrated by a barmaid who lives in a trailer about 130 miles from Casper, Wyoming, concerning three wild girlfriends and one of their just-as-wild boyfriends named Elk.

> There's a feeling you get driving down to Casper at night from the north, and not only there, other places where you come through hours of darkness unrelieved by any lights except the crawling wink of some faraway ranch truck. You come down a grade and all at once the shining town lies below you, slung out like all western towns, and with the curved bulk of mountain behind it. The lights trail away to the east in a brief and stubby cluster of yellow that butts hard up against the dark. And if you've ever been to the lonely coast you've seen how the shore rock drops off into the black water and how the light on the point is final. [16]

The narrator goes on to tell how that span from her town to Casper was once an ocean floor. This fact was also noted by that inveterate chronicler of the American experience, Washington Irving. In his 1886 book on the Northwest Fur Company trapping expedition, he talked of how the Great American Desert was supposed to be the bed of an ancient sea whose "primeval waves beat against the granite bases of the Rocky Mountains."[17] The trip to Casper ends really badly. So does the relationship between the narrator and her husband, which does not come as a surprise. From the opening paragraph, the maw of the Great American Desert threatens to swallow up some lives.

The desolate feeling of Wyoming surfaces again in "Brokeback Mountain," the saga of the doomed love affair between Jack Twist and Ennis del Mar, two "high school dropout country boys" from opposite ends of the state. The story begins with Ennis waking up, pouring leftover coffee in an enamel pan, urinating in the sink. Jack Twist had been in his dream that night:

> The stale coffee is boiling up but he catches it before it goes over the side, pours it into a stained cup and blows on the black liquid, lets a panel of the dream slide forward. If he does not force his attention on it, it might stoke the day, rewarm that old, cold time on the mountain when they owned the world and nothing seemed

wrong. The wind strikes the trailer like a load of dirt coming off a dump truck, eases, dies, leaves a temporary silence.[18]

With spare but telling detail, Proulx lays out the path of the forbidden relationship that began in 1963. It is about as close as a story can come to the sound of a harmonica in the high lonesome air, full of inchoate yearning.

According to Proulx, Jack and Ennis came to her in a bar. It was probably a night like the one she described in "The Mud Below," dusk fallen on the streets outside, "the bar neons spelling good times."[19] Proulx states that: "There was the smell of sex in the air. But here was this old shabby-looking guy …watching the guys playing pool. He had a raw hunger in his eyes that made me wonder if he were country gay. I wondered, what would've he been like when he was younger? Then he disappeared, and in his place appeared Ennis. And then Jack. You can't have Ennis without Jack."[20] In the case of "Brokeback Mountain" the characters came first. But nearly all of the time, she has said, her stories start with landscape, and from that landscape and climate follow the economic situation[21] that forms the bones of the story. As in "Brokeback Mountain," there always seems to be a twist.

Annie Proulx was not the first outside author to become smitten with Wyoming. A little over a century before Proulx came to Wyoming, another Easterner came West, on doctor's orders. Photographs show a sturdily-built man, but Owen Wister was prone to maladies both physical and mental. An exemplary student, friend of Theodore Roosevelt, and talented composer, Wister came from old money. Wister arrived in Medicine Bow in 1885. His first impression (if the narrator in his first novel can be equated with himself) doesn't sound much different from a description that might appear in a story in Proulx's *Close Range*:

> Until our language stretches itself and takes in a new word of closer fit, town will have to do for the name of such a place as Medicine Bow. I have seen and slept in many like it ever since. Scattered wide, they littered the frontier from the Columbia to the Rio Grande, from the Missouri to the Sierras. They lay stark,

dotted over a planet of treeless dust, like soiled packs of cards… Yet serene above their foulness swam a pure and quiet light, such as the East never sees; they might be bathing in the air of creation's first morning.[22]

Wyoming smote Wister with all of the delicacy of two-by-four between the eyes. He began making annual pilgrimages to Wyoming, taking copious notes and writing short stories. His law career was left behind. In 1902, Macmillan came out with *The Virginian: Horseman of the Plains*, Wister's novel about "a slim giant, more beautiful than pictures,"[23] who is the exemplary horseman, gentleman and Western man. Other books about the West have enjoyed great popularity but perhaps none has had the explosive impact of *The Virginian*, which sold 100,000 copies in three months. The book featured a dedication to Roosevelt, illustrations by the great Western artist Charles M. Russell and drawings by the equally renowned Frederic Remington, a friend of Wister's.

Nearly 100 years have passed between the Virginian's mannered courting of Molly Stark Wood (who happened to hail from Vermont) and the ground-out existence with moments of stolen bliss that Ennis del Mar and Jack Twist subsist on. The wide-eyed reverence with which the male narrator treats the Virginian ("Had I been the bride," he says, early on, "I should have taken the giant, dust and all."[24]) would elicit a few winks and nods today. The world of which Wister was writing was already vanishing. Some of the sections of the book that had been separately published before the turn of the 20th century employed the present tense. "It is true no longer," Wister said in a foreword. He had changed them to the past tense. And he wondered: "What is become of the horseman, the cow-puncher, the last romantic figure on our soil?"

In Proulx's *Wyoming Stories*, whose first edition also featured illustrations by a celebrated Western artist (William Matthews), cow-punchers have not gone anywhere. Some would say they've gotten nowhere. Horsemanship is still prized. Rodeos flourish. The bronc rider, though, hasn't exactly gotten ahead.

Throughout Wyoming, and the West, there are ranches that have been in families for generations (though the number

is dwindling), and new ranches being born, just as there are hundreds of different ways being tried to make a living from the Western land. These days the rancher and his ranch hands don't always ride a horse, but sometimes drive pickup trucks or ATV's. Nowadays, as then, sometimes the rancher is not a "he." Issues that the rancher faces include forces of development, changes or restrictions in land use, water use and grazing rights, predatory species reintroduced into the wild, the "brain drain" of sons and daughters of ranchers seeking their fortunes in the cities. The cow-puncher of Annie Proulx's day faces a much more compli-cated set of challenges than the Virginian did. But the compen-sations for hardship—above all, the beauty of the landscape of Wyoming—remain, and that is why so many cow-punchers and ranchers do. "Other cultures have camped here and disappeared," Proulx writes in one story. "Only earth and sky matter. Only the endlessly repeated flood of morning light. You begin to see that God doesn't owe us much beyond that."[25]

A love supreme: "The country, its horses and cattle, suited them and if they loved anything that was it…there builds up in men who work livestock in big territory a kind of contempt for those who do not."

– E. Annie Proulx
"People in Hell Need a Drink of Water"
GQ, 1999

— Wyoming

E. Annie Proulx

RICHARD FORD (1944-)

*A*T WAS A GAMBLE. By 1986, Richard Ford, a writer who hailed from Mississippi—the patch of earth that had been tilled so well by Eudora Welty and William Faulkner—had published a couple novels. They hadn't done so well. He'd launched a career in sportswriting but the magazine he worked for had gone under. Now he had a new novel, *The Sportswriter*, at Simon and Schuster—a firm from which his editor had recently departed. Ford believed in the novel but he was afraid it wouldn't get the right treatment after his editor left. So he bought the novel back and got it published through Vintage Books as a paperback (no hardcover edition was released). "If that book took a dive," Ford has said, "I was out of business."[1] Instead, *The Sportswriter* was a breakthrough, selling over 400,000 copies. The sequel, *Independence Day*, won him the Pulitzer Prize in 1996. A third novel, *The Lay of the Land*, followed in 2006.

The Sportswriter introduced the reading public to the acts and musings of Frank Bascombe—himself a son of Mississippi, former author, sportswriter (though Ford insists that Bascombe's resemblances to himself are incidental). At the time, Michiko Kakutani of the *New York Times* praised the "pliant" voice of Bascombe, clearly "someone attuned to the random surprises of daily life, its discontinuity and its capacity to startle and wound."[2] Besides bringing us Bascombe, Ford also furnished an American tableau through which he roams. It is centered in New Jersey—along the coast and in its verdant western townships—but it stretches to New England, upstate New York and into the "bricky warp" of our major cities. Make no mistake about it: Richard Ford has a lot to say about the lay of the land in America. He's come at the subject through Frank Bascombe for 20 years and maybe he hasn't said the last word yet.

Richard Ford's father was on the road selling for the Faultless Starch company when he and his wife, who was traveling with him, conceived. Ford was born in 1944, an only child and, by his own admission, well-loved. When he was 16 years old, his father died. These facts parallel Frank Bascombe's life, up to a point. Bascombe was born in 1945. His parents were from Iowa but were roamers until they finally took roost in Biloxi, Mississippi. Bascombe's father died when he was 14. But whereas Ford was sent back to Arkansas to live with his grandmother and her husband, who ran a hotel, Frank Bascombe's mother packed him off to a military school. Richard Ford learned quite a bit at the hotel that must serve him now as a writer. "A lot of things go on in great big hotels, behind closed doors," he has said. "And I saw behind those doors. Recklessness and mistakes…"[3]

It is not too much of a stretch to look to those early years—the early loss of a father and the exposure to the mysteries behind hotel doors—to see how those events could deepen his skill of inhabiting others. In a 2002 interview for the magazine *Book*, Richard Ford took his interviewer on a tour through New Orleans, one of the many places he has lived. They were talking about his book of short stories, *A Multitude of Sins*. "I am sympathetic to people who steal cars and fuck up," he said, with pre-Katrina New Orleans as his backdrop. "They're me. As middle class as I am, as wedded as I am to middle class values, I am capable of making terrible mistakes." Awareness of that capability runs through the Frank Bascombe trilogy.

When we first meet Frank Bascombe, he is still a sportswriter, and the quintessential American traveling man. He travels comfortably through the gigantic inner spaces of pre-9/11 airports. He does not fight the transience and contrived comforts of the business traveler who shuttles from one three-letter-code airport city to another, but accepts and even embraces them. As if he were doing a voice-over for a movie about himself, Frank Bascombe introduces himself on page 1 of *The Sportswriter*, with the kind of speech you might hear at an encounter group. "My name is Frank Bascombe. I am a sportswriter…" He tells us he lives alone in a comfortable Tudor house in Haddam, New Jersey. He is divorced. In his former life he had a promising

(Above and on pp. 268-269) **Island Beach Motor Lodge,** where Richard Ford stayed to soak up the local atmosphere. "A lot of things go on in great big hotels, behind closed doors," he has said of growing up in a hotel. This motor lodge's floor plan also lends itself to unexpected revelations and soliloquies. — South Seaside Park, New Jersey

career as a fiction writer, and wrote a book of short stories that came out to good reviews. But he stopped in the middle of his first novel, put it in a drawer. In *The Sportswriter* he refers to his ex-wife simply as X. He tells us they now have two children. They had three. One child died young. And that set into motion the events that led to his divorce.

Frank Bascombe wraps up his introduction with a bit of advice. If there is anything that sportswriting has taught him, he says, it is that "for your life to be worth anything, you must sooner or later face the possibility of terrible, searing regret. Though you must also manage to avoid it or your life will be ruined."[4] He is climbing the fence into the cemetery near his house. He will wait here for X so that they can visit their son's grave together. It is the early dawn of Good Friday. Just as *Independence Day* takes place over a 4th of July weekend, *The Sportswriter* transpires in the space of an Easter weekend. But don't expect any resurrections.

Mysterious Anthems – The Allure of New Jersey

"Living in a place," Frank Bascombe tells us, "is one thing we all went to college to learn how to do properly."[5] Like a lot of Frank Bascombe statements, this one sounds a bit smug and invites controversy. But in Haddam, New Jersey, where the art of living is raised to a height that exceeds some of the hedges, and college matriculants abound, such a comment would play pretty well. Settled in 1795 by Wallace Haddam, wool merchant, the town represents paradise of the kind that John Cheever so indelibly etched in his short stories: a moneyed, shady suburb, reachable from the City by train, where folks appreciate a good cocktail. The mood of Haddam is perhaps most beautifully evoked in the opening passage of *Independence Day*: "In Haddam, summer floats over tree-softened streets like a sweet lotion balm from a careless, languorous god, and the world falls in tune with its own mysterious anthems. Shaded lawns lie still and damp in the early a.m."[6]

Richard Ford

Haddam doesn't really exist. In a 2006 *New York Times* interview, Richard Ford revealed that Haddam is a composite of three real New Jersey towns: Princeton, Hopewell and Pennington. The three locations form a leafy triangle in the western part of the state, where American flags are common even after the 4th of July. Of the three, Hopewell is the closest to Ford's depiction of Haddam, though it seems too small. It possesses an old seminary—a fairly large yellow building next to Seminary Street, though Seminary Street does not boast the cozy but somewhat stodgy retail district of the book. Elsewhere, on another main street in town one finds an institution set far back from the road under formidable trees. It is reminiscent of the De Toqueville Academy that graces the town of Haddam. Pennington is small but historic. Perhaps it contributed the least of its genes to

Haddam. As for Princeton, it seems too large to be Haddam, but it has more of a racial mix than Hopewell could ever hope to attain. And this is important because, in *Independence Day*, Frank Bascombe has invested in some real estate in the black district of Haddam—which is basis for another line of musings. All in all, Ford seems not to have taken too much artistic license in his creation of a town. Haddam's cemetery is said to hold three of the signers of the Declaration of Independence. In fact, of the cemeteries within the three real towns, Hopewell's cemeteries hold one and Princeton's hold two.

It is Frank Bascombe who promoted Haddam. When he was married, he succeeded in moving the family there over the objections of his wife, Ann (a.k.a. "X"), who wanted to live in Lime Rock, Connecticut. Bascombe felt that Connecticut

Houses line a street along the Barnegat Peninsula, **bright tokens of order and amenity**. — Jersey Shore, New Jersey

was an "indecisive Judas country" and held out for a town that sounded to him like "an undiscovered Woodstock, Vermont" in a state he respected more. New Jersey holds nearly everything that Frank Bascombe could wish for. His attempts to make a go of existence, stay close to his children, and perhaps re-marry Ann, play out against its long, vertical stage (even though by the second book she has remarried and moved with the children to Connecticut). Bascombe takes comfort in the suburban quiet of Haddam where, of an evening, he can go for a walk and look at the windows of other houses in his neighborhood. His interests extend to the string of towns along the seaside, from the faded grandeur of Asbury Park on south to the Barnegat Peninsula. Of the beach at South Mantoloking—one of the pearls on that string—which is crowded with moms, secretaries,

children, the elderly, Ford writes: "Here is human hum in the barely moving air and surf-sigh, the low scrim of radio notes and water subsiding over words spoken in whispers."[7]

By *Independence Day*, Frank Bascombe has picked up real estate as an occupation. Haddam and its surrounding towns make up his territory, and he goes at his job with detachment and a not too effortful persistence that seem to hearken back to his days as a writer. Real estate is concerned with making gold from dross through the means of real estate adjectives and for this, too, Bascombe is well-suited. But he is far subtler than his literary predecessor, George F. Babbitt, ever was. He is perhaps even ambivalent, but that is debatable. One should "cease sanctifying places—houses, beaches, hometowns, a streetcorner where you once kissed a girl…"[8] that never give anything back,

Richard Ford

(*Above*) **Root beer stands** are not limited to New Jersey but, like boardwalks and afternoon cocktails, they seem to thrive in the state's rich compost of classic eras. — Lawrenceville, New Jersey. (*Next pp.* 274-275) **Vince Lombardi Service Area.** — I-95 Rest Area, New Jersey

he says at one point. And yet, by *Independence Day*, he is still living in the house where they lost their son.

In *The Lay of the Land*, Frank Bascombe has survived prostate cancer and moved to a town called Sea-Clift (though he still maintains ties to Haddam). Like Haddam, Sea-Clift does not exist on any map. Ford revealed in the *New York Times* interview that it too is a combination of three real towns: Seaside Heights, Seaside Park, and Ortley Beach. "The copy editors gave me a hard time about the hyphen," Ford said in an interview. "They argued that very few place names in America are hyphenated. But I said that this was a town invented by land developers, and they would definitely want the hyphen."[9] Ford spent a good deal of time in those towns drinking in the atmosphere (which is abundant), but always in a transient mode—staying at a motel on that narrow strip that is, like most addresses there, within walking distance to the ocean.

Richard Ford is one of many notable authors that have succumbed to the allure of New Jersey and the gems that are collected within her borders. Robert Frost once wrote that New Hampshire had "specimens"—only one of everything. New Jersey is large enough to have a multitude, but some are more unique than others. One example is the Vince Lombardi service area, one of the stops on the New Jersey Turnpike. Ford gives a pitch-perfect description of "The Vince" on a busy travel night. He nails its lobby, "chaotic as a department store at Christmas yet also, strangely, half asleep (like an old-time Vegas casino at 4 a.m.),"[10] its Vince Lombardi memorabilia, its dubious pleasures as a temporary haven from the road. Stopping at "The Vince," Frank Bascombe tries to make a connection by use of one of the pay phones that, in those pre-cell phone days, were "held hostage by 20 truckers with big chained-on wallets."[11] Like a lot of other things in his life, his phone call doesn't go as well as he would have hoped. In some respects it goes downright badly. But he persists.

Also colorfully rendered in Ford's fiction are New Jersey's bright orange root beer stands, which seem to have proliferated

there like nowhere else in the United States. In *Independence Day*, Bascombe owns a stand that he (who shares a love for puns with his son Paul) has named "Franks." Franks is located at the intersection of routes 518 and 31. Ford writes:

> Everyone over forty (unless they were born in the Bronx) has pristine and uncomplicated memories of such places: low, orange-painted wooden bunker boxes with sliding-screen customers' windows, strings of yellow bulbs outside, whitewashed tree trunks and trash barrels, white car tires designating proper parking etiquette, plenty of instructional signs on the trees and big frozen mugs of too-cold root beer you could enjoy on picnic tables by a brook or else drink off metal trays with your squeeze in the dark, radio-lit sanctity of your '57 Ford.[12]

The real-life intersection of 518 and 31, just past the Pennington-Hopewell-Princeton triangle, looks recently graded and cleared. But according to a local denizen, there once was a root beer stand there. Whether it looked like "Franks" is not known.

Choices Aplenty

As a sportswriter, Frank Bascombe celebrates the "literal and anonymous" cities of the United States: Milwaukee, St. Louis, Seattle, Detroit. What he likes about those cities is the chance that something unexpected could take place. "Choices are all we need," Bascombe maintains early in the book. "And when I walk out into the bricky warp of these American cities, that is exactly what I feel. Choices aplenty."[13] Of course, a buffet of choices can cause things to go awry. After the death of his son, Frank Bascombe has a number of affairs on his business trips. He describes how, adrift and buffered by numbness, he tried to insert himself forcibly into the lives of other people as a way to escape his own.

The most frequent targets of his efforts to belong are his wife and children. In *Independence Day*, Frank Bascombe brings his difficult son, Paul, to see the Baseball Hall of Fame in the center of the Leatherstocking region of New York. It is billed as a father and son bonding trip. The area, once only reached by the Hudson or by Indian trails through the wilderness, is the birthplace of American literature of place (see "Beginnings"). At Cooperstown, they stay at the Deerslayer Inn, whose library actually contains a copy of Frank Bascombe's book of short stories. The trip is really an unofficial excursion into the source of literary America. And Bascombe sets out on it with great, but fragile, optimism. Everything is poised as well as it could be for some kind of breakthrough. But teenage sons are difficult. And their parents are only human. Things go terribly awry.

Things go awry for Frank Bascombe when he goes to Detroit, too. In *The Sportswriter* he and his Texan girlfriend, Vicki Arcenault, fly there. He's there to do an interview with a paralyzed former football star. Detroit is close to Ann Arbor where X hails from (coincidentally, Richard Ford met his wife at Michigan State University) and perhaps that contributes to Bascombe's odd sense of levity and hopefulness on the trip. He notes with pleasure that anything can happen in another city. "It takes a real country girl," like Vicki, he says, "to bring it home." Within a few pages, Bascombe proceeds to initiate a series of wrong choices that will eventually lead her to punch him in the jaw on the front lawn of her dad's house on Easter Sunday.

"So much that is explicable in American life is made in Detroit," Bascombe tells us; a fact that, sadly, was truer in 1986 when the book was published than it is today. If he moved to Michigan, he states, ever adaptable in his choices, he would buy a new car every year "right at the factory door." He would consider a different line of work, like being a fishing guide on Michigan's numerous lakes (in *Babbitt*, George Babbitt had this same dream of a job). He would attend football games. Bascombe seems to feel capable of inserting himself anywhere in this country, of starting all over again.

Through the side trips and Bascombe's copious observations, the Richard Ford trilogy explodes the notion that America is one undifferentiated mass of people. Bascombe seems to feel that there is nearly as much differentiation between states or regions as one may find between countries of Europe. Cities have their own personalities and reasons for being. The regions have their own dialects. The characters' regional origins are like tags they wear for life, more defining than their parentage.

Richard Ford

"The "Vince" is a little red-brick Colonial Williamsburg-looking pavilion, whose parking lot this midnight is hopping with cars, tour buses, motor homes, pickups—all my adversaries from the turnpike—their passengers and drivers trooping, dazedly inside through a scattering of seagulls and under the woozy orange lights, toting diaper bags, thermoses, and in-car trash receptacles, their minds fixed on sacks of Roy Rogers burgers, Giants novelty items, joke condoms, with a quick peep at the Vince memorabilia collection from the great man's glory days on the 'Six Blocks of Granite' ..."

— Richard Ford
Independence Day, 1995

Richard Ford

Ford revealed in a *New York Times* interview that his fictional
Haddam was a composite of these three towns.

To Create a Literature Worthy of America

As of 2006, Richard Ford had owned seven houses and lived
in 12 different states. Some of the research for *The Lay of the
Land* took place on successive trips to the New Jersey shore. He
never lived there in a permanent fashion. His research does not
consist of "plundering around trying to find nice little ancient
graveyards, or going down to the historical society," he said in
a 2003 *Guardian* interview. "I do the normal things – go to the
hardware store to buy hornet spray, get my tires rotated, go have
lunch. Whatever is around in the ambiance here I'll find it."

Frank Bascombe is resistant to viewing the past as a way
to define oneself. Ever the unsentimentalist, he sees his own
history as "a postcard with changing scenes on one side but no
particular or memorable messages on the back." As for Ford, he
resists those who would define him through his art. He side-
steps attempts to associate him too closely with Bascombe and
bristles at questions that link Bascombe's infidelity to his own
private life. Richard Ford has been married to the same woman,
Kristina, for many years. They married when he was 23.

Richard Ford is not Frank Bascombe. For one thing, Frank
Bascombe is a failed novelist. In the end, he had an inability
to penetrate deep enough, and he had the sense to realize it.
In the trilogy, Ford, on the other hand, has created one great,
fully realized character. "Life is not always ascendant," Frank

Long after Independence Day has come and gone, **a street in Hopewell, New Jersey** continues to evoke a Haddamesque idyll: well-kept homes, shady yards and American flags anointed by a benevolent if languorous god. — Hopewell, New Jersey

Bascombe rues. He is the unreliable narrator who knows he is unreliable. Like Rabbit Angstrom, of Updike's great Rabbit series, he does harm, and we see so many of his failings that we realize he is a hard man to love. But boy, he never stops thinking about love and being loved.

Ford once stated that his goal was: "to create a literature worthy of America." He has succeeded. At one point Frank Bascombe says: "I think I am just more at ease in the mainstream. It's my version of the sublime."[14] Within *A Journey Through Literary America*, authors have written of the beauty of the vertical sublime. [See "Beginnings" entry.] Philip Roth perhaps coined the phrase "manmade sublime." [See Roth entry.]

Perhaps there should be an "American sublime" as well—to describe locations that are compelling in a purely American way—like the palm card reader in a strip mall from *The Sportswriter*, or the house of Vicky Arcenault's father, who is restoring an old car in his basement and has a poodle named Elvis, or the somewhat kitschy comfort of the Deerslayer Inn. Ford is a great practitioner of it. Not plundering about but instead covering the normal things, and guided by the realization that we are all capable of making terrible mistakes, he has fashioned something sublime out of mainstream America. ॐ

Richard Ford

APPENDIX

A Journey Through Literary America has a companion website:
http://www.LiteraryAmerica.net

On the site you will find addresses and driving directions for the locales within this book, including many that are off the beaten path. You will also find more photographs, more literary locales for more authors, more commentary, links to other websites of literary interest, our blog, notices of upcoming events, listings of bookstores that sell this book, and an online store where you can order our line of greeting cards, limited edition fine art prints or more copies of this volume.

We invite you to use the book and website to launch your own journey into literary America. Please drop us a line along the way. ❧

Thomas R. Hummel
4551 Glencoe Avenue, Suite 110
Marina del Rey, California 90292
tom@literaryamerica.net

Tamra L. Dempsey
tamra@literaryamerica.net

Tamra's Journeys ๛

DEPARTED: August 29, 2007

- *Santa Barbara, CA*
- *Monterey, Pacific Grove*
 & Salinas, CA
- *Carmel & Big Sur, CA*
- *Yakima & Port Angeles, WA*
- *Wyoming*
- *Sauk Centre, MN*
- *Horton Bay*
 & Walloon Lake, MI
- *Clyde, OH*
- *Lorain, OH*
- *Akron, OH*
- *The Catskills, NY*
- *New Bedford*
 & the Berkshires, MA
- *Vermont & New Hampshire*
- *Concord, Salem*
 & the Berkshires, MA
- *Brooklyn, NY*
- *Harlem, NY*
- *Newark & Mendham, NJ*
- *Princeton, Hopewell,*
 Pennington & the Shore, NJ
- *Shillington, Plowville*
 & Reading, PA
- *Asheville, NC*
- *Milledgeville, GA*
- *Oxford, MS*
- *Red Cloud, NE*
- *Leadville, CO & the West*

RETURNED HOME: Dec. 1, 2007

DEPARTED: August 2, 2008

- *Santa Barbara, CA*
- *Acoma Pueblo, NM*

RETURNEND HOME: Aug. 5, 2008

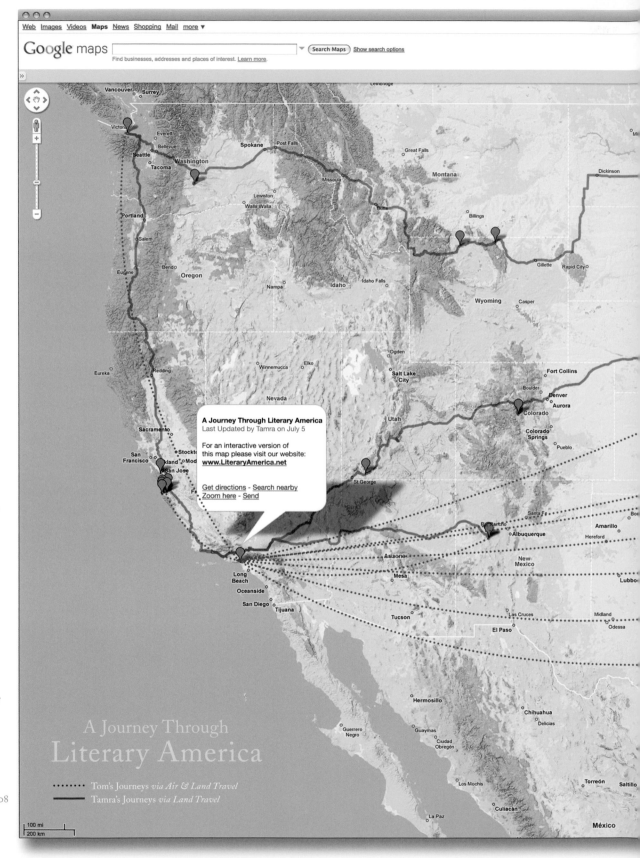

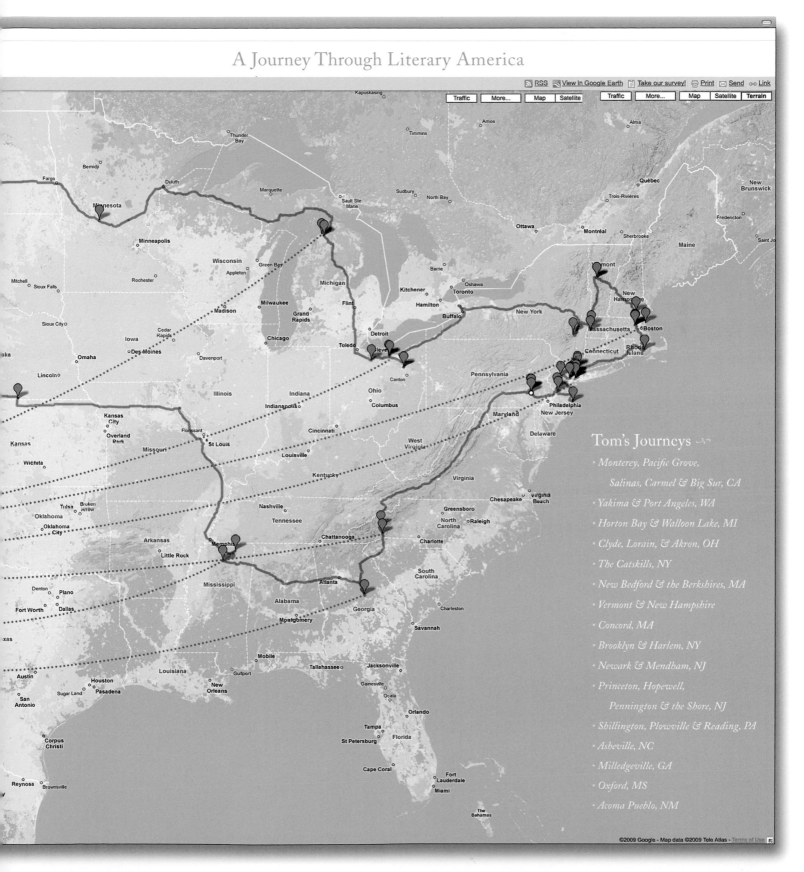

A Journey Through Literary America

Traffic | More... | Map | Satellite Traffic | More... | Map | Satellite | Terrain

Tom's Journeys

- *Monterey, Pacific Grove, Salinas, Carmel & Big Sur, CA*
- *Yakima & Port Angeles, WA*
- *Horton Bay & Walloon Lake, MI*
- *Clyde, Lorain, & Akron, OH*
- *The Catskills, NY*
- *New Bedford & the Berkshires, MA*
- *Vermont & New Hampshire*
- *Concord, MA*
- *Brooklyn & Harlem, NY*
- *Newark & Mendham, NJ*
- *Princeton, Hopewell, Pennington & the Shore, NJ*
- *Shillington, Plowville & Reading, PA*
- *Asheville, NC*
- *Milledgeville, GA*
- *Oxford, MS*
- *Acoma Pueblo, NM*

ACKNOWLEDGEMENTS

I AM VERY GRATEFUL TO THE FOLLOWING PEOPLE: To my parents, who instilled in me and my siblings a passion for literature, taught us how to live, and who were so supportive in the making of this book. To my brothers Paul and Peter and my sister Maria; a few words cannot express my emotions and high regard. To my relatives, especially my Aunt Patty, who is so enthused about this book. To my parents-in-law, Dan and Aiko Ochiai. To Doyald Young, constant friend and inspiration. To my publisher, Paul Chutkow, for enthusiasm and sagacity. To my editor, Malena Watrous; I could not have asked for a better one. You refined my writing without altering my style and, when you were done, I felt sure the book was solid. To Julie Simpson, who skillfully copyedited the book after I had concluded my final document was grammatically flawless. I am so glad we encountered you and your energy. To my great friends Fabiola Zambon and Richard Jones with whom I shared so many struggles and so many experiences over the years. To my boss, Yusuke Suzuki, who has supported me in this endeavor. You are irreplaceable. To Johnny Leung, for friendship and expert color. To my current colleagues Mary McGee, Mari Nomura, and Joseph Liao, and to my past colleague Carolin Stransky. To Toppan Hong Kong: my old friend Alfred Chung and to Zoe Wong, Kit Tsang, Jannifer Cheung, Vincent Choi, and Stanley. To George Maruta, President of Toppan America, and to John Lee, from whom I have learned much. To Dana Levy and Tish O'Connor of Perpetua Press from whom, again, I have learned much. To Marty Lee. To John McLaughlin. To Daniel Funk. To Ed Conklin of Chaucer's Books in Santa Barbara, for his guidance and enthusiasm. To my teachers. To writers and biographers everywhere. Thank you.

— Thomas R. Hummel

FIRST AND FOREMOST I must thank Jacob Morgan—I don't know how I could have done this book without your love, support, patience and time. Even the simple little things made all the difference, like knowing which direction I meant and not getting frustrated when I said, "go left." Thank you.

To my family, my mom, my brother Lance, my sister-in-law Stacy and especially to my father: Thank you for shaping my life, I absolutely love it. To Olive, my grandmother; you are my one true inspiration. To Vera, my grandmother, who doesn't let me forget to make every day count. I thank you both and only hope that I can follow in your footsteps - and like my mom who did just that - be one of the dearest women to walk the earth.

To Bob; to Kathy; to Cheri and JoAnn; to Theil and Philip; to Kelly; thank you for being more than just family.

To my very good friends Lynn Cobb, Melissa Fitzpatrick and Kristin Kelly; thank you for your enthusiasm and support for the past 20 years. To my dear friend Chris Jordahl; its comforting to know you are always there.

To Glen Serbin, you are a true visionary; to Elizabeth Owen, my life-saver and my friend; I thank you both for being models of an unending aspiration for excellence; I have learned so much. To Theil Shelton, Barbara Kuhn and Keane Roberts; thank you for filling in, taking up the slack and keeping the production dept. in order while I was away, but most of all thank you for your friendship.

To Jain Lemos; thank you for sharing your knowledge and encouraging us with your quintessence of optimism.

To the many, many photographers I've come to know and admire over the years (you know who you are), thank you.

And finally to Tom; for giving me the opportunity to work with you on this project; enlightening me; and challenging me to capture "words." The journey has honestly made yet another dream come true, and for all of that, a heart-felt thank you.

— Tamra L. Dempsey

NOTES

BEGINNINGS

Washington Irving & James Fenimore Cooper:

1. Robert Spiller, *The Cycle of American Literature*, 6.

2. Washington Irving, *A History of New York from the Beginning of the World to the End of the Dutch Dynasty*, 186.

3. James Fenimore Cooper, *The Deerslayer*, 3.

4. From the Introduction to *The Deerslayer* by Basil Davenport, Dodd Mead edition, 1979.

5. From the Preface to *The Deerslayer* (Dodd Mead edition).

6. Irving, *Spanish Papers*, Vol. 2, 482-483.

7. Irving, "The Legend of Sleepy Hollow."

8. Cooper, *The Pioneers*, 229.

9. Quoted in Roland Van Zandt's *The Catskill Mountain House*. Original source unknown.

10. Cooper, *The Pioneers*, 231-232.

11. Thomas Cole, quoted in *The Catskill Mountain and the Region Around*, 1867, Source: Van Zandt, 215.

12. Cooper, *Home as Found*, 114, Source: "Epiphany at Ischia: The Effect of Italy on James Fenimore Cooper's Literary Landscape Painting," Allan M. Axelrad, 1993, http://external.oneonta.edu/cooper/articles/suny/1993suny-axelrad.html (July 2009).

NEW ENGLAND

Ralph Waldo Emerson & Henry David Thoreau:

1. Nathan Haskell Dole, "Life of Ralph Waldo Emerson" (From the Introduction to *Early Poems of Ralph Waldo Emerson*), http://www.emerson-central.com/others/life_of_ralph_waldo_emerson.htm#dole (July 2009).

2. From the Introduction to *Mosses from an Old Manse* by Nathaniel Hawthorne.

3. Ralph Waldo Emerson, "Nature," Chapter III: Beauty.

4. Emerson, "Nature," Chapter I: Nature.

5. Emerson, "Nature," Chapter IV: Language.

6. Samuel A. Schreiner, *The Concord Quartet: Alcott, Emerson, Hawthorne, Thoreau, and the Friendship that Freed the American Mind*, 30.

7. From the brief biography of Emerson that precedes *Nature* in the *Norton Anthology of American Literature*, 992.

8. Henry Seidel Canby, 111.

9. Words taken from Ellen Sewell's letter to Henry David Thoreau's Aunt Prudence, who had also chaperoned John on his visit to Scituate.

10. Canby, 82.

11. Ibid., 399.

12. Henry David Thoreau, "The Village," *Walden*, 150.

13. Ibid., 152.

14. From *The Writings of Henry David Thoreau*, Houghton Mifflin, Volume XVIII, 389, 390, as quoted in Canby's *Thoreau*.

15. Ralph Waldo Emerson's *Journal*, August 1848.

16. Ibid., June 1863.

Nathaniel Hawthorne:

1. Quote attributed to Elizabeth Peabody.

2. From the Introduction to *Complete Short Stories* by Henry James, 2.

3. One of the letters from the voluminous correspondence between Nathaniel Hawthorne and Sophia.

4. From the Introduction to *Mosses from an Old Manse* by Nathaniel Hawthorne.

5. Ibid.

6. Ibid.

7. From a letter collected in the *Almanac of American Letters*, Randy F. Nelson, editor.

8. Sophia Hawthorne's *Journal*.

9. From the Introduction to *Complete Short Stories* by Henry James.

10. From the Introduction to *Mosses from an Old Manse* by Nathaniel Hawthorne.

11. Ibid.

12. Ibid.

13. From "Hawthorne and His Mosses" ostensibly written "By a Virginian spending July in Vermont." The author was later revealed to be neither a Virginian nor spending time in Vermont, but Herman Melville of the Berkshires.

14. Robert Spiller, *The Cycle of American Literature*, 74.

15. Hawthorne wrote this in a letter to Horace Mann, according to the article "Hawthornes in Lenox," *The New York Times*, August 5, 1900.

16. Nathaniel Hawthorne, *Septimius Felton or The Elixir of Life*, 1.

17. As quoted by Philip McFarland in *Hawthorne in Concord*, 297.

18. Hawthorne, "The Great Carbuncle," *Twice Told Tales*, 1.

19. From the Introduction to *Complete Short Stories* by Henry James.

20. Hawthorne, "The Virtuoso's Collection," *Mosses from an Old Manse*.

Herman Melville:

1. Hershel Parker, *Herman Melville: A Biography*, 1996, 773. Original source: the diary of Sophia Hawthorne.

2. Herman Melville, *Redburn*, 7.

3. Melville, *Moby Dick*, 4.

4. Ibid., 114.

5. Ibid., 229.

6. Melville, *Omoo* (Library of America edition of *Typee • Omoo • Mardi*), 431.

7. Parker, 196.

8. Melville, *Typee* (Library of America edition of *Typee • Omoo • Mardi*), 45.

9. Parker, 842.

10. Parker, 786.

11. Ibid., 278.

12. Ibid., 282.

13. Ibid., 270.

14. Ibid., 236.

15. Melville in a letter to Hawthorne, November 17, 1854.

16. From the *Journal* of Nathaniel Hawthorne.

Robert Frost:

1. Robert Frost's letter to Miss Susan Ward, April 22, 1894, as quoted in Elizabeth Shepley Sergeant's *Robert Frost: The Trial by Existence*, 39.

2. Letter to Louis Untermeyer, February 15, 1950.

3. Sergeant, 57.

4. Ibid., 65.

5. Letter to Miss Susan Ward, February 10, 1912, as quoted in *Robert Frost: The Trial by Existence*, 87-88.

6. *Robert Frost: The Trial by Existence*, p. 87.

7. Letter to Louis Untermeyer, February 21, 1950.

8. Letter to Thomas Bird Mosher, as quoted in *Robert Frost: The Trial by Existence*, 87-98.

9. The quotes for this oft-repeated story come from the *Paris Review* interview with Robert Frost in the Summer-Fall 1960 issue.

10. Ibid.

11. Sergeant, 151.

12. Robert Frost, "Directive," *Collected Poems of Robert Frost*.

13. Sergeant, 169.

14. Letter to Louis Untermeyer, February 27, 1950.

15. Frost, "New Hampshire," *Collected Poems of Robert Frost*.

16. "Robert Frost: The Way to the Poem," John Ciardi, http://www.drama21c.net/text/ciardi.htm (July 2009).

17. *Robert Frost: The Trial by Existence*, 251.

18. Stanley Burnshaw, *Robert Frost: Himself*, 21.

19. Letter to Louis Untermeyer, November 7, 1917.

20. Frost, "New Hampshire," *Collected Poems of Robert Frost*.

21. He said this in a 1959 speech at a special event in honor of Frost's birthday.

22. From a description of Frost by Reginald Cook, as quoted in *Robert Frost: Himself*, 257.

23. Sergeant, 373.

24. Letter to Louis Untermeyer, Oct 27, 1917.

25. Ibid.

REELING WESTWARD

Willa Cather:

1. Willa Cather, "Macon Prairie."

2. Mildred R. Bennett, *The World of Willa Cather*, 12.

3. Ibid., 11.

4. From an original interview that appeared as "Lure of Nebraska Irresistible, Says Noted Authoress," in the *Omaha Bee* October 29, 1921.

5. Cather, *My Ántonia*, 19.

6. Ibid., 80.

7. Ibid., 98.

8. Bennett, 66.

9. Cather, *My Ántonia*, 168.

10. Ibid., 129.

11. Ibid., 126.

12. Ibid., 131.

13. Ibid., 131.

14. Ibid., 131.

15. Ibid., 131.

16. Ibid., 142-143.

17. Ibid., 77.

18. Ibid., xxiv.

19. Bennett, 73.

20. Ibid., 148.

21. Cather, *Death Comes for the Archbishop*, 273.

22. Cather, *My Ántonia*, 199.

Wallace Stegner:

1. Wallace Stegner, "Thoughts in a Dry Land," *Where the Bluebird Sings to the Lemonade Springs*, 45.

2. From the Introduction to *Where the Bluebird Sings to the Lemonade Springs*, xx.

3. Ibid., 4.

4. Stegner, "At Home in the Fields of the Lord," *Marking the Sparrow's Fall*, 30.

5. Stegner, *The American West as Living Space*, 4.

6. "Thoughts in a Dry Land," *Where the Bluebird Sings to the Lemonade Springs*, 52.

7. Stegner, *Angle of Repose*, 4.

8. Ibid., 49.

9. Ibid., 29.

10. Ibid., 69.

11. Ibid., 199.

12. "Living Dry," *Where the Bluebird Sings to the Lemonade Springs*, 59.

13. The Wilderness Letter was later published in one of Stegner's books: *The Sound of Mountain Water*.

14. Jackson L. Benson, *Down by the Lemonade Springs*, 126.

15. Wallace and Page Stegner, *American Places*, 35.

John Steinbeck:

1. Jay Parini, *John Steinbeck*, 10.

2. Parini, 41.

3. As quoted in Raymond Carver's book review "Fame is No Good, Take it From Me," *New York Times*, April 22, 1984.

4. "John Steinbeck's Pacific Grove Driving Tour." Copyright Esther Trosow, http://www.93950.com/steinbeck (July 2009).

5. Ibid.

6. Kevin Starr, *Endangered Dreams: The Great Depression in California*, 256.

7. Steinbeck, "The Harvest Gypsies – Starvation under the Orange Trees," 6.

8. Parini, 201.

9. Steinbeck, *The Grapes of Wrath*, 214.

10. Ibid., 241.

11. Parini, 290.

12. Ibid., 295.

13. Steinbeck, *Travels with Charley*, 5.

14. Ibid., 70.

Robinson Jeffers:

1. Robinson Jeffers, "The Torch Bearer's Race."

2. From the Introduction to *The Collected Poetry of Robinson Jeffers* by Tim Hunt, 4.

3. Jeffers, "Continent's End."

4. Jeffers, "The Bed by the Window."

5. Hunt, 109.

6. September 18, 1943 letter to Frederic I. Carpenter, as quoted in Hunt, 110.

7. Jeffers, "Cassandra."

8. Jeffers, "Eagle Valor, Chicken Mind."

9. From the Foreword to *The Double Axe* by William Everson, http://www.english.uiuc.edu/maps/poets/g_l/jeffers/everson.htm (July 2009).

NOT FORGOTTEN

William Faulkner:

1. William Faulkner, *Absalom! Absalom!*, 86.

2. Anecdote from Stephen B. Oates, *William Faulkner: The Man and the Artist*.

3. Faulkner, "Mississippi," *Essays, Speeches, & Public Letters*, 4.

4. Ibid., 1.

5. Ibid., 28.

Thomas Wolfe:

1. *The Letters of Thomas Wolfe to his Mother*.

2. Ted Mitchell, *Thomas Wolfe: A Writer's Life*, 8.

3. Thomas Wolfe, *Look Homeward Angel*, 41.

4. Ibid., 46.

5. Ibid., 83.

6. Ibid., 88.

7. Ibid., 124.

8. Ibid., 129.

9. Ibid., 136.

10. Ibid., 235.

11. Ibid., 212.

12. Carol Johnston, "Thomas Wolfe's First Triumph: 'An Angel on the Porch'," in *The Thomas Wolfe Review*, Vol. 13, No. 2, Fall, 1989, 53-62.

13. From *The Letters of Thomas Wolfe*.

14. Wolfe, *Look Homeward, Angel*, 386.

15. Ibid., 109.

16. From the Introduction to *Look Homeward, Angel*, written by Perkins on the occasion of a large donation of Wolfe's papers to Harvard.

17. Ibid.

18. Ibid.

19. Richard Walser, ed., *The Enigma of Thomas Wolfe*, vii.

MAIN STREETS

Sinclair Lewis:

1. Mark Schorer, *Sinclair Lewis: An American Life*, 19.

2. Ibid., 173.

3. Ibid., 188.

4. Ibid., 189. Quote attributed to Mary Heaton Vorse.

5. Ibid., 193. Quote attributed to Edna Ferber's book, *A Peculiar Treasure*.

6. James M. Hutchinsson, *The Rise of Sinclair Lewis, 1920-1930*. 15.

7. From *With Love From Gracie: Sinclair Lewis, 1912-1925* (New York: Harcourt Brace, 1955) as quoted in *The Rise of Sinclair Lewis, 1920-1930*, 25.

8. Ibid., 25.

9. Ibid., 18.

10. Ibid., 31.

11. Ibid., 3.

12. Ibid., 486.

13. From *With Love from Gracie*, as quoted in *The Rise of Sinclair Lewis, 1920-1930*, 145.

14. Hutchisson, 33.

15. From Alfred Harcourt's memoir *Some Experiences*, as quoted in *The Rise of Sinclair Lewis, 1920-1930*, 24.

16. Hutchisson, 42.

17. "Notes on Journalism," *Chicago Tribune*, September 19, 1926.

18. Hutchisson, 56.

19. Sinclair Lewis, *Babbitt*, 1.

20. Hutchisson, 89.

21. Ibid., 62.

22. Reproduction of Lewis's original typescript, as reproduced in *The Rise of Sinclair Lewis, 1920-1930*, 67.

23. From Harcourt's *Some Experiences*, as quoted in *The Rise of Sinclair Lewis, 1920-1930*, 63.

24. Lewis, *Babbitt*, 27.

25. Ibid., 27.

26. From Mencken's article "Portrait of an American Citizen," *Smart Set 69* (October 22) as quoted in *The Rise of Sinclair Lewis, 1920-1930*, 70.

27. Hutchisson, 135.

28. Ibid., 315.

29. Lewis, *Dodsworth*, 10.

30. Ibid., 13.

31. Ibid., 153.

Sherwood Anderson:

1. Sherwood Anderson, *TAR: a Midwest Childhood*, 9.

2. Ibid., 15.

3. Ibid., 16.

4. Ibid., 33.

5. Ibid., 34.

6. Ibid., 104.

7. From a list provided by the Clyde Public Library, Clyde, Ohio.

8. Anderson, *The New Republic*, October 11, 1922.

9. Often cited anecdote. Original source unknown.

10. As quoted in Raymond Carver's book review "Fame is No Good, Take it From Me," *New York Times*, April 22, 1984.

11. Horace Gregory, *The Indispensable Sherwood Anderson*, 23.

THE INNER MIGRATION

Langston Hughes:

1. Langston Hughes, *The Big Sea*, 55.

2. Ibid., 18.

3. Ibid., 38.

4. Ibid., xix.

5. Hughes, "The Weary Blues."

6. Ibid.

7. Hughes, *The Big Sea*, 203.

8. Ibid., 212.

9. Wallace Thurman, *Negro Life in New York's Harlem*, 100.

10. Hughes, *The Big Sea*, 225.

11. Thurman, 99.

12. Hughes, *The Big Sea*, 233.

13. Arnold Rampersad, *The Life of Langston Hughes: Volume I: 1902-1941*, 147.

14. Hughes, *The Big Sea*, 313.

15. Rampersad, *The Life of Langston Hughes: Volume I: 1902-1941*, 147.

16. Rampersad, *The Life of Langston Hughes Volume II: 1941-1967*, 148.

17. From the Foreword to *Montage of a Dream Deferred* by Langston Hughes, 1951.

Toni Morrison:

1. Profile by Colette Dowling in *The New York Times Magazine*, May 20, 1979, 44.

2. Ibid., 44.

3. R. L. Hartt, *Atlantic Monthly 84*, November, 1899.

4. Toni Morrison, *The Bluest Eye*, 105.

5. Interview by Bonnie Angelo, *Time*, May 22, 1989, 120.

6. Morrison, *The Bluest Eye*, 81.

7. Morrison, *Sula*, 89-90.

8. Ibid., 90.

9. Dowling, 44.

10. Dowling, 42.

11. Interview by Charles Ruas, *1987 Fiction Writers Market*, 5.

12. Quote is from her own biographical sketch, as noted in *Current Biography 1979*, 265.

13. Morrison, *The Bluest Eye*, 10.

14. Morrison, *Sula*, 5.

15. Ibid., 94.

16. Interview with Toni Morrison in the *Lorain Journal*, January 16, 1982.

17. Interview by Charles Ruas, *1987 Fiction Writers Market*, 6.

18. Ibid., 6.

Rita Dove:

1. Rita Dove, "The Gorge," *Grace Notes*.

2. Walter Havighurst, *Ohio: A Bicentennial History*, 151.

3. Dove, "The Event," *Thomas and Beulah*.

4. Dove, "Jiving," *Thomas and Beulah*.

5. Ibid.

6. From an interview in *Giving their Word: Conversations with Contemporary Poets*, Steven Ratner, editor.

7. Ibid.

8. Dove, "Pomade," *Thomas and Beulah*.

9. Interview with Rita Dove conducted by Elizabeth Alexander, *The Writer's Chronicle*, Volume 38, Number 2.

TWENTIETH CENTURY EXCURSIONS

Henry Miller:

1. Robert Ferguson, *Henry Miller: A Life*, 5.

2. Henry Miller, "A Boyhood View of the Nineties," *New York Times*, October 17, 1971.

3. Miller, *Book of Friends*, 21.

4. Miller, "The 14TH Ward," *Black Spring*, 4-5.

5. "A Boyhood View of the Nineties," *New York Times*.

6. Miller, *Stand Still like the Hummingbird*, 46.

7. Miller, *Tropic of Capricorn*, 342.

8. Miller, *Book of Friends*, 14.

9. Letter to Emil Schnellock, April, 1930.

10. Miller, *Book of Friends*, 15.

11. Miller, "Reunion in Brooklyn," *The Henry Miller Reader*, 98.

12. "The 14TH Ward," 9.

Ernest Hemingway:

1. Ernest Hemingway, "Now I Lay Me," *The Nick Adams Stories*, 146.

2. "Three Shots," *The Nick Adams Stories*, 15.

3. Letter from Ernest Hemingway to Emily Goetsmann, 1916.

4. Letter from Ernest Hemingway to Bernard Berenson, March 20-22, 1953.

5. "On Writing," *The Nick Adams Stories*, 239.

6. "Big Two-Hearted River," *The Nick Adams Stories*, 183-185.

7. Robert Coltrane, "Hemingway and Turgenev: The Torrents of Spring," *Hemingway's Neglected Short Fiction: New Perspectives*, edited by Susan F. Beegel, 156.

8. Ibid., 89.

9. "Big, Two-Hearted River," *The Nick Adams Stories*, 177.

10. Ibid., 179.

11. Ibid., 187.

12. "On Writing," *The Nick Adams Stories*, 238.

13. "The Last Good Country," *The Nick Adams Stories*, 111.

14. Letter to Ernest Hemingway, dated July 24, 1920.

15. Item 754 in Hemingway papers at JFK Library.

Flannery O'Connor:

1. Jean W. Cash, *Flannery O'Connor: A Life*, 22.

2. Flannery O'Connor, *The Habit of Being*, 166.

3. Ibid., 5.

4. Ibid., 22.

5. O'Connor, *The Complete Stories*, 357.

6. Ibid., 367-368.

7. Ibid., 179.

8. Ibid., 285.

9. Cash, 101.

10. Wendy Lesser, "Southern Discomfort: The Origins of Flannery O'Connor's Unsettling Fictional World." *Bookforum*, Feb/Mar 2009.

11. O'Connor, *The Habit of Being*, 144.

12. Cash, 237.

John Updike:

1. "Of Prizes and Print," remarks delivered by John Updike on the occasion of his receiving the 1998 National Book Foundation Medal for Distinguished Contribution to American Letters, http://www.bookreporter.com/authors/au-updike-john.asp (July 2009).

2. Academy of Achievement interview, 2004, http://www.achievement.org/autodoc/page/upd0int-2 (July 2009).

3. Ibid.

4. From the Introduction to *The Early Stories* by John Updike.

5. Academy of Achievement interview.

6. Bruce R. Posten, "John Updike's children remember the time they spent vacationing in Plowville." *The Reading Eagle*, March 15, 2009.

Philip Roth:

1. Philip Roth, *The Plot Against America*, 212.

2. Al Alvarez, "The Long Road Home," *The Guardian*, September 11, 2004.

3. Roth, *The Plot Against America*, 202.

4. Roth, *Goodbye, Columbus*, 9.

5. From the back cover of *Goodbye, Columbus*.

6. Chronology of Philip Roth from the Modern Library Edition of his works.

7. Philip Roth, "Writing American Fiction," *Commentary*, March, 1961, 225.

8. Ibid., 233.

9. Roth, *Portnoy's Complaint*, 54.

10. Ibid., v.

11. Ibid., 244.

12. Roth, *The Plot Against America*, 4.

13. Interview by Jeffrey Brown with Philip Roth, November 10, 2004, Jim Lehrer NewsHour online.

14. Roth, *The Plot Against America*, 134.

15. Ibid., 207.

16. The Jim Lehrer NewsHour interview.

17. "Writing American Fiction," 224.

18. Roth, *American Pastoral*, 86.

19. Ibid., 74.

20. Ibid., 43.

21. Ibid., 219.

22. Ibid., 219.

23. Ibid., 189.

24. Roth, *American Pastoral*, 13.

25. Interview on Houghton Mifflin website, http://www.houghtonmifflinbooks.com/authors/roth/conversation.shtml (July 2009).

26. Ibid.

E. Annie Proulx:

1. Writers Program of the Work Projects Administration in the State of Wyoming, *Wyoming: A Guide to its History, Highways, and People*, 98.

2. Ibid., 50.

3. Ibid., 66-67.

4. Ibid., 7.

5. Scott McGaugh, *The Life and Times of the Virginian and Jackson Hole*, 45-46.

6. The Literary Encyclopedia, http://www.litencyc.com/php/speople.php?rec=true&UID=3654 (July 2009).

7. Ibid.

8. Interview with Katie Bolick, *The Atlantic Online*, November 12, 1997.

9. Interview with Charlie Rose, June 3, 1999.

10. Ibid.

11. Annie Proulx, "People in Hell Just Want a Drink of Water," *Close Range: Wyoming Stories*, 103.

12. From the Charlie Rose interview.

13. *Wyoming: A Guide to its History, Highways, and People*, 4.

14. "Pair a Spurs," *Close Range: Wyoming Stories*, 165.

15. "The Bunchgrass Edge of the World," *Close Range: Wyoming Stories*, 136.

16. "A Lonely Coast," *Close Range: Wyoming Stories*, 203.

17. Washington Irving, *Astoria; Or, Anecdotes of an Enterprise Beyond The Rocky Mountains*, Chapter 23.

18. "Brokeback Mountain," *Close Range: Wyoming Stories*, 255.

19. "The Mud Below," *Close Range: Wyoming Stories*, 63.

20. Entertainment News staff, "Annie Proulx Tells the Story of 'Brokeback Mountain'." December 30, 2005.

21. Interview with Annie Proulx, "More Reader than Writer," Wyoming Library Roundup, http://www-wsl.state.wy/us/roundup/Fall005Roundup.pdf (July 2009).

22. Owen Wister, *The Virginian: Horseman of the Plains*, 11.

23. Ibid., 4.

24. Ibid., 4.

25. "People in Hell Just Want a Drink of Water," *Close Range: Wyoming Stories*, 99.

Richard Ford:

1. "Ford Tough," an interview with Richard Ford by Michael Kaplan, *Book*, March 1, 2002.

2. Michiko Kakutani, "Books of the Times: The Sportswriter," *New York Times*, February 26, 1986.

3. Interview with Richard Ford in *The Guardian*, February 8, 2003, Laura Barton, interviewer.

4. Richard Ford, *The Sportswriter*, 4.

5. Ibid., 49.

6. Ford, *Independence Day*, 1.

7. Ibid., 151.

8. Ibid., 152.

9. "A New Jersey State of Mind," *New York Times* interview, October 24, 2006.

10. Ford, *Independence Day*, 178.

11. Ibid., 178.

12. Ibid., 129.

13. Ford, *The Sportswriter*, 7.

14. Ford, *Independence Day*, 272.

BIBLIOGRAPHY

❖ General

Jurca, Catherine, *White Diaspora: The Suburb and the Twentieth-Century American Novel*. New Jersey: Princeton University Press, 2001.

Norton Anthology of American Literature. New York: W.W. Norton, Fourth Edition, 1979.

Setterberg, Frank, *The Roads Taken: Travels through America's Literary Landscapes*. Athens. Georgia: University of Georgia Press (Athens), 1993.

Spiller, Robert E., *The Cycle of American Literature*. New York: A Mentor Book [The New American Library], 1955.

❖ Sherwood Anderson

Anderson, Sherwood, *The Indispensable Sherwood Anderson*. New York: The Book Society, 1950.

Anderson, Sherwood, *TAR: A Midwest Childhood*. Cleveland: The Press, Case Western Reserve University, 1969.

Anderson, Sherwood, *Winesburg, Ohio*. New York: W.W. Norton & Company, 1996.

Gregory, Horace, *The Indispensable Sherwood Anderson*. New York: Book Society, 1949.

Special thanks to the Clyde Public Library reference librarians.

❖ Raymond Carver

Carver, Raymond, *All of Us: The Collected Poems*. New York: Alfred A. Knopf, 1996.

Carver, Raymond, *Call If You Need Me*. New York: Vintage Contemporaries, 1991.

Carver, Raymond, *Where I'm Calling From*. New York: Vintage Contemporaries, 1986.

Gallagher, Tess, "Port Angeles Haunts" (Annotated map of Port Angeles). http://www.whitman.edu/english/carver/port.html (July 2009).

Stull, William L., "Biographical Essay," *Dictionary Of Literary Biography*. http://www.whitman.edu/english/carver/biography1.html (July 2009).

❖ Willa Cather

Bennett, Mildred, *The World of Willa Cather*. Lincoln: University of Nebraska Press, 1989.

Cather, Willa, *Cather Novels & Stories 1905-1918: The Troll Garden, O Pioneers! The Song of the Lark, and My Antonia*. Des Moines: Library of America, 1999.

Cather, Willa, *Death Comes for the Archbishop*. New York: Vintage Classics, 1990.

❖ James Fenimore Cooper

Cooper, James Fenimore, *The Deerslayer*. New York: Dodd Mead, 1979.

Cooper, James Fenimore, *Leatherstocking Tales I: The Pioneers, The Last of the Mohicans, The Prairie*. Des Moines: Library of America, 1985.

Van Zandt, Roland, *The Catskill Mountain House*. Hensonville, NY: Black Dome Press Corp., 1991.

❖ Rita Dove

Alexander, Elizabeth, Interview with Rita Dove. *The Writer's Chronicle*, Volume 8, Number 32.

Havighurst, Walter, *Ohio: A Bicentennial History*. New York: W. W. Norton & Co., Inc., 1976.

Pack, Robert and Parini, Jay, ed., *Introspections: Contemporary American Poets on One of Their Own Poems*. Middlebury: Middlebury College Press, 1997.

Ratner, Steven, editor, *Giving their Word: Conversations with Contemporary Poets*. Amherst, MA: University of Massachusetts Press, 2002.

❖ Ralph Waldo Emerson

Dole, Nathan Haskell, "Life of Ralph Waldo Emerson" (From the Introduction to *Early Poems of Ralph Waldo Emerson*, 1899). http://www.emersoncentral.com (July 2009).

Emerson, Ralph Waldo, *The Portable Emerson*. New York: The Viking Press, Inc., 1946.

Schreiner, Samuel A., *The Concord Quartet: Alcott, Emerson, Hawthorne, Thoreau, and the Friendship that Freed the American Mind*. Hoboken, NJ: John Wiley and Sons, Inc., 2006.

❖ William Faulkner

Faulkner, William, *Absalom, Absalom!*. New York: Vintage, 1991.

Faulkner, William, *The Hamlet*. New York: Vintage, 1991.

Oates, Stephen B., *William Faulkner: The Man and the Artist*. New York: Harper & Row Publishers, 1987.

❖ Richard Ford

Barton, Laura, "Other Voices, Other Rooms." *The Guardian*, February 8, 2003.

Dobozy, Tamas, "How Not to Be a 'Dickhead': Partisan Politics in Richard Ford's Independence Day." *Critical Survey*, Volume 18, Issue 1 (2006).

Ford, Richard, *Independence Day*. New York: Vintage, 1996.

Ford, Richard, *The Lay of the Land*. New York: Knopf, 2006.

Ford, Richard, *The Sportswriter*. New York: Vintage, 1995.

❖ Richard Ford *(cont'd.)*

Kaplan, Michael, "Ford Tough: Pulitzer Prize Winner Richard Ford On Why We Need Literature, the Importance of Imagination, and His Propensity to Get Into Fistfights." *Book* (March-April 2002).

McGrath, Charles, "A New Jersey State of Mind." *The New York Times*, October 25, 2006.

❖ Robert Frost

Burnshaw, Stanley, *Robert Frost: Himself*. New York: George Braziller, Inc., 1986.

Frost, Robert, *The Poetry of Robert Frost*. New York: Henry Holt and Company, 1975.

Frost, Robert, *Letters of Robert Frost to Louis Untermeyer*. New York: Holt, Rinehart and Winston, 1963.

Orton, Vrest, *Vermont Afternoons with Robert Frost*. Rutland, VT: Academy Books, 1979.

Special thanks to Bill Gleed, Caretaker of the Robert Frost Homestead in Derry, New Hampshire.

❖ Nathaniel Hawthorne

McFarland, Philip, *Hawthorne in Concord*. New York: Grove Press, 2004.

Special thanks to Mr. Robert Derry at The Wayside for his tremendous help and encouragement.

Special thanks also to the staff at the Old Manse and to the Minute Man Historical Park, Concord.

❖ Ernest Hemingway

Beegel, Susan F., *Hemingway's Neglected Short Fiction: New Perspectives*. Tuscaloosa: University of Alabama Press, 1992.

Helstern, Linda Lizut, "Indians, Woodcraft, and the Construction of White Masculinity: The Boyhood of Nick Adams." *The Hemingway Review*, Vol. 20 (2000).

Hemingway, Ernest, *The Nick Adams Stories*. New York: Scribner Paperback Fiction, 1972.

Mellow, James R., *Hemingway: A Life Without Consequences*. New York: Houghton Mifflin Company, 1992.

Reynolds, Michael, *The Young Hemingway*. New York, London: Basil Blackwell, Inc., 1986.

Sanford, Marcelline Hemingway, *At the Hemingways: A Family Portrait*. Boston, Toronto: Little, Brown, & Company, 1961.

Svoboda, Frederic J. and Waldmeir, Joseph J., *Hemingway: Up in Michigan Perspectives*. East Lansing: Michigan State University Press, 1995.

❖ Langston Hughes

Bascom, Lionel C., *A Renaissance in Harlem: Lost Voices of an American Community*. New York: Avon Books, 1999.

Bernard, Emily, Ed., *Remember Me to Harlem: The Letters of Langston Hughes and Carl Van Vechten, 1925-1964*. New York: Alfred A. Knopf, 2001.

Hughes, Langston, *The Big Sea: An Autobiography by Langston Hughes*. New York: Hill and Wang, 1993.

Hughes, Langston, *The Collected Poems of Langston Hughes*. New York: Vintage Books, 1994.

Rampersad, Arnold, *The Life of Langston Hughes, Volume I: 1902-1941, I, Too, Sing America*. New York: Oxford University Press, 1986.

❖ Washington Irving

Irving, Washington, *A History of New York*. New York: G.P. Putnam's Sons, 1893. (Courtesy of Google)

❖ Robinson Jeffers

Brophy, Robert, "Jeffers's 'Apology for Bad Dreams' Revisited." *Jeffers Studies*, Vol. 8, No. 2 (Fall 2004): 3-20.

Zaller, Robert, "Landscape as Divination: Reading 'Apology for Bad Dreams'." *Jeffers Studies*, Vol. 8, No. 2 (Fall 2004): 21-30.

Special thanks to the staff at Tor House.

❖ Sinclair Lewis

Hutchisson, James M., *The Rise of Sinclair Lewis, 1920-1930*. University Park: The Pennsylvania State University Press, 1996.

Schorer, Mark, *Sinclair Lewis: An American Life*. New York: McGraw-Hill, 1961.

❖ Herman Melville

Arvin, Newton, *Herman Melville*. New York: Grove Press, 1950.

Parker, Hershel, *Herman Melville: A Biography*. Baltimore: Johns Hopkins University Press, 1996.

Special thanks to Louise A. McCue, Executive Director, Berkshire County Historical Society at Arrowhead.

❖ Henry Miller

Ferguson, Robert, *Henry Miller: A Life*. New York: W.W. Norton & Company, Inc., 1991.

Miller, Henry, "A Boyhood View of the Nineties." *New York Times*, October 17, 1971.

Miller, Henry, *Book of Friends*. Santa Barbara: Capra Press, 1976.

Miller, Henry, *Henry Miller: Letters to Emil*. New York: New Directions, 1989.

Miller, Henry, *My Life and Times*. New York: Gemini Smith, Inc., 1971.

Miller, Henry, *The Henry Miller Reader*. New York: New Directions, 1969.

❖ Toni Morrison

Angelo, Bonnie, Interview in *Time*, May 22, 1989.

Dowling, Collette, Profile in *The New York Times Magazine*, May 20, 1979.

Interview with Toni Morrison in the *Lorain Journal*, January 16, 1982.

Morrison, Toni, *Sula*. New York: Alfred A. Knopf, 1973.

Morrison, Toni, *The Bluest Eye*. New York: Vintage, 2007.

Ruas, Charles, *1987 Fiction Writers Market*. Writers Digest Books, 1987.

Special thanks to Valerie Smith, Public Services Coordinator, Adult Services Department of the Lorain Public Library.

❖ Flannery O'Connor

Cash, Jean W., *Flannery O'Connor: A Life*. Knoxville: University of Tennessee Press, 2003.

O'Connor, Flannery, *The Habit of Being*. New York: Farrar, Straus and Giroux, 1979.

O'Connor, Flannery, *Wise Blood*. New York: Farrar, Straus and Giroux, 1990.

Special thanks to Craig Amason, Executive Director, The Flannery O'Connor – Andalusia Foundation.

❖ E. Annie Proulx

Bray, Rosemary L., "The Reader Writes Most of the Story." *New York Times*, March 22, 1992.

Interview with Katie Bolick, *The Atlantic Online*, November 12, 1997. http://www.theatlantic.com/unbound/factfict/eapint.htm (July 2009).

Interview with Charlie Rose, June 3, 1999. http://www.charlierose.com/view/interview/4254 (July 2009).

McGaugh, Scott, *The Life and Times of Owen Wister's The Virginian and Jackson Hole*. San Diego: Scott Communications Group, Inc., 2007.

Proulx, Annie, *Close Range: Wyoming Stories*. New York: Scribner Paperback Fiction, 1999.

Varvogli, Aliki, *The Literary Encyclopedia*. http://www.litencyc.com/php/speople.php?rcc=true&UID=3654 (July 2009).

Wister, Owen, *The Virginian: A Horseman of the Plains*. New York: Macmillan, 1902.

Writer's Program of the Work Projects Administration, Wyoming, *Wyoming: A Guide to its History, Highways, and People*. New York: Oxford University Press, 1941.

http://www.notablebiographies.com/Pe-Pu/Proulx-E-Annie.html (July 2009).

❖ Philip Roth

Alvarez, Al, "The Long Road Home." *The Guardian*, September 11, 2004.

Brown, Jeffrey, interview on Jim Lehrer NewsHour online, November 10, 2004. http://www.pbs.org/newshour/bb/entertainment/july-dec04/philip-roth_10-27.html (July 2009).

Parks, Brad "Newark 1967" – four-part series on *NJ.com*, posted July 8-11, 2007.

Roth, Philip, *The Plot Against America*. New York: Houghton Mifflin, 2004.

Roth, Philip, *Portnoy's Complaint*. New York: Random House, 1969.

Roth, Philip, "Writing American Fiction." *Commentary*. March 1961: 223-233.

Roth, Philip, *Zuckerman Bound*. New York: Literary Classics of the United States, 2007.

Rothstein, Mervyn, "To Newark, With Love. Philip Roth." *New York Times*, March 29, 1991.

"I Married a Communist." Interview on Houghton Mifflin Website. http://www.houghtonmifflinbooks.com/authors/roth/conversation.shtml (July 2009).

❖ Wallace Stegner

Benson, Jackson J., *Down by the Lemonade Springs: Essays on Wallace Stegner*. Reno: University of Nevada Press, 2001.

Stegner, Page and Stegner, Wallace, *Wolf Willow: A History, a Story, and a Memory of the Last Plains Frontier*. New York: Penguin Classics, 2000.

Stegner, Page and Stegner, Wallace, *Marking the Sparrow's Fall*. New York: MacMillan, 1999.

Stegner, Wallace, *The American West as Living Space*. Ann Arbor: The University of Michigan Press, 1987.

Stegner, Wallace, *Where the Bluebird Sings to the Lemonade Springs*. New York: Random House, 1992.

❖ John Steinbeck

Parini, Jay, *John Steinbeck: A Biography*. New York: Henry Holt & Co., 1995.

Starr, Kevin, *Endangered Dreams: The Great Depression in California*. New York: Oxford University Press, 1996.

John Steinbeck, *Travels with Charley. In Search of America*. New York: Penguin Classics, 1997.

❖ Henry David Thoreau

Canby, Henry Seidel, *Thoreau*. Gloucester: Peter Smith, 1965.

Thoreau, Henry D., *Walden: An Annotated Edition*. New York and Boston: Houghton Mifflin Company, 1995

❖ John Updike

Oates, Joyce Carol, "So Young!" review of *Rabbit at Rest. New York Times* September 30, 1990, Sunday, Late Edition - Final Section 7; Page 1, Column 1; Book Review Desk.

Updike, John, *The Early Stories*. New York: Alfred A Knopf, 2003.

Updike, John. *Rabbit Angstrom: The Four Novels : Rabbit, Run, Rabbit Redux, Rabbit Is Rich, Rabbit at Rest*. New York: Everyman's Library, 1995.

Special thanks to Herb Yellin, David Silcox and Jack De Bellis for the tour of Reading, Shillington, and Plowville.

❖ Thomas Wolfe

Johnston, Carol. "Thomas Wolfe's First Triumph: 'An Angel on the Porch'." *The Thomas Wolfe Review*, Vol. 13, No. 2 (Fall 1989): pp. 53-62.

Mitchell, Ted, *Thomas Wolfe: A Writer's Life*. North Carolina Division of Archives and History, 1999.

Walser, Richard, ed., *The Enigma of Thomas Wolfe*. Cambridge: Harvard University Press, 1953.

Edited by: Malena Watrous

Copyedited by: Julie Simpson

Book & Website Design by: Latitude 34° Studios

Prepress by: Bright Arts (H.K.) Ltd.

Printed and bound by: Toppan Printing Company (SZ) Ltd., China

Production Details:

Text Paper: 128 gsm Oji White A Matte Artpaper

Case: Japanese T-Saifu cloth over spine with Exceline front and back

Endsheets: 140 gsm Royal Elephant Woodfree

A note on the type in which this book is set:

William Caslon's typeface, released in 1722, was the first English type to seriously compete with the Dutch types of its day. It became widely used throughout the British Empire, including some restive colonies across the Atlantic. The first printings of the Declaration of Independence and the Constitution were set in Caslon. Printer Benjamin Franklin favored it. Such was its popularity that a saying arose: "When in doubt, use Caslon." The Adobe Caslon in this book was designed by Carol Twombly, who based her revival on specimen pages printed by William Caslon between 1734 and 1770.

The initial capitals throughout this volume are set in Young Baroque, designed by Doyald Young. Like Caslon, Young Baroque has English antecedents. In his book, *Dangerous Curves*, Young writes that his font "bows to the English Roundhands," and shows examples. Young Baroque's caps, as graceful as the Roundhand, are even more elaborate.